PACIFIC RIM TOURISM

Pacific Rim Tourism

Edited by

Martin Oppermann

Centre for Tourism Studies
Management Development Centre
Waiariki Polytechnic
Rotorua
New Zealand

CAB INTERNATIONAL

CAB INTERNATIONAL
Wallingford
Oxon OX10 8DE
UK

Tel: +44 (0)1491 832111
Fax: +44 (0)1491 833508
E-mail: cabi@cabi.org

CAB INTERNATIONAL
198 Madison Avenue
New York, NY 10016-4314
USA

Tel: +1 212 726 6490
Fax: +1 212 686 7993
E-mail: cabi-nao@cabi.org

A catalogue record for this book is available from the British Library, London, UK.

ISBN 0 85199 221 8

Library of Congress Cataloging-in-Publication Data
Oppermann, Martin
 Pacific rim tourism / edited by Martin Oppermann
 p. cm.
 Included index.
 ISBN 0-85199-221-8 (alk. paper)
 1. Tourist trade--Pacific Area--Congresses. I. Title.
G155.P25066 1997
338.4'791091823--dc21 97-34916
 CIP

Printed and bound in the UK by Biddles Ltd, Guildford and King's Lynn

Contents

Part five: ECONOMIC AND PLANNING ISSUES

Part six: THE FUTURE

Contributors

Richard W. Butler, Department of Management Studies, University of Surrey, Guildford, Surrey GU2 5XH, United Kingdom

Kye-Sung Chon, Conrad N. Hilton College of Hotel and Restaurant Management, University of Houston, Houston, Texas 77204, USA

Malcolm Cooper, University of Southern Queensland - WideBay, PO Box 910, Pialba, Queensland 4655, Australia

Kadir H. Din, Department of Geography, Universiti Kebangsaan Malaysia, UKM-42600 Bangi, Selangor, Malaysia

Larry Dwyer, Department of Management and Marketing, University of Western Sydney - Macarthur, PO Box 555, Campbelltown, New South Wales 2560, Australia

Carmel Goulding, Tourism Tasmania, GPO Box 399, Hobart, Tasmania 7001, Australia

Jody Hanson, Department of Education Studies, University of Waikato, Private Bag 3105, Hamilton, New Zealand

C. Michael Hall, Centre for Tourism, University of Otago, PO Box 56, Dunedin, New Zealand

Howard Harrell, Crowne Plaza Hotel, Richmond, Virginia, 1243 Clearwood Road, Richmond, VA 23233, USA

David Harrison, School of Social and Economic Development, University of the South Pacific, Suva, Fiji

Zhongliang Huang, Dinghushan Ecosystem Research Station, Guangzhou, Guangdong 510650, P.R. China

Gayle R. Jennings, Tourism and Leisure Studies, Faculty of Arts, Central Queensland University, Rockhampton, Queensland 4702, Australia

Geoffrey W. Kearsley, Centre for Tourism, University of Otago, PO Box 56, Dunedin, New Zealand

Guohiu Kong, Dinghushan Ecosystem Research Station, Guangzhou, Guangdong 510650, P.R. China

Glenda R. Lawton, Department of Management Systems, Massey University-Albany, Private Bag 102904, North Shore MSC, Auckland, New Zealand

Yiping Li, Department of Geography, The University of Western Ontario, London, Ontario N6A 5C2, Canada

Kreg Lindberg, School of Environmental and Information Science, Charles Sturt University, PO Box 789, Albury, New South Wales 2640, Australia

Shawna McKinley, RR#1, 4990 Plenton PG RD, Ladysmith, British Columbia, VOR 2EO, Canada

Nina Mistilis, Department of Marketing and Management, University of Western Sydney - Macarthur, PO Box 555, Campbelltown, New South Wales 2560, Australia

Jiangming Mo, Dinghushan Ecosystem Research Station, Guangzhou, Guangdong 510650, P.R. China

Mary Lee Nolan, Department of Geosciences, Oregon State University, Corvallis, Oregon 97331-5505, USA

Sidney Nolan, 2775 NW Glenwood Rd., Corvallis, Oregon 97330, USA

Martin Oppermann, Centre for Tourism Studies, Waiariki Polytechnic, Private Bag 3028, Rotorua, New Zealand

Stephen J. Page, Department of Management Systems, Massey University-Albany, Private Bag 102904, North Shore Mail Centre, Auckland, New Zealand

Rachel Samways, 10 Hallam Grove, Off West Avenue, Lincoln, United Kingdom

Ping Wei, Dinghushan Ecosystem Research Station, Guangzhou, Guangdong 510650, P.R. China

Heather Zeppel, Department of Leisure and Tourism Studies, University of Newcastle, Callaghan, New South Wales 2308, Australia

Friedrich Zimmermann, Department of Geography and Regional Studies, University of Graz, A-8010 Graz, Austria

Acknowledgements

This book brings together a large number of contributions on topics of concern to Pacific Rim tourism. The majority of these papers have been presented at the *Pacific Rim Tourism Conference,* which was held in Rotorua, New Zealand, in November 1996. Papers presented at that conference have been reworked from their original and/or were only available in abstract format at that time.

The *First Pacific Rim Tourism Conference* was considered by most attendees to be a huge success and the interest in Pacific Rim tourism issues was certainly a contributing factor. The rapid growth in tourism research and education in many Pacific Rim countries was also noted and a follow-up Conference is currently in the planning stages.

I would like to thank all the contributors for their efforts in revising and/or writing their contributions for this book. I believe the width of the topics selected combined with the authority of these writers in their fields are making this book a valuable contribution to the tourism literature on the Pacific Rim.

The encouragement of Tim Hardwick (CAB International) and his initiative in conceiving this book idea is greatly appreciated, as is the patience of the staff at CAB International with proof-reading the manuscript.

August 1997 Martin Oppermann

Chapter one:

Introduction to Pacific Rim Tourism

Martin Oppermann
Centre for Tourism Studies, Waiariki Polytechnic, Private Bag 3028, Rotorua, New Zealand

Introduction

Over the last one to two decades, the Pacific Rim region has gained a place in the international limelight of economic and political attention. Largely based on tremendous economic growth rates that were achieved in several subregions and/or countries over an extended period, at a time when many other world regions experienced severe recessions or otherwise slow economic or even negative growth, the world's attention has focussed on the Pacific Rim in order to gain a better understanding of how such growth can be achieved. Especially in the context of developing countries, a categorization into which most East and South East Asian countries belonged to well into the 1970s or even 1980s, the rise of the Asian Dragons or Asian NICs (newly industrialized countries) has given hope to 1other developing countries finally also being able to achieve 'development status'.

The economic boom in several Pacific Rim countries was accompanied by an expansion of the middle class and rising incomes in general. In consequence, tourism demand within the region grew at a much higher rate than elsewhere resulting in a rapid expansion of those countries' share in world tourism. Hence, the fact that the first two regional-oriented tourism journals (*Asia Pacific Journal of Tourism Research* and *Pacific Tourism Review*) were devoted towards tourism in the wider Pacific Rim region may not be too much of a surprise. Yet, before turning the discussion towards tourism and tourism growth, a closer look at what actually constitutes the Pacific Rim is required as there are several notions as to which countries and/or regions should be included or excluded. Even the two aforementioned tourism journals and their titles indicate the possible conflict and misinterpretation of what constitutes the Pacific Rim and/or Asia-Pacific.

1

Tourism Development in the Pacific Rim

Defining Pacific Rim

A look through the literature reveals that there are several terms in use which are sometimes employed interchangeably, sometimes used differently. The most widely used terms are, besides Pacific Rim, Asia-Pacific and Pacific Basin. And even the meanings of each of these terms by itself is open to debate as to what area/countries it actually covers. Asia-Pacific commonly refers to Asia, especially East and South East Asia, Australia, New Zealand and the Pacific Islands. On some occasions, it simply denotes the Asian countries bordering the Pacific Ocean. However, others include North America (Canada and the United States) with Asia-Pacific and yet others stretch the concept towards including Central and South American countries as well. For example, the Asia Pacific Economic Corporation (APEC) also includes Chile as a member country. The Pacific Asia Travel Organization (PATA), on the other hand, does not include South American countries but does embrace Mexico. It also stretches beyond the Asian countries bordering the Pacific to countries as far away as Pakistan. The economic prosperity and bright future prospects of Asia, and especially East and South East Asia, result in the interesting phenomenon that Australia and New Zealand often want to be considered and included in everything 'Asian', particularly where it relates to economic and trade unions. This is very obvious in the World Tourism Organization's (WTO) regional grouping definitions where Australia and New Zealand come under the grouping 'Australasia' despite being the only two members of that group with no Asian countries.

The term Pacific Rim is probably even wider open to discussion as to what it includes and one can distinguish between geographic-political, economic, historical, and attitudinal approaches as to what area Pacific Rim encompasses.

Geographic-Political

The fact that both terms, Asia-Pacific and Pacific Rim, make specific reference to geographic units indicates the importance of geographic boundaries in determining the extent of each respective area. The dominant inclusion of 'Asia' in the term Asia-Pacific suggests that the emphasis is on Asia rather than the Pacific. In consequence, this term has been mostly used to denote a region that includes Asia as well as Australia, New Zealand and other Pacific Islands. Often, the term East Asia-Pacific is used to denote a specific subregion, namely those East Asian countries bordering the Pacific as well as Australia, New Zealand and other Pacific Islands. Again, in some instances, some authors would include North America in the definition as well. The region East Asia-Pacific is what some see as constituting the Pacific Rim.

In contrast to Asia-Pacific, the term Pacific Rim places much more emphasis on the Pacific itself. The term 'Rim' then specifies that it is not only the Pacific Ocean itself and whatever islands therein but also the countries rimming the Pacific Ocean. Yet this gives rise to the problem of those countries that are landlocked but are

obviously part of the Pacific region, such as Laos.

With both terms the issue arises whether to include the countries bordering the Pacific as a whole or only those parts which are directly connected to the Pacific Ocean. In the cases of the United States and Canada, for example, should New York and Toronto be included? Obviously they have very little to do with other Pacific countries *per se*. Similarly, is Perth in Western Australia part of the Pacific where the Indian Ocean is so much closer? Or what parts of Russia do belong to the Pacific region? It is here where the term Pacific Basin arguably provides the best solution as it uses the watershed approach towards defining what belongs to the Pacific Ocean. Hence, only the area west of the Rocky Mountains would be included or only those parts of Australia east of the Blue Mountain range. This approach also allows for inclusion of countries such as Laos which are not directly bordering the Pacific but which are so much interrelated with their neighbouring countries that border the Pacific.

So why has the term Pacific Basin not found more widespread acceptance? The problem with it is that while it appears to be a sensible approach towards defining the region in question, it is most unpractical, especially with respect to data issues. The most comprehensive data is generally available on national level rather than on state or district level, particularly with respect to tourism data. For example, while international tourist arrivals to Australia are fairly easily registered, domestic arrivals from Western Australia in the eastern parts of New South Wales or Queensland are hardly differentiated. However, if the watershed approach would be used such arrivals would need to be counted to gain an idea of total arrivals in the Pacific Basin area. Similarly, international arrivals to the United States and Canada are generally counted but very imprecise data exist on domestic arrivals from the eastern states or provinces in the western parts, such as in British Columbia, Oregon or California: hence the prevalence of geographic-political definitions over simply geographic ones.

Economic

Hall (1994, 1997) argued that economic linkages are more important in defining the Pacific Rim than geographic boundaries. He then used this criterion to exclude Central and South American countries in his discussion of Pacific Rim tourism. While there is certainly some validity in his approach, one needs to recognize, however, that economic or trade linkages are flexible - they vary considerably over time. For example, New Zealand's trade with Asian countries was only about 14 per cent of New Zealand's total trade in 1970. This percentage has increased to more than 40 per cent by the mid-1990s and is expected to grow even further. Hence, while today New Zealand is fairly well integrated, trade-wise, with Asia, this was hardly the case two or more decades ago. Similarly, while Asian-South American trade ties may be minor today, this is likely to increase considerably in the years and decades to come. Hence, to exclude or include countries into a definition may seem appropriate according to contemporary purposes but does not provide for a more visionary perspective. Interestingly enough, one economic organization, APEC, has moved towards the

recognition of further trade interests and has Central and South American countries as members.

Historical and Cultural

While some world regions share a lot of historical and/or cultural similarities, there are very few historical and/or cultural ties between all the countries that border the Pacific Ocean. This is not to say that specific subregions could not be classified along such lines. For example, Spanish-America would denote those countries that came under Spanish colonial rule from the 15th century onwards and shared much of the same history as a consequence. They share the same language and, with respect to tourism resources, feature a similar range of attractions, for example their Indian heritage and Spanish colonial buildings.

Especially in Asia, however, there are a wide range of historical developments and cultures which do not allow for such a historical and/or cultural definition. At various times different countries expanded their empires and/or rule into Asia, such as China, Japan, India, United Kingdom, The Netherlands and Spain. Some countries, such as Thailand, remained independent throughout history. In essence, the variety makes the Asian subregion of the Pacific Rim a rich mosaic of history and culture. Obviously this also constitutes a major tourism attraction, especially in those countries or areas which still feature many different cultures today, such as Malaysia.

Attitudinal

Perhaps one needs to consider the concept of the Pacific Rim from an attitudinal perspective. Whereas most other world regions are defined by continental boundaries, and thus a land-based perspective, the Pacific Rim is an ocean-based perspective which implicitly recognizes the diminishing importance of land boundaries. It is also a juxtaposition to the traditional Euro-centered perspectives where the Pacific Ocean is conveniently used as the rimming to the left- and right-hand side of the maps and, therefore, places into people's mind a discontinuity across the Pacific Ocean. Hence, the Pacific Rim concept needs to be seen as the recognition of the fact that countries on the opposite side of the Pacific Ocean are much closer than traditionally viewed. For example, for the Pacific states/provinces of the United States and Canada, Asian countries are often much more proximate than European countries. Consequently, trade orientation has shifted in many of the areas concerned from trade linkages with or via Europe towards other Pacific Rim countries.

The definition of Pacific Rim adopted in this book is one that follows the geographic and attitudinal arguments given above. Hence, Pacific Rim is defined as all countries and areas that border or are located within the Pacific Ocean (Fig. 1.1), not unlike the definition adopted by the new tourism journal *Pacific Tourism Review*.

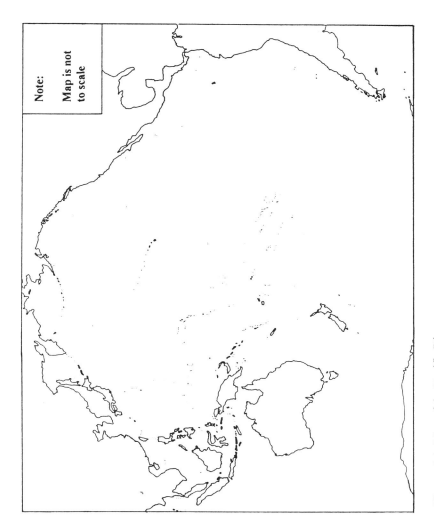

Note:

Map is not
to scale

Figure 1.1. Map of the Pacific Rim

Tourism and Development

Tourism is often viewed as an economic panacea. Sometimes dubbed the white or smokeless industry, it is considered to be a valuable development agent and an ideal economic alternative to more traditional primary and secondary sectors. Especially, international tourism from the developed to the developing countries is seen as generating crucially needed foreign exchange earnings, infusing badly needed capital into the economy of developing countries. For a lack of alternative development options and in view of the ever growing number of outbound tourists, most developing countries have opted for participation in the international tourism industry (Agel, 1993) and also most developed countries view tourism as an important component of their overall development strategy. Especially for small developing countries with few primary resources and a small industrial base, such as the small Pacific Island microstates, tourism often constitutes the only viable economic activity within their economic means and their resource base (Lee, 1987; Wilkinson, 1989).

A large number of the Pacific Rim countries are still considered developing countries, some are termed newly industrialized countries, while others are considered industrialized or developed countries. Hence, it seems appropriate to discuss the issue of development and the implications of it before proceeding towards an elaboration of specific tourism issues.

Development

Development can denote both a stage and a process of change (Pearce, 1989). However, both meanings command an appraisal and thus means to measure. In addition, an orientation of the 'development axis' seems necessary. Traditionally, in the context of nations and societies, development is commonly associated with economic situation and the most frequently used indicators have been Gross National Product (GNP) or Gross Domestic Product (GDP) per capita. These measures have been heavily criticized, however, because of their limited value for international comparisons. Often expressed in US$ per capita or as per capita income, the values differ substantially between separate organizations such as the World Bank and United Nations. In addition, many people in developing countries derive a large part of their income from sources outside the registered economic activities. The informal sector in form of subsistence production of food or the economy of the urban poor is sometimes more important than the formal sector. According to Nuscheler (1991), the informal sector employs some 60 per cent of the urban workforce and generates about 20 per cent of the national income in developing countries.

Furthermore, the expressed amounts in US$ per capita do not reveal the actual buying power of the local currency. Based on a survey by a UN research team (international comparison project), Nuscheler (1991) mentioned that the purchasing power parities (PPP) is two to three times higher than the per capita income would suggest. The per capita incomes also neglect the often wide disparities within

developing countries between regions, social strata, urban and rural areas, men and women, etc. It also ignores the ecological, social and cultural effects of 'development' by simply viewing the monetary value of, for example, a logged forest. Moreover, it places more merit on high value items such as television than on conceivably more functional items such as writing tables or pads (Nuscheler, 1991).

While GDP and per capita income still remain widely in use, other measures that integrate social aspects have been forwarded. The United Nations Development Programme uses the Human Development Index (HDI) which integrates life expectancy, literacy rate, and purchasing power parities (Trabold-Nübler, 1991). The HDI has not remained without reproach for a variety of reasons. But it would appear that any index that integrates more than just monetary variables is more plausible a reflection of existing differences among countries.

The World Bank, in its 1991 World Development Report, suggested that 'development is the most important challenge facing the human race' (World Bank, 1991:1).

The challenge of development, in the broadest sense, is to improve the quality of life. Especially in the world's poorest countries, a better quality of life generally calls for higher incomes - but it involves much more. It encompasses, as ends in themselves, better education, higher standards of health and nutrition, less poverty, a cleaner environment, more equality of opportunity, greater individual freedom, and a richer cultural life (World Bank, 1991:4).

Despite this recognition, the World Bank continues to distinguish countries by one parameter alone, their per capita income. It has established three categories: low-income countries (LIC), middle-income countries (MIC), and high-income countries (HIC). It further differentiates the middle-income category into a lower and upper middle-income. Using 1992 GNP data, low-income countries were those with a per capita income of US$675 or less, the lower middle was US$676-2,695, upper middle was US$ 2,696-8,355, and finally the high-income countries were those with US$8,356 or more (World Bank, 1994).

Another group of countries that are often distinguished are the Newly Industrializing Economies (NIC) or Take-off-Countries. These are countries that often show more similarities with the developed world than with the other developing countries and the point to include some of them among the developing countries is increasingly hard to make. Again, international organizations do not agree as to which countries should be classified as NICs. For example, while the World Bank and IWF include India, UNCTAD (United Nations Council on Trade and Development) does not. Outstanding among the NICs are the four Asian Tiger countries (Hong Kong, Singapore, South Korea and Taiwan) whose per capita income is already higher than the one of several European Community countries (e.g., Greece, Ireland and Portugal).

Whatever term is being used to group this wide range of countries, it appears fragile. The different development paths of the developing countries over the last few

decades have increased rather than reduced the dissimilarities among these countries (Körner, 1994; Nohlen and Nuscheler, 1993). Körner intimated that the central problem of developing countries, whatever their level of development, 'is the compulsion to develop resources under strong, often rapidly increasing population pressure' (1994:93). Hence, one major benefit of tourism development, namely the suggested human resource intensity and/or the provision of employment opportunities in general, appears to be well suited for developing countries in their struggle to provide an adequate number of jobs for their increasing population base.

Defining Tourists

There are many different opinions on who should be counted as a tourist. Is everybody away from home a tourist? What is home for migrant workers? Does one need to travel a certain distance before one graduates to a tourist? What may be an appropriate distance in vast area countries like Brazil, Canada, Russia, China or Brazil may mean several border crossings in Europe. Is travel purpose a deciding criterion with only people on strictly pleasure trips being tourists? It is futile to ponder all the ramifications of the diverse definitions and the interested reader is referred to works by Arndt (1978/79), Smith (1995) and Przeclawski (1993) who discussed definitions of tourism and tourists at length. In the international context, the World Tourism Organization's (WTO) definition of tourists and excursionists is widely recognized despite some recurring data problems. The WTO defines as an international tourist anybody who visits another country for more than 24 hours, but less than one year, irrespective of travel purpose. Travellers staying for less than 24 hours are defined as excursionists.

Yet, there remain several data issues unresolved, especially if one attempts international comparisons or longitudinal studies. Some of greatest obstacles one faces in analysing tourism on a supranational scale are data availability and compatibility. Even on a national level, most researchers will become frustrated at one point or the other because of changes in data gathering practices, unexplained changes in definition of tourists, non-compatibility of data from different sources, etc. In the Mexican case, for example, one can find tourist arrivals ranging from 6.4 million to 16.6 million for the year 1991 (Cockerell, 1993; WTO, 1994a, 1995c). Some are actually visitor arrivals, others are tourist arrivals and yet others are classified as air arrivals. Who is a tourist? And should land arrivals simply be discounted? And what data to use when none is available for a longer time period? These are but three simple, yet critical questions. Even relying on the same source, one may come across different figures. For example, in one publication the WTO mentioned 84 million arrivals to the Americas in 1990 (WTO, 1991), in contrast to 93.8 million in another publication (WTO, 1994a).

The aforementioned problems tend to multiply when one moves from a national to a regional level since one now deals with different countries, different tourism and statistics departments, different objectives, and many more potential areas of divergence. Hence, data availability varies from country to country and a comparative

study can only use, more often than not, the smallest common denominator or the simplest form of tourism data. This is usually total tourist arrivals because even in the breakdown of arrivals into different countries or regions of origin, the individual countries vary. For example, El Salvador provides a very detailed differentiation of its arrivals for 1992 (e.g., 77 tourists from Paraguay). Mexico, on the other hand, lists only its major segments, namely Canada, the United States and all other Latin American countries grouped into one category 'other C/S American countries' (WTO, 1994a).

A yet larger obstacle is presented to researchers when they attempt to do a longitudinal analysis instead of the common cross-sectional study. Definition and counting practices change; detailed breakdowns of tourist arrivals may be available in recent but not in earlier years. El Salvador, for example, provides detailed data for 1991 and 1992 but not for the earlier years. Another good example of definition changes is the annual publication of tourism statistics by the World Tourism Organization. Mexico used to be included in Central America but moved to the North America section in the early 1990s. Hence, a less observant researcher may be amazed at the sudden drastic decrease of tourist arrivals to Central America and a strong growth in North America.

Overview

The subsequent chapters of this book are arranged under six major categories:

- Tourism trends;
- Cultural and social issues;
- Ecotourism and sustainable development;
- Pacific Islands;
- Economic and planning issues; and
- The future.

Within the first section, Oppermann provides an overview of the development of international and intraregional tourist demand to and within the region. He highlights how intraregional demand has been the driving force of tourism in the Pacific Rim over the last few decades. Hall and Samways discuss the political and economic issues that are facing countries in the Pacific Rim region, specifically focussing on regional cooperation within the region. Hotel and resort specific industry trends are addressed by Harrell and Chon, who take a hands-on approach towards suggesting what is required to maintain a successful industry. Finally, Oppermann applies the tourism life cycle concept to outbound tourism and examines the emergence and development of the four Asian tourism 'tigers' Singapore, Hong Kong, Taiwan and South Korea. In contrast to many other discussions that focus on inbound tourism, that chapter looks at outbound tourism and provides suggestions as to what can be learned from such a perspective.

The second section deals with cultural and social issues and includes a wide range of different cases, ranging from longhouse tourism in Borneo (Zeppel) to the travel experience of cruisers (Jennings) and from cultural attractions in China and Canada (Li and Butler) to the use of sexual imagery in the marketing of Pacific destinations (Oppermann and McKinley). The section opens with a discussion by Din on the issue of indigenization of tourism development, detailing the current problems or even complete lack of such an approach and how such an approach might be used to arrive at a more equitable distribution of tourism's benefits.

The third section considers ecotourism and sustainability issues in the context of three widely different case studies. Lindberg *et al.* use a Biosphere Reserve in China to illustrate a range of management issues. On the other side of the Pacific, Nolan and Nolan raise the issue of sustainable development in the face of economic and political pressures on the Galápagos Islands, Ecuador. Concluding the section is Kearsley's discussion of social and physical impacts of hikers on New Zealand's backcountry environments.

Part four addresses a number of issues in the Pacific Islands, such as Harrison's elaborations on the topic of globalization and its impact and influence on tourism development in small island nations. Lawton and Page scrutinize the role of travel agents in providing health advice to travellers to the Pacific Islands, based on a survey of travel agents in New Zealand. Hanson uses an unusual approach towards raising the topic of sex tourism. Largely based on discussions with prostitutes, she provides an overview of the various issues involved in this industry.

Economic and planning issues are examined in section five. Cooper deliberates on the implications of the General Agreement on Trade of Services on emerging tourism destinations, using China as a specific example. Dwyer and Mistilis address MICE tourism in Australia and what needs to be done to turn it into a profitable tourism segment.

Lastly, the future of tourism is deliberated by Zimmermann in his chapter on the future of traditional versus new destinations, and by Oppermann who takes a more general view of might occur in the Pacific Rim in the years to come.

Chapter two:

International and Intraregional Tourism Demand in the Pacific Rim

Martin Oppermann

Centre for Tourism Studies, Waiariki Polytechnic, Private Bag 3028, Rotorua, New Zealand

Introduction

International tourism has expanded tremendously over the last several decades and is also predicted to expand even further well into the next millennium. In 1996, an estimated 592 million tourists travelled internationally and a multiple thereof domestically. According to WTO (1996b) estimates, domestic tourism demand constituted about 70 per cent of the total, international and domestic, demand in terms of tourist nights in commercial accommodation. This percentage also seems to be fairly stable (Table 2.1). In addition, one also needs to realize that a large portion of domestic demand is not incurred in commercial tourism establishments but rather in the residences of friends and relatives. Hence, the absolute number as well as relative share of domestic tourism can be expected to be even higher.

The World Tourism Organization (WTO, 1997b) has estimated that, over the next 25 years, there will be a strong growth in international travel of around 4 per cent annually, resulting in more than 700 million by the year 2000, topping one billion by 2010 and reaching 1.6 billion tourist arrivals by 2020 (Table 2.2).

Table 2.1. Domestic and International Tourism Demand (in million nights)

Demand	1990	1991	1992	1993	1994
Domestic	5,402	5,357	5,412	5,392	5,726
International	2,230	2,202	2,309	2,399	2,483

Source: WTO, 1996b

In particular, long haul travel is expected to increase considerably, enlarging its share from around 24 per cent in 1995 to 32 per cent by the year 2020 (WTO, 1997b). Of particular relevance to the Pacific Rim area is the fact that the East Asia-Pacific area is expected to sustain a fast rate of growth above the global average. On the other hand, international tourism growth in the Americas is forecasted to be below the world average (WTO, 1997a).

Notable in Table 2.2 is also the fact that tourism receipts have increased at a much faster rate than tourist arrivals, a function of the growing expenditures per tourist. Whereas in 1950 the receipt per international tourist was below US$100, this had increased to US$370 in 1980, US$580 in 1990 and exceeded US$710 in 1996. The faster rate of growth of tourism receipts than tourist arrivals might very well be the reason why so many National Tourism Organizations or Promotion Boards have switched to emphasizing their achievements in receipt terms rather than sheer tourist arrivals.

Table 2.2. International Tourist Arrivals and Receipts Worldwide

Year	Tourist Arrivals (in 1,000s)	Tourism Receipts (US$million)
1950	25,282	2,100
1960	69,320	6,867
1970	165,787	17,900
1980	286,249	105,198
1990	459,212	264,714
1991	465,844	271,880
1992	503,258	308,745
1993	517,607	314,249
1994	545,878	345,540
1995	566,384	393,278
1996*	591,864	423,022
2000**	702,000	n/a
2010**	1,000,000	n/a
2020**	1,600,000	n/a

Notes: * preliminary results, ** forecasts from 9 March 1997
Source: World Tourism Organization 1996a, 1997a, 1997b

International Tourism

Tourist Arrivals

As has been mentioned previously, several Pacific Rim countries and subregions have consistently outperformed many other countries and regions with respect to tourist arrival growth. Table 2.3 provides an overview of the phenomenal growth of tourism in the Pacific Rim region *vis-à-vis* other world regions. Due to the availability of data, the World Tourism Organization's major regional classifications were used and the reader is referred to the original source for a list of the geographical coverage of each region.

Obviously the fact that, amongst others, Brazil's tourist arrivals are included in the South America data and, therefore, in the Pacific Rim data as given in Tables 2.3 and 2.4 could result in an overrepresentation of the total arrivals for the Pacific Rim region. On the other hand, tourist arrivals to Russia including those in Far East Russia (e.g., Vladivostok) are included in the Europe data.

Table 2.4 provides an overview of tourist arrivals to the various Pacific Rim subregions. It indicates the wide divergence between the regions with respect to absolute tourist arrivals. While the three North American countries Canada, United States and Mexico registered over 100 million tourist arrivals in 1996, the five countries that compose Melanesia (Fiji, New Caledonia, Papua New Guinea, Solomon Islands, Vanuatu) received just 512,000 tourists between them.

Table 2.3. International Tourist Arrivals by World Region (in 1,000s)

Region	1980	1990	1994	1995	1996
Pacific Rim*	75,537	135,395	170,409	179,875	190,654
Africa	7,337	15,090	17,607	19,045	19,593
Caribbean	6,757	11,263	13,588	14,082	14,692
Europe	188,346	286,708	329,807	335,378	347,329
Middle East	5,992	7,577	9,868	13,703	15,121
South Asia	2,280	3,179	3,946	4,301	4,475
World	286,249	458,278	545,878	566,384	591,864

Note: * consisting of WTO regions East Asia-Pacific, North America, Central America and South America

Source: extracted from WTO 1996a, 1997a

Table 2.4. International Tourist Arrivals in Pacific Rim* Regions (in 1,000s)

Region	1980	1990	1995	1996	Growth 1990-1996
Americas****	**54,599**	**82,307**	**96,686**	**100,880**	**22.6%**
North America	47,321	71,924	80,443	83,868	16.6%
Central America	1,469	1,748	2,555	2,648	51.5%
South America	5,809	8,635	13,688	14,364	66.3%
East Asia-Pacific	**20,938**	**53,088**	**83,189**	**89,774**	**69.1%**
North East Asia	10,312	26,612	45,866	50,557	90.0%
South East Asia	8,300	21,316	29,251	30,495	43.1%
Australasia	1,370	3,191	5,135	5,675	77.8%
Melanesia	332	451	502	512	13.5%
Micronesia	433	1,255	2,096	2,183	73.9%
Polynesia	191	263	339	352	33.8%
Pacific Rim*	**75,537**	**135,395**	**179,875**	**190,654**	**40.8%**

Note: * consisting of WTO regions East Asia-Pacific, North America, Central America and South America;
 ** consisting of WTO regions North America, Central America and South America and excluding the Caribbean

Source: extracted from WTO 1995a, 1996a, 1997a

On a more detailed level one notes that the growth in the Pacific Rim has been far from consistent across all subregions. The highest growth in recent years has been achieved by North East Asia, Micronesia and Australasia (Australia and New Zealand) whereas tourist arrivals in North and Central America, but also Melanesia and Polynesia have been less buoyant (Table 2.4).

The fast rate growth of the East Asia-Pacific region versus the Americas has meant that in 1996 almost as many tourist arrivals were registered in the former region whereas the Americas accounted for 2.6 times as many tourist arrivals in 1980. And it appears only a matter of years before East Asia-Pacific will overtake the Americas with respect to tourist arrivals.

Tourism Receipts

Turning to tourism receipts, Table 2.5 provides an overview of the development of tourism receipts in the various Pacific Rim subregions: one notes the tremendous development in receipts in the East Asia-Pacific region from 1980 to 1996. Receipts grew almost ten times during that period whereas those in the Americas only quadrupled. As a result, tourism receipts in East Asia-Pacific were almost on par with those in the Americas and, as with tourist arrivals, can be expected to outgrow the latter in a few years.

The growth rates of tourism receipts in the 1990s for the individual subregions also indicate the wide differences not only between the Americas and East Asia-Pacific, but also within East Asia-Pacific. Whereas North East Asia, South East Asia and Australasia registered triple digit growth between 1990 and 1996, tourism receipts in the Pacific Islands grew only at about half that rate.

Table 2.5. International Tourist Receipts in Pacific Rim* Regions (in US$ million)

Region	1980	1990	1996	Growth 1990-96
Americas**	**21,891**	**60,726**	**92,938**	**53.0%**
North America	17,735	54,086	79,998	47.9%
Central America	500	869	1,562	79.7%
South America	3,656	5,771	11,378	97.2%
East Asia-Pacific	**8,648**	**38,830**	**82,203**	**111.7%**
North East Asia	3,873	17,605	37,162	111.1%
South East Asia	3,140	14,123	31,092	120.2%
Australasia	1,178	5,107	10,927	114.0%
Melanesia	146	377	556	47.5%
Micronesia	240	1,392	2,088	50.0%
Polynesia	71	226	378	67.3%
Pacific Rim*	**30,539**	**99,556**	**175,141**	**75.9%**

Note: * consisting of WTO regions East Asia-Pacific, North America, Central America and South America;
** consisting of WTO regions North America, Central America and South America and excluding the Caribbean

Source: extracted from WTO 1996a, 1997a

Table 2.6 presents data on tourism receipts per tourist from 1980 until 1996. It illustrates the wide differences amongst the subregions with respect to receipts per tourist. Quite outstanding has been the Australasia region (New Zealand and Australia) where receipts of close to US$2,000 per tourist were registered in 1996. On the other end of the spectrum was Central America were on average only US$590 were received from each tourist.

Interestingly enough, the average receipt per tourist in the Americas and East Asia-Pacific has been fairly similar over the whole period in question. And the US$919 received on average in the Pacific Rim is considerably higher than the world average of US$710. To what extent the differences in receipts per tourist are a function of length of stay cannot be derived from the WTO data. However, the very high expenditure in Australia and New Zealand is, to some extent, very much the result of the long average length of stay of about 28 days and 21 days respectively.

Table 2.6. International Tourist Receipts Per Tourist in Pacific Rim* Regions (in US$)

Region	1980	1990	1992	1994	1996
Americas**	**401**	**738**	**816**	**901**	**921**
North America	375	751	840	928	954
Central America	340	497	501	573	590
South America	629	668	703	783	792
East Asia-Pacific	413	**731**	**753**	**804**	**915**
North East Asia	376	661	616	671	735
South East Asia	378	662	796	867	1,020
Australasia	860	1,600	1,485	1,560	1,925
Melanesia	440	835	927	1,038	1,086
Micronesia	554	1,109	1,477	969	956
Polynesia	372	859	917	981	1,074
Pacific Rim*	**404**	**735**	**791**	**857**	**919**

Note: * consisting of WTO regions East Asia-Pacific, North America, Central America and South America;
 ** consisting of WTO regions North America, Central America and South America and excluding the Caribbean

Source: extracted from WTO 1996a, 1997a

Very few other countries register such long stays. For example, average length of stay of international visitors to Malaysia and Singapore are five and three nights respectively. According to WTO data (1996a), international tourist to Canada spent 2.2 nights in commercial accommodation. However, this already indicates the problem faced by many countries in their data provision, as not all nights are spent in commercial accommodation.

Travel Account

As has been noted above, a major factor in the rapid growth in tourist arrivals in Pacific Rim countries over the last few decades has been the swift and lasting economic expansion of several East and South East Asian economies. Along with the economic development came an increased income to most of their people, resulting in a growth of the middle class and, more importantly, of people who have the discretionary income available to travel overseas. Large and sustained trade surpluses in countries such as Japan and South Korea resulted in a policy adaption of encouraging their residents to travel overseas in order to show a tourism account deficit as a form of assuagement policy in order to avoid trade sanctions or barriers in other areas. Table 2.7 shows the tourism receipts and expenditures on a regional level. The difference between the two (receipts-expenditures) is called the travel account or travel balance.

Quite conspicuous in Table 2.6 is the difference in travel account for the Americas and East Asia-Pacific. While the former is very large and positive, the latter is almost zero. In fact, for most of the period 1980 to 1994, tourism expenditure by residents in the East Asia-Pacific region outnumbered tourism receipts in the region and the tourism account was largely negative. 1994 was the first year in the 1990s where travel receipts were higher than expenditures. The Americas, on the other hand, have consistently shown a positive tourism account in the 1990s.

Yet even within the Americas not all subregions had a positive account balance. In 1994, South American residents spent more money on their holidays than the international visitors to South America did. Also within the East Asia-Pacific region not all subregions performed consistently. North East Asia registered a very large negative tourism account whereas all other subregions, notably South East Asia, featured a positive account balance.

Table 2.8 exhibits the tourism receipts and expenditures of selected Pacific Rim and other countries. In 1993, the leading net exporters of tourism dollars in the Pacific Rim were Japan, Canada, Taiwan and South Korea. The countries with the largest positive travel account were the United States, China and Thailand. In an international comparison, Japan was only ranked second to Germany with respect to having the most negative travel account whereas the United States was second to none with regard to the largest travel account surplus. However, Table 2.8 also indicates that residents of many of those countries typically considered to be tourism destinations, such as Singapore, Thailand and Malaysia, also spend considerable amounts on their overseas travel.

Table 2.7. Tourism Receipts and Expenditures in Pacific Rim* Regions, 1994 (in US$ million)

Region	Tourism Receipts	Tourism Expenditures	Tourism Account
Americas**	**84,163**	**68,874**	**15,289**
North America	73,059	58,339	14,720
Central America	1,358	737	621
South America	9,746	9,798	-52
East Asia-Pacific	**61,915**	**61,834**	**81**
North East Asia	28,747	45,563	-16,816
South East Asia	23,341	10,687	12,654
Australasia	7,312	5,440	1,872
Melanesia	516	137	379
Micronesia	1,682	2	1,680
Polynesia	317	5	312
Pacific Rim*	**146,078**	**130,708**	**15,370**

Note: * consisting of WTO regions East Asia-Pacific, North America, Central America and
South America;
** consisting of WTO regions North America, Central America and South America
and excluding the Caribbean

Source: extracted from WTO 1996a, 1997a

Tourism and the Economy

One area where tourism generally receives high recognition is its potential as an
'export earner' and, on lesser basis, its contribution to the Gross National Product
(GNP). Table 2.9 presents the 1994 contribution of tourism to GNP and the export
earnings for the various Pacific Rim subregions. Quite obvious is the large
discrepancy between the regions. Despite the relatively small total earnings derived
from tourism by the Pacific Island regions, tourism features as a quite important factor
in their overall (export) economy.

Table 2.8. Travel account of selected countries, 1993 (in US$ million)

Country	Tourism Receipts	Tourism Expenditures	Tourism Account
Pacific Rim			
Japan	3,557	26,860	-23,303
Canada	5,897	10,629	-4,732
Taiwan	2,943	7,585	-4,642
South Korea	3,510	4,105	-595
Malaysia	1,876	1,960	-84
Chile	744	560	184
Mexico	6,167	5,562	605
Singapore	5,793	3,022	2,771
Thailand	5,014	2,092	2,922
China	4,683	555	4,128
United States	57,621	40,564	17,057
Other Countries			
Germany	10,509	37,512	-27,003
United Kingdom	13,451	17,431	-3,980
Brazil	1,449	1,842	-393
Egypt	1,332	1,048	284
Tunisia	1,114	203	911
Morocco	1,243	245	998
India	1,487	400	1,087
Turkey	3,959	934	3,025
Italy	20,521	13,053	7,468
Spain	19,425	4,706	14,719

Source: calculated from WTO, 1995a

The high dependence of many of these island nations on tourism can be considered a double-edged sword: on one hand, tourism is a relatively high growth industry and these countries can expect this particular industry to grow even further. On the other hand, if there should be a downturn in consumer demand for their tourism product, their economies, highly dependent on tourism, are very vulnerable.

In Micronesia in 1994, for example, 54 per cent of the GNP was attributed to tourism despite registering about 2 million arrivals and receipts of US$2 billion. While this particular region is very outstanding especially with regard to tourism's contribution to GNP, it certainly indicates the importance that tourism can play in a small and little-diversified economy.

Table 2.9. Tourism and the National Economy, 1994

Region	Tourism Receipts as	
	% of GNP**	% of export earnings
Americas*	**1.1**	**10.8**
North America	1.0	9.9
Central America	3.3	20.5
South America	0.9	9.1
East Asia-Pacific	**0.9**	**5.5**
North East Asia	0.5	3.5
South East Asia	4.5	9.0
Australasia	2.1	12.2
Melanesia	5.0	14.1
Micronesia	54.0	28.7
Polynesia	8.8	55.2

Note: * consisting of WTO regions North America, Central America and South America
 and including the Caribbean
 ** Gross National Product

Source: extracted from WTO, 1996a

Intraregional Demand

At least in the context of developing countries, which most of the Pacific Rim countries are considered to be, international tourism demand has traditionally been considered to be coming from the industrialized countries in Europe, North America, Japan or Australia/New Zealand. As Oppermann and Chon (1997a) have already shown, however, international tourism to developing countries is also largely generated by other developing countries rather than developed or industrialized countries. In general, intraregional demand generally contributes the majority of the overall demand (Oppermann and Chon, 1997a). This is also the case in several subregions within the Pacific Rim (Chon and Oppermann, 1996; Oppermann, 1994/95; Oppermann and Chon 1997a). Tables 2.10 and 2.11 clearly demonstrate that intraregional demand is the most important demand factor in most world regions. While there are some problems associated with the data in Table 2.11 (see Note underneath the Table), the development of intraregional demand between 1988 (Table 2.10) and 1994 (Table 2.11) reveals that especially in East Asia-Pacific and Africa intraregional demand has gained even more in importance. In the Americas a slight decrease was notable which was partly a function of the increased demand from East Asia-Pacific for these countries.

Table 2.10. Intraregional Demand, 1988 (in %)

| | Destination | | | | | |
Origin	Africa	Americas	Europe	East Asia-Pacific	Middle East	South Asia
Africa	33.0	0.3	2.4	0.6	23.6	2.4
Americas	3.8	80.7	7.8	13.1	4.5	9.2
Europe	48.5	12.9	86.2	16.0	27.6	38.4
E. Asia-Pacific	1.6	5.6	2.6	66.7	8.9	11.7
Middle East	12.8	0.2	0.7	0.8	33.4	5.9
South Asia	0.3	0.3	0.3	2.9	2.1	32.4

Source: WTO, 1994a

Table 2.11. Intraregional Demand, 1994 (in %)

Origin	Destination					
	Africa	Americas	Europe	East Asia-Pacific	Middle East	South Asia
Africa	45.1	0.2	1.2	0.5	8.5	2.3
Americas	3.2	74.9	6.3	7.3	4.6	9.5
Europe	34.7	14.3	77.4	12.3	23.5	45.3
E. Asia-Pacific	1.7	7.0	2.9	76.2	7.8	13.2
Middle East	3.8	0.2	0.6	0.4	35.8	5.0
South Asia	0.3	0.2	0.1	1.5	4.5	24.4

Note: The percentages at destinations do not add up to 100% with no explanation provided in the original source. One factor could be the exclusion of nationals living in overseas who are counted as tourists but not attributed to specific countries/world regions.

Source: WTO, 1996a

A Country Perspective

The Big Players

If differences between the various subregions are already considerable, these tend to magnify if one takes a look at the individual country level. Table 2.12 presents the top 15 Pacific Rim tourism destinations with respect to tourist arrivals from 1980 to 1996.

In 1996, almost 60 per cent of all tourist arrivals in Pacific Rim countries are accounted for by the top four destinations United States, China, Mexico and Canada. If one includes fifth-ranked Hong Kong which also registered arrivals in excess of 10 million then this percentage moves up to around 65%. Hence, a few countries draw the vast majority of all tourist arrivals in the region.

A closer examination of Table 2.12 reveals that most of the top 15 destinations are located in Asia, only the three above-mentioned North American countries as well as Australia managed to penetrate into the ranks. However, one also notes that growth rates in the 16 years from 1980 to 1996 have been far from uniform with the North American countries registering slower relative growth, although still gaining more absolute arrivals. Perhaps the most noticeable growth occurred in Indonesia, which was not even ranked among the top 15 in 1980 but rose to ninth place by 1996.

Table 2.12. Top 15 Pacific Rim Tourism Destinations (tourist arrivals in 1,000s)

Destination	1980	1994	1996	Growth 95-96 (in %)
United States	22,500	45,504	44,791	3.2
China	3,500	21,070	26,055	11.5
Mexico	11,945	17,182	21,732	7.8
Canada	12,876	15,971	17,345	2.7
Hong Kong	1,748	9,331	11,700	14.7
Malaysia	2,105	7,197	7,742	3.7
Thailand	1,847	6,166	7,201	3.6
Singapore	2,562	6,268	6,608	2.9
Indonesia	527	4,006	4,475	3.5
Macau	1,656	4,489	4,275	1.7
Australia	905	3,362	4,167	11.8
South Korea	976	3,580	3,815	1.7
Taiwan	1,393	2,127	2,441	4.7
Philippines	989	1,414	2,054	16.7
Japan	844	1,915	1,991	15.0

Source: WTO, 1996a, 1997a

With respect to tourist receipts (Table 2.13), the discrepancies between the first placed United States and the second ranked Hong Kong is even more pronounced than with regard to tourist arrivals. The United States alone accounts for about one-third of all tourism receipts in the Pacific Rim and the top three destinations have a share of almost half.

However, Australia, Japan, New Zealand and South Korea outperform the United States with respect to earnings per tourist. A large number of the U.S. visitors are cross-border travellers from Canada and Mexico who often do not stay very long and/or will stay with relatives, thus decreasing the overall expenditure of tourists to the United States.

Table 2.13.Top 15 Pacific Rim Tourism Earners, 1996

Destination	Receipts in 1996 (in US$ million)	Growth 95-96 (in %)	Receipts per tourist
United States	64,373	5.3	1,440
Hong Kong	11,200	30.2	960
China	10,500	20.2	400
Singapore	9,410	14.6	1,420
Canada	8,727	8.9	500
Thailand	8,600	12.2	1,190
Australia	8,264	16.4	1,980
Mexico	6,898	11.9	320
South Korea	6,315	13.2	1,660
Indonesia	5,662	8.3	1,270
Malaysia	4,409	12.8	570
Japan	3,576	10.8	1,800
Taiwan	3,075	-6.4	1,260
Philippines	2,790	13.9	1,360
New Zealand	2,663	23.1	1,770
Macau	2,475	-1.0	580

Source: WTO, 1997a

There were also wide variations in the growth rate of tourism receipts between 1995 and 1996. However, one needs to realize that some of these variations were due to foreign currency exchange fluctuations between the respective countries' currencies and the US dollar. For example, the New Zealand dollar appreciated against the US dollar in that time period, therefore, 'artificially' increasing the relative growth in that time period.

Countries with a very low expenditure per tourist are generally those which receive a large share of their tourist arrivals from neighbouring countries who in turn have a very low length of stay, for example Malaysia and Mexico.

Intraregional Destination Preferences

In lieu of an endless elaboration of the tourist arrivals to individual countries it shall suffice here to highlights a few of the main issues using intraregional flow data provided by the Pacific Asia Travel Association (PATA, 1996). A more detailed analysis of outbound flows from the four Asian tourism 'tigers' (Hong Kong, Singapore, South Korea and Taiwan) as well as Japan is provided in a later chapter (Chapter five).

Table 2.14 presents the top three destinations each for residents from selected Pacific Rim countries. Due to the geographical restriction of PATA, these top destination countries have to be located within the PATA membership area (see Chapter one for a discussion).

Table 2.14. Top Three Destinations in PATA Member Countries of Tourists from Selected Pacific Rim Countries, 1995

Origin Country	Primary Destination	Secondary Destination	Tertiary Destination
PR China	Hong Kong	Macau	Thailand
Taiwan	Hong Kong	Japan	Singapore
Hong Kong	Thailand	Singapore	Taiwan
Japan	United States	Hong Kong	South Korea
South Korea	Japan	United States	PR China
Indonesia	Singapore	Malaysia	Hong Kong
Malaysia	Thailand	Singapore	Indonesia
Philippines	Hong Kong	PR China	South Korea
Singapore	Indonesia	Thailand	Malaysia
Thailand	Malaysia	Hong Kong	Singapore
Vietnam	Thailand	Singapore	South Korea
Australia	United States	New Zealand	Singapore
New Zealand	Australia	Singapore	Fiji

Source: extracted from PATA, 1996

One can note the often close geographical relationship between the origin and the top destination countries. In the case of Malaysia and Singapore, for example, the respective top three destinations are all neighbouring countries or other members of ASEAN.

In other cases, historical, business and ethnic relationships or language similarities appear to be prime cause. Noticeable is that the United States appears only three times within the list, namely for Japan, South Korea and Australia. Similarly, Australia and New Zealand appear only on each other's top three list but nor for any of the Asian countries.

Singapore, followed by Hong Kong and Thailand, is listed most often. This appears to be a reflection of its function as a regional distribution hub, at least with respect to air traffic. A similar function is held by Hong Kong and to a lesser extent Thailand. Hong Kong, especially, is seen as the gateway to China and much traffic directed to mainland China is channelled through Hong Kong. To what extent this pattern will persist in the post-1997 era remains to be seen.

Length of Stay

The short average length of stay in some Pacific Rim countries is obvious from Table 2.15. Singapore, Malaysia and Hong Kong all have average lengths of stay shorter than five days. On the other hand, there are some countries with relatively long stays, such as Australia and New Zealand. However, overall the trend is probably towards a reduction in the average length of stay as more and more travellers are on short-break tours and/or come from origin countries where the amount of paid holidays is limited, such as in Japan, South Korea and Taiwan.

The presented averages naturally hide the fact that some origin markets have very short stays whereas others have longer ones. In the new Zealand case, for example, average length of stay of its visitors ranged from around 5 nights for South Korean visitors to more than 30 nights for some European markets (NZTB, 1996b). As was demonstrated for the same country, the differences in length of stay are a major factor in the differing geographical demand distribution within the country (Oppermann, 1993, 1994a, 1994b, 1997). In a comparative study of several Pacific Rim countries, Oppermann (1994c) showed that tourists from different nationalities seem to travel differently within the destination countries.

Unfortunately, data access limitation usually prevents a more through analysis of the primary underlaying variables of differences in intranational demand patterns and, therefore, it is difficult to judge if nationality rather than length of stay or some other variable (e.g., travel purpose, first-time versus repeat visitation, travel style) is the primary cause and the others just related influences.

Table 2.15. Average Length of Stay (Days)

Destination Country	1994	1995
Australia	24.0	24.0
New Zealand	19.0	19.0
New Caledonia	15.0	17.0
Tahiti	9.1	12.1
Indonesia	10.3	10.2
Philippines*	11.5	10.1
Taiwan	7.5	7.4
Thailand	7.0	7.4
South Korea	5.2	5.3
Malaysia*	4.8	4.8
Hong Kong*	3.9	3.9
Singapore	3.5	3.4

* Reporting by nights

Methods used in estimating average length of stay:
Sample survey: Australia, Hong Kong, Indonesia, Philippines, South Korea
Arrival/Departure Cards matching: Malaysia, New Zealand, Singapore, Taiwan, Thailand

Source: Extracted from PATA, 1996

Visitor Expenditure

Accommodation and food/beverage often constitute 50 per cent of the total visitor expenditure within the destination country (Table 2.16). The emphasis is here on within the destination country as international airfares are generally excluded from such a breakdown. However, some destinations in the Pacific Rim, especially Singapore and Hong Kong, have been able to position themselves as primarily shopping paradises and expenditure on shopping in those two mentioned countries exceeds 50 per cent. In consequence, accommodation and other expenditure items are much less important.

Table 2.16. Visitor Expenditure Breakdown, 1995 (in %)

Destination Country	Accom- modation	Food/ Bev.	Shop- ping	Sightseeing/ Transport	Enter- tainment	Other
Hong Kong	29.4	11.5	50.8	2.9	2.1	3.4
Indonesia	30.6	18.7	24.4	15.7	5.2	5.4
Malaysia	32.0	18.0	21.0	12.0	6.0	11.0
Philippines	30.4	17.2	17.1	4.9	21.7	8.7
Singapore	21.1	10.7	55.6	6.6	1.1	4.9
South Korea	19.7	11.7	39.8	6.0	6.6	16.2
Thailand	21.2	14.5	37.6	12.6	9.3	4.8

Source: Extracted from PATA, 1996

Quite interesting in Table 2.16 is also the variation among the listed countries with respect to the expenditure by tourists on sightseeing and local transportation. While the share of this sector is approaching nil in the case of the city states Singapore and Hong Kong, it exceeds 10 per cent in the 'larger' countries Indonesia, Malaysia and Thailand. Why it is only around six per cent in South Korea is not obvious and would require a more detailed analysis of the tourists' travel patterns within that country.

Conclusion

This chapter flaunted the wide variations in tourism demand patterns within the Pacific Rim region. It also presented the phenomenal growth that the region, and specifically some countries and subregions, has experienced with respect to tourist demand over the last decades. Today the Pacific Rim accounts for one-third of all tourist arrivals worldwide and for almost half of all tourism receipts. While Europe still draws a larger quota, the share of the Pacific Rim is increasing. In 1980, for example, the Pacific Rim's share in tourist arrivals and receipts was 26 per cent and 32 per cent respectively. The forecasted sustained high growth rates for several Asian economies will fuel a demand increase in the near future. The currently relatively low participation of the population in many of the Pacific Rim countries with respect to outbound travel (see Chapter 5, Table 5.1), and especially in some of the countries with a rapidly expanding economy, such as China, South Korea and Taiwan, is likely to improve and, therefore, add additional growth to the outbound sector. In turn, other

Pacific Rim countries are well positioned to take advantage of this growing outbound demand and turn it into intraregional travel demand within the Pacific Rim.

Not all countries in the Pacific Rim region, however, have been able to benefit to the same extent in the tourism growth. Notable is the small growth on a small basis in many of the Pacific Islands and in many Latin American countries. Obviously, to measure success simply with the yardstick of tourist arrivals is a misplaced emphasis on growth. Yet to use the measure travel expenditure, as is currently done and emphasized by several countries, appears also fully appropriate.

The issue of quality versus quantity, especially in light of growing environmental awareness and concern, has made many countries realize that not all tourists are the same. Depending on their origin, travel purpose, length of stay, activities, etc., they spend dissimilar amounts during their stay. Japanese and other North Asian tourists are often thought to be particularly great spenders, especially with respect to souvenirs. Some countries have purposely developed their tourist attraction base to include shopping. At least in many South East Asian countries, shopping is a major tourist activity that helps forming the architectural landscape and controls tourism activity in cities (Oppermann, Din, and Amri, 1996).

However, the sheer concentration on the tourists' expenditure ignores the fact that high per day spenders may rank among the low per trip spenders (Oppermann and Chon, 1997a) and does not take into account what the money is spend on and the cost and leakages involved in producing that product, the regional and sectoral distribution of expenditures, and what the government's objectives are.

Before a country decides what type of tourism constitutes quality tourism it should clearly define the objectives of tourism and tourism development. Without such a framework, there can be no quality tourism as any measure to distinguish quality tourists from other tourists becomes arbitrary. A preoccupation with tourists' expenditures as a measure of quality tourism also obscures other issues, such as where do tourists spend, how much on what, and who is benefiting from it? As several commentators have noted, tourism does not benefit everybody in the host community equally and some forms of tourism may be more regionally, sectorially and ethnically biased than others (Din, 1990; Oppermann, 1994a, 1994c). Expenditures by tourists with a short length of stay are more likely to be concentrated in the primary tourist destinations and international gateways (Oppermann 1994b, 1997). Travel purpose, travel organization and country of residence have been proven to be major influencing variables in the spatial distribution as well (Oppermann 1992a, 1992b). If regional development is a primary objective, then quality tourists may need to be defined as those who actually travel to those peripheral regions in question. These may turn out to be visitors with a very low daily expenditure but a very long length of stay, or those with a specific travel motivation (e.g., want to stay on a farm) or purpose (e.g., visiting friends/relatives).

Some forms of tourism may be better adapted to the country using services and goods that are mostly produced locally and do not need to be imported. Accordingly, the leakage rate is much lower and the multiplier effect higher and the net effect may be the same as of other tourism types where higher initial expenditures are incurred

which are consequently subject to high leakages.

Hence, a guideline to the governments' objectives for tourism is imperative in the establishment of criteria for quality tourism. The issue of quality versus quantity in tourism should not and cannot just be reduced to who spends the most money per day. And it is possibly in this very area, namely policy and objectives definition, that Pacific Rim countries, and those in other regions as well, have been the most slacking. While a lot of emphasis is placed on promoting the country, only passing reference is made to the objectives of tourism development and even those objectives do not serve as guidelines in the promotion and positioning of the destination. The recent growth in interest in destination branding issues is a case in point. While a lot of money is in such cases spend on designing brand logos and promotion campaigns around it, very little effort is usually going into making the product coherent, innovative and instantly recognizable.

At the moment, and likely in the next one or two decades to come, many Pacific Rim countries will be in the fortunate position to face an increasing demand, almost irrespective of their action, simply due to the mounting outbound demand growth within neighbouring countries. Once this initial stage of growth euphoria will be over, however, these countries also will need to find new solutions and it would be quite sensible on their part to already take a look into the future, by analysing the problems and issues that more traditional destination countries are facing today (see Chapter nineteen). Pro-actively positioning a country and/or destination to the changing times may be the ultimate way to gain the competitive advantage in the long run.

Chapter three:

Tourism and Regionalism in the Pacific Rim: An Overview

C. Michael Hall
Centre for Tourism, University of Otago, PO Box 56, Dunedin, New Zealand

Rachel Samways
10 Hallam Grove, Off West Avenue, Lincoln, United Kingdom

Introduction

It has now almost become a cliché to describe the Pacific as the world's fastest growing region for international tourism. However, while the Pacific Rim is now an important part of the global tourism, economic and geo-political imagination, it is only in recent years that the concept of the Pacific beyond its geographical boundaries has started to receive widespread acceptance. The concept of a Pacific economic community, now a part of global economic life, had little or no meaning up until the early 1980s, and has only become widely accepted in the 1990s. The purpose of this chapter is to provide an overview of the growth of the concept of the Pacific Rim and the related growth in Pacific Rim tourism. Indeed, the chapter argues that the two are inseparable, as the increased integration and linkages implied by the concept of the Pacific Rim go hand-in-hand with the growth in tourism in the region which is itself dependent on a particular set of transport, communication and economic linkages (e.g., investment flows) between tourist generating and receiving regions.

The chapter is divided into three main sections. First, a brief account of the concept of the Pacific Rim and of the growth of economic regionalism in the Pacific Rim. Second, a summary of the changing patterns of tourism in the Pacific. Finally, the chapter reviews likely future scenarios and issues for tourism in the region with particular emphasis on the expansion on the present set of economic and political linkages in both scope and form.

The Pacific Rim

The concept of the Pacific Rim is primarily an economic and, to a lesser extent, a geopolitical concept. Although the geographical boundaries of the Pacific Ocean are clearly an important determinant in recognizing things 'Pacific', it is the emergence of a particular set of economic and political linkages that has established the framework for the concept of the Pacific Rim. It is also significant that the concept is also primarily Asian-centered (Quo, 1982; Hall, 1997), especially with respect to the role that Japan and Australia have played in the development of the concept of the Pacific Rim and a Pacific economic community.

The world is in the midst of a dramatic shift in global economic power. In 1994, United States trade with Asia and the Pacific was more than US$424 billion, 70 per cent more than trade with Western Europe (Bureau of East Asian and Pacific Affairs, 1996). Asia-Pacific trade has rapidly grown in global importance and is expected to continue to grow well into the next century: for example, United States foreign direct investment in APEC member countries was more than US$200 billion, about 33 per cent of total United States foreign direct investment and increasing (Bureau of East Asian and Pacific Affairs, 1996). Similarly, countries such as Canada, which, outside of North America, was previously European and Commonwealth centered, and Australia and New Zealand, who traditionally traded with the United Kingdom, Europe and North America, have had their trading patterns shift north towards Asia (Bollard *et al.*, 1989; Garnaut, 1990). However, in addition to the shift in the economic perspective of the previously Euro- and Americo-centric countries of the Pacific, East Asia has itself been experiencing remarkable economic growth.

Economic growth in the Pacific Rim, and in East Asia in particular, has been the most dynamic in the world since the end of the Second World War, with Garnaut (1990) regarding such growth as representing the longest sustained growth period of any region in recorded economic history. Most significantly, intra-Asian and intra-Pacific trade is now driving growth, rather than trade with Europe and North America (JETRO, 1996). This has meant that economic growth in the region has not been so affected by global recession as it might previously have been (Rowley, 1992). The significance of intraregional trade is well illustrated in Table 3.1, which indicates the relative share of world trade by regional economic unions. During the period 1990-1995 intra-Pacific trade grew as a component of total world trade while during the same period North American and European trade fell in terms of its relative significance. The isolation of trade figures by economic union demonstrates the importance of such unions in encouraging the development of freer trade. Although substantial attention has been placed on Europe in recent years, particularly with respect to the creation of common borders and the development of a common currency, a plethora of economic cooperation and free trade agreements have come into existence in the Pacific.

Table 3.1. Trade of Regional Economic Unions - Share in World Trade and Average Growth Rate (%)

	1990	1995	1990-95 growth
World trade	100.0	100.0	7.9
Pacific trade	26.6	33.2	12.8
Intra-ANIEs	0.9	1.6	12.8
Intra-AFTA	0.8	1.4	18.6
Intra-NAFTA	6.7	8.0	11.7
Atlantic trade	42.9	37.6	5.0
Intra-EU	29.1	23.7	3.5
Intra-NAFTA	6.7	8.0	11.7
EU->NAFTA	3.6	3.1	4.3
NAFTA->EU	3.5	2.8	3.3

ANIEs (Asian newly emerging industrial economies), AFTA (ASEAN Free Trade Area), NAFTA (North American Free Trade Area), EU (European Union)

Notes: Figures for Pacific trade *de facto* indicate trade within APEC.
 NAFTA is included in both Pacific and Atlantic

Source: Adapted from JETRO, 1996 in Hall, 1997

Integration and interdependence in the region have gone through various stages. First, what might be termed an 'exploratory' stage, in which the Pacific Rim idea has been explored primarily in academic and intragovernmental circles. Second, a non-formal stage in which a network of non-governmental forums have been developed with the blessing of the various governments concerned. These include educational, scientific, defence and cultural forums in which trust building and networking between various government bodies and business organizations occurs. Third, the creation of a formal network of bilateral and multilateral government bodies which cover a wide variety of policy areas including tariff reduction and freer trade. Fourth, a formal-economic stage in which the focus of intergovernment activity is on encouraging freer trade within a specific region through various trade agreements. The fifth stage is reached when formal-economic agreements are overtly combined with the development of new political structures and relationships between the various countries involved.

The origins of the Pacific Rim concept are to be found in Tokyo, Japan, in the early 1960s when Sebro Okita, an economist, proposed that the five most economically developed countries in the Pacific - the United States, Canada, New Zealand, Australia and Japan - form a Pacific Free Trade Area. That the idea of the Pacific Rim originated in Japan should not be surprising. Dependent as Japan is for imports of natural resources, Japan is an extremely strong advocate for freer trade, except in areas of 'traditional' concern, such as rice and other agricultural products (Quo, 1982). Okita's proposal did not find full acceptance at the government level in either Japan or in the other nations he identified primarily because of the then more recent memory of Japanese expansion both prior and during the Second World War. Indeed, the memories of the war still raise questions in some circles as to whether the Japanese are now attempting to achieve by economic means the goal of a sphere of 'co-prosperity' over the Pacific which was held by the Japanese prior to 1945 (Edgington, 1990). Nevertheless, the idea did have substantial intellectual impact in both academic and government circles at a time when state communist expansion in Asia was perceived as a substantial economic and political threat to the West. For example, Australia and Japan further strengthened trade, cultural and political relationships during the late 1960s and early 1970s through a series of formal agreements. Perhaps most substantial of these was the establishment of the Australia-Japan project with the support of the Australian and Japanese governments at the Australian National University, Canberra, in 1972. The project led to the development and publication of a large number of research studies on Australian-Japanese relations and the broader questions of Pacific trade and integration. In effect the project become one of the main intellectual engines which provided the momentum for the idea of a Pacific economic community (Hall, 1997).

During the late 1970s and early 1980s discussion of the value of improved trading relationships in the Pacific grew as a response to both the changes taking place within Europe, especially the United Kingdom's joining of the European Community which meant the end of Commonwealth preferential trading agreements for Australia, Canada and New Zealand, and increases in intra-Pacific trade, especially the growth of Japan, which became a major importer of raw materials from Australia and Canada. Concepts such as 'Pacific Rim', 'Pacific Basin', and 'Pacific Community' came to be used almost interchangeably during this period as various countries in the region increasingly began to explore opportunities for greater economic cooperation. The term 'Pacific Basin' was favoured by the Russians, while 'Pacific Rim' received support from Australia, Canada and the United States. Interestingly, the 'Pacific Community' slowly fell from grace because of perceived dangers of comparison with the European Community.

Comparison with the European situation is salutary. Since the early 1980s leading proponents of the Pacific Rim concept, such as the Australia and the United States, have endeavoured to place Pacific trade within the wider context of freer global trade. The concept of Pacific Basin cooperation defined by the Special Committee on Pacific Cooperation (SCPC) in May 1981, sets the scene for much of the debate that has occurred since. According to the Committee the central thrusts of the concept are to

'secure and promote the present trend of interdependence amongst countries in the region'. Significantly, they went on to note that 'Its purpose is not to create an economic sphere of influence dominated by the "haves", or politically-oriented exclusive regional bloc, but to promote cooperative relationships based on interdependence and mutual understanding among the countries in the region' (Quo, 1982:ix).

Since the early 1980s, integration and interdependence have become a feature of the region. Therefore, in many ways the conditions for the concept of Pacific Basin cooperation have been met. As Table 3.1 illustrates, the Pacific Rim has an increasing amount of intraregional trade which reinforces interdependence between nations and a network of government and non-government forums is being created to deal with trade and other issues. For example, the Association of South East Asian Nations (ASEAN) is developing a structure for the formal reduction of tariffs between member states (Soesastro, 1995), while other international organizations, such as the Asia-Pacific Economic Cooperation (APEC) Council meet on a regular basis. The latter organization in particular, which now provides the central forum for dialogue between the major Pacific nations, has had a substantial impact on the development of greater understanding on Pacific trade and tourism issues.

APEC

APEC was established in 1989 to provide a forum for the management of the effects of the growing interdependence of the Pacific Rim and to help sustain economic growth. Originally established as an informal group of twelve Asia-Pacific economies, APEC has since grown with the admission of People's Republic of China, Hong Kong and Chinese Taipei (Taiwan) in 1991, Mexico and Papua New Guinea in 1993 and Chile in 1994. A permanent secretariat is based in Singapore, with the APEC Chair and ministerial meetings being rotated annually among members. The first ministerial meeting was held in Canberra, Australia, in 1989; since then meetings have been held in Singapore, Seoul, Bangkok, Seattle, Jakarta, Osaka, and Manila, with Canada and Malaysia hosting conferences in 1997 and 1998 respectively (Hall, 1997).

Although not a formal economic union, APEC is a major force for freer trade in the Pacific Rim and in creating improved dialogue and relations between the major economic powers. APEC has no charter which forces contractual obligations on its members, instead it works by a consensus driven approach. According to Australia's Minister of Trade 'This non-legalistic, consensus approach is sometimes seen as a source of weakness by those who are new to the process, but, in reality, it has proven to be a great source of strength' (McMullan, 1995). The declarations and recommendations of the annual ministerial conference carry significant political and diplomatic weight and provide the framework for the development of an action agenda which serves as the blueprint for meeting the commitment to 'free and open trade and investment in the Asia-Pacific', with all barriers to trade and investment to be dismantled before 2010 or 2020 by developed and developing national members, respectively (Bureau of East Asian and Pacific Affairs, 1996). As part of the APEC

framework, ten working groups have been established, covering broad areas of economic, educational and environmental cooperation, including tourism 'on the basis that the tourism industry is of growing importance in promoting economic growth and social development in the Asia-Pacific region' (APEC Tourism Working Group, 1995). The Tourism Working Group will endeavour to achieve long-term environmental and social sustainability of the tourism industry by setting priority on the following:

1. removing barriers to tourism movements and investment and liberalizing trade in services and tourism;
2. developing and implementing the concepts of environmental and social sustainability in tourism development;
3. facilitating and promoting human resource development;
4. enlarging the role of the business/private sector;
5. developing cooperation and programmes in the fields of information-based services related to trade and tourism; and
6. sharing information among APEC economies.

ASEAN

The concept of regional cooperation espoused by APEC is of course not new. The Association of South East Asian Nations (ASEAN) was established to encourage regional cooperation 30 years ago. However, it was only in October 1992 that member countries decided to adopt the ASEAN Free Trade Area (AFTA) in order to implement a Common Effective Preferential Tariff Scheme for processed agricultural and manufactured goods made and traded within the grouping. As with the larger APEC grouping ASEAN have identified tourism as a service sector accorded 'highest priority' for liberalization within the AFTA. The development of greater economic cooperation within the region has substantial implications for tourism, one of the most obvious being joint marketing campaigns such as Visit ASEAN Years. Joint economic development strategies are emerging which also have substantial implications for tourism, the most apparent of which involves the establishment of a 'growth triangle' between the Malaysian State of Johor, Singapore, and the Indonesian Province of Riau. In addition, the improvement of rail services between Singapore, Malaysia and Thailand will further integrate the tourism economies of the region (Hall, 1997).

Economic Unions

It is therefore readily apparent that in the globalized business environment the creation of regional international trading structures is seen as one of the main elements in encouraging freer trade and developing growth strategies for specific localities and sectors. Trade in 'visible' sectors such as agriculture and manufacturing tends to be at the forefront of such regional agreements, but service sectors such as

transport, communication, finance and tourism appear to follow closely behind.

Table 3.2 outlines the number of economic unions which existed in the world as at July 1996. Clearly, agreements within Europe and the Americas make up the bulk of the world's economic unions. As Table 3.3 illustrates, there has been a dramatic increase in the number of economic unions in the world in recent years, with the Asia-Pacific also being part of this movement, although it should be noted that APEC is not included in either Table 3.2 or 3.3 because it is not ratified as a formal economic union.

Table 3.2. Regional Economic Unions

Region	WTO Notifications[1]	IMF[2]	JETRO[3]
Africa	7	14	8
Asia/Oceania[4]	10	6	3
Europe	73	15	39
Middle East	3	5	4
North America & Latin America	18	24	40
Others (spanning several world regions)[5]	33	4	7
Total[6]	144	68	101

Notes:
1. Indicates agreements notified to the World Trade Organization (previously GATT) from 1948 to July 1996
2. Indicates major regional economic unions determined by the International Monetary Fund after the conclusion of the Uruguay Round
3. Indicates totals of the World Trade Organization and IMF minus overlapping agreements, agreements losing effect due to absorption by other economic unions, and non-reciprocal agreements plus some agreements independently confirmed by JETRO
4. APEC is not an economic union established by a treaty, so is not included
5. Indicates unions spanning several of the five regions
6. Unions which have been established by agreements, but which have not yet taken effect and unions currently being considered are not included

Source: After JETRO, 1996

Table 3.3. Number of Regional Economic Unions by Decade

	Before 1960	1960-1969	1970-1979	1980-1989	After 1990	Total
Africa	0	2	2	0	4	8
Asia/Oceania	0	0	0	1	2	3
Europe	0	1	2	0	36	39
Middle East	0	0	0	3	1	4
North America & Latin America	0	2	1	15	22	40
Other	0	1	1	1	4	7
Total	0	6	6	20	69	101

Source: After JETRO, 1996

Although formal economic unions provide the umbrella for economic interdependence within the region, there are also a number of special economic zones which are under development and which have provided a focal point for much tourism development. Table 3.4 identifies nine economic zones which have been designated by countries within the Pacific Rim in order to promote economic development. As the Table indicates, a great many of these zones are also the focus of tourism developments which go hand-in-hand with developments in transport linkages. Although not formally identified as economic zones it should also be noted that the Pacific states of the United States (Washington, Oregon and California) are also focusing much of their trade efforts on the Pacific, while Canada, which is hosting the 1997 APEC meeting in Vancouver, has declared 1997 as Canada's Year of the Asia Pacific (CYAP). According to the Canadian Department of Foreign Affairs and International Trade (1996), the goals of CYAP are:

1. To expand Canada's economic partnerships with the Asia-Pacific region and to equip Canada to play an increasingly dynamic role in the emerging Pacific community;
2. To highlight the important role played by the Asia-Pacific region in economic growth and job creation in Canada, in the life of the country and in global affairs;
3. To increase participation in Asian-Pacific markets by Canadian business by providing more information on opportunities in the region and on how best to act on them;
4. To enhance cross-cultural understanding of common concerns related to peace

and security, human rights and legal form, environmental and social development, culture, education and other areas; and
5. To ensure a lasting legacy through new partnerships between Canadians and Asia-Pacific business and cultural institutions, better collaboration between governments and the involvement of youth and Asian Canadians.

Table 3.4. Regional Economic Zones in the Asia-Pacific

Name [time of formation]	Region	Comment
Japan Sea Rim Economic Zone (Northeast Asia Economic Zone) [early 1990s]	Japan (Japan sea side), Russian Far East, Mongolia, Republic of Korea, North Korea, China (Jilin, Heilongjiang, and Liaoning)	This zone includes the Tumen Triangle linking the Russian far East (Nahodka & Vladivostok), Jilin province of China and the northern part of North Korea. Limited tourism development is occurring in the Russian Far East.
Yellow Sea Rim Economic Zone [late 1980s]	China (Liaoning and Shandong), west coast of Republic of Korea	This area receives numerous investments from Japanese companies. There is also the East China economic zone, linking Japan, the southern part of the Republic of Korea and various regions of China. Tourism development is occuring in south-western Korea while increased travel flows between China and Korea are also developing.
South China Economic Zone [early 1980s]	China (Fujian and Guangdong), Hong Kong, Taiwan	Ethnic Chinese capital from Taiwan and Singapore is a major component in the development of the region. The region is currently subject to massive aviation and transport infrastructure development and the development of resorts along the South China coast, geared currently for the Chinese domestic market but increasingly taking international visitors.
Cross-Straits Economic Zone [early 1980s]	China (Fujian), Taiwan	Broadly, this is a subregion of the South China Economic Zone. Investment in China from Taiwan is increasing.

Greater Mekong Subregion (Indochina Economic Zone) [late 1980s]	Thailand, Cambodia, Laos, Myanmar, Vietnam	Centred on the complementary relationship between the further developed Thailand and the surrounding countries. Ethnic Chinese capital sustains the industrial activity while tourism development is being financed from a number of sources including Australia, France and Malaysia. Thailand is the only country with a significant domestic investment in tourism. Thailand is currently attempting to make itself the transport and tourism hub of the region.
Singapore-Johore-Riau Growth Triangle [late 1980s]	Malaysia, Singapore, Indonesia	Aimed initially at a fusion of Singapore's capital, technical know-how, and information resources and the inexpensive labour forces of Malaysia and Indonesia. Has led to the development of substantial leisure and tourism infrastructure in Malaysia and Indonesia in particular for the rapidly growing Singapore middle class.
Brunei Darussalam-Indonesia-Malaysia-Philippines East ASEAN Growth Area [early 1990s]	Brunei, Indonesia, Malaysia, Philippines	Objective is the construction of complementary relationships between economically underdeveloped regions in order to promote trade. Large-scale tourism development is presently focussed on the Philippines although smaller-scale cultural tourism developments occur throughout Borneo/Kalimantan.
Indonesia-Malaysia-Thailand Growth Triangle [early 1990s]	Indonesia, Malaysia, Thailand	Aims at various tourist, agrobusiness, and electronics related projects for economic cooperation. The establishment of new railway, road and shipping linkages is also having a positive spin-off in terms of intra-ASEAN and domestic tourism.
Indonesia-Northern Territory-Papua New Guinea Growth Triangle [mid-1990s]	Eastern Indonesia, Australia (tropical Northern Territory), Papua New Guinea	Aims to develop better transport and tourism links between the three countries/areas.

Source: After JETRO, 1996; Hall, 1997

The CYAP provides a good example of the type of government and non-government networking which has become an integral part of the development of the Pacific Rim concept. However, tourism is also a substantial component of the Pacific Rim concept in terms of both benefiting and contributing to the increased sense of interdependence in the region. The next section provides an overview of tourism growth in the region.

Tourism in the Pacific Rim

The Asia-Pacific area has been the world's fastest growing tourism region over the past decade. According to the World Tourism Organization (WTO), the East Asia-Pacific region has grown from 0.75 per cent of world tourist arrivals in 1950 to 14.7 per cent in 1995 (WTO, 1997a). Over the same time period the region's share of international tourism receipts grew from 1.43 per cent in 1950 to 6.3 per cent in 1975 and to 14.7 per cent in 1995. A more detailed comparative account of global tourist arrivals is provided in Chapter two, which illustrates arrivals of tourists from abroad on a regional basis over the period 1980 to 1994. One of the key features of is the relative proportion of global international tourist arrivals captured by the Asia-Pacific region at the expense of the European and North American markets over the past four decades, and especially since 1980. However, it is also extremely significant to note that the high rate of inbound growth to the region has run parallel to the overall pattern of trade and economic growth in the region in the sense that international tourism in the Asia-Pacific is increasingly driven by intraregional travel, led particularly by ethnic Chinese and Japanese travel, rather than by arrivals from Europe or the Americas. On the basis of preliminary results for 1995, the WTO (1996c) estimated that arrivals in the East Asia-Pacific Region grew by 8.6 per cent over the previous year compared with the world average of 3.8 per cent. Tourism receipts were estimated to have grown 8.6 per cent compared with a world average of 7.2 per cent.

As noted above, it is the extent of intraregional tourism which has made the growth in Asia-Pacific so significant. As per capita incomes and availability of leisure time have increased throughout the region so outbound travel has increased as well as inbound. This has meant, for example, that countries such as Australia and New Zealand, have adopted aggressive marketing and promotional strategies in Japan and East Asia in order to attract the rapid development of outbound travel in Japan, Korea and Taiwan and, more recently, Malaysia and Singapore (Australian Tourist Commission, 1996; New Zealand Tourism Board, 1996a). Similarly, Canada has also sought to attract increased international arrivals from Japan. Although still dominated by European markets, the number of tourists from Japan grew by 22.4 per cent in 1995 (Canadian Tourism Commission, 1996). As elsewhere in the Pacific Rim, however, substantial growth was also occurring in the Hong Kong, Korean and Taiwanese markets with growth rates of 34 per cent, 44 per cent and 55 per cent respectively (Hoon, 1996a). The Canadian Tourism Commission has put more funds into promoting Canada in Asia with C$16 million being allocated in 1996/97 and a

C\$20 million budget for the region in 1997/98, including Canada's first television campaign in Japan, will be undertaken (Hoon, 1996b). Furthermore, as part of Canada's push into Asia, the CTC has signed an agreement with the China National Tourism Administration to promote two-way tourism between the two countries (Hoon, 1996b).

In the actions of the various national tourism organizations, such as the Canadian Tourism Commission noted above, one of the most significant aspects of the formation of the Pacific Rim can be seen. While cooperation operates at one level in terms of general policy settings with respect to free trade and defence, competition becomes more intense in such a business environment. The economic restructuring which is both a consequence and a contributor to globalization has meant that tourism has become of greater significance to nations, regions and communities than ever before, as a tool for economic development and employment generation. In tourism, competition implies not just competition for tourists but, perhaps more significantly, also for information, leisure, tourism and transport infrastructure and facilities.

Singapore's Tourism 21 Vision

Within ASEAN a number of centres are seeking hub status for the region, including Bali, Bangkok, Jakarta, Kuala Lumpur, Singapore and, more recently, Ho Chi Minh City (Saigon) (Hall, 1997). For example, Singapore has set itself a target of 10 million arrivals and S\$16 billion in tourism receipts at the end of the year 2000 (Hamdi, 1996a). In order to achieve these goals Singapore launched a new tourism plan *Tourism 21: Vision of a Tourism Capital* in July, 1996 (STPB, 1996). The goal of the plan is to make Singapore the tourism hub of South East Asia. In order to achieve this, six strategic thrusts have been identified (Hamdi, 1996a, b; STPB, 1996):

1. *Redefining tourism*: widening the focus of tourism from destination marketing to developing Singapore as a tourism business centre and a tourism hub;
2. *Reformulating the product*: developing new themes, events and infrastructure and linking Singapore products with those of the region;
3. *Developing tourism as an industry*: adopting a cluster development approach, creating investment incentives, and developing a competent tourism workforce, information networks, and branding strategies;
4. *Configuring new tourism space*: encouraging tourism-related investment overseas by Singaporean companies and developing partnerships with neighbouring countries in product development;
5. *Partnering for success*: encouraging tourism development partnerships at all levels; and
6. *Championing tourism*: the STPB will take on an enlarged role as a one-stop tourism agency with activities in tourism business development as well as its traditional promotional function. The STPB's name will eventually change to the Singapore Tourism Board to reflect its new role.

Critical to Tourism 21 is the idea of 'configuring new tourism space' or regionalization, in which Singapore makes a 'conscious effort to complement the attractiveness of respective countries and to produce a stronger collective product to the benefit of all countries involved' (STPB, 1996). The emphasis therefore is on 'First to Singapore, then to the region, then back to Singapore'. Such an approach has meant an aggressive investment and promotion strategy. For example, while some Western nations have shunned Myanmar (Burma) because of its human rights record, Singapore is the largest investor in hotels and tourism in Myanmar with US$453 million invested in hotel development (STPB, 1995). Tourism specific investments from Singapore firms include:

1. Strait Steamship Land which has invested $US50 million in a five-star hotel in Yangon;
2. Singapore Technologies Industrial Corporation and Liang Court which invested US$32 million in a business class hotel in Yangon; and
3. The Kuok group which has invested US$150 in two hotels (Hall, 1997).

In a similar fashion to Singapore, Thailand is aggressively developing tourism linkages with Cambodia, Laos, southern China and Vietnam, while Indonesia is attempting to promote Bali as a link to other destinations within the Indonesian archipelago and South East Asia. The regionalization strategy and the consequent search for hub status is therefore a natural corollary to the development of the economic growth zones identified in the previous section.

The Future

Tourism, as with any other industry, is dependent for its development on the creation and maintenance of transport and communication linkages. In the convergent global economy, linkages, networks and interrelationships create the most appropriate set of conditions by which places can gain their competitive advantage in tourism as well as on a general economic and geo-political basis (Cooke and Morgan, 1993). In identifying the future tourism growth prospects for tourism in the Pacific Rim it is, therefore, essential also to recognize the overall set of economic, social and geo-political factors which mean that countries and regions should be classified as emerging, rather than just developing, markets.

In the 1990s a clear distinction needs to be made between the dynamics of capital in the emerging markets and the lack of economic and business success in developing countries. Emerging market countries in the Pacific Rim, such as China, Indonesia, Korea, Malaysia, Taiwan and Thailand are distinctive in at least three ways. First, economic growth is the top priority. Second, coordination is encouraged between banks, industry and government. Third, a belief that certain major industries, especially in the infrastructure sector, are a fundamental component of economic development and growth (Choi, 1996). To this should be added a fourth

characteristic, that of a strong commitment to regionalization and the establishment of international and subnational sets of cooperative frameworks and agreements. Even China, perhaps one of the most isolationist countries in the region, has become strongly committed to the establishment of cooperative structures in its drive for economic growth (Hall, 1997).

With the possible exceptions of Brunei, Japan and Taiwan, tourism is one of the top five export industries for almost every country in the region and is a major component of international economic policy settings. However, even in the case of Japan and Taiwan, regional restructuring has led to renewed attention to the economic possibilities of tourism (Hall, 1997). None the less, discussion of previous growth and the future prospects for the region cannot be seen in isolation from the overall political and economic environment to which tourism both responds and contributes. Regionalization is an essential element in the framework of tourism development, the significance of which has perhaps been underappreciated. The developing economic and political construct of the Pacific Rim has paralleled the phenomenal growth in tourism which the region has experienced. This is no coincidence. The consequent establishment of economic relationships, interdependencies and linkages at the bilateral and multilateral level from economic zones and growth triangles to large structures such as ASEAN and APEC has provided a basis for economic growth, transport and information linkages and, consequently, tourism linkages. The political stability which such interrelationships provide has also served to encourage investment in tourism as well as tourists themselves. In the interdependent Pacific of the next millennium the greatest threat to tourism will not be the environmental and social impacts of tourism, as significant as they are. Instead, it would be the potential loss of interdependency created by a nation such as China, Japan or the United States reverting to an isolationist stance, and thereby removing the very basis which helped create stability and prosperity in the first place.

Chapter four:

Hotel and Resort Industry Trends in Asia-Pacific

Howard Harrell
Crowne Plaza Hotel, 1243 Clearwood Road, Richmond, VA 23233, USA

Kye-Sung Chon
Conrad N. Hilton College of Hotel and Restaurant Management, University of Houston, Houston, TX 77204, USA

Introduction

Globalization continues to shape the world in subtle, unexpected ways. One such result is an increase in leisure travel and a corresponding relative decrease in business travel. The results of a recent study by the International Air Transport Association (IATA) indicate that by the year 2000, only one trip in five will be for business purposes (Bartels, 1993). As a result of the changing demographics of the world, a majority of these leisure travellers will be mature travellers; people moving up the career travel ladder (Pearce, 1991); people with higher levels of disposable income as a result of increased educational attainment, dual income families, or the changing status of women (Keng, 1997); people who seek enjoyment from recreational travel (Chon, 1989); people who seek soft adventure (Chon and Singh, 1995); or ecotourism (Shundich, 1996b). Resort and hotel managers, owners, operators, and management companies must develop a mind-set to recognize a significant shift in the lodging paradigm and respond to these trends, while continuing to focus on the attributes which travellers have come to expect (Verhoven and Masterson, 1995).

Perhaps there is no other part of the world where this will be harder to do yet present the opportunity for more promising financial rewards than in the Asia-Pacific region. The primary reasons are related to: the multiplicity of governments, cultures,

languages, economies, currencies, differing levels of infrastructure or technological development, ideologies, planning or lack of planning, goals, attitudes, and general competitive natures of the principals involved in the decision-making processes.

Regardless of the geographic, social, cultural or political climates of the countries of the Asia-Pacific travel region, travellers are expected to visit this region in greater numbers in the future than they have in the past. There are many reasons why this area of the world is so appealing. The natural beauty and unspoiled freshness of the environment are virtually guaranteed to relieve the stresses brought on by the modern world. Unfortunately, the very attributes which make the region so delightful may help to cause its eventual downfall to being 'just another place on the planet'. In true Hollywood fashion, an 'if you build it, they will come' (Universal Pictures, 1989) attitude has begun to exist in the mentality of the developers of the region. As Klemm (1992) pointed out, 'to sustain product development in the future, there needs to be collaboration between both the public and private sectors', hence there is a need to safeguard future tourism-related products.

The Asia-Pacific region experienced an astounding increase of 85.8 per cent in available rooms between 1985 and 1994 (Table 4.1). This phenomenon is attributed to factors ranging from relatively few rooms in the base year, to supply catching or meeting demand. These suggestions and others are logical responses; however, the Asia-Pacific region has been in a 'take-away' mode since the early 1970s. According to the WTO the Asia-Pacific's market share has increased significantly 'from 4.6 per cent of world tourist arrivals in 1975 to 15.5 per cent in 1995 and tourism receipts more than tripled, growing from 6.1 per cent in 1975 to 19.6 per cent in 1995' (Hotels, 1996b). There is evidence that, as the growth curve begins to flatten out, there will be a moderate realignment within the region as to which countries continue to grow at a faster rate within this subset (Qu and Zhang, 1996).

Table 4.1. Changes in World's Hotel and Resort Room Supply

	Rooms (1,000s)			% Change	Market Share	
	1985	1990	1994	1985-1994	1985	1994
Africa	267	334	384	43.8%	2.9%	3.1%
Americas	3,462	4,311	4,493	29.8%	37.7%	36.8%
Asia-Pacific	915	1,319	1,700	85.8%	9.9%	13.9%
Europe	4,425	4,936	5,462	23.4%	48.1%	44.7%
Middle East	130	160	179	37.7%	1.4%	1.5%
WORLD	**9,199**	**11,060**	**12,218**	**32.8%**	**100%**	**100%**

Note: The number of hotel rooms worldwide increased 32.8% from 1985 to 1994, with more than 12.2 million rooms in the global marketplace. About one-third of the new room supply is in Europe, while available rooms in the Asia-Pacific region nearly doubled.

Sources: WTO, 1994c; Hotels, 1996a

From Table 4.1 one can certainly see why the Asia-Pacific region has caught the eye of many international hotel and resort developers. More importantly, the profitability of hotel and resort ownership in the Asia-Pacific region has attracted the attention of a multitude of investors and developers eager to cash-in on the potential riches of the area. On the land-scarce island of Hong Kong, we have already witnessed the brief product life cycle for one downtown hotel. The owner of the Hong Kong Hilton chose to convert the hotel to an office building to achieve a better return on investment (Boey, 1994). Whether this is an isolated example remains to be seen, but a precedent has been set: profitability and the 'bottom line' are paramount. If it is not profitable or if the owners can receive a higher return on investment elsewhere, they will alter their investment strategy and invest in profit-generating vehicles other than hotels and resorts.

The international chains, with the regional hoteliers close behind, are interested in segmenting the existing lodging market and exploiting every avenue of income potential, especially 2- and 3-star products built in the $40,000 to $70,000 per room range (Shundich, 1996a). Many of these properties will rely on Western technology or modular construction techniques to build within this price range, and that may present some additional difficulties for certain locations within the region. For example, Roy Murray, vice president of Choice's international division, states that 'poor roads and bridges will hamper the transportation of many of the modular systems used in the construction of Sleep Inns' (Shundich, 1996a). Additional transportation costs will add to the cost of the product and be reflected in the ultimate cost of the property. Current and future developers are going to be attracted, wooed, courted, and motivated by the allure of potential profits in this segment.

There is still a need and a demand for additional 4- and 5- star properties in the Asia-Pacific region. The value of real estate in certain markets dictates that owners invest in 4- and 5-star properties to take full advantage of the double-digit increases in real estate appreciation, while making it almost impossible for newcomers to enter the market for a high land price. Several US based hotel chains recently reviewed their expansion strategies in the mid-market segment of several gateway cities in Asia (e.g. Seoul) but they concluded the number simply did not work for a high land price. Future developers will be forced to build larger properties to equalize the cost of real estate on a per room basis. The pressures for future development will increase exponentially as the demand for real estate escalates. Meanwhile, the owners and operators will have numerous products and options to select from for future investment.

This chapter, utilizing the industry statistics available for the years 1989 to 1993, explores the opportunities which hotel and resort operators in the Asia-Pacific have to increase revenues, control variable and fixed expenses, and affect guest satisfaction. The scope of this chapter is limited by the availability of information regarding hotel and resort operations in the Asia-Pacific. While there seems to be a wealth of information on the more developed countries in the region, there is a conspicuous absence among the lesser developed countries. This, of course, is not surprising; as such, this paper will rely on PKF's lodging figures and methodology for year to year

data. The paper will concentrate on the Asia-Pacific region as a whole and avoid making country-to-country comparisons.

Lodging in the Asia-Pacific

With the emergence of a growing middle class and the Asia-Pacific region having over half the world's population, there is a great desire to segment this market and offer a wider range of lodging alternatives (King and McVey, 1996). This philosophy is heralded by the international hotel companies, international franchise organizations and domestic chains. The primary difference between the first two development groups mentioned is that the international franchise organization is the franchising division of the international hotel company. The international franchise organization promotes, services, supports, trains and aids their franchisees. There is nothing new here, except that in the recent past franchising developed a negative image, and wealthy investors in the Asia-Pacific became somewhat leery of franchising because of the horror stories which they have heard of unscrupulous franchise wheeler-dealers in the hotel and restaurant industry. Additionally, potential investors question: 1) the 'value-added' significance of franchise fees, 2) whether franchises truly deliver more business, and 3) the restrictive nature of the franchise agreements (Murray, 1996a).

With little or no access to international reservation systems for local developers, one might surmise that the international chains would dominate the Asia-Pacific region. None the less, local developers have several advantages: they were the first ones there; they built the magnificent 4- and 5-star properties that are renowned throughout the world; and they own some of the best land available for future development. According to S. Kirk Kinsell, president of ITT Sheraton's franchise operations, 'location is still the primary factor, then brand' (Shundich, 1996b). With time, this might be worked to additional advantages for the Asia-Pacific developers.

The Asia-Pacific's growing GDP and expanding infrastructure will require 'hotels galore', according to Westin's chairman Juergen Bartels (Murray, 1996b). Much of the new business is anticipated to be interregional instead of international from outside the Asia-Pacific region (Table 4.2).

While marketers try to determine who their market is and how to target and attract them, new construction of hotels and resorts continues at a brisk pace. One cannot argue with the past growth records and highly optimistic forecasts for the future. None the less, one can question the 'all-aboard' mentality of those not wishing to be left behind, who are jumping on a train that has multiple destinations but no track.

Even though there is a whisper of doubt about being over-built (Weinstein, 1996b), savvy developers are still lined up to make deals on properties that are purely speculative. The reason is that, on top of all the positively glowing statistics mentioned already, the Asia-Pacific region has outstripped all other areas of the world in profitability in the hotel and resort business for the last ten years or more (PKF, 1994).

Table 4.2. Projected Changes in World Tourism Arrivals (in millions)

	Actual Passengers 1994	World Market Share	Forecast Passengers 1999	World Market Share	Avg. Annual Growth Rate 1995-1999
Europe	192.8	37.2%	260.5	36.9%	6.2%
Asia	115.5	22.3%	172.0	24.3%	8.3%
SW Pacific	17.9	3.5%	26.1	3.7%	7.8%
N. America	98.1	18.9%	125.0	17.7%	5.0%
Latin Amer.	45.3	8.8%	60.7	8.6%	6.1%
Middle East	27.3	5.3%	34.8	4.9%	5.0%
Africa	20.9	4.0%	27.5	3.9%	5.7%

Note: A projected 1.33 billion passengers worldwide will travel either domestically or internationally through the air in 1996, a 5.1% increase from 1995. By 1999, the number of air travellers is expected to rise 15.1% to 1.53 billion. Air traffic between North East and South East Asia will exhibit the strongest growth, increasing, with average annual growth rates in traffic of 18.7 per cent and 17.9 per cent, respectively, through 1999.

Source: International Air Transport Association, 1995, as in Hotels, 1996a

There are a number of reasons why: a limited room supply with a high demand equates to higher occupancy percentages; a limited room supply also inflates the average daily room rates (ADRs); an untapped source of unskilled, inexpensive labour (in many markets); and the original 4- and 5-star operators proved to be shrewd business people who knew how to make a profit, improve, and expand their operations, thereby insulating themselves and protecting their territories.

Table 4.3 presents the Ratio of Income Before Fixed Charges (Income Before Deducting these Fixed Charges: Depreciation, Rent, Interest, Amortization, Income Taxes, Property Taxes, and Insurance) to Total Revenues section. In every year, except 1985 (tied with European hotels) and 1991 (Gulf War crisis), the Asia-Pacific region showed a greater ratio of income to revenues before fixed charges when compared to averages from international hotels (sample survey), US hotels (sample survey), and European hotels (sample survey). This is particularly significant since the Asia-Pacific hotels, on the average, have more money *before* paying their fixed expenses. As such, one may assume that these hotels also retained more money *after* paying their fixed expenses. One might also speculate that: 1) the cost of borrowing money might be less (local investors might not have a rigid interest formula to quote to borrowers - this would affect depreciation, amortization, rent and interest); 2) property taxes would be lower since the infrastructure is not as demanding; 3) income taxes are lower or non-existent (once again, not as much overhead on lesser-developed systems - then again taxes in Hong Kong, Seoul or metropolitan Japan may

be considerably higher); and 4) insurance risks and levels of liability could be lower due to different underwriting parameters. All in all, someone wanting to invest in hotels or resorts might be more inclined to invest in a region that has a history, no matter how short, of beating the major hotel and resort companies of the world for earning profit.

Table 4.3 also highlights: 1) the revenues that make up the rooms division: food, beverage (alcoholic), and other income and 2) the expenses: departmental, undistributed, total variable and fixed for the Asia-Pacific region for the years 1989 through 1993 (PKF, 1990-1994). The final column conveys the trend for the period.

Table 4.3. Operating Performance of Asia-Pacific Hotel and Resort Industry (1989-1993)

	1989	1990	1991	1992	1993	% change 1989-93
REVENUES			in per cent			
Rooms	52.1	50.5	44.7	48.4	49.2	-2.9
Food	26.8	29.1	34.5	31.2	30.4	3.6
Beverage	10.5	10.2	9.6	10.2	9.7	-0.8
Other	10.6	10.2	11.2	10.2	10.7	0.1
COSTS AND EXPENSES			in per cent			
Departmental Exp.*	41.8	45.8	50.4	48.2	42.6	0.8
Undistributed Oper.**	20.0	21.2	22.2	21.9	24.6	4.6
Total Variable Expenses	61.8	67.0	72.6	70.1	67.2	5.4
Income before Fixed Expenses ***	38.2	33.0	27.4	29.9	32.8	-5.4
Occupancy (in %)	77.0	71.4	67.1	72.2	77.6	0.6
Average Daily Room Rate (US$)	$88	$97	$104	$98	$95	$7
Average Number of Rooms per Property	495	443	392	406	433	-62

Notes: * Rooms, Food, Beverage, Telephone and Other Departmental Expenses
 ** Administrative and General, Franchise Fees (if any), Marketing, Guest Entertainment, Operations and Maintenance, Energy and All Unallocated Operating Expenses
 *** Income before Deducting: Depreciation, Rent, Interest, Amortization, Income Taxes, Property Taxes and Insurance

Source: PKF International, 1989, 1990, 1991, 1992, 1993, 1994

The most significant bit of information, other than a few peaks from year to year, appears to be that income before expenses has shrunk by 5.4 per cent. This is a direct result of an increase of 4.6 per cent in undistributed operating expenses (Administrative and General, Franchise Fees, Marketing, Guest Entertainment, Operations and Maintenance, Energy and All Unallocated Operating Expenses) for the period. Any one of the categories under undistributed operating expenses could be guilty of raising the group total. The last decade has seen an increase in each one of these categories, therefore there may be no one culprit responsible for the erosion in these catch-all expense items.

In the US, operations and maintenance, energy, and administrative and general have led the way in increases in this category. Administrative and general may have received the most publicity since downsizing has become one of the favourite buzzwords of the 1990s in corporate America. However, it would be pure speculation to state what happened in the Asia-Pacific regarding the growing undistributed operating expense account.

Another noteworthy trend is the near trade-off in revenues between the rooms division and food/beverage. This is too short a time frame to speculate about a lasting trend; however, it is significant that food records a 3.6 per cent increase in revenues over the five year period. This shows that the food service venues in the Asia-Pacific's hotels and resorts are doing an excellent job in marketing their food outlets. Also, they are not experiencing the current trend affecting lodging properties in the US which showed a steady decrease in departmental revenues from food services. The average daily rates have increased by $7.36 in five years and represent an 8.4 per cent increase over the 1989 base year. The occupancy percentages and average daily room rates are linked more to supply and demand that to other external factors and, therefore, may have fluctuated for any number of reasons. The decrease in the average number of rooms per property might reflect a trend towards smaller properties or it might be an anomaly since the previous years' totals seem to change annually.

Implications

Profits may have been relatively easy to achieve in the demand-driven economy of the last two decades; however, the supply side of the equation is about to receive a massive transfusion. The international hotel chains and franchise organizations have targeted the Asia-Pacific region for extensive investment, construction, renovation and market penetration. For the owners and operators in the Asia-Pacific to get an early start on the international companies, they may wish to consider some of the latest ideas featured in lodging and hospitality-related literature. These ideas are listed in no particular order. They may overlap, may contradict each other, or may not be applicable in every situation. However, they do represent many of the recent innovations designed to impact the profit and loss statement. These are: 1) implementing the latest technology; 2) reducing manpower through labour- or time-saving concepts and improving employee training at all levels; 3) focussing on greater

market segmentation efforts; 4) seeking brand name affiliations and/or partnering; 5) keeping a 'Green Hotel'; and (6) capitalizing on opportunities for alternative tourism.

In an attempt to convey the essence of these ideas, instead of burdening the reader with lengthy discussions, the authors will use bullet points and acronyms to aid in providing examples of each idea. Five acronyms will be used primarily: 1) Increase Revenues (IR), 2) Reduce Departmental Expenses (RDE), 3) Reduce Undistributed Operating Expenses (RUOE), 4) Reduce Fixed Expenses (RFE), and 5) Improve Guest Satisfaction (IGS), an intangible that has a direct effect on each of the revenue or expense categories. One might argue that by solely concentrating on guest satisfaction, one could dramatically improve profitability; that is why so many hotels and resorts incorporate 'providing whatever the guest wants' as part of their goals and objectives. Satisfied guests are repeat guests who can not wait to tell someone else about their experiences.

There are two main categories under technology by which an operator might affect revenues and expenses most effectively. The first is by upgrading the hotel or resort's computer hardware or software programs to include the most modern systems available, and second by installing the latest electronic operating systems that facilitate guest services.

Category 1. Two computer programs come to mind as being the most advanced and comprehensive for hotel/resort operations: DELPHI, a reservations, booking, sales, and yield management program; and BREEZES, a catering program aimed at optimizing revenues and reducing expenses while providing a few unique features that can tailor-make name or place cards in numerous calligraphy style fonts to dazzle the guests. The benefits provided by these programs can be identified as:

- Maximize efficiency in the rooms division and food/beverage (88% plus of the average Asia-Pacific hotel's revenue stream) (IR), (RDE), (RUOE) and (IGS).
- Increase savings in labour, reduction in on-hand inventory levels, smaller inventories mean less refrigeration, lighting or air conditioning (RDE) and (RUOE).
- A savings in guest comps, guest inconvenience adjustments, and over-booking/walks (IR), (RDE), (RUOE) and (IGS).

Category 2 is exemplified by using automated check-in machines; accessed by using a personalized smart card to provide:

- Additional security by using the card to access the hotel room and secured hallways (IR), (RDE), (RFE) and (IGS).
- Easy billing to personal account for all hotel charges (not constantly signing receipts) (IR), (RDE), (RUOE) and (IGS).
- Video and telecommunications capabilities by plugging into the video centre or telephone in the room or lobby (IR), (RDE), (RUOE) and (IGS).
- Reduction in errors from handling paper; lost reservations (IR), (RDE) and (IGS).
- Flexibility of rates, proprietary information (IR), (RDE) and (RUOE).

- View and manipulate data before sending (RDE) and (RUOE).
- Maximum yield management (IR), (RDE), (RUOE), (RFE) and (IGS).
- Develop and upgrade manpower skills (IR), (RDE), (RUOE), (RFE) and (IGS).
- Use as a forecasting tool (IR), (RDE), (RUOE), (RFE) and (IGS) (Hawkes, 1996).

Another segment to consider within this category is the development of detailed data banks capable of keeping track of guests' preferences. This information may be shared with partners, retained as proprietary information, or even sold to competitors. In this category there is, however, one particular warning to remember: 'if you don't up-grade technology, your competition surely will'. The international chains and international franchisees have worked for years perfecting their uses of technology, and they plan to bring every type of available technology with them to the Asia-Pacific.

Because the hospitality industry is labour intensive, virtually any idea that can reduce or eliminate unnecessary labour improves the bottom line. Once again, there are two major areas to consider in this category. The first one, implementing the latest technology, has already been discussed. The second one includes updating or modernizing equipment and processes used in day-to-day operations. Most of these ideas focus on the food and beverage department: however, there are numerous applications throughout the hotel or resort.

- Try new channels for food distribution (US purveyors, Sysco and Kraft, are expanding to international markets at their international clients' requests for canned goods, prepared fruits, vegetables, meats and bakery items) (IR), (RDE), (RUOE), (RFE) and (IGS).
- Less food waste: properly stored, prepared foods last longer; this overcomes initial price difference or resistance; foods prepared in ultra-sanitary conditions, *sous vide*, or vacuum packed reduced levels of harmful bacteria (IR), (RDE), (RUOE), (RFE) and (IGS).
- Less food on hand frees up capital, limits storage space, reduces utilities (RUOE) and (IGS).
- Automatic food processors, process-controlled equipment, fully automatic dish machines, steam kettles, pizza-style convection ovens with pizza-style conveyor belts reduce injuries and dramatically increase productivity (RDE), (RUOE), (IGS) and (RFE).
- Maintenance, housekeeping and laundry can also benefit from an upgrade in automated gadgetry (RDE), (RUOE), (IGS) and (RFE).
- Working in teams is also an area that deserves consideration, especially in housekeeping (RDE), (RUOE) and (RFE) (Barth and Wollin, 1996).

There is one other benefit that comes to mind when considering adopting new labour- and time-saving concepts. The lodging industry in the Asia-Pacific has seen a dramatic decrease in 'employee per available room'. According to Hawkes (1996),

this ratio has steadily decreased from a high of 1.6 in 1984, to 0.9 in 1995. This ratio is predicted to drop to 0.7 within the next few years in an effort to remain competitive. Therefore, operators must look for new concepts, principles and equipment to improve productivity.

Human Resources

This topic is one of the most referenced subjects in hospitality related literature. It also happens to be the common thread that connects each of these nine themes. Employee turnover, rapid advancement, organizational reassignments, lack of time, lack of adequate training materials, and apathy are some of the primary reasons why employee training and development is a topic that will *never* go away. Poorly trained employees in customer service situations can affect revenues, expenses and guest satisfaction tremendously.

Many of the domestic chains and independents have been in business long enough to have developed their own training guidelines. Singapore has a highly successful hotel training programme that includes developing individual proficiency in computer technology, the IT2000 Plan (Hotelier, 1996b,c). The IT2000 programme is the capstone of a fully integrated training system that also provides the students with accreditation at the completion of various training courses. The courses range from culinary arts to hotel management. Each course provides the student with the proper training and skills necessary to become a *bona fide* hospitality professional. All or part of the tuition is paid by the employers, a situation that may obligate, intentionally or unintentionally, the student/employee to develop a deeper sense of loyalty (a positive effect on profitability) to their employer (IR), (RDE), (RUOE), (RFE) and (IGS).

As an employer, there are several things that you can do that do not involve large financial outlays that go a long way in increasing employee morale and loyalty. Bob Bittner of the Educational Institute offers these five suggestions:

1. Know and express the company's vision, culture and mission statement (keeps everyone, including the newest hires, focussed on the company's goals and objectives) (IR), (RDE), (RUOE), (RFE) and (IGS).
2. Know the products, services, and procedures (everyone who works for you sells) (Lavenson, 1974) deliver what your guests want when, where and how, the way the guests want it (IGS), (IR) and (RDE).
3. Make sure you follow through (do your employees 'own' a problem until it is satisfactorily resolved in the guest's eyes?) (IGS), (IR) and (RDE).
4. Never stop learning (the burden of learning is always on the student, and we're all students until the day we die) (IGS), (IR), (RUOE) and (RDE).
5. Hospitality can be a great career (travel/tourism, the number one industry in the world, is in a continual metamorphosis) (Bittner, 1996).

One could go line-by-line through the profit and loss statement and find hundreds of examples of how proper, or improper, employee training affects each line item. The ultimate lesson from this segment is that properly trained employees increase revenues and guest satisfaction, and poorly trained employees increase expenses and negative experiences for the guests.

Since this chapter has already mentioned the need for 2- and 3-star properties (Shundich, 1996a), the focus of this concept will be more on further segmenting what already exists in the marketplace. Some of these activities may already be taking place within the 4- and 5-star products in the Asia-Pacific, since Table 4.3 indicated a decrease in rooms revenue and a increase in food sales.

Operators should consider further segmenting their food outlets within their hotels and resorts. One way to accomplish this is by targeting a particular market that you wish to attract; the Regent Jakarta provides an excellent example. The hotel operates three restaurants (a café, an Asian restaurant, and a signature steak house) as individual profit centres and over 80 per cent of their clientele are locals (Hensdill, 1996). Each of the venues has a distinct marketing purpose and goal. The Regent saw a need, actually three needs, in the local market and decided to fill it. No matter what time of day it is, the diners in each of these restaurants are there because they made a conscious effort to patronize that restaurant. Each of the restaurants enjoys a good deal of success and they are very popular with the locals. The fact that the restaurants do not compete with each other validates the idea for further segmenting existing markets. Not only does their arrangement increase overall revenues for the hotel, but hotel guests, hopefully, know that the three restaurants in the Regent are not 'typical' hotel restaurants: they are favourite destination-type restaurants for the locals. This should impress more than a few of the hotel guests and motivate them to dine-in more frequently (IR), (RDE), (RUOE) and (IGS).

Marketing experts know that 'perception is reality' and that 'people buy on the promise of what a brand means', states S. Kirk Kinsell, president of ITT Sheraton's franchise operations (Shundich, 1996b). Many of the Asia-Pacific hotel/restaurant relationships which have been formed recently are a combination of joint ventures and licensing contracts. One example of this type of union is Bice Restorante, Miami, Florida, in conjunction with three Asian properties: Seoul's Hotel Shilla, Bangkok's Shangri-La, and Tokyo's Chinzan-so (Hensdill, 1996). Bice's contract (and similar contracts) calls for the restaurant to operate as a separate entity, pay base rent plus a percentage, and provide room service. Under an arrangement like this, hotels and resorts that were loosing money on their food and beverage outlets are able to add to the revenue column (without having the normal restaurant expenses) instead of seeing a majority of the revenues being eroded by hefty expenses (IGS), (IR), (RDE), (RUOE) and (RFE).

The international chains have targeted reasonably priced mid-market hotels for intra-Asia and domestic travellers in hopes of gaining loyal customers who are moving up professional, economic, tourism and social ladders of life. By forming alliances with well known domestic operators and investors, the international chains hope to establish, not only name recognition, but credibility in the local markets. From

the domestic operator's point of view this may be one of the best ways to survive the anticipated proliferation of available rooms throughout the region. One of the primary dynamics at work in a partnership arrangement is a 'win-win' attitude for both parties. Therefore, hotel and resort operators need to search for alliances that benefit all partners. Hotels and resorts, food purveyors, airlines, international reservation systems and financial institutions can form strategic alliances which finance, transport foods and travellers, maintain data banks regarding individual preferences, and house future tourists (IR), (RDE), (RUOE), (RFE) and (IGS).

The concepts of energy and resource conservation (recycling, reducing, and re-using) have been heavily publicized for twenty years or more. Recently, however, hotels and resorts have come to understand the benefits of marketing their particular conservation efforts to their guests, and the guests love it. Some guests will even pay more *not* to have their linens changed daily and to leave the landscaping *au naturel*. Some 43 million people in the US, alone, are willing to pay an 8.5 per cent premium to stay in what they perceive as being an 'environmentally sensitive' property (Shundich, 1996b). When one considers the number of US travellers who travel to the Asia-Pacific on an annual basis, 7.43 per cent of US international tourists (WTO, 1994c), one begins to recognize the importance of attracting this segment. Some hotels and resorts have developed a marketing strategy that capitalizes on ecotourism, which will be discussed more in the next section, but the majority of hotels can begin to practice 'Green Hotel' keeping techniques with minimal cash or labour expenditure. The author has chosen to refer to 'Green Hotel' keeping as a separate section from ecotourism due to the relative ease and limited financial resources required to implement 'Green Hotel' keeping techniques.

At the Hotel Nikko in Hong Kong, general manager Jean Marie Leclercq saved $32,000 in 1992, $64,000 in 1994 (RUOE) by simply following the energy 'Dos and Don'ts' in a booklet, *Energy Savers* produced in conjunction with International Hotel Assocation (IHA, 1996) and American Express Travel Related Services (Shundich, 1996b). Operators looking to save money know that there is always something in the hotel that can be scrutinized to regain lost energy dollars, and the best thing is that you do not have to lower your rates when you find and convert an energy-waster. In fact, if you ask the guests, they will help you identify and resolve your energy-related problems (IGS), (IR), (RDE), (RFE) and (RUOE). By simply publicizing the hotel's energy conservation efforts at check-in or in the room, many companies discover which services the guests will forgo on a daily basis.

The Omni-Marco Polo in Hong Kong chose to retrofit the hotel's shower heads for a reduction in total water consumption of 11 per cent annually (RUOE). The best way to imagine the impact of dollars earned from energy savings is to think of those savings sitting in a bank and growing annually at compound interest rates. According to standard compound interest tables, 12 per cent doubles every 6.2 years, and it does not take too many groupings of $25,000 each doubling every six years to pay for a renovation or other major capital expense during the average life span of a hotel. From a profitability perspective, 'Green Hotel' keeping is no longer on option (Weinstein, 1996a).

More people are looking for ways to 'transform their lives in some sort of way, through education, culture and recreation' says Howard J. Wolff, vice president of Wimberly Allison Tong & Goo, an international resort design firm based in Honolulu, Hawaii (Shundich, 1996b). Here, ecotourism will incorporate the aspects Wolff identifies to deliver an experience that satisfies a want or perception of the guest.

If the hotel enhances the guest's encounter with the local tourist destination (e.g., by using native colours or themes in the decor or displays of native art work, folklore and culture in the guest rooms or public spaces), then the hotel does not have to be at the foot of the geothermal vents or alongside the aboriginal villages of New Zealand. Hotel rooms in Rotorua (New Zealand) are close enough to satisfy the guests' desire to experience the natural beauty or culture of the region (Oppermann, 1996a). If the hotel lobby or public space is large enough and flexible enough to accommodate displays of local art or dance (in partnership with the local chamber of commerce or cultural preservation society?), the hotel can bring the essence of the natural beauty and culture to the guests (IGS), (IR), (RDE), (RUOE) and (RFE). People are interested in natural settings and activities. Accommodations are far less important than the experience (Shundich, 1996b).

One of the biggest traps surrounding ecotourism is that the executives, owners, operator and managers often forget to look at the local experience from the guests' eyes. With thousands of miles of unspoiled, 'perfect' beaches in New Zealand, visitors from New York do not want (or need) a New Zealand equivalent of the Plaza Hotel. Maybe, all they need is someone to fix their picnic lunch, drive them to the closest beach, set up a beach umbrella, provide a two-way radio or cell-phone, and then come pick them up at the end of the day (IGS), (IR), (RDE), (RUOE) and (RFE).

What is special about your area that would provide an unusual experience for the tourist? Can it be marketed? How much would it cost? What are the strengths, weaknesses, opportunities and threats? Can you afford the risk? Is there a partner to share the risk?

There is one other competitive threat that the hotels and resorts in the Asia-Pacific region need to be aware of: cruise lines. In an article in *Hotel & Motel Management*, Anthony Marshall, Dean of Florida International University's Hospitality Management College, wrote about his experiences on a cruise ship excursion. He offers these answers to: 'Why choose a cruise over a resort?'

1. All-inclusive price package, which often includes airfare.
2. Big-bang-for-the-buck activities: e.g., non-stop eating eighteen hours per day (health-conscious foods are available), games, casino gambling, aerobics and exercise classes, movies, swimming, dancing and special activities for children are free on a cruise. Hotels seem to charge for everything.
3. One is able to stay within an estimated budget with no hidden surprises.
4. No hassle with tipping. The cruise line gives you a booklet prior to sailing which provides guidelines for tipping (Marshall, 1996).

Capacity in the cruise-line industry will increase by more than 40 percent by 1998. The Republic of Singapore, alone, showed an increase of 32.7 per cent in cruise traffic for 1995. Fifty-four ships made 1,707 calls to Singapore, an increase of 721 calls (73.1%) over 1994. The number of cruise passengers for 1995 was 933,249 (Hotelier, 1996a). How many lost room nights does this represent? And how many markets were affected? Are these numbers significant enough to cause concern among hotel and resort operators?

One trend, which is not new but is receiving a lot of attention recently, is marketing exceptional guest service. Hotels with reputations for exceptional guest service share some common guest strategies. They train their managers and employees to:

- Provide exceptional service.
- Be empowered and self-directed.
- Have a vision of the property's goals and objectives for the future.
- Have respect for themselves and others.
- Communicate up and down the organizational hierarchy.
- Learn what the guest wants.
- Create a 'home away from home' (IR), (RDE), (RUOE), (RFE) and (IGS) (Murray, 1996b).

It is important that individual operators are diligent in their efforts to continuously scan the environment for new opportunities and threats in the marketplace. Moreover, they must respond in such a way as to maximize revenues and guest satisfaction while reducing variable and fixed expenses.

Conclusion

The Asia-Pacific region is still in the growth stage on the product life cycle for travel and tourism development. The region has tremendous potential, as evidenced by the projections for future growth in population, intraregional travel, air traffic arrivals, economic indicators, and hotel/resort rooms to be constructed. The primary difficulty that the region faces, as a whole, is in further segmenting the market to include an inventory of 2- and 3-star products that will complement the existing 4- and 5-star products without 'flooding' or diluting the existing market in a way that will impair the profitability for all the products. The Asia-Pacific region has enjoyed years of high profits before fixed expense, and has established a reputation for providing outstanding products and services. If the current and future owners and operators can continue this tradition of excellence, everyone will benefit in the future.

Tourism is an experience, and the number of people within the Asia-Pacific region who have not had the opportunity to experience the wonders of this area is very large. The hotel and resort operators must be prepared to deliver a positively memorable experience to every guest, no matter the ranking of the property, to ensure

future growth and development. Travellers just beginning the travel ladder may choose moderately priced destinations close to home. If the experience is 'value-added', the guest will be favourably impressed and eager to tell their friends and relatives about their great travel experiences. This is the typical scenario for word-of-mouth advertising, and is a highly effective marketing tool for the hotel or resort. However, the pressure to maintain past profit levels may force operators to cut corners in service or in the quality of products offered. If the operators are not judicious in their decision-making process regarding cost controls, they may negatively affect the performance levels of the management and staff of their properties and the quality of the products used. Therefore, it is imperative that the operators look to the future with distinct goals and objectives for revenues and expenses. There is a wealth of information in lodging and hospitality journals which offer suggestions on'"How to - X, Y, or Z'.

The suggestions offered in this paper are categorized under broad headings (e.g., technology, training, 'Green Hotel' keeping). The operators must know who their target market is to effectively incorporate these or other ideas into the daily operations. The planning and decision-making criteria that the operators choose will have an impact on the success of any or all of the options. Therefore hotel and resort operators must know what type of niche they are trying to fill before they can make the necessary decisions regarding revenues and expenses.

Chapter five:

The Outbound Tourism Cycle and the Asian Tourism Tigers

Martin Oppermann

Centre for Tourism Studies, Waiariki Polytechnic, Private Bag 3028, Rotorua, New Zealand

Introduction

Over the last decade, the four Asian 'Tigers' (Hong Kong, Singapore, South Korea and Taiwan) have not only established themselves as industrial nations and export powers, but also developed into major outbound tourist generating markets. In the wake of the wave of Japanese tourists which deluged many Pacific Rim nations in the 1980s, tourists from the four Asian Tiger nations have gained a tremendous market share in the early 1990s. Although it should not have come as a surprise, many destinations had not learned from their Japanese experience. Looking at the tourist arrivals statistics of many Pacific Rim countries, one recognizes that the growth in Asian Tiger outbound tourism has drastically changed the marketplace in the 1990s. Yet, tourist arrivals provide only an indication of the changes facing a destination. Not only have the destinations to alter their marketing strategies and priorities, but all types of tourism operators have to adjust to the 'new' customers. And to assume that tourists from the Asian Tiger countries have the same expectations and behaviour as their Japanese counterparts could be an unfortunate fallacy. All four countries have a very different culture and history, and consequently their citizens have different values, perceptions and desires as compared to Japanese residents. Thus, catering to tourists from these markets will require a different approach.

In many cases, tourists from South Korea and Taiwan have overtaken more traditional markets from Europe, Oceania or North America and now constitute primary markets. While this fact is recognized by the individual destination countries, an overall comprehensive analysis of the impact of the changes in outbound travel patterns of the four Asian Tigers is still lacking. Longitudinal changes in outbound travel patterns are rarely examined, especially on a regional or national scale.

Outbound travel rarely receives the recognition that it deserves. In fact, in many countries and even in many developing countries (Oppermann and Chon, 1997a) the volume of outbound travel exceeds inbound travel and the overall travel account is often negative. Publicity is generally devoted to inbound tourist arrivals, neglecting the fact that almost as many citizens depart each year on an overseas trip (see Chapter two). The simple measure of gross outbound rate (GO), a ratio of total overseas departures to the total population, is presented in Table 5.1. It shows the wide differences in gross outbound travel between Pacific Rim countries. For a comparison, the GO of several European countries is also provided. One notes the small GO of outbound wonder Japan where, in 1992, the number of outbound trips was less than 10 per cent of the total population size.

This chapter traces the growth pattern of tourist arrivals from the four Asian Tigers to Pacific Rim countries. For a comparison, data on Japanese tourist arrivals is also included. The analysis will be placed into the theoretical framework of the life cycle theory as applied to outbound tourism. The objectives of this chapter are to (1) determine the importance of the four Asian Tigers as tourist generators for the Pacific Rim countries; (2) examine changes in tourist arrivals and outbound generation over the last few years; (3) compare tourist arrivals from the four Asian Tigers with those of Japan; and (4) analyse the growth pattern in the context of the life cycle theory.

Methodology and Data Limitations

Comparing data on tourism arrivals and/or outbound travel for several countries is commonly obstructed by data availability and compatibility. Even on a national level, changes in data gathering practices and definition of tourists as well as non-compatibility of data from different sources are routinely a chief concern to tourism researchers (see also Chapter one). A simple comparison of outbound data from country A to country B with the respective inbound data for country B often reveals different figures. In the case of Singapore travellers to Malaysia, for example, one soon realizes that a whole range of different data sets exists. The official Malaysian 1993 tourism statistics showed 4.1 million tourist arrivals from Singapore (MTPB, 1995). Yet, according to data published by the Word Tourism Organization (WTO), Singapore generated only a total of 2.2 million outbound tourists in the same year (WTO, 1995d). And another publication of the WTO speaks about 4.2 million Singapore tourists to Malaysia (WTO, 1994b). Who is a tourist? Whose definition is one to use? Data problems tend to magnify when one moves from a national to a regional level since one deals with different countries, different tourism and statistics departments, different objectives and many more potential areas of divergence.

A still larger obstacle is presented to researchers when they attempt to do a longitudinal analysis instead of the common cross-sectional study. Definition and counting practices change, detailed breakdowns of tourist arrivals may be available in recent but not in earlier years, etc.

Table 5.1. Outbound Travel Trip Generation, Selected Countries 1992

Country	Outbound Trips in millions	Gross Outbound Rate in per cent
Pacific Rim countries		
Australia	2.3	13.0
Canada	21.7	79.0
Chile	0.8	5.9
China	2.9	0.2
Hong Kong	2.2	38.4
Japan	11.8	9.5
Malaysia	14.8	78.6
Mexico	11.2	12.5
New Zealand	0.8	22.3
Singapore	1.9	66.1
Taiwan	4.2	21.8
United States	43.9	17.2
Other Countries		
Germany	50.3	62.1
Netherlands	9.4	61.9
Spain	19.9	50.8
Switzerland	5.9	85.4
United Kingdom	33.8	58.5

Sources: WTO, 1995b

This study relies almost exclusively on WTO data simply because it is the only international data source for outbound tourism statistics. However, even the WTO does not provide a breakdown of the outbound data into destination countries. Consequently, only the more widely available inbound statistics are used to arrive at

the tourist flows from the Asian Tiger countries to Pacific Rim destinations. This is similar to the approach used by the WTO in estimating the tourism market trends in East Asia and the Pacific (WTO, 1994b).

For the years 1988 to 1992, data from the most recently available *Yearbook of Tourism Statistics* (WTO, 1994a) is used for all Pacific Rim countries. In addition, the study relies on the aforementioned regional analysis by the WTO (1994c) which forwards some 1993 data for the major Asian Tiger outbound destinations. However, due to the varying level of detail in reporting tourist arrivals by the individual countries, data could not be obtained for some countries. In general, the less important the discussed markets are, the lower the likelihood of inclusion as a separate category. Hence, the discussion rests on those countries that actually provide data on one or all Asian Tigers and, for a comparison, Japan. For selected destination countries, longer time-series data from 1980 to 1994 will be used to exemplarily evidence the long range impacts of changes in outbound generation by the discussed markets.

Life Cycle of Outbound Tourism

For a long time, outbound travel has been a neglected aspect of studying tourist flows. Most studies focus on inbound travel and the changes and impacts of these inbound tourists to the destination country or region. In recent years, however, a number of studies have emerged that are specifically devoted to analysing outbound travel, changes in patterns, and the impact of outbound travel on domestic tourism demand. A big push toward recognizing the importance of outbound travel has been the inclusion of such reports in the *EIU Travel & Tourism Analyst* series (Cockerell, 1993; Lavery, 1993; McGahey, 1996; Rizzotto, 1995). A number of observers have recognized that it might prove more fruitful to scrutinize the patterns of outbound travel, especially in a longitudinal perspective, in order to better comprehend destination choice (Hamal, 1997; Hudman and Davis, 1994; Hultkrantz, 1995; Kroon, 1995; Oppermann, 1994a; Oppermann and Chon, 1995). Some authors have tried to place the emerging outbound patterns into the theoretical framework of the outbound destination life cycle (Oppermann and Chon, 1995) or the travel life cycle (Oppermann, 1994d, 1995). Arguably, considerable interest in outbound travel has emerged as the result of the drastic developments in outbound generation in the Far East markets (Huang *et al.*, 1996; Maguire, 1989; McGahey, 1996; Oppermann, 1996e; Wang and Sheldon, 1995). The 'outbound wonder' Japan of the early 1980s was replaced by the new 'Asian outbound tigers' Taiwan and South Korea in the late 1980s and early 1990s respectively (Oppermann, 1996e). Taiwan outbound tourist numbers grew by more than 30 per cent per annum in the years 1987 through 1990 and still expanded in the double digits until 1993 (Huang *et al.*, 1996). And China is set to become the outbound wonder of the late 1990s (Wang and Sheldon, 1995). Oppermann (1996e) suggested that outbound travel from these countries is like a 'wave' which first hit the proximate countries (geographical, price distance, culture and perception wise) but eventually will pass over them and move on to countries and

destinations further and further away. Oppermann and Chon (1995) showed that this was the case for German outbound travel, at least with respect to primary holiday trip generation.

While the study of outbound travel by itself is certainly of more than esoteric interest, the direct effect of such developments on the generation of domestic travel demand is of great interest to the domestic tourism industry. In Germany, for example, the tremendous shift in destination choice from domestic to foreign destination has brought many domestic tourism communities into serious financial trouble. Where in 1970 about 50 per cent of all primary holiday trips were towards domestic destinations, this percentage dropped to less than 30 per cent by the early 1990s (Oppermann and Chon, 1995).

In other countries, however, where barriers towards foreign travel had been higher and which are suddenly removed, shifts in travel patterns can be even more radical and their consequences far reaching. Such barriers can be political or financial. For example, the end of the Cold War in Europe and German reunification unleashed a 'tidal wave' of East Germans wanting to travel to the West, to countries they had heard of but were never able to visit, like Italy, Spain or simply West Germany. Where before the options for East Germans were largely restricted to Eastern European countries, suddenly the whole world was open and their outbound travel pattern changed radically. In the cases of Taiwan and South Korea it was the relaxation of outbound travel permits which released, quite suddenly, a built-up demand. While no data is available to the authors with respect to the impact of this tremendous growth of outbound travel in these markets on domestic destinations, the 'drain' of several million foreign trips is highly likely to have reverse impacts on domestic demand. Kroon (1995) illustrated how, in the Dutch case, domestic holidays were increasingly replaced by holidays abroad and indicates that the forecasted decline in domestic holidays around the year 2000 'should be a cause of alarm for those companies running resorts in the Netherlands' (1995:44).

In contrast to the abundance of studies applying the destination life cycle concept (Butler, 1980) to cities, regions and countries, few researchers have analysed the development of outbound tourism or attempted to place it into a life cycle context. The application of the life cycle concept to outbound tourism postulates that the outbound generation of country A to another country B moves through the stages of inception, development, maturity, stagnation, and decline and/or rejuvenation (Fig. 5.1). The cycle is dependent on the distance from the origin country. This already implies that the outbound life cycle curve from country A to country C may be different. Furthermore, country B is likely to be at a different stage to country C on their respective curves. And, according to Plog (1991), one may expect the type of tourist travelling at different stages to be different too. This has considerable implications for the destination countries and their marketing efforts. Application of this concept would also help destinations in identifying their direct competitors, namely countries that are at a similar stage with respect to a specified source country.

Figure 5.1. Outbound Destination Life Cycle

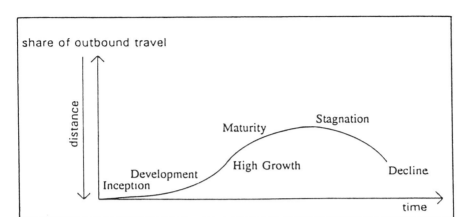

Only a few researchers have ever attempted to establish different countries according to their stage on the life cycle or product development curve. Ashworth (1991) placed several Mediterranean countries on a product development curve, however, without indicating how he derived the actual position of these countries. He also neglected the fact that each of these destinations may be at different stages with respect to different countries of origin. For example, while Spain may indeed be in the decline stage for former West German residents, it may simultaneously still be in the growth stage for residents of former East Germany.

The probably best known attempts at placing destination countries on a life cycle curve for outbound travel of one origin country are Plog's (1974, 1991) allocentric-psychocentric curves for travel by US residents. The comparison of two different years, some 20 years apart, is especially intriguing although limited by usage of many different countries and/or regions. None the less, the comparison shows how destinations such as Florida, Africa, Hawaii and the Caribbean have transgressed along the proposed development axis from more allocentric toward more psychocentric stages. Two major critiques of Plog's model remain, however, namely that the curve location of destinations is not necessarily congruent with the number of tourists they receive although this relationship is implied. And that due to a lack of making the methodology public, the same model cannot be applied elsewhere.

In a study of German outbound tourism, Oppermann and Chon (1995) argued that different countries are at different stages in Germany's outbound generation life cycle. Based on annual data from 1973 to 1992, they concluded that Austria is already in an

advanced decline stage whereas Italy entered the decline phase in the late 1980s. Spain is apparently in the saturation stage while Greece is still in the growth stage.

Analysing life-long travel patterns by German residents, Oppermann (1994d, 1995a, 1995b) showed how countries rise and fall in popularity. In addition, he highlighted the fact that while annual data as used by Oppermann and Chon (1995) indicates general patterns, a differentiation into different cohorts and/or life cycle stages may be more appropriate in tracing trends and will reveal crucial changes for destination countries or regions at a considerably earlier stage. This is in line with Butler's (1980) suggestion that the type of visitor is changing along the destination life cycle axis and with Plog's (1991) notion that different types of tourists visit different destinations. For example, Oppermann (1995b) showed that the younger German generations were more likely to choose destinations outside Central Europe than their predecessors. In addition, there were significant variations across the various life cycle stages with respect to destination choice and type of travel (e.g., type of accommodation and transportation used, group size, seasonality).

Japanese outbound tourism has also shown some preference changes which indicate that some destinations have moved into different stages in their respective outbound life cycle for Japanese travellers. The stagnation of Japanese outbound travel in the early 1990s was not felt equally across all destinations. In the period 1990-92, most notable were arrival decreases in many proximate, traditional destinations such as South Korea, Taiwan, Hong Kong, Thailand and Malaysia. On the other hand, other more 'in-vogue' destinations such as China managed to receive an increasing number of Japanese visitors.

The Japanese and German data appears to evidence that the outbound life cycle is linked, to some extent, to the distance-delay effect. More proximate destinations are visited first and, after a while, more and more distant destinations are explored and enter the growth stages of the outbound life cycle while the more proximate places enter their saturation or even decline stage. This notion was already mentioned by Christaller (1955) and is a central theme of Plog's (1974), Butler's (1980) and Cohen's (1973) studies. However, differences for countries within the same distance zone occurs (Miossec, 1977), due to historical ties, political boundaries perceptions, etc. Also, remote countries may never receive the same absolute numbers of tourists from origin A as more proximate ones even if they are in a more favourable stage of the outbound life cycle simply because of the travel costs and time (and hence barriers) involved. Thus, barriers to travel or a lack of facilities influence the development and integration of destinations into the outbound destination life cycle of a given country. A good example is former East Germany: it was among the countries with the highest Potential Generation Index (Hudman, 1979), but very few were able to travel to neighbouring West Germany and other Western European countries. Unification of Germany changed the travel patterns of these residents dramatically (Oppermann and Chon, 1995). Nevertheless, it may take decades for destinations to attain the same life cycle position as in the former West Germany.

Asian Tigers' Outbound Tourism

Between 1986 and 1993, the number of outbound tourists from the four Asian Tigers almost quadrupled, and in 1993, these four countries generated almost as many tourists as Japan (Table 5.2). A note of caution is in order. Other data from the WTO (1997c) suggested that there were 34.4 million Hong Kong tourists, 7.3 million Singaporean tourists, 4.8 South Korean tourists, 7.3 million Taiwanese tourists, and 25.2 million Japanese travellers (Table 5.3). While the figures for South Korea and Taiwan were not too different, there are wide variations for the other origin countries. One reason for the small deviations for South Korea and Taiwan is that tourists from these countries still visit mostly one country and not several during one trip, effectively reducing the number of multiple inbound counts for one outbound traveller.

In particular, Taiwan has emerged as a major outbound generator with 4.7 million departing tourists in 1994. Hong Kong and Singapore generated more than 2 million travellers each whereas South Korea's figure was above 3 million. Singapore and South Korea, especially, have some very high growth rates in more recent years. On average, between 1990 and 1994, the 69 per cent growth rate of Asian Tigers' outbound compares very favourable with Japan's 24 per cent.

An interesting aspect in analysing outbound tourism, and particularly when comparing a number of different countries, is to relate the number of outbound tourists to other socio-economic measures such as population size. Table 5.4 provides an overview of some indicators which places the discussion of outbound tourism in a larger context.

Table 5.2. Changes in Outbound Generation, 1986-1993 (in 1,000s)

Country	1986	1988	1990	1992	1993	1994	1990-4 (in %)
Hong Kong	1,207	1,570	2,043	2,233	2,483	2,798	37.0
Singapore	581	844	1,237	1,863	2,156	2,447	97.8
South Korea	455	725	1,561	2,043	2,420	3,154	102.1
Taiwan	813	1,602	2,942	4,215	4,654	4,744	61.3
Asian Tigers	3,056	4,741	7,783	10,354	11,713	13,143	68.9
Japan	5,516	8,427	10,997	11,791	11,934	13,579	23.5

Sources: WTO, 1992, 1996b

Table 5.3. Travel Abroad (in 1,000s)

Origin country	1985	1990	1995
Hong Kong	1,630	28,527	34,390
Singapore	2,873	6,205	7,345
South Korea	520	1,894	4,864
Taiwan	853	3,752	7,275
Japan	8,396	18,430	25,236

Source: WTO, 1997c

Table 5.4. Comparative Measures for the Asian Tiger Economies, 1994

Country	Population in million	Tourist Generation Index[1]	GNP per capita in US$	Tourist Expenditure per capita in US$	Tourist Expenditure Index[2]
Hong Kong	6.2	45	21,650	n/a	n/a
Singapore	2.9	84	20,224	1,250	1,500
South Korea	44.5	7	8,220	90	1,300
Taiwan	19.3	25	10,610	410	1,660
Asian Tigers	72.8	18	10,475	n/a	n/a
Japan	125.0	11	34,630	250	2,260

Note: [1] Tourist Generation Index is measured as outbound tourists x 100/population
 [2] Tourist Expenditure Index is measured as tourist expenditure/tourist

Source: WTO, 1996b

When measuring outbound tourists as a ratio of tourists per capita, one realizes the tremendous differences among the Asian Tiger countries. In 1994, Singapore's Tourist Generation Index was 84 while South Korea's was just 7. On average it was 18 which compares favourably with Japan's figure of 11. Thus, the Asian Tigers generate more international tourists per capita than Japan despite having considerably lower per capita GNPs. The Asian Tigers also tend to spend more on tourism than Japan. Both Singapore's and Taiwan's per capita expenditure is higher than Japan's. And if per capita tourist expenditure is related to per capita GNP even South Korea exceeds Japanese spending. However, Japanese tourists spend more than their Asian

Tiger counterparts; their Tourist Expenditure Index is higher than the one of Singapore, Taiwan and South Korea. Unfortunately, no data on tourist expenditure is available for Hong Kong.

Turning to the Asian Tigers' market share for Pacific Rim countries, the analysis of the available data indicates that the four Tigers' market share has increased considerably in the short time period between 1988 and 1992 or, where already high, has remained on high levels. In 1992, the four Tigers generated a sizable share of all tourist arrivals to Macau (82%), Malaysia (68%), Japan (47%), Indonesia (38%), Thailand (25%), New Zealand (13%) and Guam (13%). Six years earlier the figures were 84 per cent, 67 per cent, 35 per cent, 33 per cent, 15 per cent, 4 per cent and 3 per cent respectively (Table 5.5). The data is based on inbound data provided by the respective nations and compiled in the *Yearbook of Tourism Statistics* (WTO, 1994a). Hence, the 4.5 million Singaporean arrivals to Malaysia exceed the previously given figure of 2.2 million Singapore total outbound tourists. A similar deviation occurs for Hong Kong visitors to Macau.

The direct comparison with Japan's figures suggests that many destinations experienced an increasing Asian Tiger market share while Japan's was declining or stagnating. However, in some destinations Japan was also of growing importance, such as in the United States, Hawaii and New Zealand. One needs to be aware that a declining market share may not necessarily coincide with declining absolute tourist arrivals. Since many destinations were able to expand their inbound tourism quite considerably during the period 1988-1992, a smaller share may in fact mean higher absolute numbers.

Table 5.6 provides Japanese tourist arrival figures for some additional Pacific Rim countries. It shows that while the Japanese share in several Asia-Pacific countries may be stagnating or declining, other Pacific Rim countries are currently in the high growth stage (i.e., Fiji, French Polynesia) and still others, especially those in Latin America, are still in the inception stage.

Another way of looking at the changing nature of international tourist flows is to analyse the share of destinations with respect to the total outbound generation of the Asian Tiger countries (Table 5.7).

Table 5.7 is based on data provided by the WTO and the total number of outbound tourists is the sum of all inbound travel. Thus, it measures the relative importance of each destination with respect to the outbound travel of a specific country. One should be aware that the percentages in Table 5.7 are based on other totals than given in Table 5.2.

Table 5.5. Asian Tigers' Share in Inbound Tourism for Selected Pacific Rim Countries (in % of total inbound)

Destination Country 1988 1994	Origin Countries					
	Hong Kong	Singapore	South Korea	Taiwan	Asian Tigers	Japan
Canada	0.5	0.1	0.1	0.1	0.9	2.1
	0.8	0.1	0.5	0.4	1.8	3.0
Hawaii[2,3]	0.2	0.1	0.2	0.1	0.5	20.7
	0.4	0.2	1.7	1.1	3.5	27.2
Hong Kong[1,4]	-	3.4	1.8	19.6	24.7	22.2
	-	2.9	3.0	17.8	23.7	15.4
Indonesia	2.2	26.7	1.6	2.6	33.1	12.1
	2.1	25.4	2.6	7.9	38.0	11.9
Japan[4]	1.3	1.5	14.5	17.5	34.8	-
	0.9	1.2	26.5	18.7	47.2	-
Macau[4]	81.9	0.5	0.6	1.1[2]	84.1	6.0
	77.7	0.4	1.1	3.1	82.3	4.8
Malaysia	1.3	64.3	n/a	1.0	66.7[1]	4.5
	1.9	62.1	0.8	3.5	68.2	4.0
New Zealand[4]	1.0	1.7	0.3	1.0	4.0	10.8
	2.1	1.8	4.7	4.4	12.9	11.2
Philippines[4]	12.8	2.3	1.5	5.4	22.0	17.4
	6.0	1.8	6.2	10.0	24.0	17.7
Singapore[1,4]	3.0	-	1.3	3.6	7.9	16.3
	3.9	-	4.2	7.4	15.5	16.1
South Korea[1,4]	2.7	0.8	-	5.3	8.8	48.0
	3.4	0.9	-	3.8	8.2	45.9
Taiwan[1,4]	1.2	3.2	4.4	-	8.7	47.0
	1.6	3.3	5.8	-	10.7	38.4
Thailand	3.6	5.9	1.5	4.5	15.5	10.6
	5.0	6.3	6.0	7.3	24.6	11.2
United States	0.4	0.1	0.3	n/a	0.8[1]	7.5
	0.4	0.2	1.1	n/a	1.7[1]	8.9

Notes: [1] excludes one or more Asian Tiger countries; [2] data for 1990; [3] total arrivals for Hawaii include tourist from the mainland USA; [4] visitor arrivals
Source: WTO, 1994a, 1996a

Table 5.6. Japanese Share of Tourist Arrivals to Additional Pacific Rim Countries

Destination	1988	1994
Colombia	3.9%	0.2%
Costa Rica	0.8%	0.6%
Ecuador[1]	0.9%	0.7%
El Salvador	n/a	0.8%
Fiji	1.7%	12.5%
French Polynesia	3.6%	12.0%
Guatemala	0.8%	1.0%
New Caledonia	26.5%	27.8%
Northern Marianes[1]	78.0%	65.0%
Panama[1]	1.2%	1.0%
Papua New Guinea	5.4%	6.0%
Solomon Islands	5.5%	6.8%
Tonga	2.0%	3.0%

[1] Visitor Arrivals

Source: WTO, 1994a, 1996a

Table 5.7 reveals some very interesting developments in the time period from 1985 to 1993. For example, Japan's share of Taiwanese outbound travel dropped dramatically from 47 per cent to 14 per cent and South Korea's share was also almost halved. On the other hand, Indonesia and Malaysia were able to expand their share in the same outbound market. Figure 5.2 portrays the major Taiwanese outbound tourist flows (more than 25,000 tourists) in 1991 and 1993. It highlights the recent preference changes. For example, flows to Japan and Thailand almost stagnated, whereas destinations such as the Philippines could greatly enlarge their tourist arrivals from Taiwan.

Japan's share in South Korean outbound almost mirrored the development in Taiwan with Japan's share declining from 42 per cent to 33 per cent. Thailand, Guam and the United States were the main beneficiaries of this development.

Table 5.7. Selected Pacific Rim Countries' Share in Asian Tigers' Outbound Tourism (in %)

Destination	Origin Countries				
Country 1985 1993	Hong Kong	Singapore	South Korea	Taiwan	Japan
Canada	2.9	0.3	2.7	1.6	1.7
	1.5	0.3	1.5	0.9	2.3
Guam	0.1	n/a	0.2	0.1	3.6
	0.1	n/a	2.6	0.2	3.1
Indonesia	1.1	4.9	2.4	0.9	1.1
	1.1	14.0	3.6	5.2	0.5
Japan	3.7	1.5	41.6	46.5	-
	0.4	0.6	33.1	14.2	
Macau	67.4	0.9	1.6	n/a	1.9
	81.6	0.7	3.2	5.2	2.6
Malaysia	1.9	72.3	n/a	2.1	1.4
	1.4	65.9	n/a	4.6	1.5
New Zealand	0.3	0.3	0.2	0.4	0.6
	0.3	0.4	1.1	1.0	0.8
Philippines	3.8	n/a	2.4	4.2	1.8
	1.1	n/a	2.5	3.9	1.4
Singapore	7.0	-	6.3	10.2	4.6
	3.1	-	6.6	9.1	5.6
South Korea	3.4	0.5	-	11.7	7.6
	1.2	0.5	-	6.7	8.3
Taiwan	1.3	1.8	6.1	-	7.3
	0.4	1.2	5.9	-	5.1
Thailand	n/a	5.6	5.9	n/a	2.6
	4.1	5.6	9.9	9.6	3.2
United States	6.5	1.2	13.9	n/a	17.7
	2.4	1.1	16.0	n/a	19.7

Notes: n/a not available

Sources: WTO, 1994b

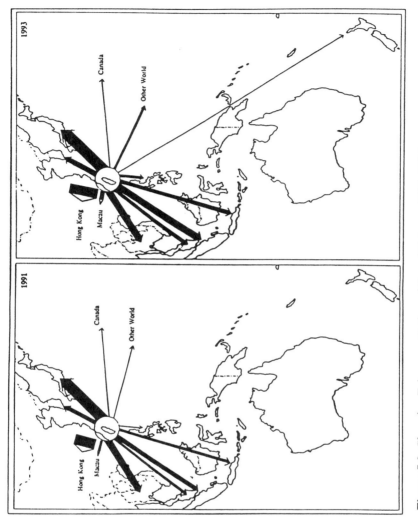

Figure 5.2. Changing Taiwanese Outbound Travel Patterns, 1991-1994

In the Singaporean case, Indonesia was able to augment its share at the cost of Malaysia. The opening and rapid development of the Indonesian Riau Islands in the close vicinity of Singapore was one of the main factors with the Riau Islands effectively competing with Malaysia's state of Johore and Tioman Island.

Figure 5.3 depicts the outbound life cycle curve for Taiwan and South Korea with respect to selected destinations. It shows that different destination have attained a different stage in the outbound destination life cycle.

Figure 5.3. Taiwan's and South Korea's Outbound Destination Life Cycle Curve (selected destinations)

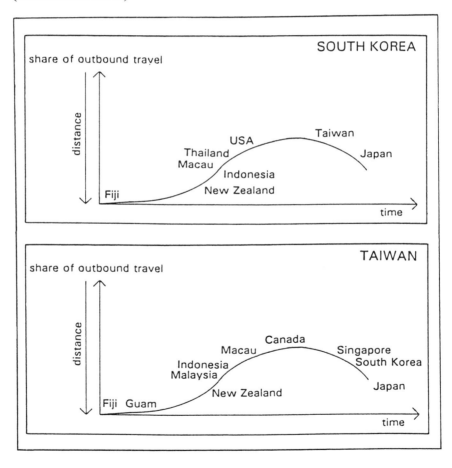

Conclusion

The data analysis suggests that tremendous changes are occurring in the Pacific Rim marketplace. Following the rapid expansion of Japanese outbound travel in the 1980s, the Asian Tigers have merged as major markets in the 1990s. By 1993, they generated almost as many tourists as Japan on a smaller population base. Thus, the continuing marketing concentration of many countries on Japan may not be justified in light of the importance of the Asian Tigers. In 1996, for example, the New Zealand Tourism Board intends to spend as much of its marketing budget on Japan as it does on the rest of North and South East Asia. However, New Zealand currently already draws over 80 per cent more tourists form these regions than it does from Japan.

While several Pacific Rim countries have developed into the maturity stage in Japanese outbound tourism (i.e., lower growth rates of Japanese arrivals), the same countries are only in the development stage (high growth rates) in the Asian Tigers' outbound tourism. This study also indicates that the growth in Asian Tigers' outbound tourism was not felt equally across the Pacific Rim but was first experienced (in the 1980s) by the more proximate countries (e.g., Japan) and only later (in the early 1990s) in the more distanced destinations (e.g., New Zealand). This suggests a distance delay in the life cycle curve with respect to outbound tourism generation.

The changing composition of international tourist arrivals constitutes one of the major challenges to the hospitality industry. Tourists from different markets have different expectations, and the hospitality industry needs to adjust to this changing environment. However, it also provides excellent opportunities for innovative entrepreneurs who anticipate these occurring changes and offer products and services aimed at the emerging markets before anybody else does.

This study also highlighted the limitations of current data availability, especially with respect to outbound travel. National Tourism Offices are called upon to place more emphasis on outbound data generation as well as more detailed information on inbound travel.

Chapter six:

Indigenization of Tourism Development: Some Constraints and Possibilities

Kadir H. Din
Department of Geography, Universiti Kebangsaan Malaysia,
UKM-42600 Bangi, Malaysia

Introduction

Discourse on tourism development very often covers an indigenous element of the destination, either as an exotic attraction, or as a passive beneficiary. The term 'indigenous' itself, however, is rarely made explicit; it can refer to the native groups, local residents, or even the entire citizenry of a country. In this paper 'indigenous' refers to the autochtonous or original population of the destination area. They can be the native groups or descendants of pioneer settlers. The dividing line is that the indigenous group was already at the scene before the onset of tourism development. As a corollary, 'indigenization' refers to the process of charting or recharting the course of tourism development so that its consequences will reflect closely the legitimate interest and identity of the original community.

In this paper it is argued that indigenization of tourism development is necessary in order to ensure a sustainable growth in the industry. There are three main reasons why this should be so. Firstly, at the level of product development, the indigenous elements cannot be substituted, even if staged versions can be reproduced for the tourist gaze. Bali, Hawaii or Langkawi without the indigenous cultural elements would be quite soulless and unspectacular. Secondly, within the context of sustainable development, equity issues including questions surrounding indigenous access to opportunities in tourism businesses, must be addressed (Tacconi and Tisdell, 1993). A mode of development that ignores the interest of local residents will never be acceptable to the host community, whose positive attitude to outsiders has always been a key ingredient in the success of a destination. Thirdly, the goals of human development, as endorsed and promoted by the United Nations and other international organizations, mandates a greater degree of participation of indigenous communities

in the decision-making process (Hughes, 1995). As the globalization process continues, universal values such as those embedded in the notions of 'civil society' and 'human rights' will prevail. The sooner the indigenous groups are legitimately incorporated into the decision-making process, the better it will be for tourism development in the destination areas. This, as many writers have argued, is what 'just tourism' is about (Hultsman, 1995).

The first part of the paper, after this introduction, examines the discussion of indigenization in the literature and relates it to the situation in the tourism sector. The second part describes the 'typical' development process and identifies a number of problems pertaining to the marginalized position of indigenous groups within the context of a rapidly expanding tourist industry. This is followed by a discussion on some of the constraints which impede their effective involvement with suggestions on possible ways of drawing greater participation among them. The final section provides a brief summary, followed by suggestions on some possible research directions for the future.

Indigenization and Tourism Development

Despite a long history of critical literature on Third World development, including writing that addresses tourism issues, there is hardly any explicit reference to the indigenization process. This is somewhat surprising considering the extensive coverage given to the predicament of indigenous groups in the former colonies of the Third World. The popular sentiment in nearly every viewpoint written on development (modernization, dependency, neo-dependency and to a lesser extent postmodern perspectives), is always benevolent of the position of the peasantry in peripheral regions. There is always a call for modernizing the indigenes in order to rescue them from the shackles of underdevelopment, but there is practically no mention about the possibility of indigenizing modernity as the Bolsheviks had tried to do in the Ukraine in the early 1920s. In the post-colonial situations the clamour for decolonization policies found expression in various ideological orientations such as 'indigenismo' in Latin America and variants of economic nationalism in nearly every country of the Third World, most of which are to be found in the Pacific Rim.

Indigenism, which was originally an anti-colonial ideology, soon became the basis for discriminatory policies against the immigrant groups during the post-colonial period (Golay *et al.*, 1969). Indigenization, thus became an instrument for redressing interethnic imbalance in the economies of former colonies which, during the colonial period, depended on indentured labour and a comparadore middleman group. While this orientation continues into the 1970s, a parallel development took root on the global scale, following the rise of universal values which were anti-(Vietnam)war, anti-poverty, pro-democracy, pro-environment, with a widespread concern for human rights and justice for all, including future generations. Alvin Toffler's concept of 'global village' became a reality in the 1980s to be updated by Naisbitt's Global *Paradox* which contains a chapter on travel. Naisbitt's reference to the

homogenization (or Americanization) of product, like Lanfant's concern over the rapid internationalization of destinations, suggests the need for measures to ensure product differentiation in the travel industry. It is here that indigenous attributes can be regarded as a very important element of the tourism resource, and in this context there appears to be considerable scope for the indigenization of product in the travel industry.

The Tourism Development Process

For most destinations tourism development planning is a foreign-inspired process which began in the 1970s. Prior to this tourism development was almost synonymous with the construction of accommodation facilities which was usually controlled through municipal land use ordinances. Since the late 1950s Third World countries have received advice from foreign experts who recommended large-scale tourism as a viable option for economic development (Pearce, 1989). Typically, the client government is presented with a plan which contains an optimistic market projection, a professionally mapped inventory of resources, a concept plan which details a hierarchy of access gateways, together with a schema recommending priority development regions and sites, and a list of general recommendations which sometimes include detailed project profiles. Until very recently, the plans (master, structure, strategic, marketing, action, etc.), say little about the local population beyond generalities. The general tendency to be expedient is rarely reported, perhaps because experts, being recognized as such, are presumed to know what is best for the target destination. Once in a while the 'Zinder Report error' gets noticed (e.g., Nelkin, 1975; Benveniste, 1977; Sofield, 1995).

By its very nature, the system of expert advice does have an inbuilt catch-22 problem. Expert's advice is sought because there is no in-house expertise; who then would be competent enough to evaluate the given advice? Given that normal practice is to separate the advising stage from the implementation stage, who again would be accountable for misimplementing and who, furthermore, would be responsible for monitoring? It is also not uncommon for some collusion to take place between the ambitious politician who wants to see things happen in his constituency, and the mercenary consultant who would prefer to take orders rather than risk losing subsequent bids for more projects. Such collusion is likely to produce more of a depoliticizing tool for the politician, rather than a useful advice in the interest of the public. In this respect the idea of community tourism planning, as proposed by Peter Murphy (1985) more than a decade ago, may not be readily applicable to Third World destinations where public scrutiny is lacking owing to a universal ignorance of the planning procedure, especially with regards to the role of the review process. Yet the same issue was discussed by Gray two decades previously (Gray, 1967).

The above situation implies that advisory inputs, though expensive, are largely insulated from public scrutiny. Perhaps for this reason, the interest of the indigenous target group, as often emphasized in policy goals, is seldom accorded a priority status

surrounding national culture, national language and ethnic integration, and the position of Islam as the official religion, has never been addressed in consultancy reports, despite their priority positions in the national development agenda.

The ideals of a human development strategy as repeatedly invoked in UN agency reports (Anon, 1990; Griffin and McKinley, 1994), call for the empowerment of the target population which is closely similar to Freire's notion of conscientization. Yet at the practical level, one rarely reads a subtitle in expert reports relaying that intent. This leaves the interest of the indigenous group perpetually marginalized from the development process.

Constraints in Local Participation

The list of impediments against indigenous involvement is long and some of these have been alluded to above. Looking at the position of the host community, it appears that ignorance is the greatest barrier to effective participation. For most indigenes, who are peasants, the urban business culture is an alien feature that has surfaced in their community only recently. Indeed in many areas, for example the interior of Sarawak, the traditional hospitality culture would not even allow them to treat hosting as a commercial proposition. Furthermore, they are not in the position to compete with experienced operators who are already well connected, well funded and have access to planning and business intelligence. Being outside the family or ethnic group that controls the trade, it is unlikely that their partnership will be sought after by their competitors. Ignorance as a barrier is not restricted to the resident population alone: it also affects the planning machinery, and the bureaucracy who are vested with the task of implementation.

To overcome the above constraints, it is imperative that an indigenization policy be integrated into the planning process and suitable strategies identified, not only to mandate advisory consultation with the host community but, more importantly, to ensure that they are encouraged to be actively involved in the tourism development process. This requirement may be clearly stipulated in the terms of reference given to consultants, and may be achieved through longer interaction between the local residents and the expert advisors. In other words the experts must be made to communicate on a more meaningful level with the indigenes, with an explicit instruction that indigenous involvement is to be treated as a priority item in the development agenda.

In the past NGOs have been excluded from the development process on account of their adversarial stand with respect to government plans. It may be desirable to coopt suitable NGO 'experts' to team up with the consultant group, so that the former will be in the position to act as a mentee, while collaborating with them in identifying suitable strategies and projects which can incorporate indigenous involvement. In the long run such collaboration can also act as an incubator mechanism which can facilitate the transfer of know-how, so that there will eventually be a sufficient pool of local expertise to monitor and review foreign input. The team assignment may also

of local expertise to monitor and review foreign input. The team assignment may also include specific programmes aimed at raising awareness and understanding (conscientization) of the local community. Such open communication would not only make the consultant's fieldwork easier, but may also provide an effective avenue through which local support for tourism projects can be gained.

Saglio's success case in lower Cassamance (Senegal) may be repeated elsewhere. In his model locals are mobilized through mutual-aid projects; logically, the same process can also be deployed to organize training for locals in related activities.

Conclusions and Implications

The conventional approach to tourism development has always been informed by the constructionist paradigm where the emphasis is on the development of touristic quality facilities, namely accommodation, restaurants, transportation, landscaping, recreation and entertainment. These facilities are complemented by marketing and human resource development programmes which are undertaken to ensure commercial viability of tourism projects. Such an approach very often deviates from existing policy and political pronouncements which customarily emphasize the distributive aspects of development, especially those addressing the need to encourage broader community participation in tourism businesses and in decision-making affecting the host community. It also tends to run contrary to the larger goals as declared in the national political manifestos and the UN charters and policy documents especially those that address issues on human development and sustainable growth.

This paper directs attention to the need to include more serious thinking on how to incorporate more active indigenous involvement in tourism development programmes. It is suggested, in particular, that the role of technical advisors be reexamined to ensure that tourism consultants will pay greater attention to the interest of local residents when giving their expert advice to authorities in destination areas. The crux of the argument here is that tourism advisors and researchers ought to devote more attention towards ensuring a greater degree of indigenous participation that they have done in the past. This requires more efforts to be devoted to understanding the development process itself why is there a lack of local participation and how can the situation be remedied.

In terms of priorities in research agenda, there is still a great deal to be understood about the policy implementation process itself. A political economic approach may be more appropriate in analysing the above process, so that the gap between public policy and consultant's viewpoints can be bridged. Too often the playing field is assumed away as levelled, so that locals are allowed the luxury of choice between wanting to get involved or not. In the standard analyses, advisors have always appeared with a ready set of answers: they must begin with an inventory of resources to come up with a concept plan. From there development can be facilitated through institutional changes, HRD strategies and incentive schemes to encourage delivery of

factor inputs. The issues surrounding national goals and politico-bureaucratic impediments are always left outside the scope of analysis. In the end the advisors' recommendations are accepted without an effective review procedure. Their job ends at the point of report submission. If any guidance is drawn, it tends to be on a self-serving and line-of-least-resistance basis which invariably leaves the interest of indigenous groups unattended. Clearly, a great deal more needs to be done to examine the role of expert advisors and the effectiveness of the implementation process. Experts ought to begin looking at the development process from an emic perspective, i.e. from the point of view of the indigenous host community. Only then can the interest of host community be placed in a more equitable plane.

Chapter seven:

Headhunters and Longhouse Adventure: Marketing of Iban Culture in Sarawak, Borneo

Heather Zeppel
Department of Leisure and Tourism Studies, University of Newcastle, Callaghan, New South Wales 2308, Australia

Introduction

> When you tell your friends how you holidayed amidst towering rainforests with hosts who were formerly headhunters, they'll see it as quite an achievement. As well as the adventure of a lifetime. The fact is, you can still lose your head in Sarawak.
>
> (Sarawak tourism advertisement *A real feather in your cap*)

Iban longhouses are a feature tourist attraction in Sarawak, a Malaysian state on the island of Borneo. The hospitable Iban, comprising the largest ethnic group in Sarawak, are famed as former headhunters and for their warp ikat *pua kumbu* textiles. In 1991, over 16,456 tourists went on package tours staying overnight at a rural Iban longhouse. A longhouse is a village under one roof, with family apartments joined together and a long communal gallery. Tourists on longhouse tours come mainly from Western Europe, USA, Canada, Australia and small numbers from Singapore and Japan. These adventure tours mainly visit select Iban longhouses on the lower reaches of the Skrang, Lemanak, Engkari and Ulu Ai Rivers, a day's journey from the capital of Kuching. Iban people living on these rivers still continue a longhouse lifestyle, practise their animistic religion and observe traditional customs including *gawai* or ritual festivals. Some Iban longhouses on the Skrang River have been visited by tour groups since the mid-1960s (Kedit, 1980). Other Iban longhouses on the Lemanak and Engkari Rivers have only recently become the focus of tourist visitation. In a fast developing region, this type of Iban longhouse 'experience' is unique to Sarawak.

Tourist Marketing of Iban Culture

In Malaysia's tourism industry, Sarawak is promoted as an exotic 'Adventureland in Borneo'. Sarawak tour brochures particularly feature traditional Iban culture, the unique longhouse lifestyle, adventure in a jungle setting and the thrill of meeting former headhunters. This chapter compares the tourist marketing of Iban culture by local tour operators in Sarawak with the international marketing of Iban longhouse tours by mass market, special interest and adventure travel companies in Australia. The promotion of Iban culture as an exotic tourist attraction in Sarawak, Borneo is revealed through content analysis of both text and images used in these commercial tour brochures. This approach is based on Cohen's (1989) analysis of 'communicative staging' of authenticity in posters advertising hilltribe trekking tours in Chiang Mai, Northern Thailand. This verbal communication of authenticity relies on rhetoric to 'sell' tribal cultures and attract tourists. With the tourist marketing of Iban culture, a contrast is made between references to contemporary Iban lifestyle and tourist brochure representation of the Iban as headhunters.

Current tourist marketing of Iban longhouse tours mainly presents a standard set of cultural markers such as trophy skulls, tattooed Iban men and the longhouse building (King, 1993; Selwyn, 1993). To move beyond cultural stereotypes, however, there is a need to 'link the study of touristic images with that of tourism proper' (Cohen, 1993:42). These commercial images of the Iban, in Sarawak and Australian travel brochures, are further contrasted with actual tourist responses to Iban longhouse tours. Field research on Iban longhouse tourism was conducted in Sarawak during 1992 at three Iban longhouses: Serubah and Nanga Kesit on the Lemanak River and Nanga Stamang on the Engkari River. Observations of tourist-Iban encounters, and visitor survey responses to Iban longhouse tours (Zeppel, 1995), suggest that tourists prefer meeting Iban people rather than seeing stereotyped cultural markers. Content analysis of Australian travel brochures, in particular, indicates social involvement with Iban people is an important feature in marketing longhouse tours.

Headhunting and the Iban

Headhunting was the most famous of all Iban customs. The Iban, also widely known as Sea Dayaks, became notorious for their headhunting exploits in northwest Borneo during the nineteenth century (Vayda, 1975). Iban motives for headhunting were to rectify a series of misfortunes (crop failures, deaths, disease, infertility), to end mourning periods and, indirectly, the need to acquire new farming land. For Iban men, headhunting was proof of bravery and a means to acquire personal prestige. Men who had taken human heads were tattooed on the back of their hands. Traditionally, Iban women used a *pua kumbu* ikat textile to receive the severed heads brought back by victorious Iban warriors (Ong, 1986). Prized human trophy skulls were hung up in the gallery of an Iban longhouse. The skulls were, and still are, spiritually appeased with smoke from a fire burning underneath and honoured with food offerings. Tourists in Sarawak can still see trophy skulls hanging in many Iban longhouses.

The former Iban propensity for headhunting is often used in tourist advertising for Sarawak. One striking magazine advertisement, headlined as 'A real feather in your cap', features a face portrait of a tattooed Iban man wearing a spectacular plumed headdress. For would-be adventure tourists, this advertisement emphasizes the thrill and excitement of meeting former headhunters in Borneo. The text highlights meeting 'hosts who were formerly headhunters'; 'spending a night in a native longhouse'; being welcomed by 'intricately tattooed men adorned with a plumage of hornbill feathers'; and joining a 'blowpipe expedition'. The head-and-shoulders tourist snapshot of an Iban man, used in this advertisement, prompts the observation 'Who is headhunting whom?' As a further irony on the importance of collecting heads to the Iban, tour operators in Sarawak pay a standard 'head tax' (*cukai pala*) of M$10 per tourist as an admission fee at Iban longhouses. This chapter will examine tourist images and responses to Iban culture.

'Unexplored Borneo': Sarawak Travel Brochures

In Sarawak, travel brochures were collected from 20 Kuching-based local tour operators conducting Iban longhouse tours during 1992. The brochures varied from a mono-colour tract illustrated with line sketches to glossy fold-out sheets illustrated with colour photographs or art illustrations of native people and wildlife. Two brochures featured Iban textile designs along their borders. Titles for these Kuching travel brochures included: *Borneo Experience, The Borneo Adventure, Borneo Unexplored, Sarawak: Land of the Hornbill, Sarawak: Malaysia's Legendary Borneo* and *Sarawak: A potpourri of exotic experience*. The unexplored frontier, wild places, adventure and exotic tribal cultures in Sarawak were common themes (Selwyn, 1993). Cover photographs mainly depicted Iban people in ceremonial attire, rainforest vegetation, other Dayak or native people, coastal and river scenery, orangutans, hornbills and pepper plants. Iban men and women were shown posing in ceremonial costume on the longhouse verandah; standing above a waterfall; and poling or paddling a longboat along a jungle river.

All the Sarawak travel brochures include a guided Iban longhouse tour as a standard package tour. These include both full day tours and a 2 day/1 night tour (or longer) visiting rural Iban longhouses. The overnight-stay longhouse tours are described as a 'River Safari'; 'Longhouse Adventure'; 'Sea Dayak (Iban) Longhouse Tour'; 'Iban Longhouse Safari'; and, in one brochure, as 'The Intriguing Iban Longhouse Expedition'. Each longhouse tour itinerary describes the scenic river journey, Iban culture, traditional dancing and the longhouse lifestyle. Aimed at foreign visitors (few Malaysian tourists visit Iban longhouses), these Kuching travel brochures emphasize the adventure of visiting Iban people living in their jungle longhouses. Local tour operators market Iban culture mainly in terms of headhunting, longhouse living and the environmental setting.

In Sarawak travel brochures, the Iban are frequently portrayed as former headhunters. This warlike image is further embellished by referring to the Iban as

pirates and warriors. Many brochures also refer to human trophy skulls still hanging in Iban longhouses. 'The illustrious Ibans were once a fearsome tribe which dabbled in piracy and headhunting . . . Evidence of their eventful past are still very much on show with trophies (skulls of enemies) hanging from the eaves of the longhouse' (Agas Pan Asia Travel). This emphasis on the Iban as headhunters, and seeing trophy skulls, is more pronounced in descriptions of a one-day Iban longhouse tour. One brochure describes an intriguing tourist activity, 'witness the demonstration of head hunting', presumably a reference to seeing human trophy skulls at an Iban longhouse (Kalimantan Travel). Another tour itinerary only indirectly refers to headhunting, 'No air conditioning, no room service, but fun, and your head should be safe!'(Inter-Continental Travel). Five Kuching tour operators, however, make no mention of the Iban as headhunters in their brochures. Instead, these more established operators focus on the longhouse lifestyle, ongoing Iban cultural practices and the natural jungle setting as the principal tourist drawcards.

Seven Kuching tour brochures also mention the Iban now live peacefully as farmers, fishermen and hunters. This present-day description of the Iban usually follows the statement about being former headhunters. The warlike Iban are now safe for tourists to visit: 'Today however one does not have to scheme to keep one's head and valuables as they live peacefully farming the land, hunting in the wilds and fishing the waterways' (Agas Pan Asia Travel). Several brochures describe tranquil rural scenes of Iban people travelling in a longboat or hunting in the jungle. This text presents the Iban living close to nature, in their original (i.e. authentic) state.

Most Kuching travel brochures highlight the unique Iban longhouse lifestyle in Sarawak. Tour descriptions refer to Iban communal living and the longhouse way of life, with the lifestyle described as unchanged, original or traditional. 'Accept the hospitality of one of Sarawak's largest ethnic groups and share in their unique style of communal living' (Agas Pan Asia Travel). Two brochures refer to the natural Iban longhouse lifestyle, meaning unspoilt or close to nature. Some brochures mention Iban lifestyle skills such as the use of blowpipes and the skill of Iban boatmen in river travel. While these Kuching brochures describe Iban lifestyle, there is scant reference to the personality of Iban people. Apart from their renowned hospitality, only one tour itinerary describes the Iban as friendly, with no mention of being headhunters: 'The natives are indeed friendly and helpful people and you can just sit back and relax among them' (Saga Travel). One other Kuching tour brochure generally describes native people in Sarawak as 'open and warm in their hospitality', including the Iban (Borneo Adventure).

Some Kuching tour operators have begun to emphasize Iban environmental 'know-how'. Two brochures describe a jungle walk near an Iban longhouse where tourists can learn 'the native ways of setting-up of animal traps' (Borneo Transverse Travel). Extended 'River Safari' tours include fishing and collecting jungle products like bamboo shoots with Iban guides. One Kuching tour operator features Iban environmental knowledge as a key part of their longhouse tour, 'Learn Iban jungle craft, hunting, fishing traps, collect jungle food, water, native cooking and help build jungle shelters for the night' (Singai Travel). Tourists learn about jungle survival

skills from their Iban guides. This commercial focus on Iban environmental culture is a more recent tourist marketing trend.

Most Kuching travel brochures highlight recreational aspects of an Iban longhouse tour. These outdoor activities include longboat travel (shooting the rapids, hauling the boat upriver), jungle treks, swimming at waterfalls and a picnic lunch by the riverbank. Two brochures describe searching for wild orangutan in primary rainforest, together with an Iban longhouse tour, on their 'Ulu Ai River Safari'. Such back-to-nature activities are a more recent feature of Iban longhouse tours in Sarawak. These extra recreational or wildlife activities divert tourist attention away from the longhouse and Iban culture *per se*. These changes are similar to the inclusion of river rafting and elephant rides as standard features of hilltribe trekking tours in northern Thailand (Dearden and Harron, 1992). The tourist focus is drawn away from cultural impacts of modernization at villages and longhouses to adventure activities and the natural environment.

Communicating Authenticity: Iban Longhouse Package Tours

Nearly all Kuching tour brochures 'frame' authenticity by listing typical Iban activities for tourists to observe and record on their longhouse tour. One operator, for example, explicitly states 'Iban women will dress up in full ceremonial costumes for tourists to take photos' (Journey Travel). Most longhouse tour itineraries clearly indicate what tourists will see of traditional Iban culture, including colourful ceremonial costumes, dance performances, blowpipe use, cockfighting demonstration, etc. There is a clear contrast between Iban culture performed for tourists, as passive observers (the main emphasis), and opportunities for tourists to actively experience or participate in the Iban lifestyle. A few brochures refer to social interaction with the Iban, mainly by drinking rice wine or tourists joining in with dances. Some Kuching brochures invite tourists to join in with everyday Iban activities, 'Feel free to join the natives in their daily chores like making baskets, mats, fishing nets, weaving pua kumbu, feeding their livestock, washing their clothes, fishing and swimming in the river' (Borneo Exploration Travel).

With one exception, all of the Kuching travel brochures mention Iban dance as *the* key tourist attraction. Longhouse tour itineraries largely describe Iban dance as a tourist spectacle, 'Witness the Iban War Dance with gong music' (Journey Travel), though a few invite tourist participation, 'do not hesitate to join them in doing the war dance'(Bel Air Travel). Convivial tourists may also 'join the tribal revelry in the longhouse' and 'imbibe the locally brewed rice wine "tuak"' (M.L. Travel). This longhouse entertainment is generally the extent of tourist participation in Iban culture, as described in Kuching tour brochures. With one exception, none of the local brochures depicts tourists dancing or interacting with their Iban hosts. The Iban are presented as an object for the tourist view.

The word authentic is not used in Kuching travel brochures to describe Iban culture. Instead, the word 'traditional' is often used to describe the Iban longhouse, welcome ceremony, Iban dance and rice wine. One brochure mentions a traditional

longboat, though all those required for tourist transport are powered by outboard motors. Two local operators refer to the Ulu Ai River as the traditional home of Iban people. Most Kuching tour brochures refer to Iban customs, like the welcome ceremony, or else describe the appearance of an Iban longhouse, to establish authenticity. The word 'primitive' is occasionally used to infer authenticity: applied to the Iban, an upriver longhouse or the river atmosphere, in three brochures (Cohen, 1989).

Authenticity is further ascribed to tourist meals on longhouse tours, more by where and how the food is eaten rather than culinary content. On tours where visitors sleep in the longhouse, brochures state tourists will experience 'a longhouse feast - a natural-style dinner on the mat-covered floor' and have 'dinner with the headman' (Inter-Continental Travel). Or that tourists will simply 'dine longhouse style' (Singai Travel). Other tour operators use the more fanciful term jungle feast to describe the tourist's dinner, eaten in a separate guesthouse building, using food brought from Kuching. Two brochures further describe a jungle picnic where 'Lunch will be served in native style at the riverbank', with food cooked in bamboo, in the only reference to Iban culinary traditions (Borneo Transverse Travel).

Some Kuching tour brochures further link authenticity with the type of travel, the river destination or the distance travelled. The Ulu Ai River Safari is described as a '*real* adventure' where tourists can experience the 'natural lifestyle' and search for wild orangutan (Kalimantan Travel). In this tour, the Iban are presented as part of the jungle environment. The search for authenticity relative to the distance travelled provides a marketing device to sell longer Iban river safari tours. These four-day tours visit Kachong, 'one of the most traditional longhouse (sic)' on the Lemanak River (Borneo Transverse Travel), and Panchor or Kujong longhouse on the upper Skrang River, described as 'more primitive' since they are 'located deep in the interior' (CPH Travel). Greater authenticity is also implied where tourists stay in the Iban longhouse itself rather than sleeping in a tourist guesthouse.

Images of Iban People in Sarawak Tour Brochures

Colourful photographs of Iban people illustrate most Kuching tour brochures. These depict Iban men and women wearing traditional costume (44): posing for the camera, dancing at the longhouse, or performing other typical cultural activities (Zeppel, 1994). Tattooed Iban men are shown using the blowpipe, holding a rooster, poling a longboat, throwing a cast net, lighting a cigarette, collecting jungle produce and performing a *miring* or blessing ceremony, while Iban women are shown weaving. Other photographs depict longboats moored at the riverbank (7) or travelling on a river (3), views of the longhouse (8), and human trophy skulls (3). Tourists are shown travelling upriver in a motorized longboat, driven by Iban men in casual clothing (10). Only one brochure depicts social interaction between tourists and Iban hosts, portraying a 'famous' tourist, Hollywood actress Jane Seymour, dancing with an Iban man watched by other residents in the longhouse (CPH Travel).

These brochure illustrations rarely depict everyday Iban activities or domestic

scenes inside a longhouse. There are no photographs of Iban children, mothers and babies or Iban family groups commonly seen in the longhouse. There are also few pictures of Iban people in casual clothes, apart from men transporting tourists in longboats, longhouse folk watching a tattooed Iban man dancing in a sarong and an Iban man watching a cockfighting bout. The three brochure photographs depicting everyday Iban life include a woman making a sun hat, another woman weaving a *pua kumbu* textile (while wearing a batik sarong) and an Iban man preparing food offerings for a festival. These are unposed photographs showing routine scenes from rural Iban longhouse life. While the featured longhouses regularly host tourist groups, photographs of tourists socializing with the Iban are conspicuously absent in Kuching brochures.

Australian Travel Brochures: Marketing Iban Culture

Travel brochures from Australian tour companies were also examined in this study, to analyse the international marketing of Iban longhouse tours. Brochures were collected from twelve Australian travel agents offering a range of tours in South East Asia, Malaysia and Borneo, from 1990 to 1994. The following review compares the marketing of Iban culture by mass market (Qantas Jetabout, Jetset, Viva! Holidays, Venture Holidays), special interest (Adventure World, Destination International, New Horizons, Special Interest Tours) and adventure travel (Intrepid, Peregrine, World Expeditions, Access) companies in Australia. These tour brochures vary in the way they market an Iban longhouse visit as an exotic travel experience. They target a particular segment of the Australian travel market, by emphasizing different aspects of Iban culture and the degree of comfort in the tour itself.

The former custom of Iban headhunting was mentioned by only five of the Australian travel companies packaging tours to Borneo. Brochures for two adventure travel operators, Intrepid and Peregrine, both highlighted the Iban reputation for headhunting. The 1994 Peregrine brochure, however, contained no reference to Iban headhunting, while the 1993/94 Intrepid brochure excluded the former reference to seeing trophy skulls on display. With special interest tour operators, Adventure World simply described the Iban as former headhunters while Destination International elevated this former Iban practice to the realm of 'mythical' and 'fabled'. Only one mass market brochure, for Venture Holidays, mentioned headhunting, erroneously referring to shrunken heads not skulls. In contrast to the emphasis on headhunting in Kuching travel brochures, this historic aspect of Iban culture would seem to have only limited appeal to the Australian travel market.

Australian brochures emphasized varying aspects of Iban lifestyle to attract different tourists. The adventure travel operators described staying with Iban people in a traditional longhouse and participating in the rural lifestyle. From this direct personal encounter, adventure tourists would learn about Iban culture. The tourist experience of Iban lifestyle varied from looking (mass market travel) and learning (special interest travel) through to participation and sharing (adventure travel). Some

tour brochures used cultural facts or knowledge about the Iban to assert authenticity. The 1991/92 Peregrine brochure, for example, described animist beliefs, in the only reference to Iban religion; their 1992 brochure listed an Iban guide explaining traditions and lifestyle; while their 1992/93 brochure mentioned asking permission to stay in an Iban longhouse. None of these Iban customs, however, was described in the 1994 Peregrine brochure. Unlike the brochures for Sarawak tour operators, Australian brochures neither emphasized nor described the appearance of an Iban longhouse.

Some adventure tours described basic amenities for tourists sleeping at an Iban longhouse, 'Facilities in the longhouse are primitive. Washing is local-style in the river, toilets are makeshift and you sleep on the wooden floor' (Adventure World). The New Horizons brochure referred both to 'isolated Iban longhouse villages' (remoteness) and travelling by 'motorized longboat' (modernization). Iban blowpipe skills are described both as a current (tourist) activity and as a former means of hunting for animals. Mass market brochures emphasized the excitement of visiting an Iban longhouse in the untamed jungle environment, 'An adventure into the thick jungle setting of the longhouse people at Skrang River to experience their unique lifestyle' (Venture Holidays). Adventure travel brochures, however, emphasized the experience of daily life in an Iban longhouse.

The personality of Iban people was mainly described in the adventure travel brochures. Intrepid highlighted the 'wonderful Iban people in longhouses that rarely have western visitors', with these Iban people as yet unaffected by tourism being 'more hospitable hosts'. In their 1993/94 brochure, Intrepid added 'Be warned - the Iban love to party!' The Access brochure simply referred to the Iban as 'hospitable people', while the 1991/92 Peregrine brochure stated the Iban 'now graciously welcome guests'. In one special interest travel brochure, for New Horizons, the Iban residents of rural longhouses are described as 'extremely friendly people'. Iban hospitality is a key feature of the visit.

The special interest and mass market Australian travel brochures described organized activities as the principal tourist experience of Iban culture. These mass market brochures, along with Adventure World and Destination International, simply listed Iban cultural events on display for tourists to 'witness', 'enjoy' or 'be entertained' with. The main tourist emphasis was on passive observation of organised activities at the longhouse. Special interest travel brochures, for New Horizons and Special Interest Tours, however, encouraged tourists to actively participate in Iban culture either by joining in with Iban dancing or trying daily chores. Adventure travel operators highlighted the personal challenge of drinking Iban rice wine, 'At night be prepared to indulge in Tuak - the local firewater' (Intrepid). The Australian travel brochures varied in their marketing from simply looking at Iban culture, to more active involvement and social interaction.

Like Kuching tour operators, Australian travel brochures also used other supporting statements to assert authenticity on their longhouse tours. Peregrine and Intrepid claimed to visit remote, unspoiled Iban longhouses away from other tourists. Destination International emphasized the ancient or unchanged character of Iban

culture, customs and heritage. Jetset described tourist meals eaten in the Iban manner, sitting on the longhouse floor. Intrepid and Peregrine further highlighted the knowledge and expertise of their Australian guides who had lived in Borneo, while Intrepid also included written testimonies from previous travellers on their adventure tours: 'Your trip showed us the real Borneo' (Anthony Greer, Vermont, Victoria).

The word authentic was not used in Australian brochures. Instead, the word traditional was often used to describe an Iban longhouse or Iban dancing. Adventure travel operators, and Destination International, focussed more on describing the longhouse as traditional. The mass market and other special interest travel operators, however, mainly described Iban dancing as traditional. In 1990/91 Intrepid referred to a traditional Iban longhouse, but their later brochures referred only to seeing displays of 'traditional dancing, hunting or craftwork'. Cultural aspects of the ongoing Iban lifestyle assumed more importance than the actual longhouse dwelling.

Images of Iban People in Australian Brochures

Iban longhouse tours featured in Australian travel brochures were mainly illustrated with photographs of tattooed Iban men. Wearing a loincloth, Iban men posed by the riverbank, held up a blowpipe, gathered jungle plants or danced on the longhouse verandah. Three mass market travel brochures also depicted Iban women in ceremonial costume along with Iban men. Adventure travel brochures, in particular, featured colourful portraits of tattooed Iban men. Occupying up to half a page, these striking photographs projected a wild image of Borneo. Two adventure travel brochures further depicted a male tourist using a blowpipe and another male tourist shaking hands with tattooed Iban men on the longhouse verandah. This masculine emphasis in portraying Iban culture may reflect the fact that adventure travel is still predominantly male-oriented and associated with challenge and taming the wild rather than personal growth and enrichment (Beezer, 1994).

Some 'natural' portraits of Iban people, wearing casual clothes, were depicted in the adventure travel and special interest travel brochures. These included pictures of an old Iban woman, a mixed group of Iban drummers and an Iban woman and child bathing by the river. Such unposed photographs of Iban people, however, were usually quite small (about 5cm square) and located at the bottom of the page. Two larger 'natural' portraits at the top of a page further depicted an Iban woman basket weaving (Destination International) and a tattooed old Iban man in shorts (Intrepid). The latter image was a stark contrast and change from the more common pictures of Iban men in loincloths and feathered headdresses. These 'real-life' images reinforced the naturalness of everyday Iban longhouse life for would-be adventure travellers in Borneo.

Content analysis of commercial travel brochures indicates that most tour operators in Kuching and some in Australia continue to promote the Iban as headhunters. This stereotyped image of the Iban, however, may no longer be seen as credible nor confer authenticity. Some adventure travel operators in Australia now emphasize social interaction with Iban longhouse residents. This trend for promoting social

involvement with Iban people should replace the outdated image of the Iban as headhunters. Tourist responses to guided Iban longhouse tours reinforce this real desire for social interaction.

Looking for Skulls: Guided Iban Longhouse Tours

Tourist marketing of Iban longhouse tours, in Sarawak and Australian travel brochures, clearly revolves around presenting a colourful and exotic image of Iban culture in Borneo. Tour operators in Sarawak therefore arrange and structure longhouse tour programmes to meet tourist expectations of experiencing 'real' Iban culture (Zeppel, 1995). At the longhouse, tour guides mainly talk about traditional aspects of Iban culture. Comments on contemporary Iban lifestyle, including education, health and livelihood, are mainly discussed in response to tourist questions about these issues. Tour guides also direct tourist attention to the primary markers of Iban cultural authenticity, that is, the longhouse building, tattooed Iban men and fire-blackened human trophy skulls. The reality is, however, that tourists will also see Iban people in western clothing and sarongs, living under tin roofs, using outboard motors and chainsaws and other modern consumer items (Caslake, 1993; Linklater, 1990; Zeppel, 1994).

This author suggests that the marketing of Iban culture influences how tourists interact with Iban people on a guided longhouse tour. During fieldwork at three Iban longhouses in 1992 (Serubah, Nanga Kesit and Nanga Stamang), most guided Iban longhouse tours were based on 'Cultural Sightseeing' but some tours provided a more informal 'Meet the people' experience (Zeppel, 1993). Tourists visiting Serubah longhouse experienced an object-oriented tour, while, at Nanga Kesit, longhouse tours focussed more on Iban people and their routine activities. Some freelance tour guides at Nanga Kesit encouraged social interaction, where tourists sat down with Iban people, drank rice wine and enjoyed typical Iban hospitality. At Nanga Stamang, tourists slept in the longhouse, mingled with their Iban hosts and shared in daily life.

Cultural Sightseeing Tours

Tourists on 'cultural sightseeing' tours at Nanga Kesit and Serubah were preoccupied with taking photographs and videos, selectively recording 'exotic' aspects of Iban life. A particular feature was the rite of photographing the human trophy skull (Kesit) or skulls (18 skulls in three bunches, Serubah) hanging from a beam in the longhouse gallery. Tourists were often photographed standing next to a trophy skull and, on one occasion, at Nanga Kesit, posing with a tattooed Iban man touching the skull. Tour guides highlighted the human trophy skulls, as evidence confirming Iban status as former headhunters. At Nanga Kesit longhouse in 1992, tourist attention was clearly directed to the single trophy skull, wrapped in rattan and hanging from a rafter. This skull was placed in the longhouse specifically for tourists to look at and photograph. During a preliminary visit to Nanga Kesit in June 1991, a fellow Australian tourist

had commented that no human skulls were seen in this longhouse. In contrast, at Nanga Stamang tourists were not shown the single trophy skull tucked away in the roof of the gallery, not far from the main entrance.

These 'cultural sightseeing' tourists would spend, on average, 30 minutes on their guided tour of an Iban longhouse. The group moved systematically along the communal gallery (*ruai*) recording snapshots of Iban life. Any tourist involvement in Iban culture occurred within a structured activity such as cultural dances, games, blowpipe demonstration, or participation in a *miring* or blessing ceremony. Sightseeing tourists also bought many Iban handicrafts as further tangible evidence of their encounter with an 'exotic' native culture. These purchases highlight the touristic goal of cultural sightseeing, that is, to souvenir Iban culture. These handicrafts, however, may also compensate for a lack of personal involvement with Iban people during a longhouse tour.

'Meet the People' Experiences

In contrast to 'cultural sightseeing', some tour guides set up encounters with Iban people which provided a warmer, more intimate experience of Iban life. At Nanga Kesit, such 'meet the people' experiences were conducted by one freelance tour guide for small groups of four to six people. More outgoing people out of a larger group tour, generally only one to three tourists, also chose to interact with Iban people by joining in with social activities. These tourists would spend more than one hour sitting with Iban people, either out on the gallery or inside a private family room. Conversation was directed through the tour guide, with the conviviality of the social gathering enlivened by drinking *tuak* and calling out for other people - Iban and tourists - to join in.

An older Iban man at Nanga Kesit, who ran the longhouse store, regularly invited tourists into his family room *(bilek)*, entertained them with *tuak* and rolled Iban cigarettes. He also passed around three *parang* or swords, with carved and decorated hilts, for tourists to handle and admire. On one occasion at this *bilek*, four tourists participated in a ritual libation, each pouring some *tuak* into a glass. The Iban man then offered this *tuak* to the spirits by pouring it through the floorboards while intoning a short prayer. The tour guide explained the significance of this ritual action to the visiting tourists.

These observations of tourist behaviour indicate that hospitality, spontaneity and personal involvement with Iban people enhanced tourist appreciation of Iban life and overall satisfaction with the longhouse visit (Robles, 1996). Tourists involved in a small group 'meet the people' experience tended not to use their camera at all, or at least very sparingly. For these tourists, photographs and handicrafts were secondary to the immediate enjoyment of a personal encounter with Iban people.

Conclusions

Sarawak tour brochures mainly portray the Iban as former headhunters. Content analysis of Australian tour brochures, however, indicates social involvement with Iban people is replacing the outdated image of headhunters, in the special interest and adventure travel markets. In Sarawak itself, fieldwork observations of tourist-Iban encounters support this tourist demand for social interaction with the Iban. This includes sharing Iban life and meeting Iban people rather than seeing cultural markers such as trophy skulls or tattooed Iban men. This study suggests tourist marketing of Iban culture in Sarawak, by local and international tour operators, should emphasize social involvement with Iban hosts rather than perpetuating the cultural stereotype of the Iban as headhunters. In this new approach to promoting Iban culture, tourists interact with friendly hosts instead of Iban 'playing the native'. Indeed, the current Internet entry on Longhouse Tours in Sarawak acknowledges that 'for many visitors it is not exotic costumes and rituals that are the highlight of the trip, but a glimpse into everyday longhouse life' (Sarawak Tourism Board, 1996). More realistic tourist images of the Iban in travel brochures may well enhance this unique cross-cultural experience for both hosts and guests. In the words of one American tourist on a longhouse tour, 'Experience of Iban culture however it is currently lived is important. If they no longer live traditionally I would not want them to do it just for tourists.'

Chapter eight:

The Travel Experience of Cruisers

Gayle R. Jennings

Tourism and Leisure Studies, Faculty of Arts, Central Queensland University, Rockhampton, Queensland 4702, Australia

Introduction

Tourism related cruising literature has tended to focus on travel and tourism associated with 'cruisers' who are the fee paying passengers on a cruise ship, that is, 'a vessel undertaking scheduled, deep water cruises of two days or more, with a passenger capacity of 100 or more' (Cruise Lines International Association in Commonwealth Department of Tourism, 1995). This paper focusses instead on 'cruisers' of a different kind, that is, people who have adopted a sailing based lifestyle, who live aboard their own yachts, have independent means, are self sufficient and have been away from their port of departure for an extended period of time (Jennings, 1996). In the course of pursuing their lifestyle, these cruisers undertake ocean passages which vary from world circumnavigations, circular trips of the Pacific or voyages of varying lengths to locations considered by cruisers to be within geographic proximity to their home ports.

Whilst the first type of cruising mentioned above involves passengers in tourism experiences associated with a passage aboard a cruise ship and with the various ports of call, the latter involves cruisers in touristic (tourist-like) experiences resulting from the pursuit of a sailing based lifestyle. In pursuing their lifestyles, cruisers stop over at various locations for provisioning, boat maintenance, rest and recreation or to wait for favourable weather or a change of season to occur. Such stop-overs provide cruisers with the opportunity to become 'tourists'. The kind of 'tourist' the cruiser becomes can best be likened to the special interest tourist, particularly, the cultural tourist. This paper considers the similarities and differences between cruisers and special interest tourists, and cultural tourists in particular. The discussion is based on data collected in an ethnographic study of some 130 long term ocean cruisers during 1993 and 1994 at ports and locations along the eastern and western seaboards of Australia. The ports and locations were stop-over points for the cruisers while waiting

out the passing of the cyclone season or for the taking on of provisions or both.

Specifically, the data were collected using semi-structured interviews which were supplemented by some questionnaire-based material relating to cruising and yacht inventories, as well as tourism activities and budgetary items. The researcher had ocean cruising experience and was living aboard her yacht whilst engaging in her fieldwork and was an accepted member of the cruising subculture. Yacht arrivals were monitored on a daily basis. Long term ocean cruisers were discerned either by the flying of a courtesy flag from the yacht's rigging if an overseas yacht or by the general appearance of the boat, its equipment and the crew. All yachts which entered into the study area were approached on the second day of their arrival to ascertain whether the crew would agree to participate in the study. The second day of arrival was chosen as the crew would have been rested from the pervious day's passage and planning for the time in port would have been organized. During the first contact with the cruisers, ethical considerations were dealt with as outlined by de Vaus (1995). Of all cruisers approached only four refusals occurred, one because the cruiser thought the interview would be ultimately used by government sources, another because the yacht was departing that day, still another because the cruiser failed to appear at the agreed time (a follow-up indicated that the cruiser did not really want to participate) and the last refusal occurred because mechanical repairs had not been completed and time for an interview was no longer available.

At the first contact with the cruisers, some questionnaire material was left for completion prior to the interview time. On the day of interviews, the cruisers were re-acquainted with the purpose of the interviews and any queries were answered. The semi-structured interviews were tape-recorded in all but three cases where consent was refused and hand transcription was used. The interviews lasted from two to three hours depending on each cruiser and had a break point in the middle. The interviews focussed on cruisers' descriptions of their motivations for cruising, the cruising lifestyle, touristic experiences, cruising and cruiser impacts and cruisers' attitudes to regulation of yacht travel. Interviews were transcribed and analysed using the Nudist software package while questionnaire data were analysed using descriptive statistics. Both sets of analysed data provided the material for this discussion as well as a review of literature on special interest tourism and cultural tourism.

Prior to the commencement of the discussion of travel experiences, several terms need to be defined. For the purposes of this paper, special interest tourists will be taken to mean people who travel to specific locations or areas in pursuit of a particular interest (Read, 1980). According to Read, the interest '*is the hub around which the total travel experience is planned and developed.*' Such a definition when applied to cruisers does not appear to be problematic. Cruisers, like special interest tourists, have a specific interest: a sailing/cruising lifestyle. This interest in a sailing/cruising lifestyle takes cruisers to various locations in the world. Further, for cruisers, sailing/cruising, or more specifically the yacht, is 'the hub' around which the entire travel experience is based. However, cruisers and special interest tourists differ when the components of the '*total travel experience*' are considered in more detail.

To explain the '*total travel experience*', Killion's (1992) tourism adaptation of

the recreation experience developed by Clawson (1963 in Jubenville, 1976) will be used to analyse cruisers' total travel experiences. In 1963, Clawson (in Jubenville, 1976) developed a hierarchical or chronological model of the recreation experience, this model noted the following elements of a recreation experience: planning and anticipation; travel to site or destination; on-site experiences and activities; return travel; and recollection (Fig. 8.1).

Killion (1992) adapted Clawson's recreation experience to the tourism context and modified Clawson's hierarchical presentation of the experience into a circular model. Killion (1992) purported that since the recollection stage influenced future travel experiences especially the planning and anticipation phases, Clawson's model should be circular in nature (Fig. 8.2).

Whilst not supporting a circular model, Craig-Smith and French (1994) also noted that the recollection phase may merge with and influence the anticipation phase of future travel experiences. Instead of a circular model, Craig-Smith and French (1994) proposed a three phase linear-repetitive time model of the travel experience which exhibits similarities to the Killion-Clawson model (Fig 8.3).

In the Craig-Smith and French model, the anticipatory phase represents the Killion-Clawson planning and anticipation phase, while the experiential phase combines the travel to, on-site activities and travel from phases of the Killion-Clawson model. Finally, the Craig-Smith and French reflective phase parallels the recollection phase of the Killion-Clawson travel experience. Although the models are similar, Killion's model has been applied to the analysis of special interest tourists and cruisers, as it emphasizes the travel to and travel from components of the travel experience as significant elements of the travel experience. This is important for, as Jubenville (1976) noted, recreation experiences are more than the on-site activity, and by association, Killion reiterated this in relation to travel experiences.

Whilst Killion's model has been adopted in this paper, it should be noted that the model represents travel primarily to a single site destination rather than multiple site destinations. Consequently, when the nature of a cruise is considered, Killion's model might be modified one stage further in order to reflect the total travel experience of cruisers (Fig. 8.4). In the process of taking a trip, cruisers plan their total travel experience recognizing the experience is a composite of travel experiences. Each destination reached triggers the conclusion of one travel experience and the commencement of a new one. For example, if a cruiser intends to travel from New Zealand to New Caledonia to Vanuatu to the Solomon Islands to Papua New Guinea then on to Australia and back to New Zealand, an overall travel plan is created, then smaller plans are made for the various legs. Each destination reached involves planning, travel to, on-site activities, travel from and recollection. Within each travel experience, as Craig-Smith and French (1994) suggested, some overlap of phases may occur. For example, when still 'on-site', cruisers may be 'planning and anticipating' the next leg of travel and whilst 'travelling to' the next destination, a cruiser may also continue the 'planning and anticipation' as well as engage in 'recollection'.

Figure 8.1. Clawson's Model (1963)

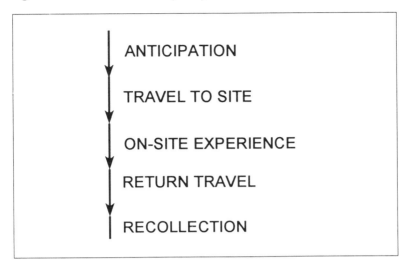

Figure 8.2. Killion's Model (1992)

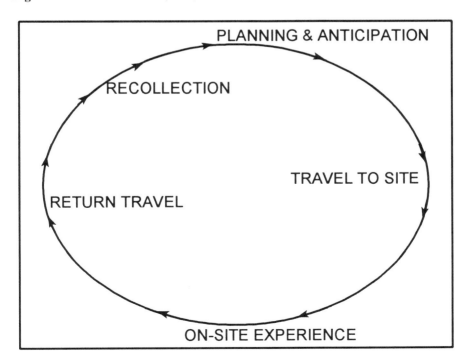

Figure 8.3. Craig-Smith and French's Model (1994)

Craig-Smith & French's travel experience		
Anticipatory phase	Experiential phase	Reflective phase

Figure 8.4. Proposed Cruisers' Travel Experience Model

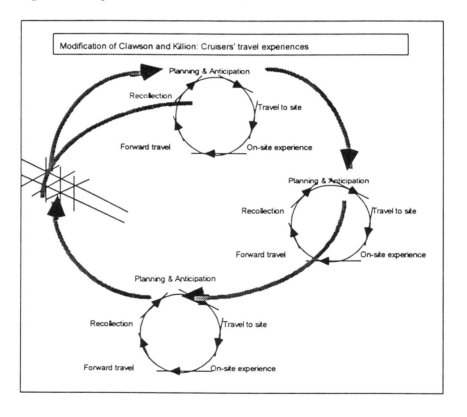

The repetitive model of the travel experience presented above (Fig. 8.4) may also be reflective of travellers who are engaging in a world tour or of independent travellers, for example, backpackers. The model could also be applied to the travel experience of the *'specialized cultural tourist'* who in the course of journey may *'[go] to different cities, regions, or countries in search of exemplars of, ... a kind of art, history, festival, or museum'* (Stebbins, 1996). It could even apply to other special interest tourists who pursue their interest at various locations during the one trip, for example, mountain climbing and trekking which involve the completion of various stages to achieve the total experience.

However, despite having suggested the further modification of Clawson's model, the paper will only apply Killion's model in order to simplify the analysis. Subsequently, each phase discussed will represent the sum of the individual phases from each of the travel experiences encountered on a voyage for cruisers or a journey for special interest tourists. The paper will now consider the similarities and differences between cruisers and special interest tourists in regard to each of the phases of the *'total travel experience'*: planning and anticipation; travel to site or destination; on-site experiences and activities; return travel; and recollection .

For both the cruiser and the special interest tourist, the planning and anticipation phase is pervaded by the special interest. Cruisers plan their travel based on their special interest: in so doing they must take into account ocean currents as well as weather conditions; gather charts and plan their passages and stop-overs; provision and determine water, food and fuel restocking points; prepare and receive immigration and departure papers; organize cruising permits; arrange for money exchanges and management of business affairs whilst abroad; check the boat and boat related equipment; inventory, check and add spare parts; organize and arrange children's schooling. It may also even mean building or buying a boat. In this phase, cruisers may refer to technical guides, such as how to build a boat, cruising guides and magazine articles, talk with other cruisers and government officials and personnel employed in sailing related businesses and services, for example, chandlery workers or marine engineers regarding spare part facilities and service centres for marine engines within the area to be visited.

Similarly, special interest tourists will plan and prepare their travel based around the pursuit of their special interest be it hiking or tramping, mountain climbing or abseiling, scuba diving or yacht chartering, nature based studies or cultural studies. They too may read guide books, magazines and relevant literature, talk with other similarly minded special interest travellers, contact clubs and government agencies. However, most special interest tourists will use personnel involved with the travel system to organize the journey and it is this point which separates the special interest tourist from the cruiser. Whilst special interest tourists are reliant on the tourism system to varying degrees during this phase of the total travel experience - to arrange travel, accommodation, equipment, tours and activities - cruisers are not. Apart from government agencies associated with tourism such as immigration, customs and quarantine personnel, cruisers draw on their own skills and resources to plan and prepare for their travel. They are the quintessential independent travellers who have

very little interactions with the tourist industry. Cohen (1972) termed them also as 'explorers' and 'drifters'.

In the next phase, the travel to the site or destination, further differences between the cruiser and the special interest tourist start to appear. For the cruiser, the interest, that is sailing, is also the transport mode and consequently remains the focus of this phase of the travel experience. During travel to the destination, cruisers are constantly engaged in their special interest: plotting courses; taking sextant sights; helming the boat; trimming and changing sails; checking weather; standing watch; maintaining the boat; and keeping the log of the journey. For special interest tourists, travel to the site or the mode of transport used is generally not the special interest. Rather it is the means to reach the location where the interest may be pursued. The exception may be steam train enthusiasts and sea kayakers. However, even in these cases, the special interest tourists still have to travel by some means to their departure point in order to undertake their special interest 'journey'.

Like the special interest tourist, when the cruiser is on-site, the experiences and activities are still linked to the interest: however, instead of sailing, the yacht becomes the primary focus. The yacht provides accommodation; a source of food and beverages; transportation - dinghies and bicycles which may be stored on board; entertainment in the form of books, games, radio, music, videos, television; and day sailing excursions, as well as a venue for reciprocating hospitality and a sanctuary away from the host environment. Unlike most special interest tourists, the cruiser can feel at home no matter the location. For most special interest tourists, the on-site experiences and activities are not supported by the level of self-sufficiency experienced by cruisers. Special interest tourists remain reliant on the tourist system in various ways for the fulfilment of their basic needs and activities during this phase of the travel experience. The possible exceptions being special interest tourists who use campervans, caravans or camping equipment.

Another difference between cruisers and special interest tourists during this phase relates to the time devoted by cruisers to the maintenance and repair of equipment as opposed to the pursuit of on-site touristic experiences. Apart from campers, 'caravanners' and special interest tourists such as abseilers, mountain climbers, scuba divers, surfers, kayakers, who may take their own personal equipment, very few other special interest tourists become involved in maintenance and repair of their special interest equipment or mode of transport to the degree which cruisers do when travelling. For example, cruisers reported that a once a year 'on-site activity' involves hauling out or careening the boat and painting (antifouling) the hull to protect it from marine organisms which may damage the vessel. Thus, one of the on-site experiences becomes wholly planned and dedicated to the maintenance of the boat, which is primarily completed by the cruisers themselves to save money. Most special interest tourists generally do not plan a trip so as to travel to a site solely to repair their equipment; they would usually do that at home save for accidental breakages and faults.

Although the boat remains the primary focus for cruisers during stop-overs or 'on-site experiences', cruisers also reported that during stopovers they engaged with both

expatriate and indigenous people in various ways and interacted with the local environments as they went about their daily living activities. For example, cruisers exchanged money for goods and services or traded with the locals, participated in local activities and visited natural and built environments. That is, cruisers reported engaging in cultural tourism-like experiences in the course of their daily life in the 'on-site' phase.

Various definitions of cultural tourism can be found in the tourism literature, ranging from descriptions of tourism associated with visits to view material culture (for example, the arts, crafts, foods, clothing and buildings) and/or non-material culture (for example, customs, traditions and religions) to definitions of cultural tourism as experiential tourism (Zeppel and Hall, 1991). During the study, cruisers reported cultural encounters similar to the first definition: visits to historic and heritage sites; attendance at festivals; and the viewing of arts, crafts and the visual and performing arts (Tighe, 1986). As an adjunct to self-reports, a questionnaire based on Peters' list of tourist attractions (Peters, 1969 in Robinson, 1976) was also provided for cruisers' completion. Cruisers were asked to note to which tourist attractions if available at a stop-over they would be drawn. Cruisers' responses are recorded in Table 8.1. Not all cruisers responded to the questionnaire. Of the 130 cruisers interviewed, 40 did not complete the questionnaires. Some chose not to respond; in other cases, if two persons on a boat were interviewed some cruisers would say their responses would be the same as their partner's. In these cases, the interviewer only recorded the person who responded. Others had limited time and the indepth interview became the major focus of the contact with the cruisers rather than questionnaire completion.

Based on Tighe's (1986) definition of cultural tourism, the Peters' categories of cultural attractions, traditions and entertainments represent cultural attractions. Zeppel and Hall (1991) also noted that scenic attractions are part of cultural tourism and these are also reflected in Peters' list within the scenic attractions category. From Table 8.1, it can be seen that the majority of cruisers are drawn to and will visit archaeological sites and areas, historical buildings and monuments, places of historical significance and museums. Traditional festivals, arts and handicrafts, traditional lifestyles and customs as well as local foods and cuisine were also attractions for cruisers. A significant number of cruisers who responded to the questionnaire were also drawn to elements of the natural environment, primarily outstanding panoramas and areas of natural beauty as well as wildlife.

Whilst the questionnaire forced cruisers to choose which attractions they would visit provided an attraction was available in the vicinity and there was time to visit it, indepth interviews highlighted the experiential nature of cruisers' involvement with cultural tourism. Subsequently, it is Zeppel and Hall's definition which best accords with cruisers' descriptions of their participation within the cultural settings they visited. For example:

We actually like to meet people and talk to people and just find out about their lifestyle. ... Say when we were in like Vanuatu, we would go out to the remote

islands and have a neat time with the people there and just sit in a hut, I'd take my guitar ... you had a really neat time and left really good friends behind you who were looking forward to seeing you again. (Cruiser 309f)

Tourists [institutionalized tourists] are only going to the special places that are made for tourists; we get to see the real life of the countries we visit. (Cruiser 384m2)

... we were invited to a feast for the opening of a church [in the Trobriand Islands], which was incredible. ... we were part of their celebrations, it wasn't put on for the tourists, we got to see what they [the Islanders] just do amongst themselves, ... the feast was part of their normal lifestyle and we were invited to it. (Cruiser 335f)

... when you are anchored off a village, well then you are right there, you are right in their backyard and even if you don't have much contact with them in a social way, you have a lot of visual contact with them and you can see how they live and you can certainly learn more about how they live. (Cruiser 374m)

... we share our lifestyle with them and they share theirs ... We buy our food in the markets and do things the way they do ... (Cruiser 403f)

In terms of Hall's definition of a special interest tourist, cruisers are seeking '*novel, authentic and quality tourist*[ic] *experiences*' only without the '*provision of such experiences by the tourism industry*' (Hall, 1989 in Zeppel and Hall, 1991). Further, cruisers report that they experience 'authentic' culture as they mainly move in the backstage areas where neither the people nor the settings are contrived (MacCannell, 1976; Cohen, 1979; Pearce, 1988). This area is one to which special interest cultural tourists are unlikely to gain access since their experiences are provided and/or generated by the tourism industry.

According to Zeppel and Hall (1991), some definitions of cultural tourism distinguish between cultural tourism, ethnic tourism, historical tourism and environmental tourism (Graburn, 1978; Smith, 1978), but such distinctions were not made by cruisers. Cruisers, like Brokensha and Gulberg (1992), discussed cultural, ethnic, heritage and environmental tourism as a whole not as disparate units experienced in isolation from each other. When asked to complete the questionnaire based on Peters' attractions, cruisers encountered some difficulty. They had not previously compartmentalized their experience into a checklist of experiences or a viewing of attractions. Instead, for cruisers, cultural encounters and attractions were part of the total experience of cruising, not separate entities pursued in their own right.

Table 8.1. Number of Cruisers who would Visit Attractions Categorized by Peters (N = 90)

Tourist Attractions	Number of Cruisers
A. Cultural attractions	
1. Sites and areas of archaeological interest	70
2. Historical buildings and monuments	70
3. Places of historical significance	68
4. Museums	71
5. Modern culture	32
6. Political institutions	9
7. Educational institutions	19
8. Religion	22
B. Traditions	
9. National festivals	62
10. Arts and handicrafts	67
11. Music	52
12. Folklore	50
13. Traditional lifestyles and customs	71
C. Scenic attractions	
14. Outstanding panoramas	82
15. Areas of natural beauty	89
16. National Parks	76
17. Wildlife	89
18. Flora and fauna	76
19. Beach resorts	29
20. Mountain resorts	26
D. Entertainments	
21. Participation and viewing sports	27
22. Amusement and recreation parks	16
23. Zoos and oceanariums	47
24. Cinemas and theatres	36
25. Night-life	11
26. Cuisine, local food dishes	69
E. Other attractions	
27. Climate	65
28. Health resorts or spas	3
29. Unique attractions not available elsewhere	67

Thus, while cruisers appear to have similarities with special interest tourists and participate in cultural tourism-like experiences, it must be remembered that cruisers are engaging in a lifestyle (Macbeth, 1985, 1993). In pursuit of this lifestyle, all other aspects of the overall travel experience are arranged around and are dependent upon it. Even when away from their yachts, undertaking touristic activities, cruisers' minds still focus on their vessels, particularly their safety and security. Subsequently, for cruisers any touristic experiences are defined by and are a consequence of the pursuit of the lifestyle not the overall aim.

The penultimate phase of the travel experience is the 'return travel' phase and here, the phase is referring to the traveller's return to home or a new home base in the case of some cruisers. In this phase, cruisers are still focussed on their interest as it is their mode of transport and the source of their travel experiences. The cruisers must continue to deal with officials, plan and plot courses, check weather, provisions, stocks and the boat, navigate, sail and helm the boat, keep watch, eat, sleep and prepare for landfall. For special interest tourists, it is unlikely that the return transport mode will provide experiences related to their special interest. However, both cruisers and special interest tourists may take a different route 'home' from the destination/site to that used in the 'travel to' phase. Special interest tourists may also take an alternative form of transport and stop-over at locations not visited during the 'travel to' phase. Both, however, Clawson's model would suggest, will have mental attitudes different to those held at the outset of the journey (Clawson, 1963 in Jubenville, 1976). Their anticipation will be different, while the special interest tourist may just wish to get home and resume her or his life's 'normal' pattern, the cruiser will be concerned with the method of getting home and the completion of his or her journey and the ramifications of that completion on future life choices. For example, how to resume a land based lifestyle, how to fit back into a land based society, what to do with her or his time, what does the future hold and what will it be like? When can the lifestyle be resumed? Will the boat have to be sold? While the special interest tourist returns to 'routine life', the cruiser does not.

In the final phase of the travel experience - recollection - both the cruiser and special interest tourist focus on their special interests which may initiate further planning and anticipation of another travel experience. Stories are told, photographs, slides and videos are shown, mementoes are shared and experiences recorded and read and re-read. For cruisers, the recollection may be a daily event should they continue to live aboard their boats. If the boat is sold, then depending on the mementoes kept around them, the recollection phase may continue to be a daily event or an occasional one. According to Killion (1992) and Craig-Smith and French (1994), the recollections may serve to trigger future travel events. For both cruisers and special interest tourists, this may be associated with the same special interest or another type. For example, some cruisers after completing a world circumnavigation have sold their boats and returned to locations previously visited by boat and have travelled these locations using motor-homes and campervans. Others have organized travel using the tourism system (Personal communications with cruisers). On the other hand, special interest tourists may begin thinking and planning of their next trip:

for example, which of the world's highest peaks to climb, which cultural centre to visit, which arts festival to attend, which educational tour to undertake, or which dive site to visit. For both cruisers and special interest tourists, however, the planning and anticipation phase of the next travel experience has begun.

Thus, to conclude, one of the differences between cruisers and special interest tourists relates to the all-pervasive influence of the cruisers' special interest within the entire travel experience compared to the phase specific role of the interest for special interest tourists. Another difference which was discussed related to the degree cruisers and special interest tourists utilize the tourist system. Special interest tourists are relatively reliant upon the tourist industry for their total travel experience whilst cruisers are not. The phases having most similarity for both groups were the planning and anticipation, the on-site activities and experiences, and the recollection phases. Specifically, within the 'on-site' phase, cruisers reported touristic activities similar to cultural tourists, particularly cultural tourism as experiential tourism.

The main difference between cruisers and special interest tourists, however, is linked primarily to the fact that long term ocean cruising is a lifestyle rather than a form of tourism (Macbeth, 1993). Cruisers interviewed during the 1993-1994 study supported this view stating that cruising was an holistic pursuit in which touristic encounters were part of the overall experience not the key focus. Although some cruisers stated that cruising was the means which enabled them to travel and, for them, travel was the key motivation for their adopting the cruising lifestyle.

Chapter nine:

Sustainable Tourism and Cultural Attractions: A Comparative Experience

Yiping Li
Department of Geography, The University of Western Ontario, London, Ontario N6A 5C2, Canada

Richard W. Butler
Department of Management, University of Surrey, Guildford, Surrey GU2 5XH, United Kingdom

Introduction

Description of tourism as 'the industry of heritage' (Boniface and Fowler, 1993:2) reflects the growing significance of ethnic based cultural tourism. This type of tourism practice is consistent with the shift in tourism markets from manipulated, uncritical 'old tourists' to mature, critical and emancipated 'new tourists' (Picolla, 1987). China and Canada are both well positioned to benefit from this trend. Ethnic tourism is not, however, a panacea. It is characterized by its own sets of opportunities and challenges for the development, management and marketing of destinations. While prevailing market forces may suggest a competitive advantage in pursuing an ethnic tourism strategy for practitioners, the associated specifics of implementation are less much obvious.

Ethnic tourism caters to the desire of many tourists to learn about, witness and experience ethnic cultures. The fact that tourists place a high value on these opportunities is demonstrated by their willingness to allocate significant expenditures in the pursuit of these experiences. While the destination strives to turn these expenditures into local revenue and income, critics have warned that tourism may actually destroy the very resources upon which it is based (Turner and Ash, 1976). The reality is that a variety of economic, environmental and social/cultural impacts accrue to the destination; some of which are positive while others are negative.

Figure 9.1. Economic Perspective of Ethnic Tourism

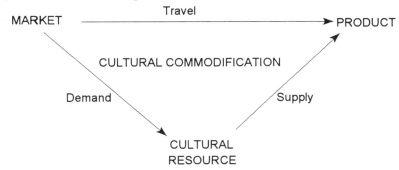

Source: Hinch and Li, 1994:82

This paper examines the phenomenon of ethnic tourism and its prospects for sustainability in the context of two cases - the Yunnan Folk Cultural Village in China and Wanuskewin Heritage Park in Canada. This examination is accomplished by first presenting an economic perspective of ethnic tourism followed by a review of the findings from the two case studies. The analysis of the comparative experience is concluded with discussions of future directions for sustainable ethnic tourism development.

Economic Perspective of Ethnic Tourism

Tourists have become increasingly discriminating. A second rate attraction supported by functional transportation and accommodation infrastructure is no longer acceptable to the vast majority of travellers (Weiler and Hall, 1992). Satisfying travel experiences are now more likely to result from a visit where tourists enjoy a 'greater integration with the place visited and fuller involvement in the social and cultural life of the holiday destination' (WTO, 1985:3). Under this form of tourism, the pursuit of ethnic experiences represents the primary motivation for visiting a destination. From an economic perspective, ethnic tourism exists due to the forces of demand and supply. More specifically, it exists due to the scarcity and uneven distribution of these ethnic cultural resources.

Figure 9.1 illustrates this economic perspective of ethnic tourism. The market consists of those people seeking a unique ethnic cultural experience. This market demands certain resources which they feel will facilitate the experience. However, like many other types of economic activity, further processing of basic resources is required. While the raw cultural resources in a destination may provide the context and environment for tourism, further refinement is necessary to produce a tangible product appropriate for consumption by a tourist. The tourism literature commonly refers to this process as the commodification of culture (Graburn, 1989; Greenwood,

1989). Unfortunately, negative connotations are often attached to this process based on arguments that commodification destroys the authenticity of culture. Yet it can be countered that commodification may actually represent a mechanism to protect the cultural resource. Destinations that selectively transform cultural resources into tangible products not only facilitate the exchange of this cultural experience for a fair financial return, they also create a situation in which they can promote sustainable development through the careful management of resources (Craik, 1991). While the market's original demands focussed on the resource, its actual consumption will be of a processed product. The physical travel of tourists will occur between the location of the market (origin) and the location of the product (destination). To the extent that the production and distribution of this product is controlled by the destination (temporal and spatial), the hosts have the opportunity of protecting their cultural resource. Thus, ethnic tourism is an activity of coexistent benefits and costs as shown in Figure 9.2. These impacts accrue to the economic, social/cultural and environmental realms. Examples of benefits include employment income and foreign exchange earnings, cultural revitalization and improved political influence, and the protection of ecosystems from less sustainable use (Burchett, 1988; Harron & Weiler, 1992; Swain, 1990). At the same time, costs such as inflation, the denigration of sacred sites, and pollution represent just a few of the negative impacts that may accompany tourism development (Mathieson & Wall, 1982). While it is convenient to categorize these impacts into specific realms, it must be appreciated that the realms are interconnected and indeed that the tourism system as a whole is not closed to outside influences. For example, the erosion of local customs through inappropriate tourism will not only have direct effects on the cultural way-of-life within the destination but repercussions will eventually be felt in the economic realm as the resource is destroyed.

Figure 9.2. Manifestations of Destination Impacts

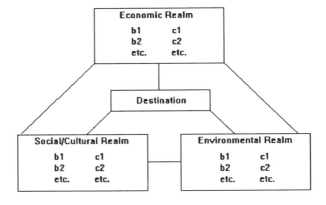

Source: Hinch and Li, 1994:83

The manifestation of tourism impacts in the destination is therefore complex rather than simple. Development strategies represent an attempt to ensure a net positive balance by maximizing the benefits and minimizing the costs. This is no easy task since decisions must be made and strategies developed in a dynamic environment containing many interrelated variables. As a result, ethnic tourism is a controversial phenomenon.

The Methods for the Study

In spite of the major differences in social systems, ethnic tourism development in China and Canada has important common characteristics. Ethnic minorities involved in tourism face a push for change based on the commercial dynamics of tourism. Paradoxically the attraction of the ethnic group is based on the expectation that the minority populations will stay quaintly 'ethnic' (Swain, 1989). Therefore, for both sites, a major challenge for ethnic tourism is balancing socioeconomic integration with ethnic cultural distinction. A modified version of Swain's (1989) conceptual model of indigenous tourism development (Table 9.1) is used to examine this major challenge through comparing the practice and the prospects for ethnic tourism at the two sites.

Table 9.1. Conceptual Model of Indigenous Tourism Development

	Sphere of Influence		
	Nation State	Tourism Industry	Ethnic Group
1. Characteristics of Development Process	autonomy of ethnic group	marketing of ethnic forms	social/cultural response
2. Paradoxes Encountered	state regulation vs ethnic control	freezing culture vs cultural evolution	cultural pluralism vs integration
3. Strategies for Sustainable Ethnic Tourism	as above	as above	as above

Source: Based on Swain, 1989:37

This model defines the units of analysis as being the state, the industry and the indigenous group associated with ethnic tourism development. Within this analytical framework, discussions are focussed on issues such as characteristics of the development process; the paradoxes encountered, and strategies for sustainable ethnic tourism in the two interpretive centres.

Primary data were drawn from the opinions of selected representatives from the various participant groups associated with the attractions. Semi-structured interviews were conducted based on purposive sampling in the qualitative approach (Henderson, 1991). A combined total of 15 personal interviews were conducted inclusive of representatives from the state, the industry and the host ethnic group. These data were supplemented with field notes and documentary records.

Comparative Experience - Case Study Settings

The Yunnan Folk Cultural Village is located in the west suburb of Kunming, the capital city of China's southwestern province, Yunnan. The whole site covers approximately 230 acres and at present 8 minority ethnic sections have been developed and 17 others are scheduled for completion in 1996. In the first two years after its inception in 1992 the Village hosted 1.4 million domestic and overseas tourists. The focus of the Village is on selected aspects of traditional and contemporary minority cultures such as architecture, performances, festivals and music. Wanuskewin Heritage Park is located on the banks of the South Saskatchewan River just north of Saskatoon, Saskatchewan. This site covers over 300 acres of land and, in contrast to the Yunnan Folk Cultural Village, Wanuskewin remains largely in its natural state featuring a variety of archaeological sites typical of the Northern Plains Indians' cultural heritage. Opened in 1992, the Park offers carefully designed walking trails, outdoor display and performance areas, a full scale archaeology laboratory and a state-of-the-art visitor centre which contains a gift shop and restaurant, two small specialized theatres, and art gallery and main gallery. Interpretive themes at Wanuskewin are based on the period of the Northern Plains Indian culture prior to contact with European based cultures.

Characteristics of Development Process

The development process of the Yunnan Folk Cultural Village has been supervised by the central government as manifest through the Han ethnic majority in their roles as planners and decision makers while ethnic minority people work mainly in operational positions. The Village itself is a part of a larger central government tourism project - Kunming Dianchi National Tourist and Vacation Zone. This project was initiated by China's [Central] State Council and is controlled by the China National Tourism Administration. Since the Village is under the Administrative Commission of the Dianchi National Tourist and Vacation Zone, the local ethnic autonomous administration has little control over the site (Figure 9.3).

Figure 9.3. The Current Decision Making and Development Process at Yunnana Folk Cultural Village

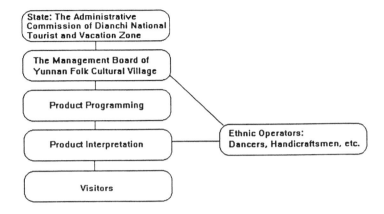

Source: Li, 1995:38

However, capital funding shortages have resulted in the active pursuit of joint-venture projects with a variety of investors. To the extent that these investors come from the minority groups, ownership and management responsibility is likely to shift toward the minority groups (Figure 9.4).

Figure 9.4. Possible Future Management Hierarchy at Yunan Folk Cultural Village

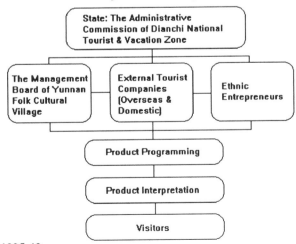

Source: Li, 1995:40

In contrast, Wanuskewin has been developed with an attempt of more direct participation by the native ethnic communities. The park is planned and managed under a non-profit organization known as the Wanuskewin Heritage Park Corporation: the corporate board of which is made up of major stakeholder including representatives of various levels of government. This corporate board operates the Park in association with another corporate body - Wanuskewin Indian Heritage Incorporated (WIHI): the Indian board. This body articulates the interests of the native communities in relation to programming, land use and development issues and all ceremonial and spiritual matters (Figure 9.5).

Notwithstanding explicit commitment to the principles of native leadership and guidance, the operationalization of these principles has been limited by a perceived shortage of qualified aboriginal managerial personnel and financial dependence upon outside agencies at least in terms of the initial capital investment. Figure 9.6 shows the financial dependence of the Park on outside agencies. This dependence, to a certain extend, determines the relationship between the Park board and the outside interest groups as shown in Figure 9.7. Although the WHP is theoretically independent, its reliance on outside financial donors certainly complicates, if not compromises this independence.

Figure 9.5. WHP Planning and Management Structure

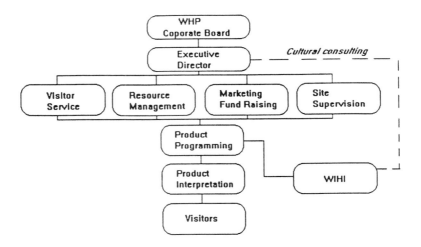

Source: Li, 1995:73)

Figure 9.6. Wanuskewin Capital Budget Funding

Wanuskewin Funding

*Gov't of Canada
$4,952,000
*Gov't of Saskatchewan
$1,050,000
*City of Saskatoon
$600,000
*Meewasin Valley Authority
$639,000
*Corporate Sector Campaign (target)
$3,200,000 **TOTAL**
 $10,441,000

Source: based on anonymous article in *The Star Phoenix*, 1992

Figure 9.7. The Relationship between WHP and its Outside Interest Groups (Size of Circle Indicates the Percentage of Capital Contribution)

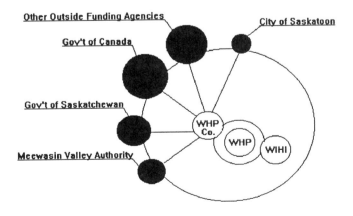

Source: Li, 1995:75

Paradoxes Encountered

One of the greatest paradoxes encountered in both ethnic interpretive centres is the contradiction between ethnic tradition and contemporary lifestyle. While guests sometimes expect ethnic hosts to remain quaintly non-modern, tourism itself introduces many enticing opportunities for progress and change within the minority culture. The Yunnan Folk Cultural Village highlights progressive modern lifestyles of minority ethnic people as well as traditional cultural characteristics. Notwithstanding this intent, the economic advantages of maintaining traditions are illustrated in the ethnic group practice of adopting ethnic clothing as a type of business uniform. Even street vendors were observed wearing ethnic clothes over modern ones presumably so that they could be identified as part of a minority ethnic group and derive the associated benefits of perceived authenticity. At Wanuskewin the official policy of the centre is to interpret Indian lifestyles that existed in the area prior to contact with European explorers, fur traders and settlers. This policy has been criticized as a tendency to stereotype Indian people into a definite and unchanged scheme of inviolable tradition. However, contemporary Native culture is also evident on site. A small example of this display of modernity is that Native employees in the Park normally dress in contemporary styles while working on the site.

Strategies for Development

Key strategies for achieving sustainable tourism at both attractions involve physical design and management. In terms of physical design, both attractions attempt to reflect minority ethnic culture through architecture and landscape design. Of the two attractions, the Yunnan Folk Cultural Village is more intensively developed and was created as a replication of features that are spatially removed from the Village. In contrast, Wanuskewin is located on a site long used by Native peoples and it has been developed less intensively so that the natural and archaeological features of the site can be preserved. While ethnic minority people represent the majority of front line staff in both attractions, senior management personnel tends to be from outside of the host minority ethnic groups. Both attractions are trying to balance economic and cultural objectives: however, the Folk Cultural Village currently places more emphasis on its performance as a profit centre while in relative terms Wanuskewin's emphasis seems to be on managing cultural issues.

Conclusion and Future Directions

The operation and management of the Yunnan Folk Cultural Village and Wanuskewin Heritage Park are consistent with the economic perspective of ethnic tourism. Ethnic culture is the resource but the tourism products are the interpretive programmes offered at the two sites. The study has demonstrated that benefits and costs coexist and sustainable development requires a net positive balance of these benefits and

costs. This is no easy task since decisions must be made and strategies developed in a dynamic environment containing many interrelated variables. Ethnic interpretive centres as cultural tourism attractions are, therefore, far from being panaceas for ethnic minority people. However, it can be one option for economic development which provides a rationale for continued ethnic identity, ethnic rights, and cultural diversity. To obtain a positive outcome, it is important to develop a policy which integrates all three of the realms: the economic, the social/cultural and the environmental.

The first and perhaps fundamental requirement of this kind of a policy is that planners and decision makers integrate an ethnic tourism attraction into the ethnic community. 'For tourism, cultural development is a part of attraction development, an essential part of new economic and social input of community' (Gunn, 1994:354). It is necessary, therefore, to coordinate the ethnic minority people involved in the economic development, design, and planning of the attraction. Resolution of the inherent paradoxical issues of an ethnic tourism attraction need to be sought using the acknowledged rights of ethnic minorities within a national setting. Conventional wisdom in international development programmes notes that adaptation of economic interventions to the local culture and incorporation of indigenous decision making processes are critical ingredients for sustainable results. Any plans for ethnic tourism development should be formulated with not only an understanding of the host culture, but must involve the ethnic society fully in all levels of decision making (Swain, 1989).

Commodification of ethnic culture is an important process in developing ethnic tourism attractions. This commodification process can be used as a positive mechanism in the pursuit of sustainable tourism development. The two sites' operation and management have proven that this process may be used to determine the nature of cultural products and the control of access to these products in terms of how they will be offered for consumption by tourists. By using this mechanism appropriately, the competitiveness of the attraction will be strengthened. Having this competitiveness is vital for an ethnic attraction and the destinations in which it is located. An ethnic tourism attraction should make ethnic sites, events, festivals, art forms into living, interactive and animated programmes without sacrificing their cultural integrity.

It is normal for tourists of another culture to be both fascinated and apprehensive about a destination's different cultural and social structures. An appropriate strategy for meeting these conflicting demands is to protect carefully the integrity of an ethnic attraction while modifying supporting infrastructure and services to conform more closely to tourist expectations (Wahab, 1975). Given the comprehensive nature of culture and ethnicity, however, special care needs to be given to what constitutes an ethnic attraction and what constitutes infrastructure and service. In conjunction with this approach, education programmes for tourists as well as hosts would be useful in clarifying appropriate behavior (Harron and Weiler, 1992). Hopefully this type of interpretation would lead to appropriate behaviour and increased understanding between tourists and ethnic hosts.

At the same time, efforts must be made to maintain the ethnic integrity of an ethnic tourism attraction. Ethnic tourism business 'can turn exotic cultures into commodities and individuals into amusing "objects" for tourist "consumption"' (Klieger, 1990:38). As a result, novel encounters gradually become routine for both tourists and the ethnic hosts, and cultural presentations become more and more removed from the reality of everyday life. The related temptation to 'freeze' culture in time should be avoided. Culture is not a static entity as all 'viable cultures are in the process of "making themselves up" all the time' (Greenwood, 1982:27). There are numerous forces in addition to tourism that influence cultural change. Tourism planners and managers need to anticipate major trends and take them into consideration.

To conclude, this study has presented ethnic tourism development at the Yunnan Folk Culture Village and Wanuskewin Heritage Park mainly from the perspective of the state, the tourism industry and the ethnic communities. The study did not investigate changes in tourists' knowledge about ethnic minority peoples. It has been suggested by interviewed subjects at both Yunnan Folk Cultural Village and Wanuskewin Heritage Park that educating tourists about ethnic culture is important for sustainable ethnic tourism. One of the future directions for ethnic tourism attraction research would be the investigation of how the changes in tourists' knowledge about ethnic culture can contribute to sustainable ethnic tourism. Finally, this study followed Swain's (1989) model of indigenous tourism development and attempted to prove the model's validity in the context of a particular type of cultural tourism attraction. Research findings support Swain's model as conducive to the study of the sustainability of an ethnic tourism attraction in certain aspects, such as the importance of exercising sufficient ethnic control and addressing major paradoxical issues of ethnic tourism. However, additional contributions could have been made through this study if investigation went beyond Swain's categories of nation-state, tourism industry and ethnic group to address more issues which are equally important. This study has contributed to the understanding of the sustainability of cultural tourism development in the form of ethnic interpretive centres and, by so doing, it has provided a stronger foundation for future research in this area.

Chapter ten:

Sexual Imagery in the Marketing of Pacific Tourism Destinations

Martin Oppermann
Centre for Tourism Studies, Waiariki Polytechnic, Private Bag 3028, Rotorua, New Zealand

Shawna McKinley
RR#1, 4990 Plenton PG RD, Ladysmith, British Columbia, VOR 2EO, Canada

Introduction

Over the last few decades the general use of sexual imagery to advertise many types of products has greatly increased (Kerin, Lundstrom and Sciglimpaglia, 1979; Soley and Reid, 1988). Idealized sexual images and information have long been used in marketing to sell products and nowhere is this more evident than in the tourism industry. A swift glance through any tourism brochure will soon reveal not only an obvious gender bias, but also a preponderance of naked skin, especially among the portrayed female models. Bikini-clad tourists lounging at pool sides, exotic locals in grass skirts and happy couples strolling on the beach have been used as images in travel and tourism promotion for a long time. 'The romance, mystique and eroticism of the South Pacific' has been identified as a promotional option for a regional South Pacific tourism strategy (Yacoumis, 1989). In addition, the smiling looks of flight attendants and the promise of subservient service have also been used in airline promotions. It cannot be denied that the use of sexual imagery and sexual innuendo is widespread in tourism marketing. Yet, few studies have examined the effect of such advertising on the actual travel decision. In a more general view, Smith (1983) questioned advertising's effect on changing travel patterns due to a lack of supportive hard data. This paper will deliberate on why, how and to what extent sex images and sexual imagery are used in tourism destination marketing.

Tourism Destination Images

For more than 20 years, images and perceptions of tourism destinations have been a major area of tourism research (e.g., Chon, 1990; Echtner and Ritchie, 1993; Gartner, 1993; Hunt, 1975). Essentially, most authors have argued that tourist visitation patterns are greatly influenced by tourists' images and perceptions of destinations. Studies have also examined advertising's ability to influence tourists' perceptions and behaviour, concluding that marketing plays an important role in creating tourism destination images (Dilley, 1986). Tourism promotions can therefore be very powerful economic tools as 'image is the most important aspect of tourist attraction' (Lew, 1987).

Images of tourism destinations are the sum of ideas and beliefs about a destination. Thus, they are highly individualistic in nature and may change at any time. Unfortunately, the term 'image' has been used in several different ways with similar, yet distinct meanings. Hence, one needs to distinguish between the 'presented' and 'perceived' image. The former is the image presented by the destinations, operators, travel agencies, etc. It is what Gartner (1993) termed 'induced images'. In contrast, 'organic images' are formed from sources not directly related to the destination area, such as movies, documentaries, word-of-mouth and news. The presented or induced image along with the organic image are the 'input' into the individual's image formation process. All these inputs are filtered whereby the 'filter' is determined by the individual's own experiences, desires, background, etc. At the end of this process emerges a perceived or cognitive image of a tourism destination, a specific holiday package, a travel agency, an airline, etc.

The sum of all individuals' images of a destination in a specific market may be termed the 'market's image' of that particular destination. This gives recognition to the fact that the very same destination is usually perceived quite differently in different markets (Crompton, 1979) and that marketing strategies need to be tailored to these differences (Dilley, 1986). Destinations need to be very aware, however, that once a negative image is established in a market, it may take a long time to recover from such an image as it tends to linger around (Lucas, 1994).

Today's media is a powerful agent in the formation of destination images, especially of distant places that the viewers and/or readers are not familiar with (Butler, 1990). The tourist killings in Florida and California made world headlines as do military coups and volcanic eruptions. Any such event has an almost instantaneous impact on tourist flows. For example, Florida suffered from reduced tourist arrivals and Egypt experienced a major reduction in the aftermath of the politically oriented tourist killings in the early 1990s. As Richter (1992) already pointed out, the four 'S's, namely 'sun, sand, sea and sex' need to be expanded to five 'S's, namely by adding 'safety'. The latter is arguably as powerful an agent in directing and redirecting tourist flows as the others.

Despite the large number of studies that have investigated tourism destination image, to our knowledge, none has explicitly included 'sex' as a variable. Typically, destination image studies have investigated the importance of a range of physical,

historical and cultural destination attributes, such as climate, coastline, historical buildings and friendliness of the people. Yet, for a long time, it has been recognized that holiday destination promotion emphasizes, besides all the natural, cultural and historical beauty, 'sex'.

Nudity in Advertising

Nudity and sexual innuendo have been increasing in advertising (LaTour and Henthorne, 1993). The reason for the use of sex in marketing is the insight 'that sexuality is a persuasive motivator in consumer behaviour' (Gould, 1995:395). Gould also observed that there has been little systematic effort in studying the relationship between sexuality and consumption patterns. Where such studies have been conducted they usually showed mixed results. While nudity and sexual content usually increase the attention directed towards that advertisement, this does not translate into positive feelings about that ad or the product promoted. Quite to the contrary, it is often perceived as offensive (Alexander and Judd, 1979; LaTour and Henthorne, 1993; Mitchell, 1986). In addition, Peterson and Kerin (1977) argued that the actual outcome may be largely influenced by the congruence of product and the sexual content of the ad.

In looking at print advertising, LaTour and Henthorne (1993) argued that sexual or erotic advertising uses two approaches, namely the amount of nudity and the degree of suggestiveness. Suggestiveness is often achieved by using more than one model in an ad and whose respective positions may suggest anything from romanticism to very close intimacy (Lowry, 1993).

The typical tourism destination advertisement, however, consists of more than just a picture. Thus, these two dimensions may be complemented by a third, namely the language used. Commonly, sexual innuendo in language used goes hand in hand with the actual imagery. In some cases, they only obtain a sexual meaning by being combined in an ad.

'Advertising presents an unrealistic or idealized picture of people and their lives' (Richins, 1991:71). By using attractive models, advertisements invite a social comparison of the viewers with these models which may result in lower self-satisfaction among viewers, despite being aware of the unrealistic nature of the ads. Joseph (1982) showed that ads with attractive models are generally more effective, which would support the implicit or explicit promise of ads that one's life will more closely approach the ideal by product use even though this promise is imperfectly, if at all, fulfilled (Richins, 1991).

Gould (1995) has forwarded the notion of 'product sexualization'. He postulated 'that just about anything may become a conditioned sexual stimulus when paired with an unconditioned one. Thus, a product, ... becomes sexually conditioned when it is associated with an unconditioned sexual stimulus, such as an attractive model in an ad or a sexually attractive person in an actual consumption situation' (1995:396). Furthermore, he argued that such a sexualization approach may be used for

positioning products among competitors. And where better to use product sexualization than in promoting exotic as erotic tourism destinations?

Sexual Imagery and Tourism Marketing

In tourism marketing, product sexualization is very prominent. In fact, it is so flagrant that commentators have called such advertisements 'body shots' (Heatwole, 1989) to denote the conspicuous emphasis on the sexualization approach. Having noted the existence and preponderance of such imagery in tourism destination advertising, Heatwole proposed and discussed a number of reasons why body shots of women might be used to promote tourism destinations. His 'Climatic Hypothesis' that body shots inferred warm climates is countered by the fact these photographs are primarily of women and are emphasized year-round. The 'Heterosexual Hypothesis' argues that 'what you see is what you get', indicating the attraction of sexual fantasy. This hypothesis is not supported by statistical evidence and the dominance of female body shots would indicate tourists are primarily male, which is not the case. The 'Female Fantasy Hypothesis' argues female body shots encourage women to live out their fantasies to be as beautiful as the women pictured in advertisements. This view is countered by studies that prove women are more attracted to pictures of couples and actually identify female body shots in advertising as methods of exploitation. Another hypothesis suggests that the emphasis on women's bodies would allow the promotion of an unphotogenetic destination. In a sense, by providing body shots and other generic imagery, destination may be able to provide a photogenic stimulus to potential customers that otherwise might not exist. Finally, the 'Hedonistic Hypothesis' argues that body shots suggest a destination of rest, relaxation and indulgence, because bathing suits are the most popular apparel, the model's pose almost always projects leisure, and the settings generally connote leisure environments. In conclusion, Heatwole argued that while body shots are successful in attracting attention to the advertisement, although some are offended by them, 'To most people a body shot suggests that a pleasant vacation awaits in a pleasant place. And that is what tourism-related advertising is all about' (Heatwole, 1989:11).

Uzzell (1984) identified three levels at which tourism brochures try to relay a message. The first is the prototypical 'sun, sand, sea and sex' image. On the second level, destinations are trying to sell place attributes that act as enhancement to the customer's self-image. The simultaneous neglect of actual destination features themselves ties in with Heatwole's (1989) observation that very little of the actual destination is shown. The third dimension is where destinations are trying to sell us the image of ourselves in a reality and fantasy world of meaning. Thus, Uzzell believes that many of these advertisements intimate consumer involvement in the pictured scene. When sexual imagery is used, this would suggest tourists' realization of the sexual fantasy portrayed by buying the advertised product.

Britton (1979) argued that sexual images in tourism promotion can cover up reality, mystifying and inaccurately representing destinations as sensuous and unspoilt

remnants of Paradise. According to him, marketing of Third World tourism destinations make little if any reference to the locals and the actual reality in such countries. 'Locals are generally absent from illustrations; ... when references to the local society cannot be avoided, it is rationalized or romanticized' (1979:323). Sexual liaisons with non-whites is another theme where locals may be used in advertisements.

Yet, it is important to recognize that the perception of sexual material in tourism promotion is a very subjective process. What one person might see as a sexual image will most often depend on that individual's perceptions and frame of reference. Therefore, recognition of a sexual image will often be a reflection of what an individual is personally attracted to. This frame of reference may vary depending on age, culture, education, gender and numerous other things. Unfortunately, comparative investigations of what is perceived as sexual innuendo, erotic or blatant sexual imagery is still lacking.

Sex and Marketing of Tourism Destinations

Tourism marketing uses both information and image-based advertising (Laskey, Seaton and Nicholls, 1994). The information and images provided by these advertisements may be as diverse as the people, climate and history of the destinations they promote. Despite these differences, however, it is possible to identify certain themes that are commonly presented in tourism marketing. Marketed information and images may be based on landscapes, culture or services (Soley and Reid 1988). Uzzell (1984) identified the most superficial emphasis of holiday destination promotions to be sun, sea, sand and sex. Such emphases, especially sexual imagery, are common mediums for marketing tourism destinations.

One study compared destination brochures from a wide range of different countries (Dilley, 1986). Using content analysis of the pictures in these, Dilley disclosed differences in the positioning of the analysed destinations. Interesting to note is that he failed to categorize sex as an individual category. However, the more thorough reader soon discovers that the category 'recreation', primary category for most Caribbean Islands, indeed includes mostly nudity and sexual innuendo. 'Island vacation spots from Bermuda to Trinidad and Tobago not surprisingly concentrate on projecting themselves as paradises for wearing or watching bikinis' (1986:64). The 4 'S's (sun, sand, sea and sex) dominate the Caribbean-area literature.

Lowry (1993) presented a study on how sexual imagery in tourism advertising might be interpreted given individual frames of reference. She argued that the use of female body shots in tourism advertising causes different responses in males and females. While males tend to respond positively to such advertisements, many women believe these marketing methods objectivize and exploit women. Of those women who did respond positively, their attraction was based on the possibility of becoming like the women pictured in these advertisements by travelling to the featured destination. Both sexes agreed that sexual imagery grabbed their attention, but did not insure purchase of the product promoted by it.

The Case of Marketing Pacific Tourism Destinations

This case study surveys, analyses and interprets the sexual images used to promote Pacific tourism destinations. It aims to identify what sexual images and information are used in advertisements and uncover whether or not there are any trends evident in the use of such images and information. The study also attempts to identify any contrasts in the use of sex in tourism marketing between different countries in this region, hoping to reveal how commonly sex is used in tourism promotion.

Material was petitioned from South Pacific Islands, American and Asian sources. National and governmental tourism offices for countries within this area were sent letters designed as general tourist inquiries. Letters requested that any information or promotional material be sent in order to explore tourism opportunities at a given destination. These inquiries were very general in nature, emphasizing open and flexible holiday plans, although the inquirer was known to be female and from New Zealand. Brochures and travel booklets on Pacific destinations were also collected from local travel and tourism agencies. These were generally produced by airline companies including Air New Zealand and Singapore Airlines or by organized tour groups such as Contiki and Integrity Tours.

The response rate from the inquiries sent was very good as approximately 75 per cent of requests were accommodated. Replies were received from offices in Tahiti, Singapore, Vanuatu, Australia, New Zealand, Canada, Thailand, Hawaii and the Cook Islands. Tourism information on America, India, and various other Asian countries was also collected. This provides an excellent cross-section of promotional material from a variety of Pacific tourism destinations. The packages returned and collected included numerous brochures and booklets providing much information about these destinations as well as maps, airfare and transportation information and numerous advertisements for tourism services provided in the area.

There are many different images and much information that are provided by tourism promotions of Pacific destinations. Sex is a common theme present throughout much of this material. The manner in which sex is used in these promotions appears to fit into three general categories. Along the lines of previous studies they are termed:

1. body shots,
2. suggestive postures, and
3. sexual innuendo in language.

The first two of these categories address the pictorial content that is used in tourism promotions. The most common and direct of these images involves body shots of locals and visitors, whether they are male or female. The female body shots that are the subject of Heatwole's study fit into this category. Allusive postures refer to how individuals are arranged in space, indicating an attraction or special relationship between them. In certain circumstances how individuals are arranged within images and in relationship to the audience may cause these images to be

interpreted in a sexual manner. Suggestive language can also provide sexual references in tourism promotion, especially in circumstances where connotative language is teamed with potentially evocative pictures.

Body Shots

Although tourism promotion for destinations in the Pacific makes use of both image and information based marketing, it is image based marketing that makes the most use of sex to promote a destination. Body shots of locals most commonly, and in many cases most blatantly, portrayed these people in a sexual manner. Body shots of indigenous peoples usually clothe them in a traditional manner which conveniently shows a great deal of skin. Those aboriginals pictured in such a manner are generally young, beautiful or handsome, and curvaceous or muscular. The dark skin and more primitive clothing of these people combine to present them as exotic symbols of culture, still living a wilder, simpler and unspoiled life in paradise. It would not be unreasonable to imagine feelings of desire and attraction developing toward these people and their lifestyle as a result of such portrayals. Picturing locals as exotic symbols of a destination has the effect of objectivizing these individuals. Locals are 'put on display' for visitors by demonstrating their crafts and talents.

The material studied also contained body shots of individuals who are most likely visitors to these destinations. In most cases delineated from locals by their fair skin and western dress, visitors are commonly as young and attractive as their local counterparts. Body shots of visitors may not be as common as those of locals, but are none the less present in tourism promotion. Tourists, both male and female, are commonly relaxing at pool sides, lying in the tropical sun or strolling along on the beach, clothed in little more than bathing suits. Such situations create feelings of desire not only for the situation that is portrayed, but often for the individual that is pictured as well.

When using body shots to promote a destination it is most common to use females as subjects. Both women of indigenous cultures and those who appeared to be visitors were the subject of advertisements making use of body shots. Bathing-suit-clad pool side shots of women were perhaps the most frequent example of this, although photographs of local women in traditional costume were also dominant. Female body shots appeared to be a staple for the promotion of accommodation services throughout the Pacific. Couples were also used in such a manner, lying on hotel room beds or sharing drinks at cocktail bars. Body shots of men were used, although these were far less common than those of women. Photographs of local males were much more frequently used than those of male tourists. Bare-chested and muscular indigenous men were pictured both on their own and with other local women, while body shots of male tourists generally accompanied others of female tourists or locals.

Suggestive Postures

Visitors and locals are portrayed as both single and in couples. Either way, however, the message is clear that travel to the destination promoted provides a guarantee of uncovering romance. This is indicated by relational references present in the promotional images studied. Such clues may be present in the position of bodies, the prevalence and types of touch between individuals or facial expressions. Certain individuals may appear closer together than others, touching or looking at each other in a way that may indicate more than basic friendship.

In the case of couples there are many images that may indicate the presence of intimate relationships. Common images show couples strolling along beaches, reclining on beds in their hotel rooms, chatting intimately over meals or reflecting romantically at tropical sunsets. Although the majority of such images picture individuals who are probably tourists, the opportunity to develop sexual relationships between locals and visitors is also suggested by some promotional material. Quite curiously, of all the material studied only one publication made reference to homosexuality, as most concentrated on heterosexual attraction within groups and between couples. Some tourism promotions also indicate many opportunities for those unattached or travelling independently to develop relationships and have loads of fun with members of the opposite sex. Trekset and Contiki Tours indicate that their companies provide opportunities for young people to meet numerous members of the opposite sex, and do not rule out the opportunity of developing intimate relationships within tour groups.

Sexual Innuendo in Language

Sex is much less, although still, evident, in information-based promotion of Pacific tourism destinations. When promoting their holiday packages to Tahiti, Air New Zealand labels the country 'one of the Pacific's most alluring and romantic destinations'. In other cases the sexual use of language in tourism is much less obvious. The connotative value of language can often give dual meanings to phrases that are written on tourism promotions and in many cases these vague meanings could be used to make reference to sex. For example, Singapore Airlines promote their:

> Gentle Singapore Girls, in their distinctive sarong kebayas, (who) will serve you delicious three-course meals with an outstanding selection of wines and drinks, as you recline in comfort ...

The meaning of such information is supplemented by smiling and complacent beautiful young women, who appear eager and happy to serve every need of passengers who purchase the Airlines' 'Asian Affair' holiday packages. Another example can be found in the advertisement for The Rarotongan Resort Hotel, where photos of men dancing with traditionally dressed female dancers complement invitations to satisfy your hunger 'for the taste of Paradise' in the hotel's 'exciting,

pulsating traditional floor shows'. The accompaniment of such invitations can cause images to be interpreted in a sexual manner.

Differences among Destinations

It has been proven that sex is present in tourism promotion and that there are trends in its presentation, yet how common is its use in tourism marketing? The predominance of sexual imagery and information in tourism advertisements appears to vary among the destinations that are promoted. For example, in a 139-page booklet received from Tahiti Tourisme approximately 28 per cent of these pages had at least one sexual image as described in the previous section. This is quite a high proportion when it is considered that the same percentage of pages had no images on them, meaning roughly 40 per cent of the pages with photos on them in this publication displayed at least one sexual image. In contrast, a similar 117-page booklet filled with photographs received from the Australian Tourist Commission contained only 10 images that could be considered sexual in nature.

The frequency of sexual images and information in destination promotion varies between three sub-regions within the Pacific area studied:

1. the Pacific Islands, excluding New Zealand,
2. Asia, and
3. the Western countries.

Each of these regions used differing types and amounts of sexual imagery and information in their tourism promotions.

Pacific Islands

Pacific Island nations were the destinations most likely to use sex as a means of tourism promotion. Body shots of attractive and youthful tourists and locals predominated the booklets and brochures that were received and collected from Hawaii, Tahiti, Vanuatu, the Cook Islands and other South Pacific destinations. Both men and women were the subject of sexual images, although women were most likely to make bathing-suited appearances in hotel and resort advertisements. Sexual images of indigenous people also tended to be far more common than those of visitors in South Pacific tourism promotions.

Western Countries

The other extreme was demonstrated by more developed countries. Advertisements for Australian, New Zealand, Canadian and American destinations made the least use of sex in their promotions. To complement the prior Australian illustration, Air New Zealand's booklet advertising Swing Away packages to Canada and America makes use of only seven sexual images and contains just one instance of sexually connoted language. All of the sexual images included in this booklet were used to advertise accommodation services, rather than display the exotic appearance of locals, and were

rather small and inconspicuous. These destinations tended to place far more emphasis on family and seniors' holidays, special attractions and scenic and historic values over sexual attraction.

Asia

Asian destinations occupy the middle ground in this spectrum. Although Asian tourism promotions make less use of sex to sell destinations than South Pacific marketing tools, more of this subject matter is employed than in Western developed states' advertisements. Booklets and brochures that were collected promoting Singapore, Thailand, India, and Singapore Airlines Asian Affair Holidays employed very few semi-nude body shots of visitors and locals. In truth, visitors were very rarely pictured in these promotions at all as most images captured locals. Unlike South Pacific advertisements, Asian promotions were far less likely to include men in these images. Women were more commonly pictured in advertisements for restaurants, shops, hotels and other tourist services. Again locals were traditionally dressed, yet national costumes revealed much less than in the South Pacific examples. Even so, the facial expressions given by women in traditional dress had the potential to create feelings of attraction. The manner in which Asians were portrayed still indicated the entertainment value these people might have to the tourism industry, further objectivizing them and their culture.

Notable was that the promotional material provided by the Tourism Authority of Thailand must be singled out for its publication of unique images for the purpose of this study. Unlike all of the other material collected, the information sent by the Thailand Office furnished what appeared to be the most accurate and realistic representation of tourism in that destination. The majority of images presented in the brochures and booklets acquired from this country presented visitors and locals in realistic and modest dress and their actual less than perfect appearance. The photographs included seemed less staged and artificial as well as more spontaneous than the other publications studied. Sunbathing tourists were not as physically perfect or attractive as the models used in other promotions. Sexual imagery was still present in Thailand's promotions: however, it was portrayed in a more natural and less blatant way than many other advertisements. Photographs of city nightlife showed many young people interacting with Thai natives at clubs and restaurants. One can only speculate a more natural appearance of sexual images is because such opportunities to pursue sexual relationships actually exist as a tourism opportunity in Thailand. However, that is another study entirely.

Conclusion

There is little literature identifying how sex is used in tourism promotions and less proposing there are any trends in its representation. How common is sexual imagery in tourism marketing? Are certain images more common than others? Do tourism

promotions give equal representation to both sexes or are different gender roles evident? Are certain destinations more likely to employ sex as a means of promoting themselves than others? It is important to identify how sex is used in tourism marketing and whether or not these usages contain any trends or similarities before identifying the effect that such promotions have on tourist behaviour.

There is no doubt that sex is a common subject in tourism marketing. Body shots, relational references and connotative language can all indicate the presence of sex in tourism advertising. Although some Pacific destinations may employ sexual images and information more frequently than others, all of the destinations studied used this type of advertising in some way or another. Whether using sex in advertising contributes to an 'embarrassing abstraction' of a destination's image is a topic of study beyond this paper. However, if promotion is such a strong factor in creating a destination's image and image *is* the most important part of tourist attraction, then the effect of sexual images and information in such advertisements cannot go unnoticed as sex in tourism marketing is so very widespread.

Chapter eleven:

Ecotourism in China: Selected Issues and Challenges

Kreg Lindberg
Charles Sturt University, PO Box 789, Albury, New South Wales 2640, Australia

Carmel Goulding
Tourism Tasmania, GPO Box 399, Hobart, Tasmania 7001, Australia

Zhongliang Huang, Jiangming Mo, Ping Wei, and Guohui Kong
Dinghushan Ecosystem Research Station, Guangzhou, Guangdong 510650, People's Republic of China

Introduction

Ecotourism has become a popular focus of consumer, commercial and research activity in tourism. However, little analysis has been undertaken regarding ecotourism in China. This chapter reviews ecotourism in China, based on the limited published literature (e.g., Tan, 1996; Tisdell, 1996), discussions with managers of Chinese protected areas, and research at Dinghushan Biosphere Reserve in Guangdong province (Lindberg, Goulding *et al.*, 1996). Particular attention is paid to similarities and differences between ecotourism in China and other countries.

A large and increasing literature provides background on ecotourism (e.g., Cater and Lowman, 1994; Ceballos-Lascuráin, 1996; Lindberg and McKercher, 1997). A common element of this literature is the discussion of ecotourism definitions, of which numerous exist. As noted by Lindberg and McKercher (1997), most concepts and definitions of ecotourism can be reduced to the following: ecotourism is tourism and recreation that is both nature-based and sustainable. As used here, sustainability incorporates environmental, experiential, sociocultural and economic dimensions.

Though various conceptions of tourism sustainability exist (e.g., Hunter, 1995;

McCool, 1996), for purposes of this chapter it is conceived as tourism that generates, overall, positive impacts across these four dimensions. Xing (1993) proposed a similar concept of ecotourism. The means to achieve or enhance sustainability is to plan and manage tourism so that positive impacts are increased while negative impacts are reduced. This conception of sustainability, and thus ecotourism, is consistent with commonly cited ecotourism goals, including:

- minimize negative impacts on the natural environment;
- provide economic benefits to the natural area, ecotourism businesses and local communities (which can be particularly important for remote areas);
- provide a high-quality visitor experience in order to sustain these benefits;
- provide environmental interpretation (which can reduce negative environmental impacts and enhance the visitor experience); and
- minimize negative sociocultural impacts.

Though tourism in Chinese natural areas may not always meet the ecotourism criteria, the term is used here to describe existing nature tourism in China and to focus discussion of issues and attention to planning, development and management to ensure they are met in the future.

Of course, there are both commonalities and differences when one evaluates ecotourism across countries. Most countries share many or all of the related goals listed above. However, each country is unique. In addition, one can distinguish general differences across groups of countries. For example, due to pressing economic needs, economic benefit for communities and natural areas tends to be a higher priority issue in developing countries than in OECD countries. Conversely, environmental interpretation and sociocultural impacts on adjacent communities tend to be higher priorities in OECD countries than in developing countries.

Consider the five broad actors that may be present in ecotourism situations - natural areas and their managers, the ecotourism industry, local communities, government agencies (excluding area managers), and the visitors themselves - with the relevant actors varying across and within countries and possibly including others, such as environmental and rural development non-governmental organizations (NGOs). One common phenomenon is that an actor may be ambivalent toward ecotourism because it tends to generate both positive and negative impacts. For example, natural area managers in China tend to value the potential for ecotourism to generate financial benefits, but also are concerned that ecotourism will generate environmental damage.

A second common phenomenon is that ecotourism can generate both symbiosis and conflict between the actors. The potential for ecotourism to result in symbiosis between conservation (e.g., natural areas) and development (e.g., businesses) has been widely touted, but the potential for conflict should not be ignored. For example, natural area managers and ecotourism businesses have a shared interest in conserving the natural environment. However, in China and elsewhere there often is conflict regarding the appropriate level of tourism development.

This chapter discusses some of the issues arising from such tensions not only for certain actors (natural area managers in particular), but also between the various actors. The discussion is intended to provide perspective on ecotourism in China relative to other countries and to suggest an initial agenda for research and action designed to address the issues.

Tourism and Ecotourism in China

In recent years, China has experienced rapid expansion in tourism development and strong increases in domestic and international visitation (Bailey, 1995; Xing, 1993). In part, this growth has resulted from the political and economic environment encouraging a more market driven industry (Zhang, 1995). Though visitation may plateau in certain international source markets, tourism overall is expected to continue its growth with expansion in incomes, educational levels and tourism infrastructure.

However, this growth presents a number of challenges, including the need to istribute tourism more widely (Yongwei, 1995). With 90 per cent of China's tourism receipts being earned in cities and an overwhelming concentration of tourism destinations in coastal regions, it has been suggested that ecotourism could help decentralize the tourism industry by dispersing tourism to rural areas (Wen and Tisdell, 1996). China has been rated highly in ecotourism value (Herath, 1996). With a wealth of cultural and natural resources, it has been referred to as one of the world's twelve 'mega-biodiverse countries' (Thwaites and DeLacy, 1997). Almost 7 per cent of China's total land area is legally protected, with many of the nature reserves located in non-coastal areas (Figure 11.1).

Amongst the first 'conservationists' in China were the early Taoist and Buddhist religious orders, many of which sought isolated, mountainous areas to practise principles of harmony with the environment. These traditions meant that areas surrounding religious sites were conserved while other areas in China were cleared for agriculture or other economic activities. This has led to the presence of religious and cultural sites within many of the country's reserves. In more recent times, the growth in reservation of natural areas has been steady, with the number of nature reserves expanding from 34 in 1983 to 763 in 1993 (Han and Guo, 1995). Of these reserves, ten have been included in UNESCO's international biosphere reserve network.

Dinghushan Biosphere Reserve

Dinghushan Biosphere Reserve (DBR) is located approximately 100 km from Guangzhou, in the province of Guangdong in southeastern China (Figure 11.1). DBR was established in 1956 and is China's first nature reserve. The reserve is 1,155 hectares in size and is situated near the Tropic of Cancer, a transitional belt between

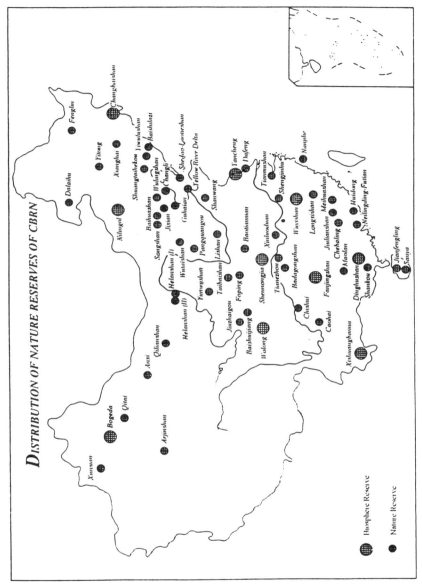

Figure 11.1. Map of China's Nature Reserves

subtropical and tropical zones. Subtropical broadleaf evergreen monsoon forest forms the chief component of the reserve.

In 1979, due to the reserve's geographic location and relatively intact ecosystem, it was included in UNESCO's Man and the Biosphere network. Biosphere reserves are zoned, multiple-function areas that attempt to integrate conservation to the process of economic development and human interaction with the environment.

This is achieved through the integration of a number of central roles including protection, research and monitoring, and sustainable economic development (Batisse, 1986). The zones within a biosphere reserve include a buffer area allowing sustainable economic activity including tourism development, a core area that is a protected area with activity generally restricted to scientific and education based research, and a transition area allowing agricultural activities, settlements and other uses.

The Chinese Academy of Sciences (CAS) is the principal funding agency of the reserve, and responsibility for land management is vested in the Dinghushan Biosphere Reserve Arboretum (DBRA), a unit of the CAS. Scientific research within the reserve is the principal role of the Dinghushan Forest Ecosystem Research Station (DFERS). Other nature reserves in China are managed by a variety of agencies, with the Ministry of Forestry being responsible for the majority. The large number of responsible agencies, with concomitant coordination difficulties, have limited efficient reserve management in China (Anon, 1995).

The Dinghu Tourism Bureau, which is located within the reserve and is a unit of Zhaoqing City Government, collects and distributes entrance fees and is responsible for much of the infrastructure development within the reserve. Government agencies generally play a larger economic role in China than in other countries. In the Dinghushan context, government is responsible not only for infrastructure development through the Dinghu Tourism Bureau, but also for hotel development, with three of the four hotels in the reserve being government-affiliated.

Located two hours from Guangzhou and 30 minutes from Zhaoqing City (renowned in southern China for its karst formations), DBR is ideally located as a nature based experience with relatively easy access for dwellers of Guangzhou and the surrounding urbanized areas. The reserve offers a range of visitor activities and experiences including cultural, religious, historical and nature based activities such as hiking and water based recreation. The reserve offers old growth forests, with some trees estimated to be 1,300 years old, and various flora and fauna, including 20 rare and endangered species. Attractions within the reserve are easily accessible via hardened walking trails leading through the dense subtropical forests.

Of the natural and cultural attractions, Qingyun Temple, Feishuitan Waterfall, Tainhu Lake and Baizhangling Shrine are the most visited sites within the buffer zone. The Qingyun temple dates to the Tang Dynasty (AD 618 to 907) and combines both a cultural and religious experience, with the orthodox Buddhist Chan sect practising daily worship rituals. The temple offers the opportunity to worship or view worship involving offerings of incense or other goods within a number of small and large areas

containing gold deity figures symbolizing luck, fertility and long life. The temple also offers scenic views of the reserve and surrounding areas. During peak visitation days, mostly weekend and religious feast days, crowds of up to 1,000 people are observed at the site, with resulting incense smoke visible from great distances.

The Feishuitan Waterfall, also known as the Sun Yat Sen swimming pool, is the most utilized swimming area within the reserve and is frequented by both the local community and visitors (local residents typically visit the reserve 'after hours' without paying the entrance fee). The area is relatively small but attracts a high level of visitation, particularly during weekend days, with up to 200-300 visitors observed in the area. Many visitors use the site for photo opportunities.

The core zone is the protected section of the reserve and covers 750 hectares. It offers the most scenic and peaceful environment with the reserve. A hardened trail within the core winds through the relatively undisturbed forest and offers the cultural experience of Baiyun Temple and Yuelong Buddhist nunnery as well as refreshing waterfalls and the scenic beauty of old growth forest. Visitation to the core areas is restricted to the summer season, and reserve managers estimate there are approximately 5,000 visitors to the area each year. The area is monitored by two staffed police stations, and permission is required for entrance. An additional entrance fee of 17 yuan (approx. US$2) is charged, with revenues going to DBRA.

The combination of DBR's cultural and natural environment plus its accessibility to urbanized areas contributes to its high visitation. In 1995, the reserve attracted 670,000 visitors. Visitor statistics from DBRA indicate total visitation has remained relatively constant over a five year period, but it does exhibit seasonality (Fig. 11.2 and 11.3). The entrance fee has increased since 1990. Because total visitation has remained fairly constant, the fee increase has led to an increase in fee revenues from 1.5 million yuan in 1990 to 13.5 million yuan (approx. US$1.7 million) in 1995. The majority of the fee revenue goes to the Zhaoqing City Government and is used to fund infrastructure development in the reserve. Five per cent goes to DBRA.

Figure 11.2. DBR Annual Visitation

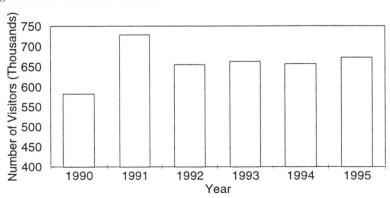

Figure 11.3. DBR Monthly Visitation

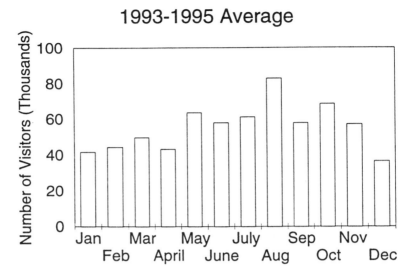

The constancy of visitation and growing involvement of government agencies in the management of the reserve has led to an acceleration in tourism development both within the reserve and surrounding areas. Tourism operations at Dinghushan include several hotels, ranging from small to large scale, and numerous tourism vendors selling souvenirs, food and other items.

Summary of Research Activities

This chapter is based in part on research undertaken at Dinghushan during the peak visitation period of June to August 1996. The research included a survey of visitors, a series of semi-structured interviews, and on-site observations (more detail can be found in Lindberg, Goulding *et al.,* 1996).

The survey contained questions on: 1) basic visitor behaviour, such as visit frequency and length of stay; 2) motivation and satisfaction; 3) perceptions of problems and support for management actions; 4) environmental attitudes; 5) expenditure; and 6) demographics. It was translated into Mandarin and administered at the reserve by DBR staff and a research assistant. Four hundred and forty visitors completed the survey, for a response rate of approximately 51 per cent. Nonresponse was most common with family groups, large tour groups, and females (particularly those over 40).

Survey results were complemented with a series of semi-structured interviews and on-site observations. The interviews targeted key organizations and individuals involved in reserve management, tourism development and tourism activity.

Ecotourism Issues

Biosphere Reserve as the Dominant Protected Area Model

Most countries contain a variety of protected area designations that allow various levels of human activity. For example, national parks specifically provide for recreation as well as conservation, while strict nature reserves allow much less human use. However, even national parks can be viewed as a 'closed style' designation that places primary emphasis on protection of the environment whilst limiting human interaction and activity. On the other hand, the biosphere reserve designation can be viewed as 'open style', which emphasizes the integration of protection and development (Zhao and Han, 1996). Biosphere reserves are not only designed to provide local benefits, but also to involve local participation as a means of linking conservation and development (UNESCO, 1995).

Several studies have focussed on the concept of the biosphere reserves and their use in developing economies (Halfter, 1980; Thwaites and DeLacy, 1997). For countries with high population densities and relatively low rates of per capita income, the 'open style' protected area model is the most realistic. China has chosen the open style biosphere reserve as the dominant protected area model for the country.

Though significant visitor-related infrastructure has been developed in national parks around the world, biosphere reserves specifically allow for, and promote, such development. Increasingly, ecotourism is viewed as having the potential to support the principles and the process of integrating conservation and development within the biosphere reserve framework. However, evaluations of ecotourism as a sustainable development option for biosphere reserves are relatively recent and limited in number, particularly within China.

In short, relative to other types of protected areas, biosphere reserves stress provision of economic benefits and community participation. In China, reserves are believed to provide significant benefits to local communities, including generation of income, improvement in transport and restoration of degraded ecosystems (Han and Guo, 1995). At Dinghushan, stakeholders believe the reserve has played a positive role in the community, reporting direct benefits from the reserve as increased opportunities for employment, improvement in site facilities and access to new industries. These beliefs are supported by survey results, which indicate that ecotourism at DBR generates an estimated 47 to 100 million yuan (US$6 to US$13 million) per year in visitor expenditure for the district (Lindberg, Goulding *et al.*, 1996).

Community participation has been stressed in both the biosphere reserve and the tourism literature (Cock *et al.*, 1996; Simmons, 1994). At Dinghushan, community participation is not as high as desired. This results from various causes, including political structures and traditions, and the significant role played by the local government in *de facto* reserve management.

In summary, due to its socioeconomic situation, China has pursued an open-style biosphere reserve model for protected areas. The result is a stronger focus on

economic development, including tourism, than is typically the case with national parks. Moreover, public participation is an explicit objective. DBR makes a strong contribution to local economic development, with tourism at the reserve apparently being the primary generator of local jobs. Though there are opportunities to enhance community participation in many countries, this is particularly true in China, and especially at DBR, where political norms and complex institutional arrangements hinder high levels of community participation.

Control of Tourism Within Reserves and Level of Environmental Impacts

As noted above, ecotourism potentially leads to symbiotic relationships between natural areas, communities, visitors and the tourism industry. However, the symbiosis ultimately is limited, and conflict may arise. For example, industry may wish to increase visitation beyond the level considered acceptable to protected area managers. Because industry tends to have greater political power, and in some cases because government agencies benefit from increased visitation, protected area managers may have limited ability to restrict visitation and associated infrastructure development.

Officially, DBRA owns Dinghushan Biosphere Reserve and has the right to control tourism there, including the right to charge fees. However, the Zhaoqing City government has *de facto* control over tourism development, including fee administration. Therefore, while protected area managers in many countries fight to *retain* control in the face of political pressures, at Dinghushan managers have the more difficult task of *obtaining* control. Though the situation varies across reserves in China, there is an apparent tendency for local government, and thus ultimately the Communist Party, to have more control over protected areas in China than in other countries. Naturally, this locus of control has implications for environmental impacts, revenue generation, and other issues.

Parallel to the control of infrastructure is the management of visitors. Few natural areas, particularly in developing countries, have the human and financial resources to implement comprehensive visitor management strategies. Moreover, managers often must overcome the limitations of a trail network that existed prior to reserve designation. At Dinghushan, this network stems from centuries of access to temples in the area, while in other countries the network might stem from fire control roads, trails to historic scenic or recreation areas, and so on.

Given a pre-existing trail network, external control of recent trail developments, and lack of resources, there is very little visitor management at DBR aside from restricting visitation to the core zone. This situation leads to continuation of relatively high levels of depreciative visitor behaviours, including the destruction and removal of flora and fauna, and the littering of streams and pathways. Research indicates that the high level of visitation and the increasing use of motorized transport, with 130,000 to 140,000 vehicles entering DBR each year, have generated negative impacts on air and water quality, as well as soil condition (Kong *et al.,* 1993).

Though pressure to expand infrastructure may be decreasing as visitor numbers stabilize, future control over infrastructure and visitor behaviour remains a critical

issue. In principle, the industry should impose self-regulation to ensure that development does not destroy the experience sought by visitors. Such a principle is supported by responses to the visitor survey. For example, when asked how important 'to view scenery in the reserve' was as a motivation for the visit, 46 per cent of the respondents selected 4 or 5 on a 5-point scale from 1=Not Important to 5=Extremely Important. Similarly, 58 per cent of respondents said they would support or strongly support restrictions on the construction of hotels and other buildings in the reserve.

Moreover, self-regulation may provide important economic benefits to current tourism businesses in the reserve. Many businesses report declining sales over the past few years, with entrance fee increases or a general economic slowdown being blamed. However, the decline also may be due in part to growth in the number of businesses and the limited diversity of products sold. Future growth in the number of businesses may generate further downward pressure on sales, such that existing businesses have a natural self-interest in restricting such growth. Despite these considerations, further increases in infrastructure have been proposed, and restrictions on the number of businesses appear unlikely.

The importance of impacts depends on tourism-related management objectives, which have not yet been specified in detail at DBR. For a biosphere reserve like DBR, impacts may be more acceptable, depending on the zone, than for a strict nature reserve. None the less, the current lack of DBRA control over infrastructure or visitors is a cause for concern and should be remedied in order to enhance prospects for achieving the ecotourism goal of minimizing negative environmental impacts.

Level and Distribution of Financial Benefits

As is typical for protected-area systems around the world, funding levels for biosphere reserves in China are considered inadequate (Han and Guo, 1995). The potential for ecotourism to complement traditional funding sources is a major reason for its popularity amongst conservationists and reserve managers. Though ecotourism can indirectly increase revenues as a result of enhanced political support, the more direct avenue is for ecotourism-related fees to be collected and earmarked for reserve management (Lindberg, Enriquez, and Sproule, 1996).

Figure 11.4, which is based on results from a survey of protected areas around the world, illustrates that approximately half of the areas charge entrance fees, the most common source of direct ecotourism-related revenue. Results should be considered tentative due to the potential for nonresponse bias and the trend toward implementing fees in recent years. None the less, the data indicates that many areas have yet to capture the potential of ecotourism fee revenue.

Dinghushan has captured this potential, with an estimated 13.5 million yuan (approx. US$1.7 million) generated by entrance and related fees in 1995. However, this revenue has made little contribution to DBRA management of the reserve, as only 5 per cent is allocated to DBRA. Thus, substantial revenue is generated, but the revenue primarily has contributed to infrastructure development rather than to environmental interpretation, visitor management, or general reserve management.

Figure 11.4. Revenue Sources used by Protected Areas - Developed and Developing Country Averages

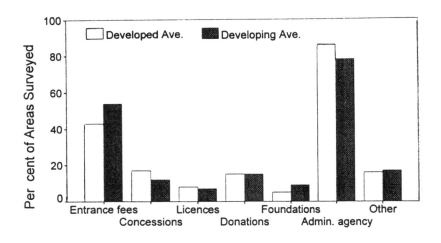

Source: Giongo *et al.*, 1994

It appears common in China for revenue to benefit local government more than the agencies that own and manage the reserve, but there are exceptions. For example, Tianmushan Biosphere Reserve retains tourism-related revenue in addition to government allocations (Tan, 1996). Survey results indicate visitor support for a greater portion of entrance fee revenues to be dedicated toward DBRA, as opposed to tourism bureau, functions. When asked how revenues from entrance fees should be distributed, 18 per cent selected the '100 per cent to conservation, research and education' option while 43 per cent selected the '75 per cent to conservation ... and 25 per cent to construction for tourism' option. Both options would represent a substantial change to the current distribution of only 5 per cent to DBRA for conservation, research and education.

Focus on Ecological Rather Than Social Issues in Research and Management

There is a global tendency for protected area staff to be trained in the natural sciences, particularly biology or ecology, and the staff of DBRA are no exception. However, it has become clear, at Dinghushan and at many other areas around the world, that the challenges reserve managers face are more social and political than ecological and technical. Protected area visitation has a technical ecological component (e.g., the environmental impact of ecotourism), but it also has a significant social and political component.

Due to their training, and associated worldview, it is natural for ecologically oriented protected-area staff to seek technical solutions to problems that are at least partly socio-political. An important example of this is the inclination of reserve managers to embrace the carrying capacity concept as a solution to the environmental impacts of ecotourism. Unfortunately, the problem of ecotourism impacts is only partly technical, such that sociopolitical judgements by managers and other stakeholders will be necessary to address the issue properly (Lindberg, McCool and Stankey, 1997).

The limitations of such a disciplinary focus are exacerbated at Dinghushan by its focus on research. DBRA is a branch of a research organization and has established an impressive research programme. However, the challenge of gaining greater control over tourism in the reserve will be more dependent on political skills than research skills.

Several related outcomes often result in part from the tendency of protected area staff to have an ecological orientation, and, to a lesser degree, a research orientation. First, planning and management tends to focus on the natural environment rather than the human environment, and on visitation in particular. For example, though tourism-related planning has been pursued in some Chinese reserves (e.g., Tisdell, 1996), it appears uncommon.

Second, it often is difficult for staff to work effectively with tourism professionals, who typically have very different training, priorities and personalities. As a result, it is difficult to develop the trust and personal relationships that contribute to effective cooperation. Third, it often is difficult for staff to work effectively with local communities. Though some reserves in China have actively developed symbiotic relationships with local communities (Tan, 1996), such programmes are challenges for other reserves in China and internationally.

Both the ecotourism and the biosphere reserve concepts stress the importance of the natural *and* social environments, as well as the importance of developing effective and symbiotic cooperation between protected areas, local communities and tourism businesses. However, this is a challenge around the world, and to achieve these goals it will be necessary to broaden the skills and interests of existing reserve staff and/or to hire new staff with these skills.

Sociocultural Impacts and Community Attitudes Toward Tourism

The impacts of tourism on local communities, and the related community attitudes toward tourism, have been an important topic of research and discussion both within ecotourism and within tourism generally (Lindberg and Johnson, 1997; Pearce, Moscardo and Ross, 1996; Smith, 1989). In the ecotourism context, local economic benefits can lead to support not only for tourism, but also for the natural area with which it is associated (Han and Guo, 1995; Lindberg, Enriquez and Sproule, 1996). Conversely, negative economic or other impacts can jeopardize support for

tourism and associated areas. For example, in some areas of China, tourism has led to a reduction in resident access to areas set aside for tourists. In various countries, ecotourism is developed in regions with declining resource-based industries and is presented as an alternative to such industries. The result may be antagonism from those local residents who identify with, or have been employed in, these industries.

In China, there appears to be widespread support for tourism by local communities. Residents value the benefits of job creation and the development of tourism-related infrastructure, for example roads and airports (Tisdell, 1996). Conversely, there appear to be relatively few negative impacts, perhaps because tourism has been developed only recently and because most tourism remains domestic, such that the impact of pronounced cultural differences been hosts and guests has not been great.

Visitor Motivations and Desired Experiences

Ecotourism can provide an important additional impetus for conservation. In principle, visitors wish to experience nature in a relatively pristine state. If that state is jeopardized, the benefits provided by ecotourism may be lost. However, this principle critically depends on the importance of environmental integrity as a contributor to the visitor experience. This importance depends on visitor motivations and the experiences desired by visitors as well as general environmental knowledge and attitudes.

Results from the visitor survey, as described above, suggest that many DBR visitors are motivated by the opportunity to view scenery in the reserve, as well as to learn about nature. These motivations lead to support for restricting activities, including infrastructure development, that might threaten natural features. None the less, observation of visitor behaviour in DBR suggests that these responses should be interpreted cautiously and with due regard to the cultural context. For example, there is a much higher tolerance for littering in the reserve than would be the case in many Western reserves. Moreover, cross-cultural evaluations of human relationships with the natural environment suggest that, relative to Western cultures, Eastern cultures tend to favour human manipulation of nature in order to enhance its appeal in contrast to preservation of nature in a pristine state (Kellert, 1996). Thus, DBR visitors may be more tolerant of human changes to the nature reserve than would be true of visitors in many Western reserves.

More generally, though little empirical research has been conducted on cross-cultural motivations and desired experiences in ecotourism settings, observation and discussion with researchers and reserve managers in many countries suggest that substantial cross-cultural differences exist. The example of litter suggests that perceptions of depreciation and environmental degradation caused by other visitors varies across cultures. Similarly, perceptions of crowding may vary across cultures. Of the 242 respondents who reported that they saw at least 200 other people during their visit, fewer than 25 per cent selected the number 5 or higher on a scale of 1 to 9, with 1 being 'not at all crowded' to 9 being 'extremely crowded'. The reserve is

located within two hours of a city of six million people, and it is unlikely that visitors expect a wilderness experience. None the less, the level of crowding in the reserve probably is much more tolerable to Chinese visitors than to Western visitors.

Of course, there is variability within cultures, with certain individuals and groups in Chinese society being more sensitive than others to environmental degradation and crowding. For example, Xing (1993) notes the high levels of visitation at Wuyishan, Changbaishan, and Huangshan reserves (with the latter having more than 10,000 visitors per day during peak periods) and observes that such visitation levels, and associated infrastructure, may devalue the natural beauty of the reserves.

Two other issues are of interest. First, DBR and many other reserves in China offer not just natural attractions, but also religious and cultural attractions. In pre-communist times, leisure travel consisted primarily of pilgrimages to Buddhist or Taoist temples (Qiao, 1995). On-site observations indicate that religious pilgrimage is still a key component of tourism activity at Dinghushan, particularly for older visitors. Of the seven motivations presented on the visitor survey, 'to have a spiritual experience' was reported as the least important, but this result may be due to under-representation of older visitors in the survey sample (many older visitors refused to participate in the survey).

Second, given that most Dinghushan visitors travel in groups, it was interesting that 'to do something with friends or family' was not highly rated as a motivation. However, this may be explained by recent research on leisure and values in China, which indicates that family is not a preferred context for the participation in leisure activities (Freysinger and Chen, 1993).

Reserve managers around the world must cater to visitors with differing motivations and desired experiences. In the DBR context, an example is the challenge of managing general temple visitors whose behaviour may conflict with the desired experience of visitors who go to the temple for religious purposes. In countries where cross-cultural differences are great, which often is the case for developed-country ecotourists visiting sites in developing countries, this challenge is exacerbated. Currently, most reserves in China cater to domestic visitors, but this issue must be considered if international visitation is pursued.

Environmental Interpretation and Education

A particular component of the visitor experience is the provision of environmental interpretation and education. Dinghushan and other Chinese reserves currently contain some interpretive material, but generally it is limited (Tisdell, 1996). Staff at DBR are keen to further develop the interpretive programme, which potentially contributes not only to the quality of the visitor experience, but also to management of visitor behaviour.

Lack of funding and the difficulty of attracting to remote areas the qualified staff to develop and present interpretive material are common limitations to effective interpretive program,es in many countries. The lack of funding illustrates the intertwined nature of the issues discussed here - if DBRA were to receive a greater

proportion of the entrance fee revenue, they would be able to upgrade the interpretive programme. However, given that tourism stakeholders also are interested in implementing such a programme, this challenge presents an opportunity for developing mutually beneficial collaboration between DBR staff and the tourism authorities. Moreover, DBR is more fortunate than many reserves insofar as it is located reasonably close to the provincial capital (Guangzhou) and to other population centres, including Zhaoqing City, which may facilitate efforts to attract and retain high-quality interpretive staff.

Summary

Few, if any, sites around the world fully achieve the ideals of ecotourism. The issues and challenges presented here face natural-area managers in many countries. However, some features of ecotourism in China stand out. First, many reserves stem from the conservation principles of Taoism and Buddhism, and many contain religious sites. Second, China is pursuing an open-style protected-area management model based on the biosphere reserve concept. This model is very consistent with ecotourism's sustainable development objectives. Third, local government, which also plays an industry function, has a larger role in reserve management in China than in many other countries. Though this role facilitates tourism development, it may jeopardize conservation objectives.

Fourth, DBRA and other reserves in China have implemented significant entrance fees which, when combined with high levels of visitation, lead to substantial revenue. However, in the case of DBR, most of the revenue goes to local government rather than DBRA. Fifth, DBRA is faced with the challenge of supplementing its ecological and research focus with a sociopolitical and management focus. Sixth, impacts on local communities currently are perceived as overwhelmingly positive. Lastly, the justification that the natural environment must be conserved to retain ecotourism benefits may not be as strong at DBR as at other sites. Thus, managers must rely on the traditional rationales for minimizing human impacts on the environment. More generally, the DBR example illustrates how cultural norms lead to differing motivations and desired experiences, which has important implications for ecotourism management.

Challenges in the management of ecotourism result from difficulties plaguing general reserve management in China and elsewhere, including unsystematic legislation, lack of government funding, lack of coordination between agencies, and the difficulty of attracting and retaining staff in remote areas (Anon, 1995). However, provided appropriate policies and management strategies are implemented, ecotourism also can be used to meet some of these challenges, including lack of funding and the need to enhance public education.

Acknowledgements

This chapter benefitted from conversations with reserve managers during the Chinese National Committee for MAB Ecotourism Training Course held at Dinghushan Biosphere Reserve in December 1996. Also, we thank Rik Thwaites for reviewing an early draft of the paper.

Chapter twelve:

Limits to Ecotourism Growth and Sustainability: The Galápagos Example

Mary Lee Nolan
Department of Geosciences, Oregon State University, Corvallis, OR 97331-5505, USA

Sidney Nolan
2775 NW Glenwood Rd., Corvallis, OR 97330, USA

Prologue: Political Manoeuvring in a Fragile Environment

The Galápagos Islands of Ecuador are at a critical crossroads in their history. The source of Charles Darwin's inspiration for his theory of evolution, the unique ecosystems of the islands face a future either of continued responsible conservation management to maintain their intrinsic values, or virtual destruction of their resource base through over development for short-term economic gain. The outcome of political manoeuvring to direct the course of tourism development will determine that future.

The battle lines are drawn with proponents of the current application of ecotourism principals facing advocates of mass tourism development and large scale exploitation of marine resources. If ecotourism loses the contest, the archipelago may be left with its land area fit only for rats and feral goats, pigs, dogs and cats, and its surrounding seas desolate from over-fishing and pollution.

The current crisis has been smoldering since 1995 when Sixto Duran-Bellen, then president of Ecuador, vetoed legislation which favoured the development of more tourist facilities around the islands' principal human settlements as well as relaxed fishing regulations. The sponsor of this legislation, Galápagos representative to the national congress Eduardo Véliz, organized protests by local residents, principally fishermen, that eventually led to a two-week siege of the Charles Darwin Research Station and the headquarters of the Galápagos National Park. Despite broadcast calls

by Véliz for the protesters to burn and loot the facilities, as well as seize tourists as hostages, the demonstrations ended peacefully.

In the Spring of 1996, Ecuador's political attention turned to the election of a new president. In the waning days of the Duran-Bellen administration, Véliz ushered a second 'Socio-ecological Law for the Galápagos' through the national congress. Key provisions of Véliz' new attempt included restricting migration of Ecuadorians to the islands - a positive move in the eyes of conservationists - and expansion of the existing marine reserve around the Galápagos from 15 to 40 miles offshore, while at the same time reducing effective controls on exploitation of the waters by applying the general Ecuadorian fishing regulations to the area. In addition, the law would have required the overall administration of the islands to provide for the social and economic needs of the local population, including the building of roads in undeveloped areas of the Galápagos National Park.

The law was delivered to the Presidential offices on August 9, 1996, the last day of outgoing administration, but there was no one there to receive it. Therefore, the fate of the legislation was left for incoming President Abdala Bucaram Ortiz to sign or veto. Bucaram Ortiz, much to the surprise of many observers, ultimately vetoed the law, despite the fact that Véliz is one of his supporters in the congress. The new president, a former mayor of the port city of Guayaquil, is widely regarded as an opportunistic political entrepreneur known for appealing to the populist cause by promising much but delivering little. When he justified his veto on the grounds that it was unconstitutional to restrict the free movement of Ecuadorians within the national territory, and that expansion of the marine reserve was unacceptable because of its potential impact on commercial fishing, conservation interests wondered what hidden agenda awaited the future of the Galápagos.

Meanwhile, in June of 1996, a UNESCO team had visited the Galápagos and recommended that the islands, which have held World Heritage Site status since 1979, be demoted to the rank of Patrimony of Mankind Endangered unless prompt action is taken to increase conservation efforts such as restricting the growth of the islands' population and controlling illegal fishing. Now, the world community - like much of the Ecuadorian nation - is waiting to see what an unpredictable administration has in store for the country and the Galápagos.

Ecotourism and the Galápagos

Ecotourism, defined as nature-oriented, alternative tourism that emphasizes ecological and social responsibility (Cater, 1994), is the current management philosophy in the Galápagos. The islands illustrate the workings of an ecotourism system centered on a resource base and affected by the dynamic interactions of tourists, local people, competing economic and political interests, and infrastructure. These interactions contain elements of symbiotic as well as conflicting relationships, all of which contribute to, or detract from, the ideal of sustainable ecotourism. The current struggle between conservation and exploitation highlights both the opportunities and

limitations of ecotourism as a viable economic endeavour for developing nations.

In any case, where the potential of ecotourism development exists environmental restrictions will be self-imposing, for if the resource-based attraction is degraded by the impact of excessive visitation, then ecotourism's *raison d'être* will be lost. Effective policies must be in place to restrict tourist access to the attraction within the limits of a scientifically determined carrying capacity. In the Galápagos case, the tourists are distributed in small groups among sites under the watchful eyes of trained guides. In addition, the numbers of tourists are limited by the relatively high cost of a visit to the Galápagos. Therefore, ecotourism resources should be sustainable for the foreseeable future unless irrational political and economic forces prevail.

The main attraction of observing a relatively undisturbed environment has drawn a growing number of visitors to the Galápagos. Visitation has exceed 50,000 in recent years and is expected to top 60,000 in 1996 without serious degradation of the ecotourism experience or the islands' unique ecosystem. However, several factors within the tourism sector, as well as in the other components of the system, may adversely affect the sustainabilty of current visitor levels, or shift the management emphasis to mass tourism development and exploitation of marine resources for short-term economic gain.

The Environment

The Galápagos, which is a province of Ecuador, lies 960 kilometres west of that nation's coast. The archipelago consists of 8,000 square kilometres of land area distributed among 21 islands that range in area from barely one-tenth to nearly 4,600 square kilometres and more than 40 smaller islets. The islands are largely volcanic in origin. The oldest islands are approximately five million years old and the younger islands of Fernandina and Isabela probably emerged above the sea less than a million years ago.

Because of their isolation from any continental land masses, colonization by plant and animal species occurred largely at the whim of ocean and air currents, and by the migratory patterns of sea birds, fishes and marine mammals. Subsequent development of land based sub-species led to variations in the ecosystems of individual islands.

The History of Human Activity

The first recorded sighting of the Galápagos occurred in 1535 when a Spanish ship carrying the Bishop of Panama to Peru was becalmed and drifted into the archipelago. The bishop described the giant tortoises and iguanas, and noted the remarkable tameness of the birds. For the next 150 years, the Galápagos served mainly as a haven for pirates who preyed on the Spanish treasure ships out of Lima, Peru, bound for Panama. They used the islands' giant tortoises and sea turtles for food. The first black rats on the islands may have come ashore from their ships, and were probably a factor in the extinction of several species of endemic rice rats.

The first scientific mission to the Galápagos was commissioned by the King of

Spain in 1790, but its records were lost. In 1793, English seamen investigated the whaling potential of the islands, and produced the first reasonably accurate charts. Two years later, Captain George Vancouver cruised the islands and noted the abundance of seals, penguins, and '. . . large Lizards swimming about in different directions & basking at their ease' (Jackson, 1993:3).

Whalers and sealers exploited the island waters for much of the nineteenth century, and fur seals were hunted nearly to extinction. During this period an estimated 100,000 giant tortoises were removed, primarily to be stored alive on ships to provide food during long voyages. In 1813, the United States Navy frigate *Essex* destroyed a British whaling fleet in the archipelago, but is blamed for releasing the first goats on Santiago Island. This marked the beginnings of an increasingly serious problem of competition between feral goats and native species.

The young nation of Ecuador officially annexed the Galápagos in 1832, and a small settlement was established on Floreana. This island became a penal colony for criminals, political exiles and prostitutes, and this continued to be a principal use of the islands until the 1930s. During World War II, the United States built a military airfield on Baltra Island, which was turned over to Ecuador after the war. One of the landing strips still functions as the islands' major airport.

International attention was focussed on the Galápagos as the result of a five-week visit in 1835 by the British naturalist Charles Darwin in the course of his five-year voyage around he world aboard the HMS *Beagle*. In 1845, he published a descriptive chapter on the Galápagos in his account of the voyage. And, in 1859, he proposed his theory of evolution through natural selection in his *Origin of the Species*, based largely on his observations of the various adaptations to local environment by the flora and fauna of the Galápagos, especially the sub-species of finches.

Recognition of a need to protect the islands' unique ecosystems and their scientific value was slow in coming, however. The first protective legislation was passed by the Ecuadorian government in 1934. It was strengthened in 1936, but it had little effect on the use of the islands' resources. Fishing, farming and ranching continued to be pursued and, as a result, increasing numbers of introduced plant and animal species became established to compete with the native and endemic flora and fauna. A study of the islands' fossils suggests that most of the extinctions of native species of the Galápagos have occurred since the first arrival of humans in 1535, with the highest rate of pre-human extinctions probably being 100 times less than the modern rate (Steadman, 1986).

Prior to 1978, the Galápagos were a special territory administered by the Ecuadorian national government so that migration of people from the mainland could, at least theoretically, be restricted. However, since that year the islands have had the autonomous governmental status of a province of Ecuador. Because a prevailing interpretation of the nation's constitution holds that Ecuadorian citizens can freely choose to live anywhere in the country, migration to the Galápagos is uncontrolled. As a result, the human population has been growing at rates of up to 8 per cent per year, and has doubled since 1990 to more than 14,000 people, concentrated on the islands of Santa Cruz and San Cristóbal. Many of the new inhabitants arrive hoping

for jobs in the tourism industry, but others come to engage in fishing - both legal and illegal - and still others come to provide services for the growing population.

The Advent of Conservation and Ecotourism

The Galápagos National Park was established in 1959 to protect the land area of the islands outside of the established settlements and farms. The park is administered by the *Instituto Ecuatoriano Forestal y de Areas Naturales y Vida Silvestre* (INEFAN), an agency of the Ministry of Agriculture. The mission of the park includes control of non-native species, the restoration of native species and the management of human impacts.

In the same year, the Charles Darwin Foundation for the Galápagos, headquartered in Brussels, was founded with the purpose of promoting the conservation of the islands' natural resources and facilitating scientific research. In 1960, work was begun on establishing the Charles Darwin Research Station adjacent to the headquarters of the National Park near the town of Puerto Ayora on Santa Cruz Island. The CDRS facilities were inaugurated in 1964, and in 1991 the Ecuadorian government extended the station's permission to operate for 25 years.

By 1968, cooperation had been established between INEFAN, the CDRS, and the tourism industry to establish and control visitor sites, build and maintain nature trails, and designate scientific study reserves for this 'living laboratory of evolution' (Muñoz, n.d.). Organized group tourism was inaugurated by Metropolitan Touring of Quito in 1969.

Conservation efforts accelerated after 1979 when the Galápagos was designated the first World Heritage Site by UNESCO as a natural area worthy of international protection. In 1986, the Ecuadorian government established the Galápagos Marine Reserve to include all internal waters of the archipelago plus a zone extending 15 miles out from the islands. Special fishing regulations were subsequently enacted that limited the activity in the reserve to artesianal, or small-scale, low technology fishing for subsistence and local consumption.

Following the lead of The Ecotourism Society, an international organization established in 1990 to promote conservation through tourism worldwide, the Ecuadorian Ecotourism Association was formed in 1991 to 'unite both government and private sectors for the advancement of sustainable development through environmental awareness' (Muñoz, n.d.). This group, the first of its kind in Latin America, focussed on improving practices within the tourism industry in Ecuador's prime natural areas in the Amazon region and the Galápagos, as well as among the indigenous populations of the highlands who are an important component of the country's cultural attraction base. In addition, the EEA sought to combat the problems of 'irresponsible oil exploration, illegal fishing, mining and lumbering' (Muñoz, n.d.).

The EEA adopted the Ecotourism Guidelines for Nature Tour Operators published by The Ecotourism Association in 1993, and in 1994-95 implemented a proprietary 'Green Evaluation Consumer Questionnaire' in cooperation with the Recreation, Travel and Tourism Institute at Clemson University in South Carolina.

This questionnaire, which was to be distributed to 8,000 tourists, was designed to determine how closely the participating tour companies had been adhering to TEA guidelines. Results of the survey were to be reported to the participating tour companies so that they could self-evaluate their ecotourism performance from the point-of-view of the consumer.

Galápagos Tourism Today and Its Future

Recorded visitations to the Galápagos National Park rose from approximately 6,000 to 55,782 between 1979 and 1995, with occasional temporary declines. Before 1976, virtually all of the tourists were foreign nationals (Carrasco, 1992 in Jackson, 1993). By 1979, the percentage of Ecuadorian nationals had reached 19 per cent and continued to rise through the early 1980s, reaching a high of 55 per cent in 1985, then declining to 37 per cent by the end of the decade. In 1995, Ecuadorians accounted for only 28 per cent of the park visitors (INEFAN, 1996). Because the actual number of Ecuadorian tourists rose steadily throughout the period, the proportional rise in foreign visitors reflects a much greater growth in that segment of the market. This partly reflects the increasingly high cost of a Galápagos vacation which rose during a period of economic hard times for middle income Ecuadorians. Even with special rates for Ecuadorian nationals, a Galápagos trip is out of reach for most people in the country. More affluent Ecuadorians can, and usually do, choose alternative, higher status, destinations such as Florida for approximately the same cost. This, in turn, reflects the very limited ecotourism market within Ecuador. As one high middle income Ecuadorian recently said to another upon hearing of her friend's Galápagos vacation plans, "Why on earth do you want to go see all those boring animals?'

The world market for Galápagos ecotourism is obviously much larger, although most of the tourism executives and officials interviewed pointed out that many foreign visitors to the islands spend only three or four days on a cruise as part of a more general South America tour, and are not necessarily that interested in nature tourism *per se*. Many are retired people who have travelled widely and are primarily interested in adding the islands to the list of well-known attractions they have visited, whereas others are essentially cruise enthusiasts looking for something different. These interests are reflected in the content of evening programmes on some of the larger ships which feature cursory slide shows along with social hours rather than in-depth nature lectures. Also, ample time is allowed on shore for sun-bathing and swimming on various beaches.

Regardless of the degree of the foreign tourists' interest in ecology, the Galápagos currently constitutes a prestige destination or stop over on the international tourism circuit. This in turn attracts many tourists to Ecuador who might not otherwise consider the country in their travel plans. According to Jorge Barga, the director of INEFAN in the Duran-Bellen government, Galápagos tourism contributes US$60 million each year to the Ecuadorian economy. The share of Ecuador's total tourism accounted for by Galápagos visitors is difficult to determine because of the usual

problems associated with categorizing travellers. Tourism officials estimate that 20 to 30 per cent of international pleasure travellers who arrive in Ecuador include the islands in their itineraries. Luis Maldonado Robles, vice-president of Metropolitan Touring, one of the nation's major packaged tour operators, estimated that only about 20 to 25 per cent of their international clientele visit the mainland without going to the islands. Of those who visit the islands, about 60 per cent also spend time elsewhere in Ecuador, principally in the highlands around Quito, or in the Amazon region. According to tour operators, repeat visitation to the Galápagos is not common among international visitors, but it is not unusual for Galápagos tourists to return to Ecuador to visit other places on later trips.

At present, tourism is relatively well regulated, but growing, although not at the rates projected in the late 1980s. Within the islands, the National Park's tourism office currently oversees the operation of 88 boats ranging in size from 8 to 100 passengers. Each boat must submit proposed itineraries for each year. Once approved, the larger cruise ship itineraries are difficult to change, although the smaller boat have more flexibility. Small boats carrying hotel-based passengers on day trips are also required to have site visitation permits, but these can be arranged a few days, or even hours, before a trip. Private yachts are required to have an authorization from the Naval office to spend a limited time in Puerto Ayora to take on supplies. According to Edgar Vargas, Chief of Tourism for the Galápagos National Park, visiting the park by private boat is strongly discouraged. Yachters may request permission to remain at anchor in the Puerto Ayora harbour long enough to take a cruise on one of the licensed boats. Affluent yachters with connections can sometimes obtain special permission to cruise the islands and land at specified sites, but only if accompanied by a licensed tour guide, and then at a cost of $200 per person per day including all crew members as well as passengers.

Although most of the islands' land area is included within park boundaries, access is extremely limited. The park has identified between 55 and 60 landing sites, some of which have associated nature trails. Not all of the sites are open at any given time. According to Midland Robles of Metropolitan Touring, only about 20 of these sites are of high level interest. Sites also vary considerably in the extent to which they have been developed and the effort required to explore them. Some trails branching out from the less frequently visited landing places require considerable physical stamina, so these are unsuited for many of the elderly tourists attracted to the islands. In addition, the larger cruise ships are limited to stopping at only a few of the more developed sites. Visitation to the sites is allocated on the basis of carrying capacity that takes into account the physical and wildlife characteristics of each site. For example, when ground-nesting birds might be disturbed, no tourists are permitted within the nesting area.

Once ashore, each group of tourists is supervised by a licensed naturalist-guide trained by national park personnel. Park policy requires one guide for each 16 tourists, but this rule is flexible for the larger cruise ships that are allowed to use one guide for groups of up to about 20 people. Guides appear to take their responsibilities seriously, even at the risk of offending some of the more wayward tourists. As stated

by Vargas, 'the guides are the eyes of the park'. Most of the approximately 250 guides are Ecuadorians, but because of the language demands of an international clientele, some foreign nationals are hired by the larger tour companies. Tourists visiting areas outside national park boundaries, such as the agricultural zone and parts of the highlands of Santa Cruz, are usually accompanied by guides, but this is not required. According to Vargas many more visitors could be accommodated with little or no environmental impact through increased use of beach recreational sites and other areas in the populated zones outside park boundaries.

At current ship-board capacity, based on numbers of berths, the islands could theoretically accommodate 110,000 visitors per year if occupancy were 100 per cent and all the boats were capable of running all the time. In addition, there are hotels on Santa Cruz, San Cristóbal and Isabela islands. The consensus among government officials and tourism operators was that 100,000 or more annual visitors would be too many. Their estimates of a maximum number of visitors that could be handled annually without straining the available facilities or the resource base ranged around 70,000. However, they all agreed that it would be hard to manage transportation to the islands for so many people due to an air transportation bottleneck. Currently, service from Quito and Guayaquil to the airport on Baltra Island is monopolized by *Transportes Aeros Militares Ecuatorianos*, or TAME, which is controlled by the Ecuadorian Air Force. During peak seasons, TAME flights are consistently overbooked, and there have been instances of large tour groups being stranded when they were denied seats on their return flights to the mainland.

The numbers of boats and hotels operating in the Galápagos are regulated by a permit system controlled by the national government in Quito. In 1995, approximately 54 per cent of these permits were held by island-based interests, but most of these were for smaller, lower quality hotels and small day-trip boats. Mainland based operators controlled 60 per cent of the islands' visitor capacity, mainly in larger cruise boats and more expensive hotels. This discrepancy has led to dissatisfaction among local entrepreneurs and government officials who would like to have tourists spend more time ashore and patronize locally owned businesses. However, two factors work to frustrate these desires. First, most of the hotels do not meet the quality standards expected by a majority of the foreign tourists and, secondly, the limited airline capacity and reservations chaos makes it difficult for cruise ship passengers to conclude their cruise with an island land stay without taking a chance on getting bumped from return flights and possibly missing international connections. To plan the land visit before a cruise currently means risking a longer than expected stay in Quito or Guayaquil while island hotel reservations go to waste.

Other physical limitations also work against expansion of land-based facilities in the Galápagos. Foremost among these is the limited supply of ground water. In addition to being brackish, water in the settlements is subject to contamination by the practice of emptying sewage into fissures in the volcanic landscape without any knowledge of the ultimate destination of the wastes. Electrical power is also limited. Puerto Ayora, the largest settlement in the islands, is supplied by a diesel-powered generator only from 8 a.m. to 11 p.m., to the considerable midnight annoyance of

uninformed tourists who have paid a high surcharge for air conditioned rooms. The larger hotels operate their own generators for other hours and for backup during the frequent power outages.

While the assessment of the prospects of the market for the relatively expensive Galápagos tourism experience varied among the government officials and tour company representative interviewed, they were in general agreement about the most serious threats to the valuable and fragile island ecosystems. As stated by a United States Embassy spokesperson, the most serious problems can be summarized as related to: (1) the spread of non-native species; (2) fisheries exploitation; (3) emigration from the mainland; and (4) the politics of tourism.

Most of these problems are worsened by underfunding, particularly of the Galápagos National Park and other agencies responsible for ecological control. Until 1995, the National Park had direct access to all of the fees collected from visitors. However, that year the Ministry of Finance diverted those funds to the national treasury from which the park must draw its operating expenses in competition with all other demands for government services. As of March, 1996, only $16 million had been appropriated to operate the park for the year. In order to maintain its physical facilities and fulfill its natural resources conservation mandate, including training tourist guides, the park employs a staff of 10 in the administrative offices at Puerto Ayora and 80 park guards. A patrol boat needed to guard the marine reserve was donated by a wealthy Japanese businessman, but it seldom leaves port due to limited operating funds.

Fortunately, the Charles Darwin Foundation and other international organizations are available to assist the Galápagos National Park in fulfilling the part of its mission aimed at restoration and maintenance of native species of plants and animals. Of critical importance in 1996 has been the eradication of feral goats on Isabela Island. Prior to 1994, the goats had been confined to the southern part of the island that is separated from its northern extension by a narrow neck that had been a barren lava field. However, the last warm El Niño current shift in the Pacific brought enough rain for vegetation to become established in the lava, thus providing a food trail across the lava for the goats. By 1996, the goat population had grown large enough to threaten the food supply for the giant tortoises that inhabit the rim and crater of Alcedo Volcano. However, a goat eradication programme is being coordinated by the Charles Darwin Research Station with assistance from international contributors. It involves shooting the goats, and leaving the carcasses to replenish nutrients in the relatively poor soils of the area, and to provide carrion for the Galápagos Hawks that especially relish goat tongues and eyes. The depredations of cats, dogs, burros and other non-native animals are also a continuing problem.

Less immediately obvious, but perhaps equally damaging to the ecosystem, is the spread of non-native plants, usually as the expense of native species. The micronia shrub lands, for example, are seriously threatened by the spread of several weedy shrubs introduced from other areas, and this could affect the survival of endemic bird and insect species adapted to that humid highland zone.

Another threat to the ecotourism resource base lies off-shore. Fishing in the island

waters is supposedly limited to 450 small boat operators using simple techniques for subsistence and small-scale marketing. However, the fishermen are subsidized by mainland Ecuadorian interests dealing in the tuna, lobster and sea cucumber trade. The taking of sea cucumbers, a culinary delicacy in East Asia, has been banned in Galápagos waters since 1994; however, the fishery for the marine invertebrate continues due to lack of enforcement. This activity directly competes with the maintenance of the underwater attraction that makes the Galápagos a prime destination for recreational scuba diving. In addition, depletion of the fisheries stock eventually could threaten the sustenance of the sea birds and marine mammals that make up such an important part of the islands' ecology as well as their tourist attraction base.

The problem of immigration of people from the mainland is intensified by the economic opportunities that tourism and fisheries exploitation are perceived to present. Disappointment of new immigrants whose expectations are not met combines with the lack of an adequate infrastructure to support the growing population. This, in turn, offers fuel for the fires of political demagogues who see tourism development as a source of short-term gain through exploitation rather than a resource that can be sustained through conservation. None of the government officials or tourism executives interviewed in the spring of 1996 thought that out-of-control tourism development or the simple presence of too many tourists presented a major problem for the immediate future, but that may change soon.

The Galápagos Lesson

Four major threats to the prospects of sustaining ecotourism can be generalized from the Galápagos example. These are related to the local population, competing economic and political interests, and infrastructural components of the system. Specifically, these include: (1) the increasingly large numbers of people who may migrate to the area of an ecotourism attraction in search of the economic benefits of tourism and other resource uses; (2) the pressure from various interest groups to exploit the resources for economic gain or political power; (3) the growth of non-tourism elements of the infrastructure necessary to sustain a larger resident population and resource-exploitive activities; and (4) the impact of the tourists themselves if their numbers are allowed to exceed the carrying capacity of the very ecosystem that they come to observe. Control of these factors depends on the formulation and enforcement of consistent governmental policies as national and local political interests shift, and a source of adequate funding of the responsible public agencies. However, this is not always possible.

Epilogue: Political Turmoil Puts the Galápagos on Hold

The Galápagos example reinforces the often-repeated warning that ecotourism's success may be the primary weakness that leads to its downfall (Cater, 1994). If that success is perceived to be an indicator of a seemingly infinite source of economic gain, and tourist impact is allowed to exceed the carrying capacity of the resource, then ecotourism is doomed. Tourism as an economic activity may survive, but the quality of the ecotourism experience will be lost.

As long as Galápagos resources are managed in accord with the philosophy extant prior to the Ecuadorian presidential election in 1996, and infrastructual and population problems are responsibly addressed, then ecotourism with continue to be the saviour of the islands' unique ecosystems. However, the economic pie is too tempting for short-term exploitation proponents to resist.

From the time Abdala Bucaram took office in August, 1996, the various interests began manoeuvring to get control over the Galápagos. But, that proved to be an exercise in futility for them. A general strike protesting Bucaram's economic policies and the blatant corruption of his administration paralysed Ecuador in February, 1997. In a night session on February 6, the Ecuadorian congress declared Bucaram 'mentally incompetent' to hold office and impeached him. After a few days of having three persons claim the presidency, the congressional leader Fabian Alarcon was recognized as Interim President by everyone but Bucaram, who had fled to Panama. Alarcon has a reputation in Ecuador of being a master political operator and consensus builder. His skills have earned him the popular nickname 'El Mago' (the Magician).

In the final congressional action on February 11 to appoint Alarcon, Eduardo Véliz of the Galápagos was one of the former Bucaram supporters who shifted positions. When he announced his vote, he was booed by the anti-Bucaram majority. He may have switched sides in the hope of retaining his influence over the Galápagos law, but he may have waited too long to jump for Alarcon to feel obligated to consider his proposals.

So, Ecuador and the world wait to see what 'El Mago' can do for the Galápagos now that 'El Loco' has gone. As of the end of February, 1997, Alarcon had not announced any environmental policy, and no appointments had been made to fill the vacancies of Minister of Environment or INEFAN director, even though almost all the other cabinet positions had been filled. The new administration was focussed on trying to reduce a yawning budget deficit made worse by the apparent looting carried out by Bucaram and his cronies as they departed.

The Galápagos commission had a third draft of a bill ready, but no one to submit it to, and many of the seats on the commission were empty due to the change in government. Meanwhile, the World Heritage Committee's June deadline approached for Ecuador to show some progress in addressing the threats to the islands lest they be declared a World Heritage in Danger in November, 1997.

Interviews were done with the following persons in the process of this research:

José Andrade, Alcalde, Municipalidad de Santa Cruz, Puerto Ayora, Galápagos, April 5, 1996.

Jorge Barba, Director Ejecutivo, Instituto Ecuatoriano Forestal y de Areas Naturales

Vida Silvestre, Ministerio de Agricultura y Ganaderia, Quito, March 27, 1996.

Chantal Blanton, Director, Charles Darwin Research Station, Puerto Ayora, Galápagos, April 5, 1996.

Eduardo Diez, Quasar Nautica Galápagos Expeditions, and Presidente, Asociacíon de Operadores de Turismo en Galápagos, Quito, March 27, 1996

Luis Maldonado Robles, Vice-president, Metropolitan Touring, Quito, March 27, 1996.

Oswaldo Muñoz, Nuevo Mundo Travel Agency, and Presidente, Asociacíon Ecuatoriana de Ecoturismo, Quito, March 27, 1996

Edgar Vargas, Jefe de Turismo, Parque Nacional de Galápagos, Puerto Ayora, Galápagos, April 5, 1996.

Chapter thirteen:

Perceptions of Social and Physical Impacts upon New Zealand's Back Country Environments

Geoffrey W. Kearsley
Centre for Tourism, University of Otago, PO Box 56, Dunedin, New Zealand

Introduction

New Zealand relies heavily upon tourism as a major component of its modern economy and as a significant source of foreign exchange earnings. A current total of just under 1.5 million visitors brought in some \$4.8 billion of overseas funds in 1995/6 (NZTB, 1996a, 1996b) and the industry continues to grow in size and value. The natural environment is an important resource for this industry, as it always has been, both as a spectacular scenic backdrop and as a venue for a wide range of outdoor and adventure pursuits, including tramping (hiking or backpacking).

Outdoor recreational land is plentiful. Substantial areas of largely unmodified country are vested in the Crown as public lands, in the form of National Parks, Forest Parks and a variety of other Reserves. In fact, over 30 per cent of the country is held in what is known as the Conservation Estate, a figure that rises to well over half in the South. This Conservation Estate is almost completely uninhabited and forms the bulk of what has long been known as the Back Country. The first National Park was established in 1887 and very large areas of largely unmodified country continue to be added; the latest National Park, Kahurangi, in the north west of the South Island, is the country's second largest, and was only opened in 1996. From the earliest days of European settlement, the back country has been used for tramping, climbing, skiing, hunting and fishing, and, as a consequence, an outdoor recreational ethic has been a substantial component of New Zealand's culture and way of life (Fitzharris and Kearsley, 1988).

International tourists have become major visitors to the back country, too

(Higham, 1996; Higham and Kearsley, 1994). In 1975, some 250,000 international tourists visited New Zealand. They tended to be Australians and to patronize scheduled coach tours and few left the highways and scenic highlights. Even in 1982, a study of Fiordland National Park, by far the country's largest, showed that almost all of the overseas back country users were Australian (Kearsley, 1982). By 1985, the number of tourists had doubled to half a million, with a much greater range of nationalities and a high level of demand for adventure experiences, such as white water rafting and bungy jumping. The present total is marginally below one and a half million, many of whom use the Conservation Estate, especially the more popular walking tracks and scenic destinations such as Milford Sound.

In recent years, several studies have suggested that the rise of overseas visitors has begun to impact upon the more established and popular parts of the Conservation Estate and to generate perceptions of crowding (Harris, 1983; Higham and Kearsley, 1994; Kearsley, 1990, 1996; Kearsley and O'Neill, 1994; Keogh, 1991), as well as other inconveniences. Generally there have been two sets of consequences. One has been for the Department of Conservation to introduce limited access and overnight hut booking systems on the most heavily used tracks, such as the Routeburn and Milford, and to foreshadow similar restrictions on others. Associated with this has been a wide ranging public debate about the need to charge more for the ever increasing maintenance and facilities that are needed for the continued enjoyment of the natural environment by increasing tourist numbers. While no conclusions have been reached, suggestions that access fees might one day be charged or that facilities charges might rise substantially have caused some considerable popular alarm.

The second consequence has been for the suspicion to arise that some domestic, and possibly some of the more adventurous overseas, trampers might be displaced into marginal environments or seasons as a consequence of avoiding perceived crowding. One consequence of this, if it is happening, is increased visitor pressure on more remote locations and displacement of moderate wilderness purists (Kliskey and Kearsley, 1993) into a limited reservoir of pristine sites, with obvious physical impacts. Similarly, there will be an impact on host community satisfaction as domestic recreationists are displaced by overseas visitors. Both of these consequences will have implications for the sustainability of tourism in New Zealand. These issues and some introductory studies of displacement patterns are discussed in Kearsley (1995, 1996).

This paper reports some of the results of a questionnaire survey made possible by funding from the New Zealand Foundation for Research, Science and Technology Public Good Science Fund and carried out during the tramping season of 1995/6. Some 950 back country users were contacted in the field and invited to take and subsequently complete and return a self-completion mail-back questionnaire. Respondents were contacted throughout the whole of the country and in a wide range of back country environments, ranging from the highly popular Great Walks, such as the Routeburn, Abel Tasman and Kepler Tracks, to scarcely used wilderness routes. Half of the respondents were New Zealand residents and half were international visitors. The aim of the survey was to measure perceptions of crowding, motivations and degrees of satisfaction with the experiences gained and to gain some sense of the

extent to which displacement and coping strategies were taking place in a large sample. The focus of this paper is on the aggregate sample and comparisons between locals and visitors; later studies will compare location specific results and the perceptions of subsets of the sample, according to various demographic and socio-economic criteria.

Degrees of Crowding

The overall extent to which crowding was perceived is set out in Table 13.1, using a scale developed by Shelby *et al.* (1989) and used elsewhere in New Zealand (Kearsley and O'Neill, 1994). These aggregate figures are of indicative value only because they cover such a wide range of environments and tramping experience, which are topics for further analysis.

Although the domestic and international figures appear, at first glance, to be very similar, the fact that visitors tended to be on the more popular tracks requires that further analysis be attempted before firm conclusions can be drawn. None the less, in the back country in general, while 30 per cent overall felt quite uncrowded, some 16 per cent reported moderate to extreme crowding. The apparently higher perception of the absence of crowding by New Zealanders is a reflection again of their concentration in the more remote places, itself a possible indicator of displacement.

The Department of Conservation (DoC) has classified back country environments and their facilities (such as tracks and huts) in terms of their appropriateness to the needs of a range of market segments (Department of Conservation, 1995). Those using the most developed environments, such as the so-called Great Walks, are characterised as Back Country Comfort Seekers (BCCS), the more adventurous, seeking more spartan and simple provisions are described as Back Country Adventurers (BCA), while those who nearly seek the most pristine wilderness and very remote, often untracked, places are designated Remoteness Seekers (RS).

Table 13.1. The Overall Extent of Crowding (in Per Cent)

	Domestic	Overseas
Not at all crowded	36	24
2	15	17
3	15	15
Slightly crowded	15	17
5	5	9
Moderately crowded	7	11
7	4	4
8	1	2
Extremely crowded	3	1

Table 13.2. Perceptions of Crowding by Location (in Per Cent)

	BCCS	BCA	RS	Abel Tasman	Milford	Heaphy	All
Not at all	20	37	26	20	20	34	30
2	14	20	13	12	22	14	16
3	17	13	13	17	15	19	15
Slightly	20	14	17	16	17	19	16
5	9	4	9	4	2	6	7
Moderately	11	6	13	15	20	5	9
7	5	4	4	6	5	1	4
8	2	1	-	5	-	1	1
Extremely	2	1	4	7	-	1	2

In the present study, 63 per cent of the BCAs were resident in New Zealand, whereas only 44 per cent of the BCCSs were from this country. The very small sample of RSs (n=24) was evenly split. In terms of specific tracks, the variation is even greater. International visitors dominate the most popular tracks, with 68 per cent on the Routeburn and 75 per cent on the Dart/Rees, whereas only 27 per cent of the Hollyford and 20 per cent of the Huxley visitors were not resident in New Zealand. Even the relatively well known Heaphy Track has only 37 per cent overseas visitors. Table 13.2 shows how perceptions of crowding vary for the DoC user classifications and for illustrative selected tracks.

BCCSs are less inclined than any others to feel 'not at all crowded' and this is reflected in the figures for two of the most popular tracks, the Milford and the Abel Tasman. BCAs are the most likely to feel uncrowded. Moderate to extreme crowding is most apparent in BCCS environments (20%), with a full 33 per cent of Abel Tasman users reporting this level of crowding; such levels are not reported on the Milford Track because this is a carefully regulated walk requiring boat access at both ends for all but the most experienced trampers. Low levels of crowding perception were also recorded on the Heaphy Track, even though there is no formal regulation of numbers.

The extent to which perceived crowding was said to have affected enjoyment is set out in Table 13.3. Twenty-two per cent of the sample said that crowding had affected their enjoyment, and some two thirds of those said that it had done so moderately to extremely. In detail, a quarter of BCCSs were affected, but only 18 per cent of BCAs; a full 42 per cent of RSs were affected, mostly to a moderate extent, so that, even though only small numbers are involved, this group seems particularly susceptible to the presence of others. When the motives for going to the back country are examined (Kearsley, 1996; Kearsley and Higham, 1996) it can be seen that about 38 per cent of both domestic and international back country users as a whole see solitude as an important or very important motive for tramping. By contrast, 63 per

cent of RSs see this as an important or very important motive, compared with 31 per cent of BCCSs and 45 per cent of BCAs.

When asked if specific sites could be identified as being crowded, nearly half were able to name such places, and, while it is not possible to list or analyse them all here, it is noteworthy that most were in fact overnight huts, usually on the more popular walks. Overall, it seems quite clear that a substantial minority had experienced crowding, both among visitors and domestic users.

Table 13.3. The Extent to Which Crowding Affected Enjoyment (in Per Cent)

	Domestic	Overseas	BCCS	BCA	RS
Not at all	83	74	75	83	58
2	5	7	7	4	21
Moderately	8	14	13	8	17
4	2	5	4	3	4
Extremely	1	-	1	-	-

Other Impacts

Apart from crowding, respondents were asked to consider a range of other impacts and to say how far these had spoilt their overall experience. A range of possible impacts was suggested, Table 13.4, and others were offered by respondents in addition to these.

As can be seen in Table 13.4, noise was the predominant irritant, especially for overseas visitors, who tended to be in the busier locations, and who were especially aware of both aircraft (including helicopter) and boat engine noise, as well as noise disturbance in huts. Both groups were aware of litter and untidiness in huts, while the presence of commercial operations was again most noticed by overseas groups. Smaller numbers noticed wear on tracks and widening through muddy areas, but around 10 per cent felt that track standards were sometimes too high, and some objected to the presence of boardwalks, which are used to protect highly vulnerable areas. Other complaints included the unavailability of bunks in high use huts and the sometimes unnecessarily high standards of hut accommodation. A small but significant 4 per cent were disturbed by the presence and behaviour of hunters, with some expressing concerns for their safety.

Among the impacts volunteered were poor track maintenance (4%), the bad behaviour of tourists (3%) and the presence of sandflies (2%). A further 2 per cent emphasized the problem of hut crowding.

Many of the people interviewed sought wilderness and wilderness experiences and, as Kearsley (1990) had shown, they tend to associate it with the National Parks environment. Sixty-nine per cent of the sample expected to encounter wilderness conditions; 73 per cent of overseas visitors and 65 per cent of locals expected to do so. However, while most considered that the track that they were on displayed some degree of wilderness character, Table 13.5, few thought that it was pure or pristine wilderness.

Table 13.4. Perceived Impacts that Largely or Totally Spoilt Overall Enjoyment (in Per Cent)

	Domestic	Overseas
Noise in huts	11	13
Aircraft noise	10	15
Commercial operations	8	13
Jet boat noise	8	11
Untidy huts	9	7
Track standard too high	9	10
Litter on track	10	8
Track widening	7	7
Excessive track wear	7	5
Bunks unavailable	7	5
Accommodation quality too high	6	5
Boardwalks	5	5
Behaviour of hunters	4	3

Table 13.5. The Extent to Which the Track Exhibited a Wilderness Character (in Per Cent)

	Domestic	Overseas	BCCS	BCA	RS
Not at all	4	3	3	3	-
2	11	13	14	10	4
3	31	31	33	30	48
4	43	47	42	49	35
Pure Wilderness	12	5	9	9	13

Nevertheless, 71 per cent of the sample said that they had, in fact, encountered wilderness in their trip; 73 per cent of New Zealanders and 69 per cent of visitors claimed to have found wilderness, so that most of those who expected wilderness conditions did in fact find them. Of the minority who did not, most said it was because

tracks were too well formed, signed and hardened. This view was held by 56 per cent of the overseas visitors who did not encounter wilderness and 40 per cent of locals, reflecting the fact that New Zealanders tended to be encountered in the more remote environments whereas overseas respondents were more likely to be on the more developed popular tracks. Thirty-six per cent of each group cited crowding as detracting from wilderness values and a quarter believed that overnight huts were too comfortable and even luxurious, and this, too was a comment mostly associated with the Great Walks. Boat and aircraft noise was again mentioned by significant numbers.

Perhaps unsurprisingly, RSs found pure wilderness most frequently, but BCAs were the group that most frequently found conditions that approached wilderness, with half grading the degree of wilderness encountered at four on a five-point scale. The perceptions of overseas visitors closely mirror those of BCAs, although, in fact, the bulk of international visitors are BCCSs. It would seem, therefore, that their expectations of wilderness are somewhat more tolerant of human impact than are those of New Zealand residents.

Displacement

Displacement occurs as the result of dissatisfaction with present or past experiences or expectations of likely future conditions and refers to the unwilling movement out of preferred places or times or to the re-evaluation of actual experiences. Displacement may be spatial, when recreationists move to another site in order to obtain a preferred experience, or it may be seasonal (Anderson and Brown, 1984; Nielson and Endo, 1977; Shelby *et al.,* 1989). Others may reinterpret the meanings and benefits expected from a site in a process of 'product shift', as when a crowded track is seen as providing social experience in a natural area rather than a wilderness encounter. In spatial displacement, those with a low tolerance for crowding, for example, may be displaced by those with a higher.

In a context where there is a clear hierarchy of sites and tracks, as in Southern New Zealand, displacement down the hierarchy is an all-too-likely possibility. Thus, one could argue that the very large increases in overseas users of the most famous tracks, such as the Routeburn, and consequent rationing, has displaced some domestic recreationists (and perhaps some tourists) to second or third tier tracks or, indeed, out of tramping altogether. Similarly, their arrival might displace others yet further down the hierarchy or into more dangerous seasons, and there is a clear danger that inexperienced trampers might be forced into wild and remote environments and conditions that are beyond their capacity to manage. And, as noted above, such a process might well breed resentment and visitor dissatisfaction.

There is ample evidence to suggest that a fair degree of displacement is going on, in support of the somewhat anecdotal studies reviewed by Kearsley (1995). A fifth of those interviewed (17 per cent of visitors and 23 per cent of locals) said that they had chosen the track where they were contacted in order to avoid other people; 39 per cent of each group were carrying tents and 80 per cent of locals were carrying cooking

equipment although only 66 per cent of visitors were doing so. When asked if carrying such equipment was to avoid using crowded huts or over-used facilities, over half said that it was, at least to some extent (Table 13.6). In some cases, of course, where there are no huts or overnight facilities, it is essential that a party should be self-sufficient, so that almost all RSs and many BCAs would need to be.

Given the emphasis accorded to crowding and reactions to it, it is not surprising that many people reacted to the presence of what they saw as too many others. In general terms, about a fifth of all respondents expected to see fewer people than they actually did and 34 per cent would certainly have preferred to see fewer. This was particularly true of international visitors, who were most prevalent in the most popular locations; 25 per cent would have preferred to have seen a few less and a further 16 per cent a 'lot less' than they actually did. Again, the overseas visitors closely mirror the perceptions of BCAs and the New Zealand residents those of BCCSs. This is the reverse of what might perhaps have been expected, and merits further investigation.

As a consequence, 15 per cent of those who felt that they had seen more people than they expected reported that they had become dissatisfied with their actual experience and about 16 per cent said that they would choose somewhere else next time. When asked where they would go, everyone indicated that it would be to a more remote or a less well known destination. Effectively, then, one in six has expressed the potential for both product shift and spatial displacement. Specifically, 16 per cent of New Zealand residents said that they had changed their thoughts about the track, a figure that rose to 24 per cent of the overseas component, representing considerable product shift and raising questions about the images that New Zealand projects of its back country.

When asked if they took specific actions to avoid others, a third of both samples said that they did; the ways in which they did so are set out in Table 13.7. Using a tent and camping was the most popular response, others left very early in the morning, so as to be first at the next hut and thus gain a bunk; others, principally the campers, stayed behind until all others had gone. These figures echo those found by Higham (1996) for international visitors only in the South Island.

Table 13.6. The Extent to Which Tents and Cooking Equipment Were Carried Because of Crowding (in Per Cent)

	Domestic	Overseas	BCCS	BCA	RS
Not at all	43	48	43	49	48
2	11	13	10	14	13
3	20	18	20	17	22
4	12	12	14	11	4
Entirely	15	9	15	9	13

Table 13.7. Specific Strategies to Avoid too Many People (in Per Cent)

	Domestic	Overseas	BCCS	BCA	RS
Camped	40	32	26	49	44
Left early	10	18	11	20	11
Left late	8	16	22	4	-
Avoided crowded huts	13	7	9	9	22
Walked side tracks	4	14	6	9	22
Found secluded spots	7	9	15	9	-
Walked fast	5	7	9	1	-
Stayed by self	9	2	4	7	-
Walked in less popular directions	6	6	5	2	-
Allowed people to pass	5	6	8	2	-

Seasonal displacement is reflected in the fact that similar numbers from both samples, about 40 per cent, said that there were tracks that they would not attempt to walk at the time that they were contacted. Three stood out in particular, namely the Milford, Routeburn and Abel Tasman tracks, the most popular of the Great Walks. The reasons given were anticipated crowding (69 per cent of locals; 51 per cent of visitors), the cost of hut fees (14 and 11 per cent, respectively) or because they were too commercialized (4 per cent in each case).

Satisfaction and Mitigating Strategies

As earlier papers have shown, most motivations to use the back country were satisfied, and, as Table 13.8 shows, overall levels of satisfaction remain high. Almost all of the sample report positive satisfaction or even extreme satisfaction, with New Zealanders marginally the more enthusiastic, again, perhaps, a reflection of their tendency to be away from the most crowded locations. Domestic users and BCAs offer the highest proportions of extreme satisfaction, while BCCSs and overseas visitors seem marginally less satisfied. RSs seem least satisfied off all, although their sample size is too small for meaningful detailed comparison.

Previous studies (Kearsley and O'Neill, 1994) also offer the apparent paradox of considerable seeming satisfaction with particular attributes of an experience coupled with overall high levels of satisfaction with the total experience. This, in part, may reflect a subjugation of local irritations to contentment with a much more satisfactory whole. It might be that satisfaction and dissatisfaction are not necessarily polar opposites operating at just one level. Perhaps New Zealand's scenery is of such magnificence that some local discomfort is at present insignificant by comparison.

Table 13.8. Overall Lack of Satisfaction (in Per Cent)

	Domestic	Overseas	BCCS	BCA	RS
Extremely dissatisfied	-	-	-	-	-
2	1	1	1	-	-
Dissatisfied	1	1	2	1	-
4	1	1	2	1	-
Neutral	4	2	3	3	-
6	5	5	5	3	17
Satisfied	30	39	38	32	38
8	39	35	34	40	33
Extremely satisfied	20	16	16	19	13

In spite of declaring themselves well satisfied, though, about 30 per cent of the sample saw the need for more visitor management with no significant difference occurring between locals and visitors. Preferred instruments are set out in Table 13.9, where it can be seen that the encouragement of smaller groups, the provision of information and booking systems are all favoured, with first-come, first-served daily procedures preferred to long term booking opportunities. There is agreement that overall charging as a control instrument is inappropriate, but half of overseas visitors and nearly all of the locals who see a need for more control, agree that non-taxpayers only should pay more.

Table 13.9. Preferred Management Systems, Per Cent of Those Believing That Visitor Management is Necessary

	Domestic	Overseas
Encourage smaller groups	90	100
Information on good behaviour	95	100
Information on alternative tracks	93	98
Advance booking/reservations	86	84
Limit numbers	95	95
Increase prices for all users	12	10
Increase prices for non-taxpayers only	90	53
Make track on-way	59	53
Day of departure booking	90	93

Conclusion

New Zealanders' free and open access to almost all parts of their Conservation Estate has been affected by a large recent increase in overseas users, although that use is presently confined, for the most part, to the more popular and easier walking tracks.

At present, access is limited to the Milford and the Routeburn by hut booking systems and restrictions on camping. While this study has shown a high level of satisfaction with the experiences gained and the satisfaction of the motivations for a back country experience, it is clear that there are significant perceptions of crowding, and, in fact, although it is not reported here, some environmental damage and noise pollution. It is equally clear that actual displacement, in various forms, has occurred and that there is a potential reservoir of more, and there is a recognition by at least a significant minority that further visitor management controls are required as well.

In the absence of large sample national studies in the past, it is unclear at what rate levels of crowding and associated phenomena are increasing, but it seems likely that they are doing so at at least the rate of visitor increase; further studies of this type may be necessary in the future so as to monitor patterns of change and their implications.

This paper is a preliminary analysis and more detailed study of the data set is required, but it seems clear that growing use and its consequences will require more and more restrictions to be placed on the most popular back country venues. It seems inevitable, then, that further displacement will take place with associated physical and social impacts as wilderness carrying capacities are breached. At some point, New Zealanders will recognize that their culture of free access has been compromised, with almost inevitable resentment following. When that will be, and what form it will take, remains unclear, but, given the data and attitudes presented in this study, it cannot be too far in the future.

Acknowledgements

This research was made possible by a Public Good Science Fund grant from the Foundation for Research, Science and Technology.
Thanks to Emma Higham, Maree Thyne and Duane Coughlan for their considerable contribution as Research Assistants.

Chapter fourteen:

Globalization and Tourism: Some Themes from Fiji

David Harrison
School of Social and Economic Development, University of the South Pacific, Suva, Fiji

Introduction: Globalization and Tourism

'Globalization' has become something of a buzz word over the last decade. Indeed, it has come to mean almost anything going on in the modern world; as Pieterse noted, 'in social science there are as many conceptualizations of globalization as there are disciplines' (1994:161). However, for those interested in 'development', the globalization literature brings together themes which have emerged separately, albeit artificially, from modernization and underdevelopment perspectives (Harrison, 1988), in the process diluting much of the polarization and hostility which characterized a series of (some would say) rather fruitless debates. Even now, scholars approach globalization from very different angles, but the outlines of the overall approach can be summarized relatively easily.

First, globalization is a process of social change in which geographical and cultural barriers are reduced (Waters, 1995:3) and where events occurring in one part of the world have important ramifications elsewhere. As Giddens put it, 'local happenings are shaped by events occurring many miles away and vice versa' (1990: 64).

Secondly, this incredible shrinking world is the result of major improvements in transport and communications during and after the industrial revolution, making travel quicker and safer throughout and beyond 'developed' societies. What Giddens (1990) referred to as the distanciation of time and space has been further intensified by more recent developments in electronic communications, features of which are familiar to many who study the changing scene in international tourism and follow the debates over the internet.

Thirdly, such advances have occurred because of capitalist expansion: that is, a

process of production and exchange geared for profit, characterized by the division of labour and wage labour, commoditization and the expansion of international trade. One can argue about whether or not this is desirable, but the old debates between the advocates of socialist development and capitalist development are simply no longer relevant. A few dinosaurs may remain but the practical choices open to less developed countries now are from different forms of **capitalism.** Do they opt for models taken from Europe or North America or choose, instead, one of the East Asian variants? Which capitalist path do they follow?

Fourthly, the metaphorical contraction of the world is reflected in human consciousness. As old orders have been swept away, members of modern societies have become aware of a social world beyond their immediate environment. People have become reflexive, self-conscious, mindful of their different identities as individuals, members of nation states, and as human beings with human rights (Robertson, 1992). Not surprisingly, they may also have experienced a sense of rootlessness, 'homelessness' (Berger, Berger and Kellner, 1974:77), or *anomie,* depicted so graphically in Durkheim's study of the division of labour (1964).

Fifthly, and crucially, it is the spread of this consciousness, this 'modernity', primarily (but not only) from the 'core' Western societies to the less developed 'periphery', that constitutes the essential subject matter of globalization. It is a process whereby increased interlinkages at the objective level are matched by a changing consciousness of multiple identities. Using Anderson's term, Robertson suggested that 'global consciousness has partly to do with the world as an "imagined community"' (1992:183). A term used by Anderson (1983) to denote identification with a **nation** was thus used by Robertson to refer to an increasing tendency of individuals to identify themselves as members of a **global** culture. In like vein, Hannerz (1992:218) noted: 'Cultural interconnections increasingly reach across the world. More than ever, there is a global ecumene'.

Finally, as a result of the shrinking world and major advances in communications, there has been a corresponding increase in interdependence at economic, political and social levels. We rely on individuals we have not met, on institutions we did not establish, and on sciences we rarely understand and are powerless to control. As a result, although free to exercise individual and collective choice, under 'high' or 'late' modernity we are also more at risk in an environment fundamentally altered by the practice of science, where power is exercised primarily through centralized political institutions (Beck, 1992; Giddens, 1990).

There is nothing automatic about globalization. It need not emanate from the West, though it often does, and it varies in intensity and effect across sectors. Production techniques, for example, are perhaps transferred more easily than political or cultural practices, which may be more resistant to change. The process is neither inevitable nor necessarily permanent, for local conditions can produce countervailing currents. If the dominant trend, for the time being, seems to be fusion, there is always the possibility of fission.

How does this relate to tourism? Quite simply, tourism is both a cause and an effect of globalization. First, patterns of tourist movement graphically illustrate the

reduced importance of geographical and political barriers. The pattern is sufficiently well known to require little documentation. Even though most tourists move from developed societies to developed societies, usually within the same region, substantial numbers still visit the peripheries, and no part of the world (except, perhaps, the war-ravaged) can avoid being on their itinerary. Indeed, the rapidity with which tourists can be transferred from one part of the globe to another is ever on the increase, and the speed of the transfer is bettered only by the time it takes for news of their troubles to be relayed back to their home societies.

Secondly, those advances in transport and communication so closely associated with globalization are also intimately linked to the growth of tourism. In Europe in the nineteenth century, for instance, mass tourism followed the construction of the railways - and the demand for easy access to seaside resorts, in turn, fuelled the growth of more routes. The histories of shipping and air travel indicate a similar tendency. War might have prompted the construction of faster ships and planes but it was tourism that took up the surplus ships (after the First World War) and planes (after the Second).

Thirdly, the expansion of tourism complemented globalization as capitalists searched for new products and new markets, opening up the way for the explorer, the conqueror, the anthropologist and the tourist. As an economic system characterized by production for profit by wage labour, capitalism has clear implications for the tourist industry. These have been discussed elsewhere (Harrison, 1992), but commoditization, with the assignment of a cash value to products and activities previously considered non-commercial, is a major and much bewailed feature of modern tourism.

Fourthly, like other aspects of globalization, tourism challenges the way people see themselves. As Urry noted (1992), mass travel can be crucial in transforming local identities. It cannot be otherwise, for when previously isolated groups and communities are exposed to people from different backgrounds and cultures, adaptation (on at least one side) must occur.

Fifthly, and following from the previous point, tourism is a key mechanism in the transfer of 'modernity'. Host responses vary, of course, but the phenomenon of 'demonstration effects' is well known. Like it or not, tourists take their culture with them and brandish it - or parts of it - for their hosts to see. It may not be a simple matter to isolate the effects of **tourism** from other 'change agents', but at the very least the tourist reinforces other factors in the transfer of some aspects of Western culture to host societies. With the trader, the soldier, the missionary and the scholar, the tourist shows the host, especially if he/she is young and impressionable, the image of his/her future.

Finally, just as globalization involves greater interdependence at economic, social and political levels, so tourism epitomizes the need for trust and the associated awareness of risk-taking that characterize modernity. From the time the journey commences, awareness of risk is paramount. In host countries, it is evident in the tourist walk: the tentative approach and nervous awareness of one on a strange soil, wary of another's touch and suspicious of the 'stranger' who is, in fact, on home

ground. In a sense, it is the element of risk, even today, that links us with the travellers of the past, in whose steps we follow.

The background to this somewhat tentative study of tourism in Fiji, then, is that of globalization and international tourism. However, globalization in Fiji is not new. It has been occurring for centuries, whereas international tourism is a relatively recent manifestation of a continuing process.

Globalization in Fiji

The current populations of islands in the South Pacific are themselves the result of patterns of migration going back thousands of years. Initially, the movement was from Indonesia to New Guinea and the Solomons, and then later to Vanuatu and New Caledonia, and the first arrivals in Fiji, some 3,300 years ago, were probably from Vanuatu. Expansion continued further east, taking in Tonga, Niue and Samoa, until the Marquesas were reached about 2,200 years ago, thus providing a further base for even more migration to Hawaii and southernmost Polynesia (Crocombe, 1989; Nunn, 1994). The causes of these migrations have not yet been firmly established, but they appear to have been prompted as much by environmental change as by socio-cultural factors (Nunn, 1994). More important to note, perhaps, is the central position of the Fiji islands in this process, combining elements of Melanesian and Polynesian cultures, and constituting a ready-made environment for European exploration and settlement in the nineteenth century. During this period, missionaries, beachcombers, visiting traders and resident traders together (or in opposition) constituted a distinct segment of Fijian society, relating in numerous and sometimes contradictory ways to the Fijians to whom they preached, with whom they mated, and from whom they attempted to take land (France, 1969). From 1879, the social situation was further complicated by the introduction to Fiji of East Indian indentured labourers, producing the basis of a third important cultural section within the region and providing future Fijian politics with a series of problems which, as yet, have shown no sign of being resolved.

These migrations, especially those of the nineteenth and early twentieth centuries, were the result of improvements in communications and the global influence of British colonialism and led to the formation of a society which, at independence from Britain, was characterized by Fisk as 'the three Fijis' - that is, of Fijians, Europeans and Indians (1970:33-48). Indeed, although further analysis of the concept is not possible in this context, it is arguable that Fiji in 1970 - and even now - provides (far more than the Caribbean ever did) a near-classic example of Furnivall's 'plural society', in which several ethnic segments, with a variety of cultures, different forms of association, and a differential access to civil and political rights, are found together in the market place, where 'they mix, but do not combine' (Smith, 1974).

Put in another way, Fiji is a society in which globalization is ubiquitous and pervasive. There are daily reminders of the influences of Melanesia and Polynesia, of Asia and of Europe - in the faces of its peoples, the mosque and the temple, the

Methodist, Anglican and Roman Catholic churches, in the song, the sari and the sulu, in the languages spoken in the streets and in the music played on the radio. They are in the reminders of a colonial past: the styles of housing in the towns, Waterman fountain pens on sale in the jewellers, 'Manchester Goods' at the textile counters in the supermarkets, and even British Leyland buses - hallmarks of the British connection that have long since disappeared in the metropole. By contrast, too, rap and reggae are in the discotheques, international films in the cinemas, and a daily diet of North American, Australian and New Zealand soaps on TV, where *Shortland Street* is the most popular TV programme, followed by *Lois and Clark*, *Melrose Place* and *The X-Files*, with a string of serials on life (and death) in US hospitals following behind. Indeed, take away programmes from the UK, New Zealand, Australia and the USA, and there is hardly anything left on Fiji TV. All this is merely confirmed by the recent arrival of sports and film channels of *Sky TV* in the islands. On the sports field rugby reigns supreme, but women play netball and there is a minority interest in association football - and even cricket. And to drink? Western spirits, Fijian or Australian beers, or among indigenous Fijians and many Indians *yaqona*. Of course, in the acculturation process cultures have changed: the Hindi spoken in Fiji, for example, is not the Hindi of Madras or Calcutta, and Fijian Methodism, at least in some quarters, has become closely associated with Fijian nationalism and racist bigotry. Furthermore, those who expect Fijian bureaucracies - in government, business or education - to operate much as those of the UK or the USA, or New Zealand or Australia, are in for a shock. Fiji is a prismatic society (Riggs, 1964) as well as a plural society.

Tourism in Fiji

It is in this social, cultural and political pot pourri that tourism has emerged as an important export crop. However, the industry has not been without its academic critics. Described some time ago as 'another kind of sugar' (Finney and Watson, 1975) - which it rivals in Fiji as the most important contributor of foreign exchange and employment - tourism has been commonly regarded by academics as yet another indicator of underdevelopment in the South Pacific (Britton, 1982, 1987a, 1987b; 1989; Fagence, 1992; Lockhart, 1993; Minerbi 1992; Urbanowicz, 1989). Such writing has led Macnaught to deride what he describes as 'the fatal impact' thesis (1982:363). Others, while remaining critical, have been more descriptive of its role in the region (Arndell, 1990; Asian Productivity Organisation, 1988; Choy, 1984; Cole, 1993; Fletcher and Snee, 1989; Hall, 1994a; Hall and Page, 1996; Milne, 1987, 1990, 1992; Pearce, 1995; Yacounis, 1990), perhaps focussing on marketing (Cleverdon, 1988) or, in Tonga, on tourism's role in promoting local handicrafts. (Connelly-Kirch, 1982). More recently, Lea (1996) has placed tourism development in the region in the context of problems of urbanization, urban planning and land issues and, as elsewhere, studies have been carried out of the role of 'sustainable tourism' and 'ecotourism' (Hall, 1994b; Sofield, 1991).

Studies of tourism and its impacts in Fiji reflect similar concerns. Explicitly or

implicitly, the underdevelopment perspective is well represented (Britton, 1983; Racule, 1983; Varley, 1978). More recently, King and his co-workers have studied attitudes to tourism of various players in the industry, including those of the hosts (King, Pizam and Milman, 1993), employees and their families (Pizam, Milman and King 1994), and of those running the tourism industry in Fiji to environmental issues (King and Weaver, 1993). Others have focussed on the role of 'ecotourism' in the islands (Anon. 1993; Ayala, 1995), a topic much favoured in government and developmental circles, and Stymeist (1996) has written on the changes in *Vilavilairevo* (Fijian fire walking) as a result of its performance for tourists. Some of these studies, and the current state of Fiji's tourism, are discussed by Plange (1996) in a recent collection of articles on tourism in the Pacific.

Arguably, Fiji's tourism industry is struggling. Between 1961 and 1970, visitor arrivals increased by more than 600%, but from 1971 to 1980 the increase was less than 25% (Table 14.1). In the early 1980s, progress was erratic but tourism was dealt a body blow in 1987 with two successive coups and, inevitably, visitor arrivals plummeted. By the mid-1990s, the situation had again improved but by international standards Fiji and other islands in the South Pacific were struggling to retain their market share. Nevertheless, there is no rule that decrees tourist numbers must increase and, despite much lip service to vague notions of ecotourism, the government and its overseas advisers are currently focussing their efforts on increasing the availability of five-star accommodation on the main island of Viti Levu, even to the extent of condoning thoughtless damage to the environment, and in the Yasawa Group. At the same time, efforts are being made to diversify the tourist 'product' and increase the appeal of Fiji to visitors interested in the history and culture of the region.

In Fiji, then, the scenario is of a developed (perhaps over-ripe) but struggling tourism industry operating in a social, cultural and political environment which has been subject to globalization for centuries. However, within the 'plural society', cultures and traditions remain strong and while indigenous Fijians and Indo-Fijians remain suspicious of one another, firm adherence to their their own ethnic markers is likely to continue. And this neatly illustrates the way countervailing currents may resist the processes of globalization: pressures from outside may encourage conformity to wider expectations ('democracy', 'civil rights' the cash nexus and Western notions of efficiency) but these can always be countered, legitimately or otherwise, by the 'Fijian (or Pacific) Way'.

In the remainder of this paper, the relationship of tourism in Fiji to the wider globalization process is examined more closely by reference to three separate case studies of tourism development. The focus is, first, on Mana Island, in the Mamanuca Group, secondly, on Levuka, the previous capital of Fiji, on the island of Ovalau and, thirdly, on Turtle Island (or Nanuya Levu), one of the Yasawa group of islands. And the themes which arise from these studies might broadly be described as land, history and community.

Table 14.1. International Arrivals to Fiji

Year	Arrivals	Year	Arrivals
1975	162,177	1985	228,184
1976	168,665	1986	257,824
1977	172,992	1987	189,866
1978	184,063	1988	208,155
1979	188,740	1989	250,565
1980	189,996	1990	278,996
1981	187,939	1991	259,354
1982	203,636	1992	278,534
1983	191,616	1993	287,462
1984	235,227	1994	318,874
		1995	318,495

Sources: 1975-1994: Fiji Visitors' Bureau, 1995
1995: Bureau of Statistics, 1996

Mana Island

In 1996, the small island of Mana, of 300 acres, in the Mamanuca group, north-west of Viti Levu, boasted the Mana Island Resort Hotel (180 rooms) and two backpacker hostels, with a combined capacity of more than 100 visitors. The island, an attractive location for windsurfing, snorkelling and diving, is 32 kilometres from Nadi and thus within easy reach of the airport. It is also patronized by day-trippers, who are fed and entertained at the Resort Hotel. The germane point to note about the island is that the Mana Resort Hotel, which takes up nearly all the centre of the island, is separated from the two backpacker operations by an imposing, but hardly decorative, 8 feet wire fence complete with watchmen and security boxes. The reason for this fence, which gives the perimeter of the hotel grounds the appearance of a concentration camp, is that a state of hostility exists between the Hotel and the backpacker units. The history of the conflict is instructive.

The Mana Island Resort Hotel was first built in the early 1970s for an Australian operator on land leased (through the Native Land Trust Board) from landowners, who lived on the nearby island of Malolo. Later, in 1990, the lease was purchased by a Japanese operator and the hotel was further developed. It now charges from F$235.00 per person per day (including breakfast), and might be described as a medium-range four-star resort, catering especially for Japanese tourists but also taking guests from elsewhere, primarily Australia and New Zealand. Accommodation is of a good quality and additional facilities include free use of snorkelling equipment, windsurf boards and canoes, spyboards, life jackets and hobie cats. A daily programme of activities for guests will commonly include sessions on windsurfing and snorkelling, as well as organized sports and visits to a village on a nearby island.

When the Mana Island Resort Hotel was first built, there were apparently no residents on the island. The island was used by the villagers of Yaro (with a population of 300), on Malolo, to grow coconuts. By 1983, as communal landowners of Mana Island Resort and the Naitasi hotel on the island of Malolo, they were receiving about F$86,000 a year from each hotel and a substantial proportion of the adult population of Yaro village, including 55 % of the women, were working full time in one of the hotels (Racule, 1983). However, this did not prevent them from entering the tourism business on their own account. Early in the 1990s, shortly after the Japanese purchased the Hotel lease, two backpacker operations were started, next to one another and situated immediately on the border of the Hotel. The first was started by the local chief, Ratu Kini, thus one of the landowners from whom the Hotel land was leased. His hostel opened operations in 1993 and by May 1996 was able to cater for 64 backpackers, who were housed in several dormitories. The second, Mereani Vata Backpackers' Inn, was started by Ratu Kini's brother in 1995 and can accommodate around 40 backpackers. Compared with the Resort Hotel, backpacker accommodation is basic, and consists largely of dormitories with bunk beds - and very little else. The costs reflect the difference: the backpacker accommodation costed F$15.00 per day without meals, and F$25.00 a day if all meals are included.

What happened to sour relations between the Hotel and the backpackers? The account from Ratu Kini Boko Village Hostel is that the Japanese ownership resented the presence of the backpackers, increasingly made life difficult for them, consistently refused them use of the Hotel's facilities and asked them, instead, often rudely and with some violence, to leave. Indeed, early in 1996 the Japanese owners had offered to buy the backpacker operations, but their offer was rejected. In addition, they were alleged to have reported the backpacker operations for having an inadequate water supply and unhygienic facilities, only for the accusations to be rejected by a visiting Health Inspector. Ill-feeling continued to develop until, in April, 1996, the Resort constructed the fence along its boundary with the backpacker operations, leaving an entrance of only about 2 feet for the backpackers to enter from the beach. Such an action was deemed unacceptable and angered Ratu Kini and others in control of the backpacking operations, as well as the backpackers themselves (who now had to walk further to gain access to the island's best beaches) **and** some of the Hotel staff, who were themselves from the landowning community.

As one might expect, the view from the Resort Hotel is different (and has also been more difficult to obtain). It is claimed that once the Hotel was established, Ratu Kini came to live on the island and the hotel owners generously constructed a house for him, also providing him with electricity and water. A little later, two of his brothers arrived, and received the same privileges. Soon after **their** arrival, the family started the backpacking operation, continuing to use water and electricity supplied by the Hotel. The Hotel owners objected to subsidizing the backpacking operation in this way and cut off supplies, forcing the backpacking units to provide their own utilities. They also objected to backpackers cutting across Hotel land to gain access to beaches on the opposite side of the island, claiming that they were sometimes inappropriately dressed, used the swimming pool intended only for Hotel guests, and repeatedly

wanted to purchase items at the beach bars, which operated a tab system for the benefit of Hotel guests.

The owners of the Hotel, then, felt the villagers had behaved in bad faith, developing their business immediately next to the hotel and expecting their operations to be subsidized. Furthermore, backpackers had not paid to use any of the Hotel's facilities, and could quite legitimately be asked - even forced - to leave the Hotel grounds, to which they had no right of access. In such circumstances, the fence and the security guards were a necessary and legitimate defence of Hotel interests. By contrast, the village leadership claimed the Hotel was wrong to ban backpackers: the land belonged to the **landowners**, who accorded their visitors that right, and who should **also** be allowed to purchase drinks and ice-cream at the hotel beach bars. The fence should not have been built, because the land belonged to **the people**; indeed, owners of the Hotel were so vindictive that they even insisted that those of their own workers living near the backpacker hostels went the long way round the beach and did not cut through the Hotel grounds.

The Mana Island Resort Hotel and the backpacker operations were clearly not competing for customers. Perhaps because their customers were so different from the backpackers, the Resort owners wanted to separate them. From their perspective, it was almost impossible to run a relatively exclusive resort (especially for Japanese guests) if it was continually being invaded by Western backpackers. On a commercial basis, the position of the Hotel owners may be justified. However, the dispute is not simply a matter of class differences with an ethnic tinge (which, in any case, arises from the processes of globalization): the major issue, at least for Fijians operating the backpacker hostels (and amply echoed by egalitarian but cash-strapped backpackers), was the alleged right of Fijian **landowners** to control **access** to land they had leased to a third party. Hospitality, for them, meant that guests had access to their land, and the leasing arrangement to the Japanese was not seen, at least by the people I interviewed, to have removed that right.

If this tentative analysis is correct, the problem is not unique to Mana Island or to Fiji (e.g., de Burlo, 1989). It has been argued that, compared with other territories in the region, the Native Land Trust Board of Fiji has been successful in reducing conflicts over land (Volavola 1995:51). However, the land issue remains one of the most divisive in Fijian politics. It was responsible, at least in part, for the coups in 1987 and many indigenous Fijians continue to be reluctant to consider any loss of control over the land, as recent discussion of the recent findings of the Fiji Constitution Review Commission indicate (1996). Indeed, as Lea notes, attempts to privatize land in many Pacific states have led to unrest:

> Particularly problematical has been the question of customary land ownership where land has traditionally been treated as a commodity not capable of alienation to individual ownership and an asset held in the communal realm. Small wonder, then, that some developments in the region have generated widespread community opposition with consequent difficulties being experienced in attracting private capital for tourism and other forms of investment (Lea, 1996:124).

It is a conclusion that has been echoed on numerous occasions by government ministers and other outside observers concerned at the difficulties in attracting investment into Fiji (Anon, 1996; Sogotubu, 1996). And such reports are merely confirmed by frequent newspaper accounts of disputes between hotel operators and landowners. In Fiji, tourism and other industries are in an economic and social environment where the commoditization of land and hospitality is incomplete. For good or ill, traditional attitudes and obligations sometimes take precedence over commercial priorities. Globalization occurs, but does not necessarily dominate.

Levuka

If in Mana Island the dominant issue is rights over land and access to it, in Levuka it is rights to history, or 'heritage'. As in Mana Island, however, the issue has surfaced through attempts made to develop the tourism industry.

Levuka, on the island of Ovalau, a few kilometres east of Viti Levu and 65 kilometres from Suva, was the scene of the cession of Fiji to the British by Cakobau and, for a short period, the colonial capital of Fiji. Its history is indeed much linked to European settlement - so much so, in fact, that a recent leaflet introducing the town's history omits any details of the indigenous population of Ovalau, which seems to have spent much time at the end of the nineteenth century in quarrelling with the European residents of Levuka (Stemp, 1994).

Levuka developed as a port during the nineteenth century, welcoming whalers, missionaries, planters and traders in sandalwood, copra and cotton, and the town developed a reputation as the home of a somewhat drunken and unruly bunch of settlers. Nevertheless, it became the colonial capital of Fiji in 1874, when the Deed of Cession was signed, but its unsuitablility for development persuaded the British, in 1882, to move their administration to Suva. As a result, Levuka remained in something of a time warp: a town of predominantly wooden buildings now peopled by some 2,000 mixed-race descendants of Europeans, living on freehold land owned primarily by the Anglican and Methodist churches. The main and somewhat precarious source of income is now a fish canning factory, opened in the early 1960s, which employs about 500 people. It is the main source of cash for most of the inhabitants of Ovalau. By contrast, the *village* of Levuka, on the town's northern boundary, like other villages on the island, is inhabited by indigenous Fijians living on communally held land.

In the early seventies, when Fijian tourism was starting to develop, Belt, Collins and Associates (1973) proposed that, as part of the region's attractions, Levuka should be developed as a destination area for day trips and overnight stays, with zoning and architectural controls to ensure that the town's atmosphere was preserved, albeit with the addition of a small marina, visitor centre, museum and a wharf for cruise ships. After some years, this report was followed by a government request to the (then) Pacific Area Travel Association (PATA) to assess further the cultural

significance of Levuka and recommend appropriate development as a tourist-receiving area. The PATA Task Force, comprised of nine people (including three Fijian nationals), duly made several recommendations, the chief of which was that the recommendations of the Brent Collins report should be implemented, a 'Restore Levuka' project should be started, a network of interested private and public organizations developed, a Town Planner appointed to supervise the work, and a marketing plan formulated to develop tourism in Levuka and the rest of Ovalau (PATA, 1985).

Some of these recommendations were implemented in the late 1980s. A Restoration and Marketing Plan declared Levuka a 'historic place' and a Town Planning Act ensured that applications for changes to the town's buildings were vetted by a newly formed Levuka Conservation Committee. It detailed the materials and colours to be used in repairs and construction, along with types of windows, their sizes, and so on. However, progress was slow and the Fiji chapter of PATA was becoming moribund, going for as long as eighteen months without meeting. By 1992, it looked as if it would cease to operate altogether but, prompted by the wider PATA organization, a new PATA committee was formed in Fiji and took on the responsibility for developing Levuka as a heritage site.

By June 1996, progress was being made. Assisted by the PATA Foundation and several local donors (e.g., Air Pacific, Air New Zealand and the Fiji Visitors' Bureau), experts from North America had been consulted, appropriate projects for restoration had been identified, and a Project Director (an anthropologist from New Zealand) appointed. Attention was focussed on repairs to the Marist Convent School (1880) and the restoration of Nasova House, the home of the first Governor of Fiji. In addition, local attention was being fostered through the introduction, in 1994, of a 'Back to Levuka' week, designed to increase domestic tourism to the town.

Despite this rather sketchy historical background, several points about the Levuka project can be made. First, it is driven by the tourism industry and, primarily, by people who are not Fijian. Apart from the PATA secretariat, the key players in the PATA project are, first, the Director of Sales and Marketing of the Royal Sheraton, Denarau Island, Nadi and, secondly, the only inland tour operator in Levuka, who has been involved in Fiji tourism for more than twenty years. Both are expatriates and both, perhaps for different reasons, have put much time and effort into the Project.

Secondly, there is evidence that at least some residents of Levuka are unhappy at the way the project has been developed. They are now prevented from modernizing their homes by regulations governing repairs and extensions, being forced to use wood, which is more expensive than the now-common cement blocks. Shopkeepers, too, complain that they are forbidden from replacing the rotting wooden columns of their shop fronts with longer-lasting and cheaper cement columns. The Methodist Church, too, wanted to build a two-storey concrete school, to be told that this could only go ahead if the structure was clad in timber.

Thirdly, it seems that the Canadian tour operator resident in Levuka initially antagonized some local people in an apparent attempt to monopolize transport from the airstrip to Levuka Town - a journey of about 30 minutes. Shortly after setting up

his operation, and arguing that transport to the town from the airstrip was inadequate, he persuaded owners of the land which gave access to the airstrip from the road that he, alone, should have the right to ferry passengers across the land, in return for 50% of his takings. This led to a price war between him and other local carriers, and charges that his air-conditioned, nineteen-seater bus was sabotaged, and his wife threatened in anonymous telephone calls.

Just as the academic community in the Pacific has its debates about the 'ownership' of Pacific history (Ballara, 1993; Keesing, 1992; Munro, 1994; Reilly, 1996), so too does the Levuka project. As elsewhere, the preservation of historical structures is open to question. Is it valid for the tourism industry, along with such government agencies as the Department of Town and Country Planning, the Department of Tourism and Civil Aviation and the Fiji Visitors' Bureau, along with the Pacific-Asia Travel Association and its sponsors, to expect the townspeople of Levuka to sacrifice what they see as their modernity to encourage tourism? It is certainly true that the Marist Convent School caters for the primary children of central Fiji, but where do the indigenous Fijian residents of the several villages in Ovalau, including Levuka Vaki Viti, fit into this scheme of things? How do they feel about the preservation of what is, arguably, a piece of *European* history in the interests of international tourism?

Turtle Island

The 500-acre island resort of Turtle Island in the Yasawa group of islands is located some 50 miles north-west of Viti Levu. Nanuya Levu was renamed Turtle Island by American Richard Evanson when he purchased its freehold in 1972. The recent story of the island is, quite literally, his-story (Robson, 1996; Siers, 1985). A dollar millionaire who made his fortune in cable TV, a divorcee and a reformed alcoholic, the legend of Turtle Island is that Evanson 'found himself' on the island and proceeded to devote his life (and his considerable business acumen) into making it perhaps the most exclusive island resort in the Fiji group.

In some respects, Turtle Island is similar to other island resorts in the region. It is small and privately owned (with a correspondingly reduced likelihood of difficulties with landowners), and is exclusive and expensive. Only a few couples are on the island at any one time, and they are thus cossetted and pampered throughout their stay. However, in other respects it seems unique. First, over a twenty-year period Evanson has made major efforts to reinstate the flora and fauna of the island, decimated by the herds of goats he found when he arrived (Sequoia Analytical, 1994). Secondly, he has established institutions which bring permanent benefits to residents of the Yasawas and, thirdly, he has created on the island a 'family' ethos to which guests undoubtedly respond in a highly positive and frequently emotional manner. There is no doubt that, for many, he has helped provide a holiday experience which transcends the ordinary and enters into the realm of the sacred, of *communitas* (Turner and Turner, 1978:250-255).

With 14 *bures*, a maximum of 28 guests, and a daily staff of nearly 100, the staff-guest ratio is clearly appropriate to the kind of service a couple might expect for an outlay of almost US$900 per day for a minimum stay of 6 days. Clearly, extremely wealthy people are visiting the Yasawas and, for present purposes, such guests can be seen as agents of globalization. They bring a distant, outside world much closer to the hitherto isolated islands, with numerous economic benefits and, inevitably, some associated costs. For the remainder of this section, the focus will be on the sponsorship by Turtle Island of several medical and dental services for the Yasawa population (numbering about two and a half thousand) and the creation of *communitas* for the guests, with a possible loss of *community* on the part of those Fijians who work on the island.

One element of globalization involving Turtle island is the way guests are formally linked to villages in nearby islands through the Turtle Island Community Foundation and the Vukai Mission Fund, to which guests are invited to contribute during their stay in the resort. The Turtle Island Foundation was founded by Evanson in 1992 to generate funds for special projects in the Yasawa islands. He made an initial contribution of $50,000, payable over five years, and the fund, which currently stands at $100,000, is administered by Board of seven trustees. Chaired by Fiji's Archbishop Mataca, all trustees are from the region, and villages nearest to Turtle Island are represented. The focus is on health, transport, education and cultural activities in villages from which staff working in the resort come and projects under current consideration include a maternity wing and paediatric clinic, improved water supplies and educational materials.

The Foundation also administers the Vuaki Mission Fund, which was established in the early 1980s. It is devoted to the Catholic mission school in the village of Vuaki, on the nearby island of Matacawa Levu, and guests can visit the village to see the results of contributions made by previous visitors to the resort. Decisions about expenditure are made jointly by the School's principal and Evanson, and most of the funds are used to construct buildings, to provide fresh water throughout the year, and to purchase books.

These two institutions link Yasawa villages to the wider world outside and bring educational, health and other benefits to hitherto isolated populations. The Turtle Island Resort attempts to improve the health of the local population in other respects, too. Since the resort opened, it has been the scene of some 6,000 eye examinations and 250 eye operations, a once-yearly service provided to Fiji by Evanson and other sponsors. Medical professionals are given free holidays in return for their skills and in February, 1997, for example, sixteen overseas volunteers screened 1,500 people, distributed spectacles, held more than 60 cataract surgeries and (for the first time) carried out cornea transplants. In similar fashion, dentists visit the Island for short periods once a year, to work from 8am until 2pm and then enjoy the facilities of the resort.

At a (slightly) less formal level, globalization is evidenced and continued in the continuous juxtaposition and (temporary) union of guest and staff member, under the watchful direction of the Resort's owner. Such interaction, of course, is nothing new,

and characterizes tourism the world over. However, on Turtle Island, a distinctive 'family' ethos is carefully cultivated by Evanson, in the brochures, in his opening talk to new arrivals, and at meal times, especially through the linking of hands for grace (said by one of the staff in Fijian) before dinner. It can be seen in other respects, too: the use of Christian names only among staff and guests, or the closeness that emerges when guests attend a wedding in the beach *bure*. Those who claim, or seem to claim, difference are discouraged: women are asked not to wear ostentatious jewellery whilst on the island, and repeat guests, known sometimes to claim greater status through prior experience of the resort, are discussed with other guests in advance of their arrival, so that the the latter do not feel at a disadvantage. The sum total of all these efforts, much aided by the personality of Evanson himself, a constantly attentive and considerate staff, and several days of living at close quarters and sharing activities with other couples, is for many an experience for which superlatives are almost inadequate.

> We are very happy we came and see you are a GREAT FAMILY ... and we will love to be a part of IT. So don't forget us because we will be a part of here - for a lifetime!!! Vinaka for every single thing you did for us and vinaka for your help in everything we needed. To finish, we like to tell you we love the nature of Turtle but love the people of Turtle the best (Mexican honeymooners: their emphasis).

> Much more than a resort. It is a place to fall in love again - with each other, with life, and especially one of you. We truly feel blessed to have experienced the wonders of Turtle Island. Fiji and her people are wonderfully de-stressing, as are the other guests! You'll all have a special place in our hearts.

> As always, it is good to come 'home' again. The love, the laughter, songs, tricks, smiles, remind us just what the 'real' things in life are.

Time and again, departing guests refer to Turtle Island as 'magical', 'wonderful', as having 'a place in our hearts', as a 'real paradise', and time and again they say 'words are not enough'. One middle-aged woman from New Zealand, remarking that she could not understand anyone staying at the Sheraton, said of Turtle Island: 'this is Fiji'.

Of course, Turtle Island is not Fiji, but it is undeniably 'magical', of another world, not this world. It is a beautifully presented and consummately articulated illusion in which staff and guests conspire to create, for the guests, a temporary 'paradise' which is in Fiji and is yet not part of Fiji. As many guests seem to be celebrating some special event - a wedding, a birthday or an anniversary - *communitas* is to some extent anticipated. Furthermore, as an *island*, their destination has to be reached by a *crossing* of the sea, not just from their countries of origin but also from Viti Levu. From the time they alight from the seaplane, to be met by the staff and presented with coconut water, then to be ushered to their *bures* and the

waiting champagne on ice, they *do* enter another world, a 'paradise', where all around is for their benefit, their pleasure and where (having already paid the entry fee) they are relieved of their normal occupational and domestic responsibilities.

In a different way, the staff, too, are part of the globalization process. Perhaps most of all, they are brought into contact with guests from a wide variety of backgrounds. Again, this is not new - even though it is a little-studied phenomenon - but when they mix with highly paid professionals, with Senators and members of Congress, for example, or the world's top entertainers, Fijian staff are introduced into what might be described as the world of *elsewhere*. Encouraged as they are, at times, to eat with guests, to deal with them on a one-to-one basis, they are necessarily learning new customs, new social skills, and for them, too, the world thus becomes smaller. Sometimes, too, the contacts may last over time. This, again, is not unique to Turtle Island. As Frodey and O'Hara (1993) noted for a similar resort in Fiji, guests have been known to give favoured staff free travel and holidays in *their* home countries, and some guests have also helped staff members to further their training overseas.

For the staff, there are undoubted benefits in working at Turtle Island. Wages are, on the whole, better than in many other hotels and, in addition, with $250 as the recommended contribution to the Staff Fund, tips can amount to $3,000 a year for every member of staff. For those from nearby islands, about 75%, there is the added advantage that they are near their homes, and their earnings are an important addition to village economies. Furthermore, employment on Turtle Island and other resorts reduces the amount of migration from the Yasawas, and a generous Fijianization policy in staff training has increased indigenous expertise in management and numerous other crafts. That said, however, there are costs, and *communitas* for guests may be achieved through the diminution of *community* for the staff. As staff members work six weeks at a time, followed by one week off, their chances of seeing their own families are relatively few. Even if from adjacent islands, their families can visit only on Sundays - and children, in any case, (except for Evanson's own) are absent from Turtle Island for most of the year. For new staff, especially, the separation from families can be acutely felt, and they are quite specifically asked to put the interests of 'the Turtle family' before those of their own families. Indeed, Evanson himself maintains that, when hiring staff, he wants people who are themselves 'looking for a family'.

This is not to suggest that staff members are unhappy on such resorts as Turtle Island and, indeed, islanders from the Yasawas and other islands in Fiji employed elsewhere may commonly work further from their homes and see even less of their families. In addition, the contrasts in social background between staff and guest may actually operate to facilitiate at least a *sense* of homogeneity. As Frodey and O'Hara noted:

It is important to remember that most of these staff members are from small rural villages and few have gone beyond secondary school; in fact, many did not finish secondary school ... It may be that countries such as Fiji are ideally suited to this

type of resort environment (small, intimate, flexible), as it is consistent with the traditional sense of South Pacific hospitality towards visitors ... When treated with respect and given meaningful authority, they positively blossom and do not consider providing service to be menial but, instead, see it as natural hospitality, which they enjoy (Frodey and O'Hara, 1993:4).

Unlike the guests, however, the staff *do* have responsibilities and obligations, the chief of which is to cater to the guest's every need. They also have their hierarchy, with Evanson at the head, restricting access to TV, refusing them permission to join a union or drink alcohol, and a system of fines, paid into the Staff Fund, for those failing to do their job properly, as well as bonuses paid by the management for jobs well done. For them, at any rate, Turtle Island is a working environment rather than 'paradise' and, in at least one other respect, the real world of Fiji has not gone away: On Turtle Island, Indians and Fijians live in separate dormitories, thus reflecting the situation on the mainland.

Conclusions

It has been argued that tourism in the South Pacific (and elsewhere) can legitimately be viewed through a globalization perspective, which focusses on the continuing reduction in geographical and cultural boundaries, improvements in transport and communications, the expansion of capitalism and concomitant changes in human consciousness, with 'modernity' moving from centre to periphery and simultaneously linking all parts of the world in increased interdependence.

Tourism is linked to the processes of globalization as both cause and effect. Like globalization, it permeates the world through improvements in transport and communication, and similarly benefits through sustained periods of peace. It also complements the spread of capitalism, of which it is largely a part. In the process, it challenges the way individuals and groups see themselves and constitutes a key mechanism in the transfer of 'modernity', requiring host and guest alike to expose themselves to new personnel, new ideas and to new risks. And in all of this, with its long history of migration and settlement, colonialism and indentured labour, the plural society of Fiji is an established player on the world stage.

In Fiji, globalization Fiji has occurred in a series of *intrusions*, through which European ways of life have been introduced. New economic, social and political structures have forced themselves through established strata, then to claim precedence over them. As elsewhere, the extent of the intrusion depends on numerous other factors. In Levuka, for example, we see a colonial intrusion which remained undeveloped, with further changes being implemented at Suva, another and more convenient 'centre'. Levuka itself remained in a time warp, a lost capital, a piece of 'heritage' which may now receive a new history, a new and shinier past, in the future service of Fiji's tourism industry.

Elsewhere in Fiji, the conflicting demands of tourism (and other industries) and

local traditions over land indicate the strains in reconciling two opposing structures, with government sitting on an uneasy fence, vainly attempting to accommodate one constituency to another. Meanwhile, the processes of commoditization and increased market relationships, in tourism especially, necessitate a reassessment of traditional perceptions over the role of land, the *vanua*, in the provision of a more formalized, cash-informed version of traditional hospitality. Mana Island, it is suggested, is an example of such a conflict, and one which has coincidentally expanded to include two different types of tourist: the relatively wealthy hotel guest and the relatively poor backpacker.

Both globalization and tourism require new allegiances, new commitments, new friends, perhaps even new names for old homes, and this is nicely illustrated in Turtle Island. Successful tourism, like any other service industry, requires that the customer comes first and, in this instance, the customers are tourists. And if their satisfaction means the establishment of a new family, a new communnity, to the detriment of the old, then so be it. For the tourists, perhaps, the new family is but a pleasant interlude, even a seminal experience, which is (albeit regrettably) a temporary phenomenon. By contrast, for most hotel staff, the resort family is a more permanent affair, and quite likely to involve them in a conflict of loyalties with families, communities and other commitments elsewhere. As in 'total institutions' generally (Goffman, 1968), life in island resorts takes on a self-contained quality. For a time, at least, the illusion is fostered that life in such islands, to paraphrase Donne, is 'entire unto it self'.

What of the future? In so far as tourism in Fiji is concerned, the first indication is that there will be more of the same. Forms of traditional land holding, as well as the political structures to which they are linked, are under challenge, and the demands of industry, of tourism, of capitalism, will not go away. Once again, the foundation of indigenous Fijian society is being questioned and, as is evident in discussions over constitutional change (Fiji Constitution Review Commission, 1996), pressures from within and from outside indicate an uncertain future.

Secondly, government is in a quandary. It owes its power to a constitution which favours the rural over the urban and the Fijian over the Indian (and the European) but it also recognizes the need for foreign investment, secure land tenure, and stability. With one voice, it advises the landowners, its traditional supporters, through the Native Land Trust Board, and with another it encourages investment, through the Fiji Trade and Investment Board. The quandary is unlikely to disappear in the near future.

In the meantime, and thirdly, the tourism industry will be increasingly frustrated at the lack of clear investment programmes and a perceived failure on the part of government to put its own house in order. Ironically, at the same time, it will continue to promote 'traditional' Fijian culture, which is largely hostile to capitalism and the commoditization of land and hospitality, as one of its major attractions to the outside world.

Clearly, in all of these situations, pressures for change are countered by pressures to resist. Fission or Fusion? Global or local? Nobody said that globalization was automatic!

Chapter fifteen:

Health Advice to Travellers to the Pacific Islands: Whose Responsibility?

Glenda R. Lawton
Stephen J. Page
Department of Management Systems, Massey University - Albany, Private Bag 102904, North Shore Mail Centre, Auckland, New Zealand

Introduction

The interface between health and tourism has now emerged as a prominent area for research in the medical arena (Cossar *et al.*, 1990; Behrens and McAdams, 1993) and more recently among tourism researchers (Clift and Page, 1996). However, as these publications indicate, much of the published literature on tourism and health has been directly influenced by the growth in travel medicine as a discrete research area dominated by health researchers and practitioners.

Dawood (1989) provocatively argued, however, that most health problems which travellers encounter are avoidable if holiday makers are adequately informed about the range of risks they could encounter during their trip. Patterson *et al.* (1991) and Cossar *et al.* (1993) argued that it is the travel agent which is the best source through which appropriate health advice should be disseminated. This chapter examines the validity of such arguments based on a nation-wide survey of advice provided by travel agents in New Zealand to impending outbound travellers to Pacific Island destinations. On the basis of a comprehensive nation-wide survey of travel health advice within one country, New Zealand, it is possible to offer lessons for other countries in terms of the appropriateness and effectiveness of intervention in the tourism-health interface.

Tourist Health Issues and the Role of the Travel Agent

The role of the travel agent in the tourism distribution channel is well documented in existing studies of tourism marketing and need not be reiterated here. Needless to say, McGuire *et al.* (1988) and Hsieh and O'Leary (1993) outlined the significance of travel agents as a recognized source of information for impending travellers. In fact Hsieh and O'Leary (1993) found that in the United Kingdom, travel agents are the most frequently used communication channel as a source of travel information. When the issue of tourist health is introduced into the equation, one is immediately aware of the potentially detrimental effects of inadequate advice regarding potential risks and hazards to tourists. As Martin and Mason (1987) commented 'there is a growing concern about the quality of the tourism experience in all senses, including the nature of the facilities used, the state of the environment visited and the health enhancing (or detrimental) features of the activities undertaken.' Dawood (1989) argued that up to half of all international travellers are likely to experience some kind of adverse effect upon their health as a result of an overseas trip while Cossar *et al.* (1990), Cossar (1996) and Cartwright (1996) outlined the proportion of tourists experiencing specific ailments. For example, Dawood (1989) noted that diarrhoea rates of 40 per cent are regularly recorded for many European destinations and accepted as a baseline. Furthermore, Behrens *et al.* (1994) found that of the 2.1 million Australian overseas trips taken in 1991, 40 per cent were to developing countries and 54 per cent of these tourists reported some form of illness on their return. Tourist health problems can be viewed as a continuum ranging from a large number of visitors experiencing minor ailments at one end, with a smaller numbers of visitors experiencing accidents (Page and Meyer, 1996), through to fatal incidents resulting in death (Paxiao *et al.,* 1991) at the other extreme of the continuum. Therefore Haywood (1990:201) expressed an important sentiment in that 'the needs and wants of tourists are not merely economic in nature. Tourists expect destinations to be safe and clean.' Thus, the implications for travel agents as the intermediaries in the sale of holiday experiences is clear: they need to be able to refer clients to appropriate sources of advice on the precautions to take before and during their travel experience. But, as Dawood (1989:285) argued, 'many travel agents lack training or experience to know anything about the risks and rely on reference sources that are totally unsuitable ... They are unable to draw a distinction between health regulations which are an essential requirement of entry into a country for protecting that country from imported disease and recommendations to protect the individual.' Yet such sweeping statements have, to date, not been tested in any major survey of travel agents to assess their perception of tourist health issues and their ability to respond appropriately to such issues.

Travel agents, however, argue that they are not doctors and it is not their business to provide detailed health information (Dawood, 1989). While travel agents may argue that they do not have access to definitive sources of information, the World Health Organization's occasional publication *International Travel and Health: Vaccination Requirements and Health Advice* is available at low cost. The

publication lists vaccination requirements, the geographical distribution of potential health hazards, health risks and their avoidance by disease, environmental risks, risks from food and drink, HIV, malaria and considerations for special situations. In addition, many countries publish health advice leaflets for outbound travellers (e.g., in New Zealand, the *Passport to Health* leaflet, in the UK the *Health Advice to Travellers* leaflet and in Germany there is an Institution called *Zentrum fur Reisemedicin* which publishes a full catalogue on all countries).

Yet while it is not mandatory in the European Community for travel agents selling package holidays to give appropriate health advice in either ticket inserts, brochures, on booking sheets or verbally to travellers, there is still a debate world-wide as to what legal liability travel agents carry for the services they offer. For example, Witt *et al.* (1991) argued that travel agents do not accept liability for the services offered by the principal. In contrast, Wilks and Atherton (1994:14) argued that travel agents 'have wide legal duties not to engage in conduct that is misleading or deceptive. Increasing civil and criminal liability of travel agents and tour operators warrant greater management attention to understanding the legal aspects of customer service.' The real debate, however, is based on the extent to which tourists have the right to receive information and advice which is timely, accurate, detailed and capable of enabling potential tourists to make informed travel choices. However, this debate not only raises ethical issues in relation to travel agents selling holiday experiences which may be potentially negative to their clients but also raises the wider issue of the sustainability of tourism. If the holiday experiences sold to the clients continue to be tainted by adverse health experiences due to inadequate advice and information this could be counter-productive for an industry geared to the sale of mass consumption of products, often without any prior knowledge of the elements which are incorporated into the holiday experience. In fact, the relative inability of the world-wide tourism industry to seize upon this issue has led to views that if the industry is not self-regulating and able to establish standards, they may be imposed from outside (Hobson and Dietrich, 1994). Therefore, a principal challenge for the tourism industry, especially the tour operator and travel retailer, is to promote the health of travellers to ensure their long term commercial viability. In light of this debate, attention now turns to the research survey undertaken to examine travel agents' responses to these issues in the context of New Zealand.

Survey of New Zealand Travel Agents: Methodology and Survey Design Issues

Within New Zealand, there has been a relative paucity of research on health and tourism with a number of notable recent examples (Page and Meyer, 1996; Rudkin and Hall, 1996; Ryan *et al,*. 1996). Within the existing research studies, there has been no attention given to the pre-travel advice stage as highlighted in Clift and Page's (1996) travel health model. At the pre-travel stage, it is pertinent to identify

the risk factors which impending travellers should be aware of. While it is readily accepted that there are a wide range of agencies and agents involved in the provision of advice to potential tourists, this study focusses on only one such source - the travel agent. It is argued that the travel agent is often the first part of contact and therefore is a useful focus for research.

A questionnaire survey was developed, which would assess the type and nature of pre-travel advice provided by travel agents to clients at the time of booking. The questionnaire was administered using a postal survey, in which open and closed questions on tourist health were developed, expanding on the pioneering work in this field reported by Cossar *et al.* (1990). An explanatory letter was enclosed with each questionnaire, outlining the purpose of the survey together with a pre-paid reply envelope to facilitate responses which were mailed out during January to March 1996. A total of 526 questionnaires were mailed to all travel agents listed in the 1995 edition of Telecom New Zealand's Yellow Pages in Auckland, Waikato, Bay of Plenty, Wellington, Christchurch and Otago. Some 314 questionnaires were returned, comprising a 59.6 per cent response rate from an initial mailout and one further mailout to chase non-responses.

From the scale of the survey, it is apparent that the New Zealand population of travel agents is largely covered by the survey. This is reflected in the data from the Travel Agents Association of New Zealand (TAANZ), which has 353 full-time members with eight members having between 26 and 83 branches nation-wide. From the existing information, TAANZ estimate that there are approximately 750 travel agencies in New Zealand and the majority are located in the principal urban centres covered in this survey.

Results

Characteristics of the Respondents

The survey found that 89.7 per cent of respondents described themselves as travel agents while a further 11.3 per cent identified themselves as tour operators. As Table 15.1 shows, response rates varied by region within New Zealand, with higher response rates in the Bay of Plenty, Otago and Wellington. Among the principal destinations chosen by outbound New Zealanders, those located in the Pacific were among the top 10 destinations in 1993. For the purpose of this chapter, the South Pacific region is defined by Tahiti in the East, Australia/New Zealand in the South, Hawaii in the North, and Papua New Guinea in the West Pacific. Australia was ranked first with 418,700 New Zealand visitors, followed by Hawaii with 63,000 visitors and Fiji with 41,400 New Zealand visitors in 1993. The Cook Islands were ranked seventh, being visited by 13,400 New Zealanders, while Western Samoa was ranked ninth and visited by 12,600 outbound New Zealanders. Not surprisingly, Table 15.2 shows that Pacific-based travel accounts for a significant proportion of the travel agents' total business turnover.

Table 15.1. Regional Distribution of Travel Agents Responses

Postal regions	Number mailed out	Number returned	Response rate
Auckland	218	136	62.4%
Wellington	73	48	65.7%
Christchurch	88	39	44.3%
Waikato	65	30	46.1%
Otago	40	28	70.0%
Bay of Plenty	42	33	78.6%

Table 15.2. The Volume of Pacific-based Travel Booked at New Zealand Travel Agents

Pacific-based travel	Number	% of total travel booked
Less than 10%	58	19.8%
10% - 20%	101	34.5%
25% - 50%	69	23.5%
50% - 75%	52	17.7%
More than 70%	13	4.4%

Table 15.3. Percentage of Pacific-based Travel Booked at Travel Agents by Region

Region	less than 10%	10-25%	26-50%	51-75%	>75%
Auckland	18.1	31.5	21.8	17.3	11.3
Wellington	21.3	42.5	27.7	8.5	0.0
Christchurch	26.3	28.9	18.4	15.8	10.5
Waikato	11.5	50.0	19.2	19.2	0.0
Otago	29.6	14.8	22.2	33.3	0.0
Bay of Plenty	10.0	36.7	30.0	16.7	6.7

However, Table 15.3 indicates that important regional differences exist regarding the significance of Pacific-oriented travel, with Auckland, Christchurch and the Bay of Plenty reporting high levels of travel booked which is Pacific-oriented.

Travel Agents and Sources of Health Advice

After establishing the importance of Pacific-oriented travel, travel agents were asked what they considered to be the most appropriate source for giving travel health advice to travellers seeking to book through their office. Some seven sources were listed on the questionnaire: the New Zealand Department of Health leaflet *(Passport to Healthy Travel)*, advice from travel agents, the traveller's own General Practitioner

(GP), pharmacies, travel guides, information from airlines, tour operators' brochures and other sources. Respondents were asked to rank the categories, using one for the most important source, 2 for the second most important source and so on through to seven. Respondents were asked to score a zero if they did not consider the source to be appropriate. In some cases, respondents ranked more than one category with the same ranking so responses do not always equal 100 per cent. The results were also weighted and totalled to indicate which categories were most important.

As Table 15.4 shows, nearly 60 per cent of all travel agents surveyed consider the traveller's GP to be the most appropriate source of travel health advice and one-third considered the Department of Health leaflet (*Passport to Healthy Travel*) the most important source. It is important to note that only 15.9 per cent considered travel agents to be the most important source of travel health advice which confirms the argument by Dawood (1989) that travel agents consider they are not in the business of providing detailed health information.

Respondents were asked how often they gave health advice to their clients and Table 15.5 indicates that only 19.7 per cent of respondents *always* give health advice, while less than half of respondents either *always* or *nearly always* give health advice to their clients. Furthermore, 34 per cent *sometimes* give health advice while just over 20 per cent *very rarely* or *never* give heath advice. If one then considers the likely destinations for outbound travellers within tropical areas with a high incidence of health risks (e.g., the Pacific Islands) (Neumann, 1996), the absence or inappropriateness of advice may leave a large number of tourists potentially at risk. The significance of these results are that while travel agents are regarded as one of the most commonly consulted advice source, it appears that over half of New Zealand travel agents do not consistently provide any form of health advice to travellers.

Table 15.4. The Importance Placed by Travel Agents on the Different Sources of Travel Health Advice (in Per Cent)

Source of travel health information	Very Important						Unimportant			
	None	1	2	3	4	5	6	7	8	Total **
Health Dep.	3	32	27	14	7	2	1	1	*	1798
Travel agents	7	16	22	18	10	6	3	1	*	1501
Gen. Pract.	0	60	17	8	3	1	*	1	*	2091
Pharmacies	12	6	10	6	12	9	5	7	*	1059
Travel guides	9	5	10	6	15	17	9	5	1	1035
Airlines	22	2	5	5	5	8	16	13	*	640
Tour oper.	13	4	8	7	8	9	12	12	1	845
Other	6	4	1	0	0	0	0	*	3	143

Note: * below 1 per cent
 ** weighted total

Table 15.5. How Often Travel Agents Give Health Advice to Clients

How often health advice is given	Number of responses	% of total
Always	69	22.0
Nearly always	73	23.9
Sometimes	107	34.1
Very rarely	55	17.5
Never	10	3.2

To expand upon the nature of the health advice given, respondents were asked how long they spent talking about health issues with customers. Only 2.3 per cent of travel agents spend more than 5 minutes talking to customers, with 23.8 per cent spending 2-5 minutes, 40.3 per cent 1-2 minutes, 25.2 per cent less than one minute and 8.4 per cent spend no time at all talking about health issues. When questioned about the value of using the Department of Health leaflet, 40 per cent of travel agents *never* used it. A further 17.5 per cent *very rarely* use the leaflet while 15 per cent *nearly always* and 10.5 per cent *always* use it. The worrying feature of these results is that a large number of respondents commented that they had never seen the leaflet.

Health Advice Provided by Travel Agents in Relation to Specific Health Risks

Respondents were asked how often they provided advice concerning a number of travel health issues including vaccinations, malaria pills, care to ensure food and water is clean, the need to prevent insect bites and to take care in the sun. Again, the responses were weighted, with the highest total indicating that advice was most often given regarding that category. As Table 15.6 indicates, the most commonly given advice was regarding the need to ensure food and water is clean, followed by vaccinations, taking care in the sun, preventing insect bites and malaria prevention.

Travel Agent Experience of Pacific Island Destinations

Travel agents were asked to indicate which Pacific Islands they had visited personally, and which health issues they discuss with travellers intending to visit each of these destinations. The rationale behind this question was to assess the extent to which travel agents' personal experience of individual destinations was used as a basis to provide accurate and informed advice to intending travellers. The Pacific Island destinations in question are listed in Table 15.7, which also illustrates that Australia, Hawaii and Fiji had been visited by over 74 per cent of travel agents, with lesser numbers visiting the other destinations.

For each destination, respondents were asked if they discussed whether vaccinations were needed, the possible incidence of malaria and the need for malaria pills, taking care with food and water, protection to avoid insect bites and the need to

take care in the sun. Interestingly, Table 15.8 shows that only one health issue (taking care with food and water), for one destination (Papua New Guinea), is discussed by more than half (51.6 per cent) of respondents. Overall, the responses to this question indicate that there is a diversity of health advice given by travel agents in relation to Pacific Island destinations with the general level of advice given being very limited in nature and scope. Such findings tend to confirm the results of a Dutch survey cited by Dawood (1989), that travellers using a travel agent as the sole source of advice were at a marginally greater risk of illness than those who had not troubled to seek advice from any source. Several destinations are selected to illustrate the general principles apparent in the results from a broad range of destinations in Micronesia, Melanesia and Polynesia.

Table 15.6. How Often Health Specific Health Advice is Given to Travellers (in Per Cent)

Type of health advice given	Always	Nearly always	Some-times	Rarely	Never	Weighted Total
Vaccinations	39.6	26.7	17.7	9.7	6.3	1105
Malaria pills	32.5	20.1	29.4	10.7	7.3	338
Care to ensure clean food&water	38.6	24.4	24.7	7.1	5.1	1134
Need to prevent insect bites	12.0	19.6	31.6	21.6	14.0	849
Need to take care in the sun	14.7	14.7	26.9	19.9	23.8	1063

Table 15.7. Travel Agents Familiarization with Pacific Island Destination

Country	Number visited	% Visited
Australia	276	87.9
Hawaii	241	76.7
Fiji	233	74.2
Tahiti	161	51.3
Western/American Samoa	69	22.0
Tonga	85	27.1
New Caledonia	140	44.6
Cook Islands	127	40.4
Papua New Guinea	23	7.3
Solomon Islands	27	8.6
Vanuatu	101	32.2

Table 15.8. The Proportion of Travel Agents Giving Specific Health Advice for Each Pacific Destination (in Per Cent)

Destination		Travel agents' advice on			
	Vaccinations	Malaria Pills	Food/ Water	Insect Bites	Care in Sun
Australian	1.3	1.9	4.4	13.1	37.6
Hawaii	1.9	0.0	5.7	8.6	39.5
Fiji	3.8	3.5	32.5	30.3	40.1
Tahiti	3.5	2.9	28.3	23.2	34.4
Western/Am. Samoa	5.1	6.7	42.0	28.3	30.6
Tonga	5.1	4.8	42.3	28.0	32.2
New Caledonia	4.5	3.2	27.1	22.0	32.2
Cook Islands	5.4	4.8	31.8	29.9	33.7
Papua New Guinea	27.7	41.1	51.6	37.6	32.2
Solomon Isl	19.7	31.8	46.2	36.6	32.2
Vanuatu	8.9	16.9	37.3	29.6	31.2

Analysis of Travel Agent Health Advice to Intending Travellers to Pacific Island Destinations

A detailed question was developed to encourage travel agents to identify which precautions they would recommend for the major outbound destinations visited by New Zealanders. The risks most likely to affect tourists are outlined in a recent publication by Neumann (1996). However, in the absence of this publication at the time of undertaking the study, an accurate assessment of the risks were collated from the *Lonely Planet Guide* for each Pacific Island destination. These guidebooks are viewed by travellers as an authoritative source of travel advice and although critics of such information sources may argue that the information contained therein is written by journalists, it is grounded in personal experience of the destination and more importantly it can be easily accessed by travel agents and tourists alike.

Travellers visiting Australia and Hawaii are least likely to receive health advice reinforcing the common perception that these are both very safe destinations (Table 15.8). However, as Brocks (1993) showed, the threat of skin cancer among resident Australians and for visitors is increasing. For example, Queensland has among the highest rates of skin cancer in the world at a rate of 40 deaths per 100,000 population compared to 0.02 per 100,000 in Japan. However, only 37 per cent of travel agents discussed taking care in the sun with clients despite the internationally renowned '*Slip, slop, slap*' take care in the sun campaign in Australia. In the case of insect bites, only 13 per cent of respondents advise their clients to take care with this issue. This is alarming because dengue fever (a mosquito-borne disease) has occurred in

Townsville and Cairns, Queensland, in 1992, both of which are major tourism centres. A further outbreak in 1995 occurred, but no formal warnings were issued to tour operators. In the case of Hawaii, less than 40 per cent of travel agents advised their clients to take care in the sun. Leptospirisis (a bacterial disease) is present in some streams on the smaller islands in Hawaii. yet only 6 per cent of respondents commented that they advise their clients to take care with food and water in Hawaii.

In the case of Tahiti, it is malaria-free and no inoculations are required except from those arriving from areas infected with smallpox. However, 3.5 per cent of respondents recommend that they needed vaccinations, and 3 per cent advised on malaria pills. Care with food and water was recommended by 28 per cent of respondents. In Tahiti, tap water is generally considered safe to drink, and is regularly tested. In the outer islands, however, water is collected through catchments, from springs and bores, and can vary in quality. Sometimes the change in water can affect sensitive stomachs which is worth observing as a routine warning to visitors. Yet, Fay (1992) goes a stage further arguing that there are water-borne parasites on the outer islands, and raises the problem of ciguareta poisoning (e.g., eating poisonous fish). According to Neumann (1996:168) 'ciguareta poisoning (CPF) the most common type of marine food poisoning, is especially widespread in the Pacific region. The incidence appears to be on the rise, in spite of an improved understanding of preventive measures. The precise incidence of CPF is unknown. In Guam, Fiji and French Polynesia, emergency rooms see many cases a week. Estimates range from 100 to 600 cases/10,000 population per year and fatalities at 0.1 per cent of cases. In the Gambier islands of Polynesia, the incidence may be 2,300 cases per 10,000 population per year.' Neumann (1996: 169) also observed, 'short of abstaining from eating fish, preventing CFP is difficult. Fish themselves have no tell-tale signs. The toxin is heat stable and not inactivated by freezing, drying, salting, smoking or marinating. Tests to identify contaminated fish prior to consumption are not sensitive, specific or practical.' The median duration of symptoms is 2 to 3 weeks but symptoms may persist for months or years.

New Caledonia was the ninth most popular holiday destination for New Zealanders in 1993, with 5,300 visitors travelling there in that year. Despite New Caledonia not having tropical diseases and being malaria-free, 3.2 per cent of respondents advised clients to take malaria pills. Tetanus is found in New Caledonia and yet only 4.5 per cent of respondents recommend vaccinations. Although tap water in New Caledonia is safe to drink except on the Loyante Island of Ouvea where the water is saline, there are a number of illnesses that can be contracted by eating contaminated food and water and these include amoebic dysentery, bacillary dysentery, viral gastro-enteritis, hepatitis, giardia, bilharzia and worms. Care with food and water was recommended by just 27.1 per cent of respondents for travellers to New Caledonia. CFP is also a health problem for visitors to New Caledonia and while malaria is not endemic, an epidemic of dengue fever in 1989 highlights the need to avoid insect bites, a feature which only 22 per cent of respondents regularly advised clients about. Although these examples are only a small snapshot of the health risks and advice offered by New Zealand travellers to outbound travellers to wide array of

Pacific Island destinations, it does illustrate the range of potential health risks that visitors may encounter.

Summary

This brief review of New Zealand travel agent advice to intending travellers indicates that agents are expected to have a good product range and knowledge of destinations to advice clients. However, in the case of health issues, the accuracy of advice is in part related to the agents' first-hand knowledge of individual destinations and the willingness of destinations to offer travel agents educational trips. Yet, since it is widely recognized that travel agents are opinion formers for their clients, their opinions and level of information they impart should not be underestimated in terms of their influence on an intending traveller's holiday decision-making process.

Although this study focussed on the advice offered by travel agents, the issue of health advice to travellers is complicated by a host of factors. These include age, health status of each individual, the destination, the duration of the stay, the season, the type of activity to be undertaken, shifts in current preventative and prophylactic prescriptions, and a range of local conditions, which have a significant impact on the level of risk. Even though medical advice is best offered by qualified personnel, usually doctors, Cossar *et al.* (1990) argued that no one source can address all the diverse needs of the traveller and the results of this research indicate that the travel agents themselves had a wide range of opinions regarding which source is most appropriate. While 60 per cent of travel agents felt GPs were the most appropriate source of advice, other studies have suggested that GPs may encounter problems giving appropriate advice (Usherwood and Usherwood, 1989) and that general practice may not be the best practice for the location of travel advice (Jefferies, 1989). While evidence from the UK indicates that specialized travel clinics are the best outlet for such advice, New Zealand has witnessed a recent growth in this trend with clinics opening in Auckland, Christchurch and Hamilton. Yet the travel agent is still the most appropriate contact point to advise clients to seek advice from a GP or travel medicine clinic before travelling.

This research also raises important ethical question in relation to tourist travel: should the traveller take more responsibility for his/her visit to see their GP before they travel, or should the travel agent be the sole source advocating a visit? Within New Zealand, the health system has seen a growing trend towards people only visiting a GP when sick, rather than for preventative advice, because of the user pay system in place. Therefore, in the current economic climate, it is highly improbable that large numbers of outbound New Zealanders would be willing to seek advice from this source regarding travel issues without a strong incentive to do so.

It is apparent from this study that the general level of advice preferred by travel agents to their clients is woefully low, with no category of health risk being raised with potential tourists by more than 40 per cent of travel agents. Given that almost all health problems related are preventable (Dawood, 1989), it can have serious

repercussions for the tourist, the host country and sending co[...] illustrate the potentially pivotal role the travel agent may play [...] interface, it is a worrying feature if travel agents do not recognize t[...] their advice may carry.

On the basis of the results presented in this chapter, the level of advice[...] most travel agents is low, and is not particularly accurate or reliable. Thes[...] would seem to concur with Dawood's (1989) findings that a survey of US to[...] found that only 28 per cent of travellers to malaria areas received any kind[...] notification from their travel agent that malaria may be a possible risk. It is also[...] apparent from such findings that there are four different stakeholders each interlocking and with areas of mutual exclusivity in relation to tourist health: the tourist, the travel agent, the state and the destination. No one stakeholder alone can or should be expected to deal with such a complex behavioural issue, since travel agent advice may be forgotten by the time of the trip, and appropriate health promotion *en route* or at the destination should be an important prerequisite for ensuring that the health and safety of the visitor are paramount.

Nevertheless, travel agents cannot be absolved from responsibility by recommending that their clients book travel insurance, but need to become more aware of the ethical and legal responsibility to provide decisions and take suitable precautions to take. Accurate information that is easy to understand must come from both the travel agents and destinations as well as by governments and health departments otherwise tourist health problems may prove counterproductive to the sustainability of the tourism industry in some destinations.

...ntry. While this may
...n the tourist/health
...e responsibility
...offered by
...e results
...rists
...of

in New Zealand: A
²rostitutes

, ~.anson

Department of Education Studies, The University of Waikato, Private Bag 3105, Hamilton, New Zealand

Introduction

There are two choices in preparing a chapter on sex tourism in New Zealand. One is to identify a single topic and discuss it thoroughly, the other is to raise a number of issues and leave the reader with questions to consider. I opted for the latter. In so doing I want to clarify that I don't pretend to have the answers. I do, however, make some suggestions which may require some readers to shift their perspectives on the sex industry and the people who work in it. To that end, this paper begins by examining the concept of sex tourism in an historical context and then moves on to discuss sex tourism in New Zealand from the perspective of people working in the sex industry, primarily prostitutes and ship-girls. Kiwi prostitutes working abroad is the third issue raised and the fourth is the unacknowledged contribution the sex industry makes to tourism. Finally, a case is presented for supporting the struggle for the decriminalization of prostitution.

Background and Methodology

Since taking up an adult education appointment at the University of Waikato in July 1994 my research focus has been the sex industry, specifically the informal and non-formal means by which women learn to work safely in the trade. During the last two years I have met about 300 sex workers, including prostitutes, receptionists, dominatrixes, ship-girls, submissives, drivers and madams. The data I have collected varies from nine hours of taped conversation with an independent prostitute to casual comments or observations recorded in my field notes after visiting a sex work venue.

As well as studying the sex industry in New Zealand I have also conducted field research in Tanzania, Australia, the Philippines, Thailand, Vietnam, Canada and, most recently, Fiji. And, except for a couple of small grants from the university, my research has been self-financed because I prefer not to compromise my study by adhering to funding restrictions. Like Rosa Luxemburg, I view prostitution from an internationalist perspective:

> Prostitution is as little specifically Russian as tuberculosis; it is rather the most international institution of social life. But although it plays an almost controlling part in our modern life, officially, in the sense of the conventional lie, it is not approved of as a normal constituent of present-day society. Rather it is treated as the scum of humanity, as something allegedly beyond the pale (Luxemburg, 1927: 348)

Decriminalization, as will be argued later, is the initial step towards remedying this situation because it allows prostitutes to assume more control over their working situations.

My research is based on life-history as methodology developed by Sue Middleton (1993). Whereas some researchers study official documents and records, the accounts of people who were actually involved in the work - in Middleton's case, teachers; in mine, prostitutes - in the course of their day-to-day lives offers an insightful interpretation not found in the policies and reports of officialdom. By using indepth interviews as the basis of my data, an account of sex tourism, as viewed from the perspective of prostitutes who work in the New Zealand sex industry with both foreign and domestic tourists, is presented. Like Middleton, 'I assumed that the women were telling the truth about their lives in so far as they understood and remembered the events. There was no reason for them to lie. The techniques of revisiting and reinterpreting the material in subsequent interviews . . . ensured that the stories were consistent' (1993:68). In keeping with Middleton's theory, my continuing association with the sex industry confirms that accounts I heard, say, two years ago are, in fact, accurate.

The sex industry people involved in my research play an active rather than a passive role in my data collection. As Middleton noted, 'It was important to develop a methodology that would enable the women being interviewed to assist in the analysis of their own tape-recorded life histories and to try to avoid imposing alien constructions on their experiences' (1993:69). Drafts of all papers I write are widely circulated in the sex industry. Further, I try to have people whose transcripts I use in specific papers read their contribution in the context in which I have used it prior to publication. This, I feel, minimizes research exploitation and allows people in the sex industry the opportunity of maintaining control over their contributions.

My particular research focus involves heterosexual women between the ages of approximately 25-45 who work in what I refer to as the 'middle-range' of the sex industry. They are neither on the street nor are they in luxury apartments. Rather, they are generally rather ordinary women working in average sorts of parlours and

agencies in mid-size New Zealand cities, including Hamilton, Tauranga, Palmerston North, New Plymouth and Rotorua. Given the transient nature of the sex industry, virtually all of the women I interviewed in the last two years have worked with tourists, either domestic or foreign, at one time or another and many of them have worked on both the North and the South islands of New Zealand.

Sex Tourism - Is it a New Concept?

Is sex tourism really a new concept? From my readings (Forbes, 1988; Hobhouse, 1989) I argue that recreational sex has been a fact of life whenever cultures or various groups of people first encountered each other. In New Zealand, for example, it appears that sex tourism of a sort arrived with the first European ships. Papakura (reprinted in 1986) offers a perhaps somewhat bucolic account of the sexual interaction between Maori women and Pakeha men:

> The Maori had not a practice equivalent to that which is among Europeans called prostitution . . . A Maori woman would never have sold herself for money, never. She might give herself to a man if she loved him, for there was no law against this, but never for any other reason . . . It does not mean, that because the pakeha made a present of a few nails or an axe, that he was buying the girl (Papakura, 1986: 101).

Prostitution on a fee-for-service basis, it seems, arrived with colonization. According to Stevan Grigg (1984:39), 'It is possible that one woman out of ten in early colonial New Zealand was a whore for a time between adolescence and middle age'. This may well be due to the fact that 'Early colonial New Zealand was a disorderly society in which many people were heavily dependent on alcohol or narcotics, and sexual life often amounted to little more than rape or prostitution' (1984:248). Modern transportation may facilitate sex tourism, but it certainly isn't responsible for initiating it.

Foreign and Domestic Sex Tourism

The tourism industry in New Zealand tends to portray images of the country which are clean, green and rural. Tourist attractions such as trekking, bungie jumping and biking are emphasized in most of the travel guides. But, as I noted in a CBC Radio report, 'While the tourist brochures portray the squeaky-clean aspect of New Zealand, there is another side to the supposed quiet and tranquil life which is seldom discussed. The green hills and the sheep are so very far away - and yet so very close - to the peep shows on Vivian Street' (Hanson, 1994:32).

Although it generates a lot of money - both directly and in terms of spin-off industries such as bars, restaurants, hotels and retail stores - the economics of the sex industry are frequently ignored, at least officially. According to Rachel Kinder

(1994:5), 'A conservative estimation of both the Auckland and Wellington sex industries' contribution to the tourism industry is NZ \$9.4 million and NZ \$5.2 million respectively.' That is considerably more than bungie jumping which receives so much more coverage and attention.

Estimations of the number of prostitutes working in New Zealand vary from eight to nine thousand (Hanson, fieldnotes; Jordan, 1991). An exact number is difficult, indeed impossible, to calculate given the part-time and flexible nature of sex work. And as economic times become increasingly difficult for women on low incomes, there are speculations that the number of sex-workers is rising (Hanson, fieldnotes).

Seeing tourists, both foreign and domestic, as clients is a common work situation for most prostitutes. Nikki, a prostitute who has worked in New Zealand, Australia and Singapore, offers an insight into the spontaneous nature of foreign tourists visiting a prostitute in New Zealand,

> I don't think that people in other parts of the world are thinking, 'Great! Let's go down to New Zealand and have a bonking good time.' I think they're coming down here to see what they want to see and while they're here they have a good time. They like to party. And that's when you're available (Hanson, transcript).

The following interview with Jennifer is an example of how a woman starting out in the industry may well have a tourist, in this case a foreigner, as her first client.

> In Rotorua there was a lady advertising for masseurs, and I just went in thinking it was just straight massage. And then when she told me that sex was involved, I said, 'Oh, no way!' And she said, 'Well I've got this lovely guy coming around. He's from Switzerland, and he always visits us when he's in town. And I know he'd love to see you.' And I said, 'No, I can't do that.' But we sat and had a few glasses of wine. It was the wine I think that gave me the Dutch courage. The man from Switzerland was my first client ever. He rang up, and I talked to him on the phone, and he sounded quite nice. I went to his hotel and, even though I'd been drinking wine, I still felt really nervous. I went and saw him, and when it was all over I thought, 'What was I so nervous about?' He had more wine in his room and he was a real sweetie. So that was my first time. It was so easy.

When asked what she thought the contribution that working girls and the sex industry made to tourism, Tina, a prostitute who has worked in a number of cities around New Zealand, replied, 'Clients always go away happy, I reckon' (Hanson, transcript). She went on to give her analysis of sex tourism.

> Because Rotorua is a real tourist place, you see a lot of Asian clients there. Sometimes they might come into the parlour in a group of about ten. They always pay us without haggling about the price. In Rotorua the majority of the working-girls are part Maori. Many Asians would rather see Europeans, so these ladies do quite well. But some Maori girls also do okay. The Asians more or less

go for the Europeans first, though. I find foreign clients good to see and I like doing Asians because they're pretty clean and they don't try and barter with you and they are more or less Tom Thumbs.

I've had a few fights with foreign clients. Not physical fights, but arguments. The first night I was working here we had a great big American, a huge American dude, who was sitting in the lounge. He sat there for a couple of hours abusing every client and every girl in the room and nobody would go through with him because he was just such an arsehole. He told us that he had millions and millions of dollars. He was supposedly this wickedly rich American who owned lots of businesses. There was something shady about him and he couldn't wait to tell everybody in the room what he did and how he made his millions and how he wanted every girl to come and work for him.

We had a good time with some Americans once. They came over on a boat and they were parked up at the wharf for a while, down where they launch the boats. They just always kept asking for escorts.

Seeing foreign clients is easier, according to Pamela, because they are more relaxed about spending time with a prostitute.

Because the ones I've seen obviously travel around the world and they seem to have a far less judgemental attitude about seeing hookers. They're not looking for anything other than sex. They are very easy about it and they walk in and pay their money. The last foreign client I saw, for example, was Dave, a Scotsman who wanted to have a threesome with his Kiwi friend, Stuart. When Stuart was in Scotland, you see, they had had a threesome there. Anyway, we danced and then they said 'Why don't you strip?' and I said 'Why don't you guys strip with me?' which we all did. Then I gave Dave, the Scottish guy, oral sex and Stuart, the Kiwi, was just fooling around with my breasts. Then Stuart just sat back and was a voyeur because he wanted Dave to come, because he hadn't at the last threesome (Hanson, interview).

Consistent with the idea that being a tourist - either foreign or domestic - allows one to be more anonymous makes the idea of having sex with a prostitute more amenable to some men (Kinder, 1994). Toni, who has been a madam for twenty years, offers a concise analysis when she says, 'It is very simple, really. Men don't shit in their own nest so a lot of the clients we see are from out of town. That way they think they are safe and that they're not really being unfaithful' (Hanson, fieldnotes). Domestic tourists in New Zealand include businessmen who travel, men on vacation travelling to different parts of the country and sportsmen playing at tournaments in other cities.
Pamela reports that Kiwi clients are sometimes difficult to deal with because they try to push the limits of what is acceptable. Rugby players, for example, often want anal sex and she isn't prepared to accommodate this request (Hanson, interview).

Other prostitutes, such as Ann, however, report that they enjoy seeing domestic tourists, particularly businessmen, and that some of these clients have become regulars whom they have seen, be it once a month, for years (Hanson, fieldnotes).

Ship Girls

Another aspect of sex tourism frequently ignored by the New Zealand tourism industry is the contribution of the ship-girls, who are also known as coastal hostesses in some circles. While sailors are credited with having a girl in every port, the ship-girls who have a boy on every boat also have their untold stories. In many respects, being a ship-girl is a lifestyle decision, rather than an occupation. Kiwi ship-girls, for instance, share many commonalities with the pick-up girls of Manila, including exchanging sex with foreigners they find attractive or agreeable for money, meals and drinks, rather than an agreed upon fee-for-service arrangement. Ship-girls often frequent seamen's bars or go to parties on ships to meet sailors. If a woman decides to spend a night with one of the men, he will, at the very least, give her enough money to cover her taxi fare home, and pay for child-minding expenses. He will usually also either give her money, or send a gift from his next port of call if he is a long-term boyfriend. Misty, a ship-girl in Tauranga, for instance, has been given more pairs of shoes than she could ever possibly wear (Hanson, fieldnotes).

Another commonality is that the foreigners - sailors in the case of coastal hostesses and tourists for the pick-up girls in Manila - sometimes continue sending gifts of money after they have returned to their home countries. Misty told me she once received 54 Valentine cards one February. Various boyfriends have also sent her quite a lot of money from various parts of the world over the years. Coastal hostesses may have boyfriends from the Philippines, Japan, Russia, England and America on various ships and when their ships are in port the women practise serial monogamy (Hanson, fieldnotes). The work of the ship-girls, however, is ignored by tourism officials. Further, these women are often regarded as undesirable, even by the owners of some of the shops where they spend their money.

Kiwi Prostitutes as International Workers

It can be argued that New Zealand prostitutes working abroad are another variation of sex tourism seldom discussed in the tourism literature. Prostitution as off-shore work generally happens in one of two ways. The first is that women are recruited by an overseas agency and the second is that they may decide to work as prostitutes, either by going overseas or by starting to work while they are in another country.

One evening when I was visiting a parlour, for instance, I was asked what I knew about Macau. An agency from the Portuguese colony had rung, trying to recruit from five to ten Kiwi women, preferably blondes with big busts. The people at the parlour in Macau were offering a salary of NZ$10,000 a month, the opportunity to make that much again in tips, return airfare and accommodation, in exchange for a two-month

contract. Fearing long working hours, inadequate accommodation by Western standards and oppressive terms I cautioned the people involved about prostitutes working for a set sum of money (advising that women negotiating their own fee-for-service would be a better arrangement) and expressed concern about working-girls maintaining control of their passports at all times. Tabloids, such as *New Truth*, also carry recruitment ads from time to time.

The experiences of Kiwi women working in the international sex tourism area varies. Elizabeth, for instance, worked in Kalgoorlie in Australia as she wanted to earn enough money to set herself up as an independent sex worker. Her account offers an insight into the range of experiences women may have working overseas as prostitutes.

> The men [in Kalgoorlie] that came in were drunk, just about always drunk. They seemed to have the biggest dicks I've ever come across. I don't know if it's the heat, the type of work, or what it was, but they were big and they took ages to come, so you really got thrashed. They were pretty dirty, pretty drunk, and pretty coarse, and it was a living hell . . . Because you had to work all night, you were expected to sleep during the day. And there was this incredible heat, it was a very hot place up there in the desert. We were supposed to sleep in tin sheds, no insulation. Half the girls were heavy drug users; there were syringes and stuff hidden all over the place and the police would raid every now and then.

When she started working on her own, however, her experience was considerably different.

> I started working as an independent in Fremantle because nobody else was working there. I'm not very good with competition, and I always try and find a niche. So I did that when I went independent and I earned incredible money. I had a three-storey, $300 a week apartment on the water front. And $300 was quite a lot of rent in Australia at that time. In Perth, by law, as an independent, you have to do in-house calls. You're not allowed to share your home with any other person. Men aren't allowed to have anything to do with the industry, so you couldn't have your minder there. You're very vulnerable. You can't have another woman, because then you're running a brothel and you might get busted. At first I was really fearful. But, I discovered that there was no problem and it was very convenient because I could practise the piano all day, and just dash downstairs for a quickie and then go back to my music again . . . I only worked from nine to five Monday to Friday.

Some women, such as Nikki, have worked overseas and have had predominantly good experiences.

> I met a girl in Darwin and she was from Switzerland. She used to go to Singapore every year to work, so she gave me a card and I got a job there. I have lived in

Singapore before so I knew the place. It was an excuse to go back, but it was also a place where I knew I could make some money, because there are a lot of rich Chinese, and Arabs. Very wealthy men. People who come to a place like Singapore have to have money. There's all sorts of different grades of prostitutes. You can get one that stands on the corner at night, or you can get one that's hooked up with one through a pimp or you can go into a place that's set up as a parlour.

I worked in an elite place. What happened was that the clients would come in and it was set up like a bar. The girls were there. The clients had to pay a door fee to come in and select a girl. Then they would pay 50 dollars for each girl that they took out. And whatever she makes on top of that is strictly her business. The fee for sex is usually around 800 dollars, at the lowest. You get more if you're younger. Most of my clients were Asians. We had a couple of Australians come through, but mainly my clients were all rich Chinese, people from Hong Kong and Japan. And Arabs, lots of Arabs. Working with the Arabs meant you had to understand their culture. Because they're Muslim, they're very picky about who they choose and it is so easy to insult them culturally. Things like they don't like any of your neck exposed so you have to keep it covered and you can't order alcohol because then you're offending Allah - that's the worst thing you could do. If you do that they'll just tell you to leave. You learn those sorts of things fast.

I think foreign people have a better understanding of how the sex industry works. I think Kiwis are pretty backwards. Foreigners know that they have to pay for sex and they are willing to pay for it, whereas Kiwi men often think that they should always have it for free.

As some foreign men see fair haired and fair skinned women as exotic, and, thus, the opportunities for women to work overseas are readily available. The following is a personal account from my field notes written while in Fiji:

I noticed a white van pull up so I told Mahonia I thought she might have a customer which was, I decided, too bad as we were just settling into our discussion of the sex trade in Suva. She went over and leaned in the passenger window of the van to talk with him. A few minutes later she returned, saying that it was me he wanted to see, not her. In negotiating the transaction Mahonia had told him that I was very expensive - and that my price was a hundred dollars, which is a considerable amount of money in a country where a police officer or a soldier makes about eighty dollars a week. The man said he would pay the asking price. Mahonia said 'These black Fijian men, they just want to fuck white women. They will pay two or three times what they would pay me to do that.' From my perspective I was pleased that Mahonia was willing to negotiate on my behalf and that she was willing to share her patch with me. I asked Mahonia to tell the client that I would rather stay and talk with her. She smiled, delivered my message and

then returned to sit on the bench so we could continue with our conversation.

The opportunities and experiences of Kiwi women working overseas vary considerably. Working in the area of sex tourism, though, does offer them a viable way to earn money, both in New Zealand and overseas.

The Unacknowledged Contribution of Prostitutes to Tourism

Sex tourism, as documented by the life-histories of women working in the sex industry, is alive and well in New Zealand, even though it is officially unrecognized. This oversight is one which people in the tourism industry can work towards rectifying. Prostitutes, after all, play an important part in furthering relations between New Zealand and some tourists, both foreign and domestic. Progressive people in the tourism industry should consider supporting the decriminalization of prostitution.

It is important to specify decriminalization, rather than legalization. The New Zealand Prostitutes' Collective is adamant that 'We would oppose any attempt to have a legalized, but more tightly state-controlled sex industry, which would actually have the effect of driving further underground those workers and clients who were outside the state controlled sector of the industry' (NZPC, 1989:4). Thus, legalized prostitution, which imposes restrictions on women such as having to have health check-ups but not being eligible for health insurance (as is the situation which exists in Germany) would not be accepted by people working in the New Zealand sex industry. Decriminalization is also an opportunity for progressive people to support the struggle for improved working conditions of sex workers.

Prostitution is an occupation which is located in the personal service industry. Other personal service occupations - which share the characteristics of providing one-on-one service, working on a fee-for-service basis and building up a return clientele - include hairdressers, trainers at the gym and some tour guides. Although there are those who would like to think that we are becoming more progressive in our social attitudes, I would argue that it has not really changed much since Jan Jordan (1991:11) wrote, 'As sex workers these women live in a society that either refuses to acknowledge their existence, or seeks to condemn and ostrasize them'. Recognizing prostitution as being part of the personal service industry which, in turn, may be an aspect of the tourism industry may help people shift their perspective on sex work. Legitimizing sex work also moves it away from the stereotypical street 'sex, drugs and sleaze' portrayals which the media is so fond of presenting.

Ignoring an estimated 9,000 people working in an industry which generates millions of dollars is absurd. But, then, so is expecting women working in the sex-industry to pay taxes on their earnings while not being eligible for any benefits paid for by their tax dollars. By moving sex work away from the margin, prostitutes could begin to take their rightful place in society as equal, contributing citizens. And their work could be recognized for what it is - simply a service.

Acknowledgements

I would like to thank Kylie St George for her help with interviewing and Sue Turner-Jones and Val Lazenby for typing the transcripts.

Chapter seventeen:

Some Reflections on the Implications of GATS for Emerging Tourism Destinations

Malcolm Cooper
University of Southern Queensland - Wide Bay, PO Box 910, Pialba, Queensland 4655, Australia

Introduction

In recent years great changes have taken place in the economic policies of a number of Asian Countries. Governments have discarded their long-standing closed-door policies and become more open to the outside world as an impetus to economic development. Tourism is important in this process because it is now a significant vehicle for the transfer of technology and foreign direct investment between countries. This means, however, that policy makers will have to come to grips with the fact that to promote the development of tourism properly many different economic sectors will require deregulation and/or foreign investment. The recently signed General Agreement on Trade in Services (GATS) provides one vehicle that policy makers in these countries might use to ensure that they retain domestic control over the growth in tourism to their emergent economies. The benefits of developing such policies cautiously, over time, will become evident in the positive contribution that tourism will make to the development of Asia's national and regional economies.

This chapter examines the recent development of the tourism sector in one Asian country, China, and assesses the likely impact of the General Agreement on Trade in Services on the growth of this sector of the Chinese economy. It is based on a study recently carried out for the Chinese Ministry MOFTEC by the Author (April-June, 1996).

World Tourism and the Uruguay Round of GATT

International trade and international tourism are intertwined. Since the growth of international tourism depends primarily on the free movement of people there is a need to reduce barriers to such movement - including restrictions on passports and visas, currency controls and travel allowance restrictions - for tourism to prosper. Free trade in services, such as the liberalization of multilateral air transport and banking, is pivotal to the future expansion of international tourism and the economic development of developing countries. The gradual elimination of barriers to international trade in services as proposed in one of the recently signed Marrakesh Protocols, the General Agreement on Trade in Services, has the potential to increase travel flows, without compromizing security, and stimulate economies through the growth of tourism around the world.

The General Agreement on Trade on Services

The General Agreement on Trade on Services extends the rules based multilateral trading system developed since 1945, under GATT (the General Agreement on Tarriffs and Trade), to the area of trade in services. Similar advantages should accrue to developing countries from the operation of a rules based system in services as has been the case for merchandise trade. Although many developing countries are not presently well placed to take advantage of some of the improved market access opportunities which the Agreement creates world-wide, they should be in a position to do so in the future as their domestic supply capacity increases.

GATS sets up a legal and operational framework for the gradual elimination of barriers to international trade in services. Its long-term objective is to improve the free market environment, which will provide consumers with the best possible products and services at the best possible prices. Applying this principle to tourism is no exception. But putting it to work will require multilateral negotiations that call for mutual concessions and equitable compensation, as well as improved linkages amongst all services sectors.

Part II (Articles II to XV) of the Agreement covers, *inter alia*, Most-Favoured-Nation treatment, transparency, disclosure of confidential information, the participation of developing countries, economic integration, labour market integration agreements, regulation of domestic markets for services, recognition of suppliers, acceptable business practices, emergency safeguard measures, payments and transfers, restrictions to safeguard the balance of payments, Government procurement, a range of general exceptions, exceptions for security reasons, and the question of subsidies. Part III covers the specific commitments to be made by signatories on market access, and national treatment of international service providers. And Parts IV-V set out the mechanisms for progressive liberalization of trade in services through the negotiation of specific commitments and their modification where necessary.

One of the most important sections is Article IV, which sets out the rules for the increasing participation of developing countries:

1. The increasing participation of developing countries in world trade shall be facilitated through negotiated specific commitments, by different Members pursuant to Parts III and IV of this Agreement, relating to:
 (a) the strengthening of their domestic services capacity and its efficiency and competitiveness *inter alia* through access to technology on a commercial basis;
 (b) the improvement of their access to distribution channels and information networks; and
 (c) the liberalization of market access in sectors and modes of supply of exports of interest to them.
2. Developed country members, and to the extent possible other members, shall establish contact points within two years from the entry into force of the Agreement establishing the WTO to facilitate the access of developing countries' service suppliers to information, related to their respective markets, concerning:
 (a) commercial and technical aspects of the supply of services;
 (b) registration, recognition and obtaining of professional qualifications; and
 (c) the availability of services technology.
3. Special priority shall be given to the least-developed countries in the implementation of paragraphs 1 and 2 above. Particular account shall be taken of the serious difficulty of the least-developed countries in accepting negotiated specific commitments in view of their special economic situation and their development, trade and financial needs.

Presently, much of international trade is clouded by discriminatory practices, protectionism and lack of transparency. In tourism, restrictions affect companies in many ways, including:

- their ability to move staff to a foreign country;
- their use of trademarks (and their protection against others' use of these);
- the creation and operating of branch offices abroad; and
- the repatriation of profits.

Some of the impediments to the development of trade in tourism services that have occurred in the past, barriers that typically have been raised in many parts of the world, include:

- **The Disproportionate Taxation of Travellers**. Many governments see travellers as a convenient vehicle for raising taxes without further imposing on local populations. They fail to understand that the typical traveller has a choice of destinations and is price sensitive. Governments which focus on expanding the *size* of the travel and tourism tax base, rather than raising tax rates, stand a better

chance of meeting their revenue needs without impeding tourism's ability to generate jobs and economic growth;

- **Congestion**. Unpleasant travel experiences discourage travellers and make destinations less popular. Congestion at travel nodes is perhaps the chief cause of such experiences. Solutions include the streamlining of immigration clearance, upgrading of air navigation technology, air, rail and bus operations, and the upgrading of ticket issuing and collection services;

- **Safety and Official Hostility.** Again, unpleasant travel experiences discourage travellers and make destinations less popular. Governments need to ensure public safety for all, but they need also to train their border and local representatives to make the tourist welcome; and

- **Official Restrictions on Business and Trade.** Even when meeting all the requirements for establishment in a market, a foreign tourism enterprise (hotel, travel agency, restaurant or transport company) may not, for example, be permitted to take the risk unless the relevant authority recognizes that there is 'economic need' for the activity in question. GATS intends to do away with this clouded trading environment by first clearly stating the rules and then making countries apply them equally to all enterprises involved in service transactions. In GATS jargon the rules are categorized as 'cross-border supply', 'consumption abroad', 'commercial presence' and 'personal mobility' (presence of natural persons).

Benefits and Costs

GATS will benefit tourism and travel in several ways. Since the overall objective of GATS and other accords of the Marrakesh meeting is to spur economic growth, there will be more demand for exhibitions, incentive and business travel, meetings and conventions. More trade in both goods and services will mean more business opportunities for the travel trade. Developing countries, for example, can seek greater access to technology and know-how from developed countries; greater access to distribution channels and information networks; to reduced export barriers; or even the freedom to deploy not only key personnel but also regular personnel in the main tourism generating countries.

With fewer trade restrictions tourism will grow. The tourism sector will benefit not only by allowing major tour operators and hotel chains to expand their reach world-wide, but also by opening up the international industry to small- and medium-size suppliers. So far, such suppliers have not been strong enough to overcome existing trade barriers. GATS will also help strengthen the ability of developing countries to compete by allowing them to attach conditions to their market opening commitments and requesting the transfer of technology and expertise.

China and the GATS

China's market for services remains severely restricted. Foreign service providers are generally only allowed to operate under selective 'experimental' licences and are restricted to specific geographic areas. As in other sectors, the absence of transparency and a sound legal and regulatory structure, and public ignorance of those laws and regulations that do exist, hinders market access for services companies.

Foreign tourists have historically had to pay higher prices than citizens of China, on public transportation lines for example, but in turn received preferential treatment with respect to seating. While this situation has now been rectified, and any traveller in China is now able to buy any class of ticket if they so wish, the Government still denies foreign travel agents equality in national treatment. Foreign service companies continue to face significant administrative restrictions when attempting to operate. Financial institutions, law firms and accountants, among others, must largely limit their activities to serving foreign firms or joint ventures.

China has, however, expressed an intention to liberalize services markets eventually and, in some cases, has begun to do so on a trial basis. Some foreign law firms have been licensed, but are limited in their practice to a single city and are unable to take Chinese clients, appearing in Chinese courts or establishing joint-venture law firms. Travel and other tourist-related companies offering travel services are limited to 11 areas in China, and retailing firms are subject to vague guidelines that are restrictive and the implementation of which often varies considerably from locality to locality.

In June 1995, the authorities issued investment 'guidelines' detailing sectors in which investment is encouraged, restricted or prohibited. However, a continued general lack of transparency in the foreign investment approval process and inconsistency in the implementation of regulations continue to hinder investors that meet the substantive requirements of the 'guidelines'. In addition, there are many areas in which, although foreign investment is technically allowed, it is severely restricted. Restricted categories generally reflect:

1. the protection of domestic industries, such as the services sector, where the Government fears that domestic market and companies would be quickly dominated by foreign firms;
2. the aim of limiting luxuries or large imports of components or raw materials; and
3. the avoidance of redundancy (excess capacity).

Examples of investment restrictions in the Services sector are abundant: investment in the management and operation of basic telecommunications, in all aspects of value-added telecommunications as well as in news media, broadcast and television, and in the rest of the services sector, including distribution, trade, construction, tourism and travel services, shipping, advertising, insurance and education.

China and the Growth of Tourism

From 1978 to 1994, China's inbound visitor arrivals averaged an annual growth of 25 per cent, while foreign exchange earnings from visitors averaged a 20 per cent annual increase (Table 17.1). In 1994, China received 44 million international visitor arrivals, among which some five million were non-Chinese. Total foreign exchange earnings from visitors for 1994 were close to US$7.5 Billion (Table 17.2). From an almost insignificant beginning only a dozen years ago, China now ranks among the top Asian tourist destinations.

Overseas travel by People's Republic of China (PRC) citizens is a more recent phenomenon. With deepening reforms, rapidly increasing wealth, and greater openness to the outside world, more and more people in China are expressing interest in temporary travel outside the country. Cross-border day tours in the frontier areas with Russia, Korea and Mongolia in the north, and to Vietnam, Laos and Myanmar (Burma) in the south, have been rapidly increasing. Control over Chinese outbound tours has been gradually and cautiously relaxed since 1990. For most of the period since 1949, leisure travel by Chinese Nationals has been considered an unnecessary luxury, but as a result of modernization domestic tourism has also increased significantly in the past decade. Conservative estimates indicate that the number of domestic trips jumped from some 240 million in 1985 to 524 million in 1994. In the same period, travel expenditures grew from RMB8 billion to over RMB102 billion. Domestic tourism, therefore, is clearly contributing to the local economic development of many Chinese cities and regions.

Tourist Attractions

In the early days of opening to the outside world, only a select number of Chinese cities were accessible to foreign tourists. By the end of 1978, only 107 cities or regions were open to foreign visitors, and the principal attractions being offered were model factories, schools, neighbourhoods and communes. These made up the majority of attractions offered to a tour group, regardless of the tourists' interests.

The situation is totally different today. There are numerous special interest tours nation-wide, and local tourist organizations vie with each other in offering more unique and innovative tours to attract incoming tourists. Among many others, favourite tours include the Silk Road in the Northwest, Tibet's 'Roof of the World' Tour, the Three Gorges cruise along the Changjiang (Yangtze) River, the Grand Canal Tour, the Tour of Seven Ancient Capitals, the Southwest Minorities Folklore Tour, the Ice and Snow Tour in the Northeast, and special interest tours focussing on the arts, religion and health. Added to these are festivals, shopping, people watching, live entertainment, and other attractions. According to the CNTA, by the end of 1992 there were 888 cities and counties open to overseas visitors and over 500 points of entry and exit in the country (NTA, 1992).

Table 17.1. Tourist Arrivals in China, 1978-1994

Year	Total	Non-Chinese	Overseas Nationals	Chinese Compatriots*	Taiwan**
1978	1,809,200	229,600	18,100	1,561,500	
1979	4,203,901	362,389	20,910	3,820,602	
1980	5,702,536	529,124	34,413	5,138,999	
1981	7,767,096	675,153	38,856	7,053,087	
1982	7,924,261	764,497	42,745	7,117,019	
1983	9,477,005	872,511	40,352	8,564,142	
1984	12,852,185	1,134,267	47,498	11,670,420	
1985	17,833,097	1,370,462	84,827	16,377,808	
1986	22,818,450	1,482,276	67,133	21,269,041	
1987	26,902,267	1,727,821	87,031	25,087,415	
1988	31,694,804	1,842,206	79,348	29,773,250	427,700
1989	24,501,394	1,460,970	68,556	22,971,868	541,000
1990	27,461,821	1,747,315	91,090	25,623,416	947,600
1991	33,349,761	2,710,103	133,427	30,506,231	946,632
1992	38,115,027	4,006,427	165,100	33,943,500	1,317,800
1993	41,526,943	4,655,857	166,182	36704,904	1,526,969
1994	42,294,241	5,182,060	115,245	36996,936	1,390,215

Notes: * Citizens of Hong Kong, Macau, Taiwan; ** Number also included under Chinese Compatriots

Source: NTA, 1995

A significant event was the establishment of national-level 'Tourism and Vacation Zones' in the late 1980s. From proposals submitted by 26 places, the State Council has approved twelve for the establishment of long-stay tourist destinations (Table 17.3). Funds for development are expected to come primarily from enterprises and individuals in Taiwan, Hong Kong, Macau, and other foreign countries. Most of these Tourism and Vacation Zones are currently under construction.

Table 17.2. Tourism Receipts, 1979-1994

Year	Receipts (Million US$)	Indices (1978 = 100)	Change (in %)
1979	449.3	170.9	70.9
1980	616.7	234.6	37.3
1981	784.9	298.6	27.3
1982	843.2	320.7	7.4
1983	941.2	358.0	11.6
1984	1,131.3	430.3	20.2
1985	1,250.0	475.5	10.5
1986	1,530.9	582.3	22.5
1987	1,861.5	708.1	21.6
1988	2,246.8	854.6	20.7
1989	1,860.5	707.7	-17.2
1990	2,217.6	843.5	19.2
1991	2,845.0	1,082.1	28.3
1992	3,946.9	1,501.3	38.7
1993	4,680.2	1,781.4	18.7
1994	7,322.8	2,785.4	*

Note: * Not strictly comparable due to changes in foreign currency management methods

Source: NTA, 1995

Another important new development is to utilize China's forest resources as tourist attractions further. Up to February of 1993, China had opened 350 new forest parks with a total area of some five million acres. Almost two-thirds of these parks were developed in the 1990s. In addition, there are also 420 nature preserves nation-wide, providing a strong resource base for future tourism development.

Table 17.3. State Level Tourism and Vacation Zones

Tourism and Vacation Zone	Province
South Lake	Guangdong
Jinshi Beach in Dalian	Liaoning
Lake Taihu in Wuxi	Jiangsu
Lake Taihu in Suzhou	Jiangsu
Old Stone Man in Qingdao	Shandong
Zhijiang River in Hangzhou	Zhejiang
Yintan Beach in Beihai	Guangxi
Hengsha Island	Shanghai
Dianchi Lake in Kunrning	Yunnan
Meizhou Island and Wuyishan Mountains	Fujian
Yalong Bay in Sanya	Hainan

Source: *China Tourism News*, July 17, 1993.

Recent Developments

Since the beginning of the 1990s, the tourism industry in China has encountered many new challenges. Firstly, the international tourist market has expanded significantly. In order to meet this increasing demand, it has become imperative for China further to explore new resources, develop new facilities, and create more opportunities for tourism. Secondly, a phenomenal growth in domestic tourism has occurred as a result of the increasing personal incomes of the Chinese people. China experienced 350 million domestic person-trips in 1993. This number is projected to reach 700 million by the year 2000. Even more than for international visitors, tremendous pressure exists for the rapid and extensive development of tourism resources to meet the needs of increasing numbers of domestic tourists.

In the last few years, noticeable efforts to improve China's transportation situation have been undertaken, including the purchase and lease of larger aeroplanes and new train coaches, as well as continuing construction and maintenance of roadways. In spite of these efforts, under-capacity at all levels of the transportation system remains a problem. In an effort to increase efficiency in air traffic, the domestic operations of China's state airline have been divided into seven regional airlines since 1985. Air China is still the national carrier, with CAAC more of a regulatory body. In addition, five other formerly CAAC - related airlines are now in operation, as well as 16 private airline companies. At the same time, airline ticket prices have been increasing for both international travellers and domestic Chinese. The price increases have provided a temporary relief to the airlines by depressing airline ticket demand. A computerized booking system was introduced, which now makes it possible to reserve a seat on some flights at very short notice.

Despite their different backgrounds, levels of development and traditions, all

tourist destinations in China are beginning to face the challenges that are brought about by the emerging global market. These include the development of electronic information and computer systems, more knowledgeable and demanding consumers, de-regulation of markets, polarization of markets between mega-operators and small specialized operators, a lack of public capital for infrastructure development and maintenance (especially air fleet renewal), a lack of funding for human resource training, and pressure by residents and tourists for sustainable tourism development (WTO, 1994).

Table 17.4 outlines in detail common obstacles to the development of trade in services and - while thus far China's tourism industry has been able to capitalize on its comparative advantage derived from its primary source of uniqueness, its culture - in order to exploit its full potential it will systematically have to overcome these barriers.

Table 17.4. Check List of Types of Obstacles to International Tourism

I. Obstacles affecting the individual intending to travel

1. Imposed by the home country
 a) Currency restrictions imposed upon residents;
 b) Conditions and procedures for issue of travel documents;
 c) Customs allowances for returning residents;
 d) Restrictions on oveseas travel.

2. Imposed by the host country
 a) Currency restrictions imposed upon visitors
 b) Entry visas, identity documents, limitations on length of stay;
 c) Formalities concerning entry of motor vehicles, pleasure boats or other craft;
 d) Formalities concerning applicability of drivers' licences, or insurance, etc.;
 e) Restrictions on acquisition of property by non-nationals (e.g. holiday flats);
 f) Taxes on foreign visitors.

II. Obstacles affecting companies providing services facilitating travel (e.g. travel agents, tour operators)

3. Limitations on foreign investment/equity;
4. Restrictions on the establishment of foreign-owned entities' branches and subsidiaries;
5. Requirements for qualifications for operating professionally which are directly discriminatory;
6. Restrictions on non-national personnel and employment (e.g. visas, work permits);
7. Difficulties in obtaining licences to operate;
8. Relevant restrictions on transfer of funds in and out of the country (not covered under I above);
9. Restrictions upon the ability of non-established foreign companies to solicit for custom, advertise or sell direct to clients without locally established intermediaries.

III. Obstacles affecting companies providing transportation (e.g., airlines, railways, coach operators, cruise liners)

11-18. Categories as under II (3-10);
19. Restrictions on non-national airlines, coach operators or cruise liners;
20. Limitations on movement of passengers by foreign airlines or cruise ships;
21. Discriminatory landing dues, taxes, or port charges;
22. Lack of reciprocal recognition of qualifications (e.g., air crew, site guides, coach drivers);
23. Requirements for government employees to use national airlines/ferry services' enterprises;
24. Discriminatory access to special terms from state enterprises (e.g., airlines, railways), including different commissions;
25. Limitations on access to reservation systems.

IV. Obstacles affecting companies providing reception facilities (e.g. hotels, resorts, car hire firms)

26-33. Categories as under II (3-10);
34. Restrictions on importation of essential goods;
35. Requirements for placing of contracts (e.g. for site development) with local enterprises;
36. Discriminatory tax regimes for foreign entrants (including tax holidays not available to nationals);
37. Restrictions on ownership by non-nationals (e.g. leasing only permitted) and problems related to security of tenure or repatriation of investments;
38. Limitation on access to reservation systems.

V. Other Obstacles

39. Discriminatory regulations on health inspection/consumer protection, etc.;
40. Compulsory use of centralized governmental and municipal organizations or middlemen;
41. Others.

Source: OECD, 1984

Liberalization in the Tourism Sector

It is obvious that, at this early stage of development, China's tourism trade faces problems with service standards, flexibility and the range of facilities offered, as they differ from tourists' expectations and wishes. As noted above, GATS sets up a legal and operational framework for the gradual elimination of barriers to international

trade in services. China's long-term objective is to improve the market environment in the provision of services, which will provide consumers with the best possible tourism products and services at the best possible prices. Among actions recently taken, China has:

- simplified visa and frontier formalities for overseas tourists;
- introduced a star-rating classification for its hotels based on international standards;
- set up tourism offices in major markets abroad to provide necessary and up-to-date information on the country; and
- participated regularly in major world tourism exhibitions.

Year-long national tourism promotion campaigns were introduced in 1988 (Tourism Year of Dragon) and 1992 (Visit China Year). More recently, China joined members of the Pacific Asia Travel Association (PATA) to promote the 'East Asia Year of Travel' in 1994. These actions, together with other marketing moves, show that China has now embarked on integrated and open tourism development, but it has yet to liberalize banking, insurance and other essential tourist-related services. However, as an important economic sector, tourism is closely tied to China's general market-oriented policy of economic development and its foreign policy of increased openness and cooperation. The national government is paying much more attention to the industry for both economic and political purposes, and is increasing facilities and services for the general touring public both at home and abroad.

Conclusions

China is a recent actor on the stage of world tourism and has, in reality, only been an active player in world tourism for some 16 years. Nevertheless, the country has taken important steps in its tourism development. Outstanding progress has been made in understanding tourism, in searching for basic standards and principles for tourism development, and in seeking a way of developing tourism that is in accordance with the current politics and economics of China.

All nation-states, particularly those at the same level of emergent development as China, will have everything to gain from a travel and tourism industry that is given the opportunity to thrive against the background of a set of balanced rules for free and fair trade, and the General Agreement on Trade in Services provides this. With market shifts in economic and political power of nation-states occurring more rapidly in contemporary history than in previous times, countries must seek many alternatives to remain competitive. Thanks to its abundant and unique resources and favourable government policies for tourism development, in terms of competitive advantage China's tourism (both foreign and domestic) has a promising future. Given that this favourable situation will continue, China is likely to have one of the largest tourist

industries in the world in the coming century. It should, however, be emphasized that recent remarkable results in tourism development have been only minimally related to foreign holiday and vacation travel, and that this part of the international travel market has actually been relatively stagnant in absolute terms.

The reasons behind this are many and varied. However, problems of inadequate transportation, low service quality, and restrictions on travel are not the only problems tourists face. The reluctance of the Chinese authorities to open the services sector to competition and cooperation at a world-wide level is certainly affecting the growth of international tourism. Therefore, if China, with all its outstanding natural and cultural attractions, wants to attract more tourists it should seek to implement the GATS protocols as soon as possible and liberalize trade in services.

Chapter eighteen:

Challenges to MICE Tourism in the Asia-Pacific Region

Larry Dwyer
Nina Mistilis
Department of Management and Marketing, University of Western Sydney - Macarthur, PO Box 555, Campbelltown, New South Wales 2560, Australia

Introduction

A rapidly growing sector of the global tourism industry is that relating to Meeting, Incentives, Conventions and Exhibitions (MICE). National Tourism Offices are now focussing much more on the MICE business with specific strategies geared to developing this market. The former Australian government, for example, placed so much emphasis on this market that it developed a National Strategy to ensure the long term growth of the sector and to maximize the economic and social benefits to the country. Japan and Singapore have government plans to increase the number of international conventions hosted (Commonwealth Department of Tourism, 1995).

If the MICE sector is to develop in a way which maximizes the economic and social benefits to a nation, several challenges must be met by tourism managers in both the private and public sector. It is the purpose of this paper to discuss the nature of some of the key challenges and the implications for tourism management. This chapter begins with a brief discussion of the nature and scope of MICE tourism. It then lists some of the potential economic, social and cultural benefits of this form of tourism, before proceeding to discuss some challenges which must be met to maximize the scale and scope of these benefits. The challenges relate to the level of government support for MICE tourism, appropriate levels of infrastructure, service and training standards and marketing issues. Although these challenges are discussed in the context of the development of MICE tourism in Australia and Asia Pacific, they are relevant worldwide. The paper concludes with some observations concerning the development of the global MICE industry.

Nature and Scope of MICE

A number of different sectors make up the MICE industry - conventions, seminars, trade shows, events, exhibitions and incentive travel. The various definitions and classifications of such concepts as 'meetings', 'exhibitions', 'incentive travel', 'conventions' etc. will not be discussed or analysed here. While in some cases a MICE related event may be referred to as a 'meeting', 'convention', 'conference', 'exhibition', etc. and visitors referred to as 'delegates', 'participants', 'attendees', and so on, the discussion is intended to apply generally to MICE tourism. For incentives, the reason behind the journey is linked to a non-cash reward given because of the achievement of a work related goal. Incentives are used by business as a motivational tool to encourage employees to improve their productivity, sales volume or other management goals. The issues to be addressed in this report are intended to apply to the components of MICE tourism however they are precisely defined.

Stakeholders

To appreciate the multifaceted nature of the MICE industry, it may be noted that MICE activities require, to a varying extent:

- specific venues - purpose built centres and hotels
- the services of professional conference and exhibition organizers
- transportation (international and domestic)
- accommodation
- catering services
- social programmes for delegates and participants
- provision of pre- and post-conference tour opportunities
- specialized technical support such as audiovisual services
- exhibition facilities for products

This highlights the many specialists who must coordinate their respective roles for the convention/exhibition/incentive to be a success (Commonwealth Department of Tourism, 1995). The variety of stakeholders indicates the potentially wide ranging economic impacts of MICE tourism and provides the rationale for this sector's support from government agencies in many countries. At the same time, it indicates the scope of the challenges which must be met in coordinating the activities of different stakeholders to provide a quality service to organizers and delegates.

MICE in the Asia-Pacific Region

According to the International Congress and Convention Association (1995) the percentage of the world's meetings by region is as shown in Table 18.1. For several reasons, the share of meetings hosted in Asia-Pacific countries is expected to grow. Since World War II the Asia-Pacific region has been the worlds most rapidly expanding region for international tourism arrivals and receipts. The various determinants of tourism flows, such as real income growth, cost competitiveness of destinations, demographic and social changes, new product developments, technological and trading developments, and political and regulatory factors are changing in ways which favour continued growth of tourism to and within the region (Dwyer and Forsyth, 1996). Forecasted growth rates of tourist arrivals to Asia-Pacific countries are, on average, double the forecasted world average (WTO, 1994d). Within this context of tourism market growth, National Tourist Organizations in Asia are now focussing much more on developing their meetings, conventions and incentives business, both from within Asia and from Europe and North America, with specific strategies geared towards this market. Convention and exhibition facilities in the Asian region are continuing to expand with substantial government support for marketing activity and infrastructure development. Asian Pacific governments which strongly support MICE tourism by such means include Japan, Thailand, the Philippines, Indonesia, Singapore and Hong Kong (Commonwealth Department of Tourism, 1995).

Potential Impacts of MICE Tourism

A number of potential benefits of MICE tourism can be identified (Dwyer and Forsyth, 1996).

- contribution to employment and income, nationally and regionally;
- increased foreign exchange earnings for a nation;
- generation of investment in tourism/recreation infrastructure, increasing the attractions available in an area for use by locals as well as visitors;
- stimulation of business activity within and between the nations, helps in forging stronger business links between firms, providing opportunities to promote both the national interest and international cooperation;
- provision of opportunities for access to new technology, exchange of ideas, establishment of valuable business and professional contacts, and other socio-cultural impacts;

Table 18.1. World Region's Share in International Meetings Market

Region	World share	Region	World share
Europe	58%	Australia	4%
Asia	17%	Africa	2%
North America	12%	Other	2%
South & Central America	5%		

Source: International Congress and Convention Association, 1995

- attendance at conferences draws together leading national and international specialists and practitioners in their fields. They bring together world's leaders in science, medicine and business, strengthening a nation's internal capabilities in each profession;
- meetings and conventions are a source of education and training and are a forum for developing and maintaining professional contacts;
- valuable international exposure for the host country among the international business, scientific and educational communities and their families;
- successful meetings, conventions and exhibitions can be effective marketing tools for attracting new business and visitors to an area. They offer companies an effective means of promoting their products and services to a targeted audience. In international terms the promotion of a country as a tourist destination for holiday travel may be enhanced by a MICE visit;
- stabilization of tourism inflows to a nation and its subregions;
- provision of local tourism operators with useful advanced knowledge of visitor numbers. Relatively long lead times which result in hotel bookings being made years in advance greatly assist in the financial planning of tourism properties.

If any nation is to realize maximum economic, social and cultural benefits from MICE tourism several issues must be addressed. In the following section some major challenges which have been identified for Australia's MICE industry are discussed. Similar challenges may be expected to arise for other destinations which are developing their MICE industries, and the discussion is intended to have relevance beyond the Australian and Asian-Pacific situation.

Challenges to the Development of MICE Tourism: Some Issues for Australia and the Asia-Pacific

A number of factors are presently working in the Asia-Pacific region's favour as a MICE destination. One factor relates to the rapid expansion of tourism and travel and business links within the Asia-Pacific region (WTO, 1994c) which provides countries in the region with the opportunity of hosting a growing number of regionally based trade shows and meetings. As stated above, several determinants of tourism flows are changing in ways conducive to greater travel and tourism in the Asia-Pacific region (Dwyer and Forsyth, 1996). Concomitantly, as economies grow, professional associations are forming throughout the region to share knowledge and advance their various disciplines on a national, regional and international basis.

While MICE tourism is growing, so too is the extent of competition between destinations both within and outside of the Asia-Pacific region. In this dynamic context four major challenges are currently being faced by stakeholders in Australia's MICE industry. These are:

- a challenge to gain more government support
- a challenge to develop appropriate public and private infrastructure
- a challenge to improve service standards and training
- a challenge to boost MICE tourism numbers through effective marketing effort.

Each of these challenges will be discussed in turn.

Level of Government Support

The rationale for government support of the tourism industry can be based on the standard economic justification of government support for an activity which yields social benefits in circumstances of market failure and introduced distortions. The reasons for market failure are generally categorized under three headings: externalities/non-appropriability of benefits, risk & uncertainty, indivisibilities (Dwyer and Forsyth, 1994). In themselves, however, they do not offer guidance on the appropriate level of support or the best allocation of government resources between competing demands.

Australia's most important competitors are in the Asia-Pacific region - Singapore, Hong Kong, Indonesia, Thailand, the Philippines and Japan - are developing or have developed world class facilities with substantial government support. The latter takes many forms including treasury loans, investment incentives, tax concessions, training programmes and promotional and marketing campaigns (Commonwealth Department of Tourism, 1995). While additional government support for the MICE industry would be seen as very welcome by both public and private tourism operators in Australia, more information on the economic impacts and net benefits of this form of

tourism is required as an input to policymaking. The National Strategy for MICE highlights the lack of data on the economic significance of this tourism sector (Commonwealth Department of Tourism, 1995). In this respect the framework for assessment recently developed by Dwyer and Forsyth (1997) should be a valuable aid to decision-making. The more accurate the estimation of the economic impacts and net benefits of MICE tourism is, the more informed will be the planning process by both public and private sector organizations. This leads us to a discussion of infrastructure needs.

Infrastructure for MICE Tourism

Major cities worldwide, and most large provincial centres, have built facilities to make the most of opportunities provided by convention business. National and provincial governments, particularly in Asia-Pacific regions, have substantially increased their investment in MICE infrastructure in recent years. The current lack of comprehensive baseline data on the contribution of the MICE industry to local and regional economies acts as an impediment to greater support in many cases. Information on MICE associated expenditure will help to better inform governments concerned to allocate funding support to maximal effect. Increasingly, government funding for infrastructure is contingent upon projected financial availability of facilities as well as perceived net benefits to the community. In Australia, industry pressure continues to be applied to the Federal and State governments, however, to remedy what is regarded as an uneven playing field occasioned by higher levels of government support offered in competitor destinations.

A number of institutional impediments hinder the development of tourism transport infrastructure. These include a lack of cooperative and integrated approach by government in decision-making (Mistilis, 1996) and the absence of a national database for assessing transport infrastructure priorities (Tourism Task Force, 1996). While Australia's transport infrastructure in various categories is barely adequate at present to deliver current tourism flows, for regional MICE to be maintained and developed it is vital that air transport is accessible. With the pressure on capacity of some major airports increasing, it is possible that regional air traffic will be allocated to minor and less accessible airports within and near capital cities thereby impeding the growth of MICE tourism outside the major urban areas. Of course, dependence of tourism on infrastructure characterizes all countries and has the potential to impede tourism flows greatly unless strategic planning takes place at the national and regional level.

Adequate financial support must also be forthcoming to provide accommodation facilities for visitors. The need to source the investment capital required to finance future development has recently been described as 'the single most important issue facing the Australian Tourism Industry' (Tourism Forecasting Council, 1996). For example, while tourism contributed around seven per cent of Gross Domestic Product

in 1994-95, about one per cent of Australian financial institutions' property funds is invested in the property elements of this expanding industry. This situation threatens the ability of the tourism industry generally, and the meetings, conferences and exhibitions sector in particular, to service anticipated increases in demand. Without the provision of sufficient capital to fund the next phase of tourism development the MICE industry will be impaired by infrastructure bottlenecks (Tourism Forecasting Council, 1996). Some of Australia's Asia-Pacific neighbours, enjoying substantial government support for the development of this section, do not face the same constraints to expansion of needed infrastructure.

A recent survey of financial institutional investors in Australia by Macquarie Bank revealed that the risks associated with tourism assets are seen to be more complex than other investment options combining elements of both property and business risks. Few respondents were satisfied with the level of information and expertise. There was also relatively poor profitability, a lack of liquidity and a perception of volatility in income and asset values. This level of perceived risk stems from a number of issues that include poor confidence in industry information, thus challenging industry and government to work together to improve the quality, timeliness and relevance of information that can be reliably used to analyse and measure the investment performance of the sector. At the same time, it is recognized that representatives of the tourist industry, including those from the MICE sector, need to work closely at a senior level with all levels of government in creating a planning and taxation framework that is consistent with the requirements of the investment community and the unique characteristics of tourism investment (Tourism Forecasting Council, 1996). Given the time lags for development to occur in tourism infrastructure, the development community needs some confidence in future performance to invest at the present time. Similarly, the industry must cultivate a relationship with institutional investors immediately if institutions and thereby Australian ownership is to have a major role in the next phase of tourism development in Australia. Without this relationship, tourism, and MICE tourism in particular, will be disadvantaged by limited infrastructure compared to major-competitor destinations.

A positive step in the direction of providing more information to potential investors in MICE tourism in Australia is the development of a new methodology for forecasting supply and demand for tourist accommodation (Tourism Forecasting Council, 1996). The strength of the new TFC methodology is that it allows for the interplay between supply and demand in determining the price and quantity of accommodation and will lead to more accurate forecasts of the need for tourism accommodation. More accurate forecasts of the need for tourist accommodation are particularly welcome in the context of development of MICE tourism. They should help to reduce the severity and costs of large fluctuations in investment in accommodation, an issue which is vital to the tourist industry, the banking community, planners, managers and operators.

These types of initiatives assume particular importance for Australia, as compared to its competitor MICE destinations, because its economy is developing in the context of a less interventionist policy regime. Under the existing government emphasis on 'free market' economics, the goal is a reduction of impediments to industry efficiency and productivity rather than the provision of direct support to achieve competitiveness. While this policy may well produce longer term benefits for the economy, the MICE sector of Australian tourism remains relatively disadvantaged in the short term by its government's limited financial support as compared with major competitors in the Asia-Pacific.

Service Standards and Training

Staff and training requirements are changing as tourism becomes more professional. The expansion of tourism world-wide has required growing numbers of well qualified personnel at all levels to prepare and implement development policies to manage tourism operations and to staff the diverse activities which comprise provision of tourism services. The industry faces increasing market expectation that a high level of services will be provided and that it will be equipped to handle technological developments that are taking place at a rapid rate. The World Tourism Organization has recently identified certain market forces which will determine global tourism flows and trends over the next two decades (WTO, 1994d). On the demand side these include increased consumer prioritization of travel in their scale of preferences, increased demand for new more imaginative and varied tourism products and services, and increased market segmentation in travel and tourism particularly related to demographics, lifestyles and interest groups. On the supply side they include greater diversification of tourist developments in established destinations, and new facility and amenity development in line with the market trends towards 'individuality', activity-orientation and requirements for high safety standards. These demand side and supply side trends have enormous implications for human resource development. As the World Tourism Organization warned:

> The capacity of educational institutions in most countries to train staff at all levels and for all the wide range of skills required for the travel and tourism sector has rarely been adequate. There is a danger that this problem will worsen during the 1990s - at all levels, in all categories and in every type of tourist receiving country. Human resources could emerge as the single most important issue facing tourism operators into the next century (WTO, 1994d).

A prerequisite for the tourism industry maximizing its growth potential in individual countries is a supply of skilled managers. The market forces identified by the World Tourism Organization imply that present and future managers of tourism facilities and organizations must have particular skills in areas such as strategic

management, economic and financial decision making, marketing management and strategic planning, while possessing specialised knowledge of various aspects of the global tourism industry. Human resource development in management and marketing skills is identified as an area of concern in the Long Range Plan of the Pacific Asia Travel Association (PATA, 1992, 1994). Meetings, exhibitions and theme events are complex tasks requiring skills in management, marketing, negotiations, budgeting and communications (Commonwealth Department of Tourism, 1995).

Continual improvement in service standards is essential if the industry in emerging destinations such as Australia is to compete successfully with the more established MICE destinations and counteract the growing competition from Asia. Enhancing employee expertise through human resource development increases the likelihood that business objectives will be achieved (Jacobs and Jones, 1995; Swanson, 1994). Human resources are ultimately the only business resource with the creativity and adaptive power to sustain an organization's success despite changing market conditions (Torraco and Swanson, 1995). High levels of employee expertise are inevitably required if stakeholders in a country's MICE industry are to capitalize fully and quickly on emergent opportunities for business growth.

Some priority areas for action in human resource development have been highlighted in Australia's MICE strategy (Commonwealth Department of Tourism, 1995):

- industry-specific education so that the industry is able to meet the demand for qualified and trained professionals;
- accreditation and an established code of ethics to ensure that the industry conforms to professional standards;
- career paths and opportunities designed to develop the expertise of personnel and encourage their retention in the industry;
- protection for clients and for delegates attending conventions or meetings particular in relation to the responsibilities of professional conference organizers.

One problem with the tourism industry generally is that many employers do not require their staff to undergo formal training. Indeed, the availability of skilled and trained manpower is a crucial element in the successful longterm development of tourism in the Asia-Pacific Region (Hobson, 1994). There is evidence to suggest that employees with formal training receive a smaller wage premium in tourism than in other industries and that employers look for experience rather than formal qualifications when hiring. An Industry Commission survey found that the majority of employers, especially small employers, are not yet aware of the major initiatives to expand training for tourism jobs and their relevance. Only if employers are aware of and value the training now being put in place, will the intended increase in skills and training be realized (Industry Commission, 1995).

Today's business environments require that human resource development not only *support* the business strategies of organizations but that it assumes a pivotal role in the *shaping of business strategy*. Business success increasingly hinges on an organization's ability to use employee expertise as a factor in shaping business strategy. Perhaps nowhere else within the tourism industry is human resource development more crucial than in the MICE sector.

However, labour related issues pose a major challenge to continued growth and are very important in terms of service standards. Although 'progress has already been made in developing education and accreditation programmes to meet the needs of personnel working in the industry' (Commonwealth Department of Tourism, 1995:17) much still needs to be achieved in incorporating these programmes into the workforce of any individual enterprise.

Employment conditions in the industry in countries, such as Australia, are regulated by a complex set of awards and agreements which bind both the employer and employee (Timo, 1996). At the individual enterprise level in the industry, the approach to award restructuring, and its relationship to training, career path development and remuneration are at a very early stage of development.

Indeed the connection between training, award restructuring and the development of career paths is only being accepted within the industry generally and has seen little implementation. For example, in a recent study of hotel workplace reform, the single most important issue raised by staff was the issue of training and career paths (Blake Dawson Waldron, 1994). Initiatives concerning service standards and training which may be negotiated through the enterprise bargaining process could include: establishing a better trained and more committed workforce by increasing permanent and reducing casual staff; and establishing enhanced training and career path opportunities. Award restructuring provides a basis for a reformulation of labour relations within the industry, as shown by increasing trends towards enterprise agreements.

Marketing Issues

While MICE tourism to a country will grow in absolute terms if that country simply maintains its current share of this market in the Asia-Pacific, there are several strategies which can be employed to boost market share.

Four objectives drive the marketing strategies of Australia's MICE industry (Commonwealth Department of Tourism, 1995):

- enhance international awareness of Australia as a premier MICE destination;
- promote coordinated and cooperative marketing of the MICE industry;

- encourage national associations to attract overseas delegates, particularly from the Asia-Pacific region, to meetings and exhibitions in Australia;
- boost the number of delegates attending conferences in Australia at the local, national and international level.

These types of objectives are relevant to other MICE destinations in the region. With respect to the first objective, NTOs throughout the Asia-Pacific seek to enhance international awareness and appreciation of their respective countries as tourism destinations and there is an obvious synergy to be gained in promoting the MICE sector within more generic marketing activity. Australia is attempting to develop a global branding campaign to position its MICE industry competitively. It is also promoting a broad range of incentive destinations and pre- and post-event touring operations. This is to recognize that the incentives market has, perhaps, the greatest untapped potential of any sector of the MICE industry.

The Sydney Olympics 2000 should provide an unparalleled opportunity to market MICE tourism to Australia. The impact on tourism of the Games themselves will probably not be particularly large. Of greater significance to tourism is likely to be the longer term impact through increasing awareness and interest in Australia as a place to visit. These will start before the Games themselves and it will be greatest around the time of the Games or shortly afterwards. The impact can be expected to last for several years.

As regards the second marketing objective, the links between meetings, incentives, conventions and exhibitors, with their common stakeholders, is such that there are advantages to be gained by close liaison between them. The recently formed MICE industry council may be expected to play an increasingly important role in the development of a coordinated and cooperative marketing effort for Australia's MICE industry. In this respect, Australia is further advanced than other Asian-Pacific countries.

Regarding the third objective, this can be achieved by motivating national associations to promote their meetings and exhibitions as regional events. This is certainly occurring in respect of tourism conferences (e.g., Pacific Rim Tourism 2000) and represents a growing trend throughout the region. MICE destination countries can also identify associations which are in a position to form an international secretariat within the country and encourage them to do so. Professional associations can also be encouraged to offer study tours to overseas colleagues in the region to stimulate interest in organizing future meetings within a country.

The objective of boosting attendance at local, national and international conferences is better interpreted as the objective of increasing foreign exchange earnings from international visitors while reducing foreign exchange losses from conferences attended elsewhere. Conferences held within a country play an 'import replacement' role with respect to a country's balance of payments. The provision of pre- and post-conference opportunities for touring can increase lengths of stay at a

destination with corresponding additional injected visitor expenditure. Qualitative research on delegates' motivations can provide a base for more effective strategies to boost delegate numbers and to increase the economic significance of MICE tourism.

Conclusions

Tides of change are apparent in the MICE industry which is experiencing rapid development in many markets globally along with other tourism sectors. Opportunities are abundant. Even so, to manage any component of the industry successfully is a complex task, requiring an uncommon set of diverse skills.

There are major constraints in the development of the industry, including inadequate data for planning nationally and regionally, strong international competition, the timely provision of infrastructure and accommodation facilities, and service standards and training. In addition, several marketing concerns need to be addressed. As in most countries, strategies and solutions for developing the industry will be generated in some combination of both public and private arenas; an overarching constraint could be the nature of interplay between these sectors including their ability to work together in a proactive way for shared goals.

Four main points can be made which determine and underpin challenges for the industry. First, the MICE is a growth industry in the international market; second, its managers require diverse skills; third, the industry is extremely competitive; and, finally, inability to overcome any of the constraints may well result in lost opportunities for a particular country.

These complex challenges must be met by tourism and hospitality managers in both the public and private arenas if the MICE industry is to position and avail itself of opportunities, thereby maximizing social, cultural and economic benefits in their respective countries. Although Australian and Asia-Pacific examples were referred to in this paper, the issues discussed are of generic importance and apply to most other countries involved in maintenance or development of the MICE industry.

Chapter nineteen:

Future Perspectives of Tourism - Traditional versus New Destinations

Friedrich M. Zimmermann
*Department of Geography and Regional Studies, University of Graz,
A-8010 Graz, Austria*

Introduction

This chapter deals with future aspects of tourism development, based on European experiences, to provide some lessons from abroad for the Pacific Rim region. It provides answers to the question: 'What could happen to certain tourism destinations in the Pacific in 10 or 20 years?'

Europe and the International Tourism Market

Despite the very positive outlook for international tourism, several tourism areas in Europe are facing problems because of an increasing pressure from international competition. Tourist arrivals in Europe more or less stagnate since the beginning of the 1990s, and receipts registered a first drop since the mid-1980s. Europe has lost 10 per cent of its market share since 1975, while East Asia and the Pacific made the most significant gains (11 per cent). Dynamism in East Asia/Pacific can additionally be outlined by two figures:

- Receipts out of international tourism more than quintupled between 1985 and 1995 and 85 per cent of all tourism-related jobs additionally generated until 2005 (worldwide: 144 million) will be created in the East Asia/Pacific region.
- Projected into the future, international arrivals will decrease in Europe until 2010 to close to 50 per cent, while Asia is going to increase its share to more than 25 per cent (WTO, 1996c).

The main tourist flows in Europe are intraregional, accounting for more than 75 per cent of total international tourist arrivals. Therefore it is essential to know that tourists from Europe (with an international market share in arrivals of 60 % in 1995) are preferring more distant, fashionable, cheap and easily accessible (flight) destinations, attitudes which do not hold much promise for traditional tourism regions in Europe any longer. Additionally, tourist arrivals from North America (almost 20 % market share) to Europe are declining, largely due to high price levels and exchange-rate problems. Asia (market share of 18 %) as the future market for Europe, especially for city tours, business and incentive trips, is increasing its importance for the European market steadily.

Internationalization and Europeanization of Tourism

Tourism can be characterized by a dualistic structure, polarized between a small number of large companies and a large number of small enterprises. The internationalization of tourism, as part of the process of globalization of international investment, and the growth of mass leisure tourism have largely influenced and changed these structures.

1. There is an internationalization of tourist activities and investments, based on competitive strategies like product differentiation, cost leadership, niche-market policy, affecting international airlines, hotels and tour operators. This dynamism has negative effects upon the small- and medium-scale European tourism industry.

2. There is a kind of 'Europeanization' of mass leisure tourism activities, based on consumerism, changing social and demographic factors and cultural values in Europe, as well as the European Union integration tendencies, and the effects of the opening of Eastern Europe.

European Perspectives

Changes of External Influence Factors for Europe

Important changes in the social and demographic set-up of the Western European visitors have caused a new challenge for the European tourism industry at all levels. A number of elements have been identified in the literature on social change, such as:

- the move to shorter working hours;
- a dynamic development of the right to holidays;
- a high level of motorization;
- the creation of a 'new middle class';
- growing number of seniors, decrease of young people;

- increasing number of single-person households;
- saturation in the consumer sector;
- high unemployment rates; and
- the extreme development of communication media, etc.

Beside these elements, the new trends in European tourist behaviour are:

- short-term tourism (caused by a dynamic development of day trips and weekend holidays);
- spontaneous, immediate decisions where to spend the holidays (increase of single households and senior citizens, independent financially, institutionally and time-wise;
- stronger demand for reasonable last-minute offers and overseas destinations;
- individual and flexible holiday planning (with respect to time and contents);
- specialization and orientation towards certain target groups (new, niche products offer advantages);
- intensive need of excitement and adventure (exotic destinations are preferred);
- pretentious quality and high comfort;
- increased sense of life, escapism and body consciousness; and
- increasing environmental consciousness and significance of ecological quality (gentle tourism offers and sustainable developed regions as a counterpart to international mass tourism).

The European tourist in the year 2000 can be characterized by a new duality of (mass-tourism) demand:

1. Average guests who are rather passive and in need of animation and entertainment;
2. 'Educated' tourists who are initiative, lifestyle oriented, conscious of environment and health, critical towards comparable offers and conscious of quality; and
3. Besides mass-tourism, there is a small, high-income target group, preferring either small-scale, individual offers in peripheral areas or exploring new, exotic, alternative regions.

Changing Tourist Patterns and Products

The effects of the European demand developments on products should be detailed by using a product-cycle approach, using Butler's (1980) destination life cycle model (Fig. 19.1).

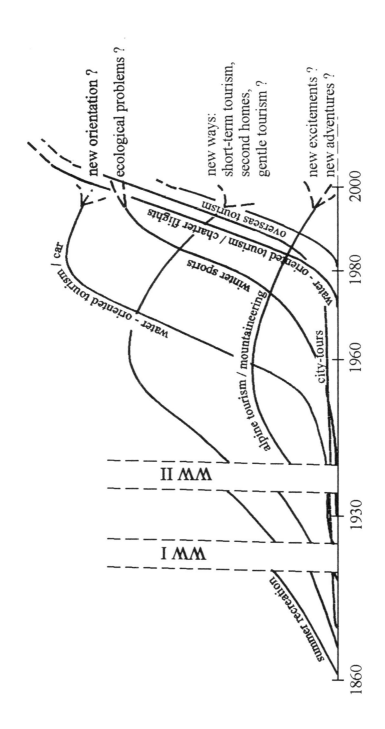

Figure 19.1. European Tourism Products - A Product Life Cycle Approach

Summer Recreation and Alpine Tourism

The development of tourism in Europe can be traced back to the 18th century, when artists, writers, poets and members of the aristocracy travelled for educational, religious or health reasons (Grand Tour). Tourism as a kind of mass phenomenon started in the second half of the 19th century with the first railroads crossing the continent. Beside the already mentioned motivations for travelling, summer recreation and mountain climbing started to become important. In 1863, Thomas Cook led the first package tour to Switzerland and at the same time climbers began to explore the peaks of the Alps. Reacting to the increasing number of tourists, cableways were established. By the early 20th century Switzerland and Austria were the most important destinations within the European Alps region, offering

- high (society) level tourism in the Grand Hotels, especially for the aristocracy;
- mountaineering in Alpine areas; and
- cures in health resorts based on thermal water.

Another very important area with tourism activities, at the beginning of the 20th century, included some locations at the seaside of the Mediterranean Sea, such as Cannes and Nizza.

Water-oriented, Summer Tourism (Automobile-based)

After World War II, water-oriented summer activities, based on automobiles which flexibilized the recreation patterns, virtually exploded in Europe. At first, at well-known places along the shores of Alpine lakes, then at the Adriatic Sea in Italy and former Yugoslavia, in Spain, Greece, etc.

Winter Sports

At the beginning of the 20th century skiing and ice-skating were invented as new types of recreation for the youth. First the preserve of the wealthy, this changed with the take-off of winter sports tourism at the end of the 1960s. The change was characterized by the development of new winter resorts and the extension of existing centres, an increasing importance of large development companies and less environmental consideration resulting in a lot of transformation for many Alpine areas. Changes became apparent in the landscape; modern and purpose-built chalets, apartments, hotels and restaurants, ski-lifts and slopes started to cover certain areas in high altitudes. Despite a dynamic development of a sub-product, snowboarding, winter sports tourism seems to have reached its maturity in the early 1990s, suffering from the decrease of young people and the competition of overseas destinations.

What is Next?

The decline of particular products and consequently the decline of certain regions is based on competition from new destinations, like water-oriented flight destinations and overseas destinations. Air transport, in former time reserved for an élite, became accessible to the masses in the 1970s as a result of strong price decreases. In consequence, air travel did significantly modify the spatial distribution of tourist activities. Cooperation with the tourism industry, business concentration, professional organization and marketing, as well as price benefits due to economies of scale and low-cost labour aggregated the tourist flows and offered the customers new travel packages.

Finally, one needs to stress another product, rural tourism, as an indigenous development in peripheral areas, which is playing an increasingly important and diversified role in local development (Cavaco, 1995). Rural tourism, based upon sustainable development strategies, offers the chances of a re-evaluation of cultural heritage, of the environment and of the identity of villages and people so that they can acquire cultural exchange, earnings in certain farming, artisanal and service structures, as well as an improved quality of life. Rural tourism has therefore been defined as a specific goal of the European Union Regional Policy, by using an integrated approach to rural development (European Commission, 1994).

Competitive and Comparative Advantages of Destinations

With the exceptions of well-known cities like London, Paris, Rome, Vienna - on tours like 'Europe in a week' - and certain flight destinations like Turkey, who are part of the international tourism business, the development chances for traditional tourism areas in Europe are negatively influenced by the following facts:

- Small-scale Europe promotes car-based, individually organized tourism;
- Single-seasonality, which is essential for several regions in Western Europe, leads to a reduced economic efficiency;
- Economic problems are caused by a decreasing demand for certain traditional offers; the domination of some multinational tourism businesses generates enormous pressure on small- and medium-scale tourism structures;
- Existence of a large number of small-scale enterprises with low marketing efficiency, indebtedness and capital shortage;
- Capital shortage and structural problems lead to lack of investments and innovations - the share of outmoded products is increasing;
- Image problems and effects of inertia avoid the emergence of new products;
- Local-concentration phenomena favour regions with initiative entrepreneurs;
- The tourism enterprises offer high quality but have to raise high prices (caused by high taxes, high labour costs);

- Organizational problems in the commercial business and at the regional and federal level remain unresolved;
- High ecological standards characterize many European destinations - they are associated with higher costs and strict development limits;
- Social changes cause a critical attitude towards tourism among guests as well as the local population - a saturation level seems to be reached; and
- 80 per cent dependency on European tourists.

All these problems lead to a lack of innovations which would be very necessary to regain competitiveness. It is doubtful whether the support of tourism through policy initiatives is effective enough, considering the competitive advantages of the international tourism.

Contrary to the European perspective, the dynamic international trends show that:

- 70 % of international tourists use air transportation (airlines structure the tourism market);
- 90 % of international tourists use tour operators - tour operators dominate the market;
- Tour operators shape the international offer and create images and fashions;
- Moreover, international capital is creating new destinations and is enlarging the amount of tourism supply;
- Business concentrations offer efficient organization and marketing;
- Price advantages by using economies of scale and low-cost labour;
- The international competition faces comparably lower ecological standards and legal restrictions;
- Travel-experienced and curious guests are looking for new excitements and new regions; and
- Diversified source areas of tourists (e.g. for Asia: 40 per cent Europe, 40 per cent Asia, 20 per cent America) result in less reliance on single markets.

Future Strategies

Asia and the Pacific

Main goals for tourism development for Asia and the Pacific were discussed at the World Conference of Tourism Ministers in Osaka, Japan, 1994. These aims and additional ideas can be summarized as follows:

- Integrated tourism planning and a multidisciplinary approach in achieving sustainable tourism development;
- Definition of development goals and carrying-capacity figures;
- Maximizing the socio-economic benefits from the development of tourism while minimizing its adverse impact;

- Promotion of investments into tourism under constraints of an improved economic situation and quality of life for the local population;
- Promotion of regional cooperation, esp. in tourism development;
- Focus on education and training measures;
- Prevention of environmental and cultural damage instead of repairing it after it has occurred; and
- Creation of mechanisms to protect traditions and the cultural heritage and to create rescue plans for regions in danger.

Europe

The basic strategies for a positive future development of tourism in Europe - and of course several ideas are applicable worldwide - are:

- Management and restructuring policies should have priority over development policies;
- The current situation increases the need for diversification of source markets;
- Improvement of cooperation strategies and concepts between businesses, local and national governments, European Union;
- A well-preserved natural environment is the main factor for future tourism products;
- Tourism must be integrated part of the quality of life in order to reduce the tourism weariness of the local population;
- National governments and the European Union will have to provide restructuring strategies and support for those regions, being not competitive any longer; and
- The response to international competition and to a new duality of tourist demand are new quality-oriented product specifications;

Health

With an increase of the number of older people in Europe and North America, health tourism will get new impulses for recovering and for prophylactic measures. At the same time, the new health trend will experience a dynamic development due to rising environmental awareness and body consciousness by younger people. An intact nature and environment will be of special importance for this kind of offer.

Sports

In the course of the new health-wave, sports will create new proportions. The potential of young seniors rather advocates tendencies of growth heading towards 'soft and gentle' activities (cross-country skiing, hiking, bicycle-riding, horseback riding, etc.) with a main aspect in enjoying the nature.

Adventure and Attractions

On the one hand a policy of filling market gaps aiming at extreme-sports adventures (mountain climbing, paragliding, rafting, etc.) promises a dynamic development, on the other hand attractions with a good-quality basis and professional know-how (recreation centres, theme parks, packages with certain topics) are definite investments into the future protecting the nature by monitoring the tourism streams.

Art and Culture

The cultural heritage in Europe offers good future perspectives on account of an increasing demand of immaterial goods.

Nostalgia and Tradition

Based on the future markets in overseas areas the disadvantages of traditional tourism structures could be overcome by combining tradition with high-quality hard- and software into a 'Nostalgia - Package Tour'.

Conclusion

A consistent orientation towards new products requires large-scale specialization of offers as well as adaptation to the holiday-styles of segmented target-groups. The tourism products must allow holidays which are as varied as possible, and must be innovative (new leisure technologies) and sociable (individual offers, personal contacts, possibilities to enjoy culture, to study according to individual interests). By using modern information and communication techniques, offers should be made consumable according to individual preferences.

The central message for tourism offers at the end of this century is:

Tourism must present not just a product but ... an attractive and individual touristic 'lifestyle'

Chapter twenty:

The Future of Tourism in the Pacific Rim

Martin Oppermann

Centre for Tourism Studies, Waiariki Polytechnic, Private Bag 3028, Rotorua, New Zealand

Introduction

With the third millennium rapidly approaching, the future of tourism in the Pacific Rim, but also on a global scale, looks very promising. More and more people in the developed world but also in the more affluent developing countries are packing their luggage and travelling farther and farther. The younger generations gain a completely different travel experience in their childhood and early adulthood, setting them on a unique stage in their travel career or travel life cycle. Research has shown that they are likely to travel to more distant destinations in later stages of their life cycle as well (Oppermann, 1995a, 1995b). Furthermore, tourism has rapidly emerged as a social status symbol with a high resistance towards monetary self-discipline in recession years. Especially long-haul travel appears little affected from recession and it is earmarked by the World Tourism Organization to be a major growth leader well into the next millennium. The major trends forecasted by the WTO (1997a, 1997b) are:

- The 21st century will see a higher percentage of the total population travelling, especially in developing countries;
- People will be going on holidays more often ... sometimes two, three or four times a year;
- Travellers of the 21st century will also be going farther and farther;
- The *Tourism 2020 Vision* forecast predicts that by 2020 one out of every three trips will be long-haul journeys to another region of the world;
- acceleration of multiple, relatively short duration trips on the part of the travellers of industrialized countries; and
- strong uptake of foreign travel by the populations of developing countries.

Furthermore, the World Tourism Organization suggests that 'the fastest rates of (outbound) growth will be achieved by the residents of countries in East Asia and the Pacific' (WTO, 1997a). However, the same source predicts a slightly below global average growth for outbound travel from the Americas. None the less, judging by the large share of intraregional travel in the East Asia Pacific and the Americas, the vast majority of this additional demand will be incurred in neighbouring countries in the Pacific Rim region.

Thus, tourism demand in the 1990s and presumably well into the next millennium is much more stable than many commentators over the last few decades have thought it to be. This does not mean that destinations can relax and watch the tourist flock to their beaches, temples, mountains, cities and forests. The rapid expansion of tourism destinations around the world with more and more countries opting for tourism developments denotes an increasing competition for the tourists. And many countries have yet to enter the competition in a serious way. India, most African countries, and the newly formed Republics in the territory of the former USSR are but a few examples of countries with great tourism potential, but which have not yet been able or willing to tap into the tourism market. Hence, while tourism demand will most certainly be expanding, the competitors and new entrants to the tourism industry are waiting to take a share of the pie. Some countries are prone to benefit from their engagement in tourism over the last few decades and their consistent work on their tourism image. Others have to overcome their non-image or even a negative image in the markets before they will be able to gain a larger share of the market.

Key Trends

Probably the most important impact on tourism demand in the Pacific Basin region has been the rapid emergence of the Asian Tigers as large outbound generating markets (see Chapter five). The growing affluence and still rapid expansion of the economies in Malaysia, Thailand and Indonesia signifies yet another wave of outbound tourism growth in the region. And China is already dubbed as the country with the greatest outbound generation potential (Wang and Sheldon, 1995). In some countries, Chinese outbound tourism certainly had already made a major impact. In Malaysia, for example, arrivals from mainland China approached the 100,000 mark in 1994, exceeding other secondary markets such as the United States, South Korea and Germany. Within a few years, it climbed from virtually nothing (less than 7,000 arrivals in 1990) to became the 10th most important source country.

However, because the great outbound growth among the Asian markets is currently only felt in the western part of the Pacific Rim area, other countries should still be aware of these source markets and, depending on their location, may be wise to actively promote their country in these markets and/or establish direct flight links. As the Japanese outbound tourist wave conquered and left behind many countries in the area on the search for newer and more remote places, a similar occurrence can be expected for the other Asian markets as well.

Socio-economic Factors

Among the socio-economic factors that are prone to sway demand for specific vacation products and destinations, one needs to distinguish those in the traditional markets (North America and Europe) and the newly emerging markets (North Asia, South East Asia, and other economic advanced developing countries). While net incomes and disposable incomes are unlikely to expand significantly in the former, profound increases are expected among the latter. Economic growth in North and South East Asia is generally expected to remain high, far above world average. The growing prosperity in this region and especially an expanding middle class with sufficient disposable income for pleasure travel will induce a growing demand for domestic but also international tourism. Furthermore, there appears to be a prevailing tendency towards increasing paid holiday leave which will amplify the disposable income effect. Hence, Western Pacific Rim countries can expect an even higher share of intraregional travel over the next few years. Also, if economic growth stabilizes in South American countries, the neighbouring countries are to benefit from it.

Trends in North America and Europe will be more influenced by other factors, as paid holiday and disposable income are not expected to increase significantly. Existing trends towards dual income families will reinforce the propensity of taking short breaks, which have been growing strongly for several years (King, 1994), because of difficulties in synchronizing holiday leaves for two. Obviously, not many Pacific Rim countries will be able to benefit from short breaks in these two important source regions as they are too far away to make the trip worthwhile.

Another trend in these markets is towards fewer and fewer children, and children at later stages in the life cycle. As a result, potential pleasure travellers are more flexible in their vacation times and can afford to take their trips in the off-season rather than during the main holiday breaks. Thus, demand may become somewhat more balanced and less concentrated in a few weeks or months which will contribute towards a lower seasonality, better occupancy throughout the year, and, therefore, improved profitability. In addition, young couples or singles with no children tend to have some of the highest disposable incomes and are more apt to take vacations overseas owing to their more adventurous nature. Some Pacific Rim countries should be able to capitalize on this trend.

Outbound travel to the Pacific Rim region from the world's largest outbound country, Germany, appears still to be growing, albeit at a slower rate than to some other long-haul destination areas (Table 20.1).

Aviation

While the introduction of an affordable supersonic jet may only occur well into the next millennium, the current trend towards larger, much more efficient and even longer-range capacity planes will bring countries in the Pacific Rim region even further together and naturally also reduce the travelling time and travel cost from other world regions.

Table 20.1. German Tour Operators' Sales to Leading Long-haul Destination Regions, 1995/96

Destination	No. of Clients/Sales	% Change over 94/95
Africa	147,648	12.0
Asia-Pacific	422,097	1.9
North America	763,286	3.7
Latin America/Caribbean	482,129	7.5

Source: PATA, 1997b

More important, however, is the current liberalization of airline policies in many Asian Pacific Rim countries. Malaysia's second airline Air Asia, for example, is expected soon to service also international destinations (PATA, 1997b). Similarly, other airlines are starting up, effectively breaking the former monopoly of the government-owned national airlines. The net result is an increased competition for passengers, and one can expect airfares to remain at current levels or even drop further. In any case, the real cost of travel is expected to decrease which will further fuel the demand for outbound travel in the region's countries.

Following the USA/Singapore agreement on Open Skies, similar arrangements are expected to follow suit for countries such as South Korea, Taiwan, Malaysia and New Zealand (PATA, 1997c). In general, such agreements can be expected to become more and more prevalent as governments realize the importance of free access and free trade.

Barriers and Problems

Transportation Infrastructure

To what extent current transportation bottlenecks, and in some cases accommodation shortages, will negatively infringe on Pacific Rim tourism remains to be seen. The fact that some of the world's largest airports are currently under construction in the Pacific Rim region, especially in the Asian part, could serve as an indicator that this problem has been recognized and will not become a crucial issue in the 3rd millennium. Many airports around the Pacific are currently upgrading their facilities and several new airports are scheduled to open before the end of the century.

Recession and Exchange Rates

Perhaps the most unpredictable issue is the future development of exchange rates. The recent slip of the yen against the US dollar meant that the buying power of Japanese outbound travel has significantly decreased. While it is still high, it could lead to a re-

orientation of travel towards domestic destinations and/or those destinations which have a more favourable exchange rate.

In a recent article, Garten (1997) warned of an overtly positive reliance on the future growth of the emerging economies, many of these located in the Pacific Rim region. Political instability could very well turn investors away from these countries and result in a drastic downturn of their economic fortunes. In consequence, outbound travel from these countries might be severely affected. In Mexico, for example, high inflation and taxes are currently strangling the middle class and, therefore, the very group where one would expect future growth in outbound and domestic travel to occur.

Safety and Health Issues

Perceived safety and political stability are among the major variables that influence international travel patterns. Richter (1992) argued that another factor affecting perceptions is how the violence in question is labelled. Political-inspired violence, urban guerrillas, terrorism or civil strife strike irrational fears among potential tourists, deflecting travel decisions away from controversial destinations. Safety checklists for overseas travellers (Japan) or lists of countries considered unsafe (United States) are but two examples of how governments in the source countries attempt to provide their citizens with information on safety aspects in destination countries. Richter identified several areas where political instability and safety issues can seriously affect tourism development: regional conflicts, area of turmoil, tourist as political pawn, and tourism as rationale for political unrest.

Regional conflicts often have an impact on the tourism industry beyond the immediate conflict area. In many Central and South American countries, tourism development is seriously hampered by the recurrence of political instability in the form of military coups, civil war and national liberation wars (Richter, 1992). For distant markets such events may be associated with the whole region and not only the country in question, especially when there is a repetition of such incidents in a number of countries in the region.

In Fiji, the two coups in 1987 did not only reduce tourist arrivals to Fiji itself but also to several neighbouring countries since many flights were routed through Fiji. While tourists were never really in danger, the long-term future of the tourism industry was. Several international airlines did not only temporarily reroute their flights but dropped Fiji as a stopover between North America and Australia/New Zealand altogether.

More threatening to the tourists themselves are instances where the tourists become political pawns in fights between the government and opposition groups. Tourists have been kidnapped by opposition groups in countries such as China and the Philippines in order to compromise the government and to destroy a major income generator. In more radical cases, tourists are purposely attacked and killed. The Shining Path in Peru, for example, has not only crippled tourism to the famous ruins of Macchu Picchu but affected the nation as a whole.

Health concerns are and have always been among the deterrents to travel in general and to some destinations in particular. Many developing countries are not free from infectious diseases such as cholera, hepatitis, yellow fever, typhus and malaria. The simple fact that one or the other disease may be prevalent in a specific destination country can prove to be an effective obstacle. In some major tourism source countries, specific medical centres have been established which advise on the existence of diseases around the world and provide immunization and health risk guidelines for all countries around the world (see Chapter fifteen).

Market Segments

Health Tourism

Health and physical recuperation are also becoming more important travel motivators (King, 1994) and some Pacific Rim countries with the appropriate resources are well poised to take advantage of this. Early tourism development in New Zealand, for example, was geared towards health tourism although this has not been emphasized in recent decades. However, judging by developments in Europe (see also Chapter nineteen), health tourism can be established as a viable and high profile niche sector.

Cruising

The cruise market is one of the world's fastest growing niche products and it is also expected to grow substantially in the years to come. According to a report by the Travel & Tourism Intelligence, it is estimated that the current market size in Asia is 250,000 alone and it is expected at least to double to 500,000 by the end of the decade (PATA, 1997a).

Convention Tourism

Several hundred million people travel each year to attend a conference, convention and/or congress. Undoubtedly the largest market for this type of travel is in North America where some 85 million person trips are undertaken for meetings and conventions (Oppermann, 1994e). But conference tourism in other Pacific Rim countries is also on the increase, such as in Singapore, Japan, Hong Kong and South Korea. Seemingly the most successful city in that respect is Singapore. It has ranked among the top 10 conference destinations for the last few years, ahead of Washington DC, New York and Hong Kong (Oppermann, 1996b). More and more countries built conference centres in order to capitalize on this newly emerging tourism sector. A good example are the Philippines, where such a centre was built in the 1980s (Oppermann, 1994/95).

Table 20.2 provides a global overview of international congresses held. It shows that while the share of the Americas has remained virtually constant over the last 40 years, the share of the Asia region has more than trebled at the expense of Europe. In a sense, this mirrors the general development of tourist arrivals on a global scale (see Chapter two).

Table 20.2. International Congresses by Continent, 1954-1993

Continent	1954	in %	1968	in %	1982	in %	1993	in %
Africa	27	3	92	3	148	3	446	5
Americas	197	19	497	18	822	19	1,802	20
Asia	40	4	212	8	470	11	1,138	13
Austr-Ocean.	6	1	29	1	110	3	162	2
Europe	788	74	1,898	70	2,826	65	5,269	60
World	1,058	100	2,728	100	4,376	100	8,817	100

Sources: Alkjaer, 1970; LaBasse, 1984; Rockett and Smillie, 1994

The major advantages commonly associated with convention tourism are the high per day expenditure of conference attendees and the seasonality of demand. Conferences are often held in the off- or shoulder season and, therefore, contribute to a better occupancy in otherwise slacking times. Besides having a high per day expenditure, many conference participants also combine their conference business travel with pleasure. They may not only take in the sights during the conference, but add a few nights before or after the conference for leisure purposes.

An obvious sign that convention tourism is not strictly business tourism and has wider impacts beyond the participants and length of the conference is the number of spouses accompanying the conference attendees. Approximately one third of association attendees in North America are accompanied by spouses. And the Association of International Scientific Tourism Experts with meetings held around the globe registers a similar spouse turnout. Another sign is that many conference programmes provide for spouse activities and agenda. Hence, an attractive destination can draw additional benefits from conferences beyond the attendees. Oppermann and Chon's (1997b) models of convention location choice and the participation decision making process illustrate the actors and factors involved in the association meetings market.

Convention tourism is a valuable tourism sector and many countries are placing great hopes on it. Important prerequisites for a successful development to a

convention destination are several factors, such as easy and relatively inexpensive access from the relevant source markets, adequate conference, accommodation and restaurant facilities and an image of a safe and exciting destination, to name a few (Oppermann 1996c, 1996d).

Backpackers

A rarely examined tourist type is backpackers: they are often disliked because of their low per day expenditure and sometimes even met with open hostility. However, they really deserve a closer look by most developing countries, as Oppermann and Chon (1997a) pointed out:

First of all, their low per day expenditures are often compensated by a much longer stay bringing their per trip expenditure often close or even higher than that of other tourists. In the cases of backpackers in Australia and New Zealand, for example, backpackers spend a significantly higher amount within these countries than any other market segment.

Secondly, their expenditures tend to go to smaller restaurants, small hotels or other accommodation forms, and local transportation companies. All these enterprises are characterized by their higher integration into the local economy with significantly lower leakages and, therefore, a higher multiplier effect. Thus, each dollar spent by backpackers is more beneficial to the developing countries than those by ordinary mass tourists.

Third, the regional impact of backpackers is much wider due to their more active intranational travel patterns and longer length of stay. Hence, peripheral and non-traditional tourist areas primarily benefit from this tourist type whereas most expenditures by mass tourists are incurred in the major gateways and resorts.

Fourth, backpackers are commonly considered the explorers or pioneers of tourism development. Except for instant resorts, it is these unusual tourists who discover locations for tourism and set the path for the later arrival of mass tourism through relating their experiences at home to virtually dozens and hundreds of friends and relatives. Hence, to ignore these trendsetters of tourism development is imprudent.

Fifth, because of their generally lower comfort standards, investments into this sector are profoundly lower than in four- or five-star hotels. They prefer smaller and less expensive accommodations not unlike many domestic tourists. From a resource point of view, developing countries can engage in backpacker tourism without having to resort to foreign financial investments and management capabilities. One may consider it as a bottom-up strategy of tourism development versus the top-down approach of modern mass and five-star tourism. The people involved in small scale tourism can gain valuable working experience and enhance their entrepreneurial skills. The latter seems, especially, a priceless advantage.

Marketing and Promotional Efforts

National Tourism Organizations (NTOs) in the Pacific Rim are amongst the highest spenders on tourism promotion. (Table 20.3). While the data needs to be interpreted with care, as accounting methods vary and hidden contributions may be present through other organizations than the NTOs, it is a useful overview and indicates the importance some countries place on this sector. Advertising accounts for 43 per cent of the NTO budgets in the Pacific Asia region (PATA, 1997b), but that ranges from as low as 18 per cent in the Philippines to as high as 59 per cent in Thailand. Not surprisingly, the research component in the budget is very small, less than three per cent in the Pacific Asia countries. Furthermore, it is generally the first area to be cut when budgets are tight.

Table 20.3. Top 20 NTO Promotional Budgets World-wide, 1995

Rank	Country	Budget, US$'000
1	Australia	87 949
2	United Kingdom	78 710
3	Spain	78 647
4	France	72 928
5	Singapore	53 595
6	Thailand	51 198
7	Netherlands	49 700
8	Austria	47 254
9	Ireland	37 811
10	Portugal	37 271
11	Israel	33 300
12	Switzerland	32 233
13	New Zealand	31 597
14	Canada*	31 504
15	Puerto Rico	30 807
16	South Korea	30 308
17	Hawaii, USA	28 686
18	Hong Kong	28 637
19	Morocco	24 541
20	South Africa	23 809

* Excludes partnership funding from state/territorial authorities and the private sector

Source: PATA, 1997b

Another notable feature mentioned in the PATA summary is that promotional spending allocated to different target markets often bears little relation to the markets' importance as a source of tourists or receipts. As an example, the Philippines allocated almost 30 per cent of its budget in 1995 to Europe despite only 13 per cent of all arrivals coming from that region. Also, Singapore devoted 12 per cent of its budget to the United States for less than 5 per cent of its arrivals (PATA, 1997b).

Final Notes

This book provides an overview of some of the main issues of tourism in Pacific Rim countries. Tourism remains a highly controversial topic in the popular and academic press. As with perceptions of destinations, the perception of the advantages and disadvantages appears to be highly individualistic in nature. Discussions of tourism effects are too often hampered by the lack of holistic approaches that encompass more than just economic or cultural impacts. Even within each of these, serious research is routinely hampered by a lack of data, both in-depth as well as longitudinal. Analysis of tourism's economic contribution remains only a rough estimate until a serious effort is made at tracking tourist expenditure and its direct, indirect and induced effects as it ripples through the economy and with a close examination of leakages and important contents for every product. Similarly, any study of cultural impacts of tourism will need to consider not only tourism as an agent of change but also other influencing variables such as television, music, movies and the changing workplace.

Finally, the World Tourism Organization forecasts that by the year 2020 international tourist arrivals will have increased to 1.6 billion (WTO, 1997b) and the World Travel & Tourism Council predicts that there will be an additional 120 million people employed in tourism by the year 2007, on top of the current 260 million (PATA, 1997c). While much of the overall growth volume will be again in Europe and North America, countries in the Asia-Pacific region and in Central and South America, especially, appear poised to benefit from this growth. While this continuing boom in world tourism may convince yet more countries to embark on tourism development, all countries and regions are well advised to plan for the continued tourism onslaught as pressure on land resources, and physical and socio-cultural effects are prone to increase at least at the same rate. The issue of quality tourism will gain more and more importance and it has been suggested that only a well-planned and managed tourism development can prevent or minimize negative side-effects of the continuing tourism boom (Oppermann and Chon, 1997a). A proactive and holistic approach to all aspects of tourism development and management is urgently required in order to keep the tourism industry sustainable.

References

Agel, P. (1993). Dritte-Welt-Tourismus. In: G. Haedrich, C. Kaspar, K. Klemm, and K. Kreilkamp (Eds), *Tourismus-Management, Tourismus-Marketing und Fremdenverkehrsplanung*. Berlin/New York: Walter de Gruyter, pp.715-728.

Alexander, M.W., and Judd, B. (1979). Do Nudes in Ads Enhance Brand Recall. *Journal of Advertising Research* 18(1): 47-50.

Alkjaer, E. (1970). Character and Problems of Congress Tourism. *Publications de l'AIEST* 10: 7-19.

Anderson, B. (1983). *Imagined Communities*. London: Verso.

Anderson, D., and Brown, P. (1984). The Displacement Process in Recreation. *Journal of Leisure Research* 6(1): 61-73.

Anon. (1990). *Global Outlook*. New York: United Nations.

Anon. (1993). Fiji: Tourism - The New Buzz is Ecology. *Asia Money, Fiji Supplement*, September, 30-35.

Anon. (1995). Proposals for Strengthening Management of Nature Reserves in China. In: *China's Biosphere Reserves - Special English Issue*. Beijing: Chinese National Committee for Man the Biosphere Program, pp. 3-5.

Anon. (1996). How to Boost Economy. *Fiji Times*, 11 September.

APEC Tourism Working Group (1995). *Asia-Pacific Economic Corporation (APEC) Tourism Working Group*. Singapore: APEC Secretariat.

Arndell, R. (1990). Tourism as a Development Concept in the South Pacific. *The Courier*, July/August, 83-86.

Arndt, H. (1978/79). Definitionen des Begriffes Fremdenverkehr im Wandel der Zeit. *Jahrbuch für Fremdenverkehr* 26/27: 160-174.

Ashworth, G. (1991). Products, Places and Promotion: Destination Images in the Analysis of the Tourism Industry. In: Sinclair, M.T., and Stabler, M.J. (Eds), *The Tourism Industry: An International Analysis*. Oxon: CAB International, pp. 121-142.

Asian Productivity Organization [APO] (1988). *Symposium Report on Productivity Promotion for South Pacific Countries*. Tokyo: APO.

Australian Tourist Commission (1996). *Marketing Australia to the World: Australian Tourist Commission Annual Review 1995*. Canberra: Australian Tourist Commission.

Ayala, H. (1995). From Quality Product to Ecoproduct: Will Fiji Set a Precedent? *Tourism Management* 16: 39-47.

Bailey, M. (1995). China. *International Tourism Reports*, No.1, 19-37.

Ballara, A. (1993). Paheka Uses of Takitimutangi: Who Owns Tribal Tradition? *Stout Centre Review* 3(2): 17-21.

Bartels, J. (1993). Global Hotel Power. *Cornell Hotel and Restaurant Administration Quarterly* 34(6): 10.

Barth, S., and Wollin, M. (1996). Housekeeping Teams Work. *Executive House-keeping*, July, 74-79.

Batisse, M. (1986). Development of the Biosphere Concept. *Nature and Resources* 22(3): 2-11.

Beck, U. (1992). *Risk Society: Towards a New Modernity*. London: Sage.

Beezer, A. (1994). Women and 'Adventure Travel' Tourism. *New Formations* 211: 119-130.

Behrens, R., and McAdams, K. (Eds) (1993). *Travel Medicine*. London: Churchill Livingstone.

Behrens, R., Steffen, R., and Lock, D. (1994). Travel Medicine: Before Departure. *The Medical Journal of Australia* 160(7): 143-147.

Belt, Collins and Associates Ltd (1973). *Tourism Development Programme for Fiji*. Suva: Government of Fiji.

Benveniste, G. (1977). *The Politics of Expertise*. San Francisco: Boyd and Frazer.

Berger, P., Berger, B., and Kellner, H. (1974). *The Homeless Mind*. Harmondsworth: Penguin.

Bittner, R. (1996). Five Tips for Training New Staff. *Hotels*, February, 22.

Blake Dawson Waldron Solicitors, and Arthur Andersen (1994). *Hotel Workplace Reform Study (A Study commissioned by the Tourism Task Force)*. Sydney: Blake Dawson Waldron.

Boey, C. (1994). Hilton Era Comes to an End. *PATA Travel News - Asia Pacific*, November, 33-34.

Bollard, A., Holmes, F., Kersey, D., and Thompson, M.A. (1989). *Meeting the East Asia Challenge: Trends, Prospects and Policies*. Wellington: Victoria University Press.

Boniface, P., and Fowler, P.J. (1993). *Heritage and Tourism in the 'Global Village'*. London: Routledge.

Britton, R.A. (1979). The Image of the Third World in Tourism Marketing. *Annals of Tourism Research* 6: 318-329.

Britton, S. (1982). The Political Economy of Tourism in the Third World. *Annals of Tourism Research* 9: 331-358.

Britton, S. (1983). *Tourism and Underdevelopment in Fiji*. Canberra: Australian National University Press.

Britton, S. (1987a). Tourism in Pacific Island States: Constraints and Opportunities. In: Britton, S., and Clarke, W.C. (Eds), *Ambiguous Alternative*. Suva: University of the South Pacific, pp. 113-139.

Britton, S. (1987b). Tourism in Small Developing Countries: Development Issues and Research Needs. In: Britton, S., and Clarke, W.C. (Eds), *Ambiguous Alternative*. Suva: University of the South Pacific, pp. 167-187.

Britton, S. (1989). Tourism, Dependency and Development. A Mode of Analysis. In: Singh, T.V., Theuns, H.L., and Go, F.M. (Eds), *Towards Appropriate Tourism*. Frankfurt am Main: Peter Lang, pp. 93-116.

Brocks, J. (1993). Threat of Skin Cancer Changing the Way Australians Live. *Canadian Medical Association* 148: 2027-2029.

Brokensha, P., and Gulber, H. (1992). *Cultural Tourism in Australia*. Canberra: Australian Government Publishing Service.

Burchett, C. (1988). Aboriginal Tourism in Australia's Northern Territory. In: D'Amore, L.J., and Jafari, J. (Eds), *First Global Conference: Tourism - a Vital Force for Peace*. Montreal, pp. 41-45.

Bureau of East Asian and Pacific Affairs (1996). *Fact Sheet: Asia-Pacific Economic Cooperation*. Washington: Bureau of Public Affairs.

Bureau of Statistics (1996). *Statistical News* 20, May.

Butler, R.W. (1980). The Concept of a Tourism Area Cycle of Evolution. Implications for the Management of Resources. *Canadian Geographer* 24: 5-12.

Butler, R.W. (1990). The Influence of the Media in Shaping International Tourist Patterns. *Tourism Recreation Research* 15(2): 46-53.

Canadian Tourism Commission (1996). *Canadian Tourism Information Network*. Ottawa: Canadian Tourism Commission.

Cartwright, R. (1996). Travellers' Diarrhoea. In: Clift, S., and Page, S.J. (Eds), *Health and the International Tourist*. London: Routledge, pp. 44-66.

Caslake, J. (1993). Tourism, Culture and the Iban. In: King, V.T. (Ed.), *Tourism in Borneo*. Williamsburg: Borneo Research Council, pp. 67-90.

Cater, E.A. (1994). Introduction: Problems of Definition. In: Cater, E., and Lowman, G. (Eds), *Ecotourism: A Sustainable Option?* Chichester: John Wiley & Sons, pp. 3-17.

Cater, E.A., and Lowman, G. (Eds) (1994). *Ecotourism: A Sustainable Option?* Chichester: John Wiley & Sons.

Cavaco, C. (1995). Rural Tourism: The Creation of New Tourist Spaces. In: Montanari, A., and Williams, A. (Eds), *European Tourism: Regions, Spaces and Restructuring*. Chichester: John Wiley & Sons, pp. 127-149.

Ceballos-Lascuráin, H. (1996). *Tourism, Ecotourism, and Protected Areas*. Gland: IUCN.

China Tourism News (1993). Beijing, July 17.

Choi, C.J. (1996). Emerging or Developing: The Critical Difference. *Business News*, Summer, 11-13.

Chon, K.-S. (1989). Understanding Recreational Travelers' Motivation, Attitude and Satisfaction. *Tourist Review* 44(1): 3-7.

Chon, K.-S. (1990). The Role of Destination Image in Tourism: A Review and Discussion. *Tourist Review* 45(2): 2-9.

Chon, K.-S., and Oppermann, M. (1996). Tourism Development and Planning in the Philippines. *Tourism Recreation Research* 21(1): 35-43

Chon, K.-S., and Singh, A. (1995). Marketing Resorts to 2000: Review of Trends in the USA. *Tourism Management* 16: 463-469.

Choy, D.J.L. (1984). Tourist Development: The Case of American Samoa. *Annals of Tourism Research* 11: 573-590.

Christaller, W. (1955). Beiträge zu einer Geographie des Fremdenverkehrs. *Erdkunde* 9: 1-19.

Cleverdon, R. (1988). Marketing of Tourism in South Pacific Countries: Trends and Directions. In: Asian Productivity Organization (Ed.), *Symposium Report on Productivity Promotion for South Pacific Countries*. Tokyo: APO, pp. 37-69.

Clift, S., and Page, S.J. (1996). *Health and the International Tourist*. London: Routledge.

Cock, P., Pfueller, S., Cook, A., Curlewis, A., Guevera, R., and Plumridge, T. (1996). A Community Planning Model for Ecotourism: Partnerships for Sustainable Futures. In: Gardner, T. (Ed.), *Strategic Alliances: Ecotourism Partnerships and Practice - Compiled Conference Papers*. Brisbane: Ecotourism Association of Australia, pp. 64-71.

Cockerell, N. (1993). Germany Outbound. *EIU Travel & Tourism Analyst*, No.2, 19-34.

Cohen, E. (1972). Towards a Sociology of International Tourism. *Social Research* 39: 164-182.

Cohen, E. (1973). Nomads from Affluence: Notes on the Phenomenon of Drifter Tourism. *International Journal of Comparative Sociology* 14: 89-102.

Cohen, E. (1979). A Phenomenology of Tourist Experiences. *Sociology* 13(1): 179-201.

Cohen, E. (1989). Primitive and Remote: Hill Tribe Trekking in Thailand. *Annals of Tourism Research* 16: 30-61.

Cohen, E. (1993). The Study of Touristic Images of Native People: Mitigating the Stereotype of a Stereotype. In: Pearce, D.G., and Butler, R.W. (Eds), *Tourism Research: Critiques and Challenges*. London: Routledge, pp. 36-69.

Cole, R.V. (1993). Economic Development in the South Pacific: Promoting the Private Sector. *World Development* 21: 233-245.

Commonwealth Department of Tourism (1995). *National Strategy on the Meetings Incentives Conventions and Exhibitions Industry*. Canberra: Australian Government Publishing Service.

Connelly-Kirch, D. (1982). Economic and Social Correlates of Handicraft Selling in Tonga. *Annals of Tourism Research* 9: 383-402.

Cooke, P., and Morgan, K. (1993). The Network Paradigm: New Departures in Corporate and Regional Development. *Environment and Planning* D 11: 543-564.

Cossar, J. (1996). Travellers' Health. In Clift, S. and Page, S.J. (Eds). *Health and the International Tourist*. London: Routledge, pp. 23-43.

Cossar, J., McEachran, J., and Reid, D. (1993). Holiday Companies Improve their Health Advice. *British Medical Journal* 306: 1069-1070.

Cossar, J., Reid, D., Fallon, R., Bell, E., Ridling, M., Follett, E., Dow, B., Mitchell, S., and Grist, N. (1990). Accumulative Review of Studies on Travellers, their Experiences of Illness and the Implications of their Findings. *Journal of Infection* 21: 27-42.

Craig-Smith, S.J., and French, C. (1994). *Learning to Live with Tourism*. Melbourne: Pitman.

Craik, J. (1991). *Resorting to Tourism: Cultural Politics for Tourist Development in Australia*. Sydney: Allen & Unwin.

Crocombe, R. (1989). *The South Pacific: An Introduction*. Suva: University of the South Pacific.

Crompton, J.L. (1979). An Assessment of the Image of Mexico as a Vacation Destination and the Influence of Geographical Location upon that Image. *Journal of Travel Research* 17(4): 18-23.

Cruise Lines International Association (1995). The Cruise Industry - An Overview. In: Commonwealth Department of Tourism (Ed.), *National Cruise Shipping Strategy*. Canberra: Commonwealth Department of Tourism.

Dawood, R. (1989). Tourists' Health - Could the Travel Industry Do More? *Tourism Management* 10: 285-287.

de Burlo, C. (1989). Land Alienation, Land Tenure, and Tourism in Vanuatu, a Melanesian Island Nation. *GeoJournal* 19: 317-321.

de Vaus, D.A. (1995). *Surveys in Social Research*. St Leonards: Allen & Unwin.

Dearden, P., and Harron, S. (1992). Tourism and the Hilltribes of Northern Thailand. In: Weiler, B., and Hall, C.M. (Eds), *Special Interest Tourism*. London: Belhaven Press, pp. 95-104.

Department of Conservation (1995). *Visitor Strategy*. Wellington: Department of Conservation.

Department of Foreign Affairs and International Trade (1996). *Canada's Year of Asia Pacific Backgrounder*. Ottawa: Department of Foreign Affairs and International Trade.

Dilley, R.S. (1986). Tourist Brochures and Tourist Images. *Canadian Geographer* 30: 59-65.

Din, K. (1990). *Bumiputera Entrepreneurship in the Penang-Langkawi Tourist industry*. University of Hawaii: PhD Dissertation (unpublished).

Durkheim, E. (1964). *The Division of Labour in Society*. New York: Free Press.

Dwyer, L., and Forsyth, P. (1994). Government Support for Tourism Promotion: Some Neglected Issues. *Australian Economics Papers*, December, 335-374.

Dwyer, L., and Forsyth, P. (1996). MICE Tourism to Australia: A Framework to Assess Impacts. *1996 Conference of Australian Tourism & Hospitality Educators*. Canberra: Bureau of Tourism Research, pp. 313-324.

Dwyer, L., and Forsyth, P. (1997). Impacts and Benefits of MICE Tourism: A Framework for Analysis. *Tourism Economics* 3(1): 1-18.

Echtner, C.M., and Ritchie, J.R.B. (1993). The Measurement of Destination Image: An Empirical Assessment. *Journal of Travel Research* 31(4): 3-13.

Edgington, D.W. (1990). *Japanese Business Down Under: Patterns of Japanese Investment in Australia*. London: Routledge.

European Commission (1994). *Europe 2000+: Cooperation for European Territorial Development*. Brussels: European Commission.

Fagence, M. (1992). The Legacy of Europe in the Pacific Region. Presented at *Tourism in Europe Conference*, Durham, 8-10 July.

Fay, R. (1992). *Tahiti: A Lonely Planet Survival Kit*. Melbourne: Lonely Planet Publications.

Fiji Constitution Review Commission (1996). *The Fiji Islands: Towards a United Future* (Parliamentary Paper No 34). Suva: Government Printer.

Fiji Visitors' Bureau [FVB] (1995). *1996 Marketing Plan: Executive Summary*. Suva: FVB.

Finney, B.R., Watson, K.A. (Eds) (1975). *A New Kind of Sugar: Tourism in the Pacific*. Honolulu: East-West Cultural Learning Institute.

Fisk, E.K. (1970). *The Political Economy of Independent Fiji*. Canberra: Australian National University Press.

Fitzharris, B.B., and Kearsley, G.W. (1988). Appreciating our High Country. In: Holland, P.G., and Johnston, W.B. (Eds), *Southern Approaches*. Dunedin: University of Otago, pp. 197-218.

Fletcher, J.E., and Snee, H. (1989). Tourism in the South Pacific Islands. *Progress in Tourism, Recreation and Hospitality Management* 1: 114-124.

Forbes, J. (1988). *Black Africans and Native Americans: Colour, Race and Caste in the Evolution of Red-Black Peoples*. Oxford: Basil Blackwell.

France, P. (1969). *The Charter of the Land: Customs and Colonization in Fiji*. Melbourne: Oxford University Press.

Freysinger, V.J., and Chen, T. (1993). Leisure and Family in China: The Impact of Culture. *World Leisure and Travel* 35(3): 22-24.

Frodey, C., and O'Hara, J. (1993). Exceeding Customer Expectations: The Key to Successful South Pacific Island Resorts. Paper presented at the *Eighth International Conference of the Operations Management Association* (UK), 'Service Superiority', Warwick Business School, University of Warwick, May.

Garnaut, R. (1990). *Australia and the Northeast Asian Ascendancy.* Canberra: Australian Government Publishing Service.

Garten, J.E. (1997). Troubles Ahead in Emerging Markets. *Harvard Business Review* May/June, 38-49.

Gartner, W.C. (1993). Image Formation Process. *Journal of Travel & Tourism Marketing* 2(2/3): 191-216.

Giddens, A. (1990). *The Consequences of Modernity.* Cambridge: Polity Press.

Giongo, F., Bosco-Nizeye, J., and Wallace, G.N. (1994). *A Study of Visitor Management in the World's National Parks and Protected Areas.* North Bennington: Ecotourism Society.

Goffman, E. (1968). *Asylums.* Harmondsworth: Penguin.

Golay, F.H., Anspach, R., Pfanner, M.R., and Ayal, E.B. (1969). *Underdevelopment and Economic Nationalism in Southeast Asia.* Ithaca: Cornell University Press.

Gould, S.J. (1995). Sexualized Aspects of Consumer Behavior: An Empirical Investigation of Consumer Lovemaps. *Psychology & Marketing* 12: 395-413.

Graburn, N.H.H. (1978). Tourism: The Sacred Journey. In: Smith, V.L. (Ed.), *Hosts and Guests: The Anthropology of Tourism.* Oxford: Basil Blackwell, pp. 17-31.

Graburn, N.H.H. (1989). Tourism: The Sacred Journey. In: Smith, V.L. (Ed.), *Hosts and Guests: The Anthropology of Tourism* (2nd Ed.). Philadelphia: University of Pennsylvania Press, pp. 21-36.

Gray, H.P. (1967). Tourism as an Export Industry in South-East Asia: A Long-Run Prognostication. *Philippine Economic Journal* 6: 155-169.

Greenwood, D.J. (1982). Cultural Authenticity. *Cultural Survival Quarterly* 6(3): 27-28.

Greenwood, D.J. (1989). Culture by the Pound: An Anthropological Perspective on Tourism as a Cultural Commodification. In: Smith, V.L. (Ed.), *Hosts and Guests: The Anthropology of Tourism* (2nd Ed.). Philadelphia: University of Pennsylvania Press, pp. 171-186.

Griffin, K., and McKinley, T. (1994). *Implementing a Human Development Strategy.* London: Macmillan.

Grigg, S. (1984). *Pleasures of the Flesh: Sex and Drugs in Colonial New Zealand, 1840-1915.* Wellington: Reed.

Gunn, C.A. (1994). *Tourism Planning: Basics, Concepts, Cases.* Washington: Taylor & Francis.

Halfter, G. (1980). Biosphere Reserves and National Parks: Complementary Systems of Natural Protection. *Journal of Science on Society* 30: 269-277.

Hall, C.M. (1994a). *Tourism in the Pacific Rim: Development, Impacts and Markets.* Melbourne: Longman.

Hall, C.M. (1994b). Ecotourism in Australia, New Zealand and the South Pacific: Appropriate Tourism or a new Form of Ecological Imperialism. In: Cater, E., and Lowman, G. (Eds), *Ecotourism: A Sustainable Option?* Chichester: John Wiley & Sons, pp. 137-157.

Hall, C.M. (1997). *Tourism in the Pacific Rim* (2nd. Ed.). Melbourne: Longman.

Hall, C.M., and Page, S.J. (Eds) (1996). *Tourism in the Pacific: Issues and Cases.* London: International Thomson Business Press.

Hamal, K. (1997). Substitutability Between Domestic and Outbound Holiday Travel in Australia. *Pacific Tourism Review* 1(1): 23-33.

Hamdi, R. (1996a). Singapore: Tourism Capital. *TravelAsia*, 2 August.

Hamdi, R. (1996b). S'pore Aims to be Tourism Capital: Lion City Launches Boldest Tourism Blueprint Yet. *TravelAsia,* 26 July.

Han, N., and Guo, Z. (1995). An Investigation into the Current Situation of China's Nature Reserves. In: *China's Biosphere Reserves - Special English Issue.* Beijing: Chinese National Committee for Man the Biosphere Program, pp. 6-9.

Hannerz, U. (1992). *Cultural Complexity: Studies in the Social Organization of Meaning.* New York: Columbia University Press.

Hanson, J. (July 1994-December 1995). *Notes from New Zealand.* Thirty Reports for the Canadian Broadcasting Corporation's (Saskatchewan) Morning Edition.

Harris, C. (1983). *Recreation on the Routeburn Track: Image and Experience.* University of Otago: MA Thesis (unpublished).

Harrison, D. (1988). *The Sociology of Modernization and Development.* London: Routledge.

Harrison, D. (1992). Tourism to the Less Developed Countries: The Social Consequences. In: Harrison, D. (Ed.), *Tourism and the Less Developed Countries.* London: Belhaven Press, pp. 19-34.

Harron, S., and Weiler, B. (1992). Review: Ethnic Tourism. In: Weiler, B., and Hall, C.M. (Eds), *Special Interest Tourism.* London: Belhaven Press, pp. 83-94.

Hawkes, N. (1996). Setting New Bench Marks for Productivity. *Hotelier*, May, 15.

Haywood, K.M. (1990). Revising and Implementing the Marketing Concept as it Applies to Tourism. *Tourism Management* 11: 195-205.

Heatwole, C.A. (1989). Body Shots: Women in Tourism-Related Advertisements. *Focus* 39(4): 7-11.

Henderson, H.K.A. (1991). *Dimensions of Choice: A Qualitative Approach to Recreation, Parks, and Leisure Research.* State College: Venture Publishing.

Hensdill, C. (1996). Partnerships in Dining. *Hotels,* February, 57-60.

Herath, G. (1996). Ecotourism in Asia and the Pacific: Potential, Problems and an Integrated Planning Model. *1996 Conference of Australian Tourism & Hospitality Educators.* Canberra: Bureau of Tourism Research, pp. 501-511.

Higham, J.E.S. (1996). *Wilderness Perceptions of International Visitors to New Zealand. The Perceptual Approach to the Management of International Tourists Visiting Wilderness Areas within New Zealand's Conservation Estate.* University of Otago: PhD (unpublished).

Higham, J.E.S., and Kearsley, G.W. (1994). Wilderness Perception and its Implication for the Management of the Impacts of International Tourism on Natural Areas in New Zealand. In: Ryan, C., and Cheyne, J. (Eds), *Tourism Down-Under: A Tourism Research Conference*. Palmerston North: Massey University, pp. 505-529.

Hinch, T.D., and Li, Y. (1994). Developing Cultural Tourism in China: Opportunities and Challenges. In: Go, F., and Qu, H. (Eds), *Reducing the Barriers to International Tourism*. Hong Kong: The Hong Kong Polytechnic University, pp. 80-87.

Hobhouse, H. (1989). *Forces of Change: Why We Are the Way We Are Now*. London: Sidgwick & Jackson.

Hobson, J.S.P. (1994). Growth of Tourism in East Asia and the Pacific. *Tourism Management* 15: 150-155.

Hobson, J.S.P., and Dietrich, U.C. (1994). Tourism, Health and Quality of Life: Challenging the Responsibility of Using the Traditional Tenets of Sun, Sea, Sand, and Sex in Tourism Marketing. *Journal of Travel & Tourism Marketing* 3(4): 21-38.

Hoon, Y.S. (1996a). Canadians Pack More Tourism Punch. *TravelAsia*, 7 June.

Hoon, Y.S. (1996b). Canadians Reassert Interest in Asia. *TravelAsia*, 8 November.

Hotelier (1996a). Increase in Cruise Traffic. May, 8.

Hotelier (1996b). Sales and Catering Automation: The Key to Increased Profits. May, 9-10.

Hotelier. (1996c). Reducing Manpower by Automation and Information Technology. May, 11-14.

Hotels (1996a). International Tourism World, Regional Prospects 1990-2010. Chart, January, 6.

Hotels (1996b). Rapid Rise in Rooms. Chart, May, 8.

Hsieh, S., and O'Leary, J.T. (1993). Communication Channels to Segment Pleasure Travelers. *Journal of Travel & Tourism Marketing* 2(2/3): 57-75.

Huang, C.T., Yung, C.Y., and Huang, J.H. (1996). Trends in Outbound Tourism from Taiwan. *Tourism Management* 17: 223-228.

Hudman, L.E. (1979). Origin Regions of International Tourism. *Wiener Geographische Schriften* 53/54: 43-49.

Hudman, L.E., and Davis, J.A. (1994). World Tourism Markets: Changes and Patterns. *TTRA 25th Annual Conference*, Bal Harbour. Wheatridge: TTRA, pp. 127-145.

Hughes, G. (1995). The Cultural Construction of Sustainable Tourism. *Tourism Management* 16: 49-59.

Hultkrantz, L. (1995). On Determinants of Swedish Recreational Domestic and Outbound Travel, 1989-93. *Tourism Economics* 1: 119-146.

Hultsman, J. (1995). Just Tourism: An Ethical Framework. *Annals of Tourism Research* 22: 553-567.

Hunt, J.D. (1975). Image as a Factor in Tourism Development. *Journal of Travel Research* 13: 1-7.

Hunter, C. (1995). On the Need to Re-conceptualize Sustainable Tourism Development. *Journal of Sustainable Tourism* 3(3): 155-165.

Industry Commission (1995). *Tourism Accommodation and Training. Draft Report.* Canberra: Australian Government Publishing Service.

Instituto Ecuatoriano Forestal y de Areas Naturales y Vida Silvestre [INEFAN] (1996). *Visitantes al Parque Nacional Galápagos de 1979 a 1995.* Puerto Ayora: Parque Nacional Galápagos.

International Congress and Convention Association (1995). *Press Release 6 June.* Amsterdam: ICCA.

International Hotel Association [IHA] (1996). *Keeping a Green Hotel.* Paris: IHA.

Jackson, M.H. (1993). *Galápagos: A Natural History.* Calgary: University of Calgary Press.

Jacobs, R., and Jones, M. (1995). *Structured On-the-Job-Training: Unleashing Employee Expertise in the Workplace.* San Francisco: Berrett-Kochler.

Japan External Trade Organization [JETRO] (1996). *White Paper on International Trade 1996.* Tokyo: JETRO.

Jefferies, M. (1989). Booster for GP Travel Vaccine Clinics. *Monitor* 2(31): 10-11.

Jennings, G.R. (1996). Cruising and Associated 'Touristic' Experiences. In: Oppermann, M. (Ed.), *Pacific Rim Tourism 2000: Issues, Interrelations, Inhibitors.* Rotorua: Waiariki Polytechnic, pp. 166-168.

Jordan, J. (1991). *Women in the New Zealand Sex Industry talk to Jan Jordan.* Auckland: Penguin.

Joseph, W.B. (1982). The Credibility of Physically Attractive Communicators: A Review. *Journal of Advertising* 11(3): 15-24.

Jubenville, A. (1976). *Outdoor Recreation Planning.* Philadelphia: W.B. Sanders.

Kearsley, G.W. (1982). *Visitor Survey of Fjordland National Park.* Wellington: Land and Survey Department.

Kearsley, G.W. (1990). Tourist Development and Wilderness Management in Southern New Zealand. *Australian Geographer* 21(2): 127-140.

Kearsley, G.W. (1995). Recreation, Tourism and Resource Development Conflicts in Southern New Zealand. *Australian Leisure*: 26-30.

Kearsley, G.W. (1996). The Impacts of Tourism on New Zealand's Back Country Culture. In: Robinson, M., Evans, N., and Callaghan, P. (Eds), *Tourism and Cultural Change.* Newcastle: University of Northumbria, pp. 135-146.

Kearsley, G.W. (1997). Managing the Consequences of Over-use by Tourists of New Zealand's Conservation Estate. In: Hall, C.M., Jenkins, J., and Kearsley, G.W. (Eds), *Tourism, Planning and Policy in Australia and New Zealand: Issues, Cases and Practice.* Sydney: Irwin.

Kearsley, G.W., and Higham, J.E.S. (1996). Wilderness and Back Country Motivations and Satisfaction in New Zealand's Natural Areas and Conservation Estate. *Australian Leisure.*

Kearsley, G.W., and O'Neill, D. (1994). Crowding, Satisfaction and Displacement: The Consequences of the Growing Tourist Use of Southern New Zealand's Conservation Estate. In: Ryan, C., and Cheyne, J. (Eds), *Tourism Down-Under: A Tourism Research Conference*. Palmerston North: Massey University, pp. 171-184.

Kedit, P.M. (1980). *A Survey on the Effects of Tourism on Iban Longhouse Communities in the Skrang District, Second Division, Sarawak* (Sarawak Museum Field Report 2). Kuching: Sarawak Museum.

Keesing, R.M. (1992). The Past and the Present: Contested Representations of Culture and History. In: Goldsmith, M., and Barber, K. (Eds), *Other Sites: Social Anthropology and the Politics of Interpretation*. Palmerston North: Massey University, pp. 8-28.

Kellert, S.R. (1996). *The Value of Life: Biological Diversity and Human Society*. Washington: Island Press.

Keng, K.A. (1997). Assessing Macro Environment Trends in Singapore: Implications for Tourism Marketers. *Asia Pacific Journal of Tourism Research* 1(2): 5-14.

Keogh, C. (1991). *Routeburn Track Market Study*. University of Otago: MBA Dissertation (unpublished).

Kerin, R.A., Lundstrom, W.J., and Sciglimpaglia, D. (1979). Women in Advertisements: Retrospect and Prospect. *Journal of Advertising* 8: 37-42.

Killion, L. (1992). *Understanding Tourism, Study Guide*. Rockhampton: Central Queensland University.

Kinder, R. (1994). *The Deviant Tourist and the Crimogenic Location: The Case of the New Zealand Prostitute*. Palmerston North: Unpublished BA(hon) thesis.

King, B. (1994). Research on Resorts: A Review. *Progress in Tourism, Recreation and Hospitality Management* 5: 165-180.

King, B., and McVey, M. (1996). Accommodation: Resorts in Asia. *EIU Travel & Tourism Analyst*, No.4, 35-50.

King, B., Pizam, A., and Milman, A. (1993). Social Impacts of Tourism: Host Perceptions. *Annals of Tourism Research* 20: 650-665.

King, B., and Weaver, S. (1993). The Impact of the Environment on the Fiji Tourism Industry: A Study of Industry Attitudes. *Journal of Sustainable Tourism* 1: 97-111.

King, V.T. (1993). Tourism and Culture in Malaysia, with Reference to Borneo. In: King, V.T. (Ed.), *Tourism in Borneo*. Williamsburg: Borneo Research Council, pp. 29-44.

Klemm, M. (1992). Sustainable Tourism Development: Languedoc-Roussillon Thirty Years On. *Tourism Management* 13: 169-180.

Klieger, P.C. (1990). Introduction: Breaking the Tourist Trap. *Cultural Survival Quarterly* 14(1): 2-5.

Kliskey, A.D., and Kearsley, G.W. (1993). Mapping Multiple Perceptions of Wilderness in Southern New Zealand. *Applied Geography* 13: 203-223.

Körner, H. (1994). The 'Third World' in the 1990s: Problems and Challenges. *Intereconomics* 29: 92-97.

Kong, G., Liang, C., Wu, H., and Huang, Z. (1993). *Dinghushan Biosphere Reserve: Ecological Research History and Perspective*. Beijing: Science Press.

Kroon, H. (1995). The Dynamics of Outgoing Tourism: Potentials and Threats of Holiday Travel and Destination Choice. *Tijdschrift voor Economische en Sociale Geografie* 86: 42-49.

LaBasse, J. (1984). Les congrès, activité tertiaire de villes privilégiées. *Annales de géographie* 93(520): 688-703.

Laskey, H.A., Seaton, B., and Nicholls, J.A.F. (1994). Effects of Strategy and Pictures in Travel Agency Advertising. *Journal of Travel Research* 32(4): 13-19.

LaTour, M.S., and Henthorne, T.L. (1993). Female Nudity. Attitudes toward the Ad and the Brand, and Implications for Advertising Strategy. *Journal of Consumer Marketing* 10(3): 25-32.

Lavenson, J. (1974). Think Strawberries: Everybody Sells. Address to the American Medical Association, New York. February 7, 1974.

Lavery, P. (1993). UK Outbound. *Travel & Tourism Analyst* 1993, No.3, 20-34.

Lea, J. (1996). Tourism, *Realpolitik* and Development in the South Pacific. In: Pizam, A., and Mansfeld, Y. (Eds), *Tourism, Crime and International Security Issues*. Chichester: John Wiley & Sons, pp. 123-142.

Lee, G.P. (1987). Future of National and Regional Tourism in Developing Countries. *Tourism Management* 8: 86-88.

Lew, A.A. (1987). A Framework of Tourist Attraction Research. *Annals of Tourism Research* 14: 553-575.

Li, Y. (1995). *Sustainable Tourism and Cultural Attractions: A Comparative Study of Ethnic Interpretive Centers in China and Canada*. University of Alberta: MA Thesis (unpublished).

Lindberg, K., Enriquez, J., and Sproule, K. (1996). Ecotourism Questioned: Case Studies from Belize. *Annals of Tourism Research* 23: 543-562.

Lindberg, K., Goulding, C., Mo, J., Huang, Z., Wei, P., and Kong, G. (1996). *Ecotourism at the Dinghushan Biosphere Reserve*. Johnstone Centre Report No. 81. Albury: Charles Sturt University.

Lindberg, K., and Johnson, R.L. (1997). Modeling Resident Attitudes Toward Tourism. *Annals of Tourism Research* 24: 402-424.

Lindberg, K., McCool, S., and Stankey, G.H. (1997). Rethinking Carrying Capacity. *Annals of Tourism Research* 24: 461-465.

Lindberg, K., and McKercher, B. (1997). Ecotourism: A Critical Overview. *Pacific Tourism Review* 1(1).

Linklater, A. (1990). *Wild People*. London: John Murray.

Lockhart, D.G. (1993). Tourism to Fiji: Crumbs Off a Rich Man's Table? *Geography* 78: 318-323.

Lowry, L.L. (1993). Sun, Sand, Sea & Sex: A Look at Tourism Advertising Through the Decoding and Interpretation of Four Typical Tourism Advertisements. *Proceedings 1993 Society of Travel & Tourism Educators Conference*, Miami, pp. 183-204.

Lucas, E. (1994). Reinventing Atlantic City - Again. *Association Meetings* 6(5): 24-37.

Luxemburg, R. (1927). Stagnation and Progress in Marxism. In: Ryanzanov, D. (Ed.), *Karl Marx: Man, Thinker and Revolutionist*. New York: International Publishers, pp. 106-111.

Macbeth, J. (1985). Ocean Crusing: A Study of Affirmative Deviance. Murdoch University: PhD (unpublished).

Macbeth, J. (1993). But We Are Not Tourists, and This is Life Not Leisure. Presented at *Australian and New Zealand Association of Leisure Studies Conference*, 14-16 April.

MacCannell, D. (1976). *The Tourist: A New Theory of the Leisure Class*. New York: Schrocken Books.

Macnaught, T.J. (1982). Mass Tourism and the Dilemmas of Modernization in Pacific Island Communities. *Annals of Tourism Research* 9: 359-381.

Maguire, P.A. (1989). *Comparison of Outbound Tourism Generation from Newly Industrialized Countries in East Asia*. Clemson University: PhD (unpublished).

Malaysian Tourism Promotion Board [MTPB] (1995). *Annual Tourism Statistics*. Kuala Lumpur: MTPB.

Marshall, A. (1996). Resorts Can Learn Much More from Cruise Ship Colleagues. *Hotel & Motel Management*, February, 9-13.

Martin, W., and Mason, S. (1987). Social Trends and Tourism Futures. *Tourism Management* 8: 112-114.

Mathieson, A., and Wall, G. (1982). *Tourism: Economic, Physical and Environmental Impacts*. London: Edward Arnold.

McCool, S. (1996). Searching for Sustainability: A Difficult Course, an Uncertain Outcome. Presented at the *1996 Global Congress on Coastal and Marine Tourism*, Honolulu.

McGahey, S. (1996). South Korea Outbound. *EIU Travel & Tourism Analyst*, No.1, 17-35.

McGuire, F., Uysal, M., and McDonald, G. (1988). Attracting the Older Traveller. *Tourism Management* 9: 161-163.

McMullan, R. (1995). *Australia's Future in the Asia-Pacific Region*, Speech by the Minister for Trade, Senator McMullan at the Evatt Foundation, Sydney, 19 December 1995. Canberra: Department of Foreign Affairs and Trade.

Middleton, S. (1993). *Educating Feminists: Life Histories and Pedagogic Issues*. New York: Teachers College Press.

Milne, S. (1987). Differential Multipliers. *Annals of Tourism Research* 14: 499-515.

Milne, S. (1990). The Impact of Tourism Development in Small Pacific Island States: An Overview. *New Zealand Journal of Geography* 89: 16-21.

Milne, S. (1992). Tourism and Development in South Pacific Microstates. *Annals of Tourism Research* 19: 191-212.

Minerbi, L. (1992). *Impacts of Tourism Development in Pacific Islands*. San Francisco: Greenpeace Pacific Campaign.

Miossec, J.M. (1977). Un modèle de l'éspace touristique. *L'éspace géographique* 6(1): 41-48.

Mistilis, N. (1996). Impediments to Private Sector Involvement in Public Infrastructure: A Tourism Industry View in Australia. *1996 Conference of Australian Tourism & Hospitality Educators*. Canberra: Bureau of Tourism Research, pp. 59-69.

Mitchell, A.A. (1986). The Effect of Verbal and Visual Components of Advertisements on Brand Attitudes and Attitude Toward the Advertisement. *Journal of Consumer Research* 13(June): 12-23.

Muñoz, O. (n.d.). *Green Evaluations: An Experiment in Ecotourism*. Quito: Ecuadorian Ecotourism Association.

Munro, D. (1994). Who Owns Pacific History? *Journal of Pacific History* 29: 232-237.

Murphy, P.E. (1985). *Tourism: A Community Approach*. New York: Methuen.

Murray, S.H. (1996a). Special Report 1996. *Hotels*, January, 30-35.

Murray, S.H. (1996b). Global Marketplace. *Hotels*, April, 18-21.

National Tourism Administration of the People's Republic of China [NTA] (1992). *People's Daily*, Beijing, December 18.

NTA (1995). *The Yearbook of China Tourism Statistics*. Beijing: NTA.

Nelkin, D. (1975). The Political Impact of Technical Expertise. *Social Studies of Science* 5(1): 35-54.

Neumann, K. (1996). Staying Healthy in the Pacific. *Travel Medicine International* 14(4): 164-169.

New Zealand Tourism Board [NZTB] (1996a). *Tourism in New Zealand: Strategy & Progress*. Wellington: NZTB.

NZTB (1996b). *International Visitor Survey 1995/6*. Wellington: NZTB.

Nielson, J.M., and Endo, R. (1977). Where have all the Purists Gone? An Empirical Examination of the Displacement Hypothesis. *Sociological Review* 8(1): 61-75.

Nohlen, D., and Nuscheler, F. (Eds) (1993). *Handbuch der Dritten Welt: Grundprobleme, Theorien, Strategien, Volume 1* (3rd Ed.). Bonn: Verlag J.H.W. Dietz.

Nunn, P. (1994). *Environmental Change and the Early Settlement of Pacific Islands*. Honolulu: East-West Center.

Nuscheler, F. (1991). *Lern- und Arbeitsbuch Entwicklungspolitik*. Bonn: Verlag J.H.W. Dietz.

Ong, E. (1986). *Pua: Iban Weavings of Sarawak*. Kuching: Society Atelier Sarawak.

Oppermann, M. (1992a). Intranational Tourist Flows in Malaysia. *Annals of Tourism Research* 19: 482-500.

Oppermann, M. (1992b). International Tourism and Regional Development in Malaysia. *Tijdschrift voor Economische en Sociale Geografie* 83: 226-233.

Oppermann, M. (1993). German Tourists in New Zealand. *New Zealand Geographer* 49(1): 30-34.

Oppermann, M. (1994a). Regional Aspects of Tourism in New Zealand. *Regional Studies* 28: 155-167.

Oppermann, M. (1994b). Length of Stay and Spatial Distribution. *Annals of Tourism Research* 21: 834-836.

Oppermann, M. (1994c). Relevance of Nationality in Tourism Research. *Annals of Tourism Research* 21: 165-168.

Oppermann, M. (1994d). Travel Life Cycles - A Multitemporal Perspective of Changing Travel Patterns. In: Gasser, R.V., and Weiermair, K. (Eds), *Spoilt for Choice. Decision Making Processes and Preference Changes of Tourists - Intertemporal and Intercountry Perspectives.* Thaur: Kulturverlag, pp. 81-97.

Oppermann, M. (1994e). *Modeling Convention Location Choice and Participation Decision Making Process: A Review with Emphasis on Professional Associations.* Aix-en-Provence: Centre des Hautes Etudes Touristiques.

Oppermann, M. (1994/95). Tourism in the Philippines: Development and Regional Impacts. *Ilmu Masyarakat* 25: 21-36.

Oppermann, M. (1995a). Travel Life Cycle. *Annals of Tourism Research* 22: 535-552.

Oppermann, M. (1995b). Family Life Cycle and Cohort Effects: A Study of Travel Patterns of German Residents. *Journal of Travel & Tourism Marketing* 4(1): 23-44.

Oppermann, M. (1996a). Visitation of Tourism Attractions and Tourist Expenditure Patterns - Repeat versus First-time Visitors. *Asia Pacific Journal of Tourism Research* 1(1): 61-68.

Oppermann, M. (1996b). Convention Cities - Images and Changing Fortunes. *Journal of Tourism Studies* 7(1): 10-19.

Oppermann, M. (1996c). Convention Destination Images: Analysis of Meeting Planners' Perceptions. *Tourism Management* 17: 175-182.

Oppermann, M. (1996d). Association Involvement and Convention Participation. In: *Abstract Proceedings of the 2nd APTA Conference.* Townsville: James Cook University, p. 57.

Oppermann, M. (1996e). The Changing Market Place in Asian Outbound Tourism: Implications for Hospitality Marketing and Management. *Tourism Recreation Research* 21(2): 53-62.

Oppermann, M. (1997). Length of Stay and Travel Patterns. In: *1997 Conference of Australian Tourism & Hospitality Educators.* Canberra: Bureau of Tourism Research.

Oppermann, M., and Chon, K.-S. (1995). Time-series Analysis of German Outbound Travel Patterns. *Journal of Vacation Marketing* 2(1): 39-52.

Oppermann, M., and Chon, K.-S. (1997a). *Tourism in Developing Countries*. London: International Thomson Business Press.

Oppermann, M., and Chon, K.-S. (1997b). Convention Participation Decision-Making Process. *Annals of Tourism Research* 24: 178-191.

Oppermann, M., Din, K.H., and Amri, S.Z. (1996). Urban Hotel Location and Evolution in a Developing Country: The Case of Kuala Lumpur, Malaysia. *Tourism Recreation Research* 21(1): 55-63.

Organization for Economic Cooperation and Development [OECD] (1984). *Tourism Policy in OECD Countries*. Paris: OECD.

Pacific Asia Travel Association [PATA] (1985). *Levuka and Ovalu: Tourism Development through Community Restoration*. Sydney: PATA.

PATA (1992). *Endemic Tourism: A Profitable Industry in a Sustainable Environment*. Sydney: PATA.

PATA (1994). *Travellers to Pacific Asia Countries top 100 million during 1993*. PATA News, San Francisco.

PATA (1996). *Annual Tourism Report 1995*. San Francisco: PATA.

PATA (1997a). *Issues and Trends, Pacific Asia Travel, March*. San Francisco: PATA.

PATA (1997b). *Issues and Trends, Pacific Asia Travel, April*. San Francisco: PATA.

PATA (1997c). *Issues and Trends, Pacific Asia Travel, May*. San Francisco: PATA.

Page, S.J., and Meyer, D. (1996). Tourist Accidents and Injuries in Australasia: Scale, Magnitude and Solutions. In: Clift, S., and Grabowski, P. (Eds), *Health and Tourism: Risk, Research and Responses*. London: Cassell.

Papakura, M. (1938/1986). *The Old Time Maori*. Auckland: New Women's Press.

Patterson, S., Niolu, R., McMullen, R. and Jong, E. (1991). Travel Agents and Travel Medicine Clinics: The Potential for Co-operative Efforts to Inform the Public on Health Care Issues. In: Lobel, H., Steffen, R., and Kozarsky, P. (Eds), *Proceedings of the Second Conference on Travel Medicine, International Society of Travel Medicine*: Atlanta, no pagination.

Paxiao, M., Dewar, R., Cossar, J., Covell, R., and Reid, D. (1991). What do Scots Die of When Abroad. *Scottish Medical Journal* 36(4): 114-116.

Pearce, D.G. (1989). *Tourist Development* (2nd. Ed.). Harlow: Longman.

Pearce, D.G. (1995). Tourism in the South Pacific: Patterns, Trends and Recent Research. *Progress in Tourism and Hospitality Research* 1(1): 3-16.

Pearce, P.L. (1988). *The Ulysses Factor: Evaluating Visitors in Tourist Settings*. New York: Springer.

Pearce, P.L. (1991). Analyzing Tourist Attractions. *Journal of Tourism Studies* 2(1): 46-55.

Pearce, P.L., Moscardo, G.M., and Ross, G.F. (1996). *Tourism Community Relationships*. Oxford: Elsevier.

Peterson, R.A., and Kerin, R.A. (1977). The Female Role in Advertisements: Some Experimental Evidence. *Journal of Marketing* 41: 59-63.

Picolla, G.E. (1987). Tourism in Asia and the Pacific. *Tourism Management* 8: 137-139.

Pieterse, J.N. (1994). Globalisation as Hybridisation. *International Sociology* 9(2): 161-184.

Pizam, A., Milman, A., and King, B. (1994). The Perceptions of Tourism Employees and Their Families Towards Tourism: A Crosscultural Comparison. *Tourism Management* 15: 53-61.

PKF International (1990-1994). *Trends in the Hotel Industry*. Houston: Pannell, Kerr, Forster.

Plange, N.-K. (1996). Fiji. In: Hall, C.M., and Page, S.J. (Eds), *Tourism in the Pacific: Issues and Cases*. London: International Thomson Business Press, pp. 205-219.

Plog, S.C. (1974). Why Destination Areas Rise and Fall in Popularity. *Cornell Hotel, Restaurant and Administration Quarterly* 14(4): 55-58.

Plog, S.C. (1991). *Leisure Travel: Making it a Growth Market ... Again!* New York: John Wiley & Sons.

Przeclawski, K. (1993). Tourism as the Subject of Interdisciplinary Research. In Pearce, D.G., and Butler, R.W. (Eds), *Tourism Research: Critiques and Challenges*. London: Routledge, pp. 9-19.

Qiao, Y. (1995). Domestic Tourism in China: Policies and Developments. In: Lew, A.A., and Yu, L. (Eds), *Tourism in China: Geographic, Political and Economic Perspectives*. Boulder: Westview Press, pp. 121-130.

Qu, H., and Zhang, H.Q. (1996). Projecting International Tourist Arrivals in East Asia and the Pacific to the Year 2005. *Journal of Travel Research* 35(1): 27-34.

Quo, F.Q. (Ed.) (1982). *Politics of the Pacific Rim: Perspectives on the 1980s*. Burnaby: Simon Fraser University Publications.

Racule, A. (1983). *The Impact of Tourism on Fijian Culture*. University of the South Pacific: Bachelor thesis.

Read, S.E. (1980). A Prime Force in the Expansion of Tourism in the Next Decade: Special Interest Travel. In: Hawkins, D.E., Shafer, E.L., and Rovelstad, J.M. (Eds), *Tourism Marketing and Management Issues*. Washington: George Washington University Press, pp. 193-202.

Reilly, M.P.J. (1996). Entangled in Maori History: A Report on Experience. *The Contemporary Pacific* 8(2): 388-408.

Richins, M.L. (1991). Social Comparison and the Idealized Images of Advertising. *Journal of Consumer Research* 18: 71-83.

Richter, L.K. (1992). Political Instability and Tourism in the Third World. In: Harrison, D. (Ed.), *Tourism and the Less Developed Countries*. London: Belhaven Press, pp. 35-46.

Riggs, F.W. (1964). *Administration in Developing Countries: The Theory of the Prismatic Society*. Boston: Houghton Mifflin.

Rizzotto, R.A. (1995). Brazil Outbound. *EIU Travel & Tourism Analyst*, No.6, 21-35.

Robertson, R. (1992). *Globalization: Social Theory and Global Culture*. London: Sage.

Robinson, H. (1976). *A Geography of Tourism*. London: MacDonald and Evans.

Robles, C. (1996). The Iban Longhouse Experience. *Sarawak Tourism Network* 2(2): 4-6.

Robson, A. (1996). *Turtle Tales*. Turtle Island, Fiji: Turtle Island Resort.

Rockett, G., and Smillie, G. (1994). The European Conference and Meetings Market. *EIU Travel & Tourism Analyst*, No.4, 36-50.

Rowley, A. (1992). Asia Above the Gloom. *Far Eastern Economic Review*, 24-31 December, 52-53.

Rudkin, B., and Hall, C.M. (1996). Off the Beaten Track: The Health Implications of the Development of Special Interest Tourism Activities in Southeast Asia and the South Pacific. In: Clift, S., and Page, S.J. (Eds), *Health and the International Tourist*. London: Routledge, pp. 90-107.

Ryan, C., Robertson, E., Page, S.J., and Kearsley, G.W. (1996). New Zealand Students: Risk Behaviour while on Holidays. *Tourism Management* 17: 64-69.

Sarawak Tourism Board (1996). *Sarawak Tourism Board Home Page*. (http://www.sarawak.gov.my/stb)

Selwyn, T. (1993). Peter Pan in South-East Asia: Views from the Brochures. In: Hitchcock, M., King, V.T., and Parnwell, M.J.G. (Eds), *Tourism in South-East Asia*. London: Routledge, pp. 117-137.

Sequioa Analytical (1994). *Environmental Audit for Turtle Island*. Redwood City: Sequioa Analytical.

Shelby, B., Vaske, J.J., and Heberlein, T.A. (1989). Comparative Analysis of Crowding in Multiple Locations: Results from Fifteen Years of Research. *Leisure Sciences* 11: 269-281.

Shundich, S. (1996a). Deal makers plot to franchise the World hotels. *Hotels*, February, 31-36.

Shundich, S. (1996b). Ecoresorts: Dollars, Sense & The Environment. *Hotels*, March, 34-40.

Siers, J. (1985). *Blue Lagoons and Beaches: Fiji's Yasawa Islands*. Wellington: Millwood Press.

Simmons, D.G. (1994). Community Participation in Tourism Planning. *Tourism Management* 15: 98-108.

Singapore Tourist Promotion Board [STPB] (1995). *Myanmar's Tourism Ministry Officials to Lure Investment as Singapore Becomes Myanmar's Second Largest Investor. Press Release 112/95(10 October)*. Singapore: STPB.

STPB (1996). Singapore Tourism 21. Singapore: STPB.

Smith, M.G. (1974). *Corporations and Society*. London: Duckworth.

Smith, S.L.J. (1983). *Recreation Geography*. London: Longman.

Smith, S.L.J. (1995). *Tourism Analysis: A Handbook* (2nd ed.) Harlow: Longman.

Smith, V.L. (Ed.) (1978). *Hosts and Guests: The Anthropology of Tourism*. Oxford: Basil Blackwell.

Smith, V.L. (Ed.) (1989). *Hosts and Guests: The Anthropology of Tourism* (2nd Ed.). Philadelphia: University of Pennsylvania Press.

Soesastro, H. (1995). ASEAN and APEC: Do Concentric Circles Work? *The Pacific Review* 8: 475-493.

Sofield, T.H.B. (1991). Sustainable Ethnic Tourism in the South Pacific: Some Principles. *Journal of Tourism Studies* 2(1): 56-72.

Sofield, T.H.B. (1995). Indonesia's National Tourism Development Plan. *Annals of Tourism Research* 22: 690-694.

Sogotubu, E. (1996). Minister Clarifies Investment Problems. *Fiji Times*, 18 January, 3.

Soley, L.C., and Reid, L.N. (1988). Taking it Off: Are Models in Magazine Ads Wearing Less? *Journalism Quarterly* 65: 960-966.

Steadman, D.W. (1986). Holocene Vertebrate Fossils from Isla Floreana, Galápagos. *Zoology* 413: 1-103.

Stebbins, R. (1996). Cultural Tourism as Serious Leisure. *Annals of Tourism Research* 23: 948-950.

Stemp, S. (1994). *Historical Guide to Levuka*. Levuka.

Stymeist, D.H. (1996). Transformation of Vilavilairevo in Tourism. *Annals of Tourism Research* 23: 1-18.

Swain, M.B. (1989). Developing Ethnic Tourism in Yunnan, China: Shilin Sani. *Tourism Recreation Research* 14(1): 33-40.

Swain, M.B. (1990). Commoditizing Ethnicity in Southwest China. *Cultural Survival Quarterly* 14(1): 26-29.

Swanson, R. (1994). *Analysis for Improving Performance: Tools for Diagnosing Organisations and Documentary Workplace Expertise*. San Francisco: Berrett-Kochler.

Tacconi, L., and Tisdell, C. (1993). Holistic Sustainable Development: Implications for Planning Processes, Foreign Aid and Support for Research. *Third World Planning Review* 15: 411-427.

Tan, W. (1996). Ten Great Achievements in Ten Years' Struggle. In: *China's Biosphere Reserves - Special English Issue*. Beijing: Chinese National Committee for Man the Biosphere Program, pp. 7-12.

Thwaites, R., and DeLacy, T. (1997). Linking Development and Conservation Through Biosphere Reserves: Promoting Sustainable Grazing in Xilingol Biosphere Reserve, Inner Mongolia, China. In: Hale, P., and Lamb, D. (Eds), *Conservation Outside Nature Reserves*. Brisbane: The University of Queensland, pp. 182-189.

Tighe, A.J. (1986). The Arts/Tourism Partnership. *Journal of Travel Research* 24(3): 2-5.

Timo, N. (1996). Managing Under Pressure: Trade Unions, Productivity and Restructuring in Tourism. In: Mortimer, D., Leece, P., and Morris, R. (Eds), *Workplace Reform and Entreprise Bargaining: Issues, Cases, Trends*. Sydney: Harcourt Brace, pp. 247-256.

Tisdell, C. (1996). Ecotourism, Economics, and the Environment: Observations from China. *Journal of Travel Research* 34(4): 11-19.

Torraco, R., and Swanson, R. (1995). The Strategic Role of Human Resource Development. *Human Resource Planning,* 11-21.

Tourism Forecasting Council (1996). Perspectives on Tourism Investment. *Forecast* 2(2): 22-25.

Tourism Task Force (1996). *Tourism Transport Needs Across Australia: A Study of the Financing and Development of Tourism Transport Infrastructure.* Canberra: Tourism Task Force.

Trabold-Nübler, H. (1991). The Human Development Index - A New Development Indicator. *Intereconomics* 26: 236-243.

Turner, L., and Ash, J. (1976). *The Golden Hordes. International Tourism and the Pleasure Periphery.* New York: St Martin's Press.

Turner, V., and Turner, E.L.B. (1978). *Image and Pilgrimage in Christian Culture.* New York: Columbia University Press.

UNESCO (1995). The Seville Strategy for Biosphere Reserves. *Nature and Resources* 31(2): 2-10.

Universal Pictures (1989). *Field of Dreams.* MCA Music Corporation of America.

Urbanowicz, C.F. (1989). Tourism in Tonga Revisited: Continued Troubled Times? In: Smith, V.L. (Ed.), *Hosts and Guests: The Anthropology of Tourism* (2nd Ed.). Philadelphia: University of Pennsylvania Press, pp. 105-117.

Urry, J. (1992). Europe, Tourism and the Nation State. Presented at *Tourism in Europe Conference*, Durham, 8-10 July.

Usherwood, V., and Usherwood, T. (1989). A Survey of General Practitioners' Advice for Travellers to Turkey. *Journal of the Royal College of General Practitioners* 39: 148-150.

Uzzell, D. (1984). An Alternative Structuralist Approach to the Psychology of Tourism Marketing. *Annals of Tourism Research* 11: 79-99.

Varley, R.C.G. (1978). *Tourism in Fiji: Some Economic and Social Problems.* Bangor: University of Wales Press.

Vayda, A.P. (1975). Headhunting Near and Far: Antecedents and Effects of Coastal Raiding by the Iban in the Nineteenth Century. *Sarawak Museum Journal* 23: 111-138.

Verhoven, P.J., and Masterson, L.A. (1995). Soft Amenity Attributes: Key to a Quality Vacation Experience. *HSMAI Marketing Review* 12(1): 39-43.

Volavola (1995). The Native Land Board of Fiji. In: Crocombe, R. (Ed.), *Customary Land Tenure and Sustainable Development: Complementarity or Conflict?* Suva: University of the South Pacific, pp. 47-54.

Wahab, S.E.A. (1975). *Tourism Management.* London: Tourism International Press.

Wang, Y., and Sheldon, P.J. (1995). The Sleeping Dragon Awakes: The Outbound Chinese Travel Market. *Journal of Travel & Tourism Marketing* 4(4): 41-54.

Waters, M. (1995). *Globalization.* London: Routledge.

Weiler, B., and Hall, C.M. (Eds) (1992). *Special Interest Tourism*. London: Belhaven Press.

Weinstein, J. (1996a). Editor's Diary. *Hotels*, March, 15.

Weinstein, J. (1996b). Editor's Diary. *Hotels,* April, 13.

Wen, J., and Tisdell, C. (1996). Regional Inequality and Decentralisation of China's Tourism Industry. *1996 Conference of Australian Tourism & Hospitality Educators*. Canberra: Bureau of Tourism Research, pp. 107-120.

Wilkinson, P. (1989). Strategies for Tourism in Island Microstates. *Annals of Tourism Research* 16: 153-177.

Wilks, J., and Atherton, T. (1994). Health and Safety in Marine Tourism: A Social, Medical and Legal Appraisal. *Journal of Tourism Studies* 5(2): 2-16.

Witt, S.F., Brooke, M., and Buckley, P. (1991). *The Management of International Tourism*. London: Unwin Hyman.

World Bank [WB] (1991). *World Development Report 1991: The Challenge of Development*. New York: Oxford University Press.

WB (1994). *World Development Report 1994: Infrastructure for Development*. New York: Oxford University Press.

World Conference of Tourism Ministers (Ed.) (1994). *Statements for the World Conference of Tourism Ministers*, Osaka, Japan.

World Tourism Organization [WTO] (1985). *The Role of Recreation Management in the Development of Active Holidays and Special Interest Tourism and Consequent Enrichment of the Holiday Experience*. Madrid: WTO.

WTO (1991). *Tourist Arrivals Worldwide and in the Americas, 1950-1990*. Madrid: WTO.

WTO (1992). *Yearbook of Tourism Statistics* (44th Ed.). Madrid: WTO.

WTO (1994a). *Yearbook of Tourism Statistics* (46th Ed.). Madrid: WTO.

WTO (1994b). *Current Travel and Tourism Indicators*. Madrid: WTO.

WTO (1994c). *Tourism Market Trends East Asia and the Pacific 1980-1993*. Madrid: WTO.

WTO (1994d). *WTO News, Jan/Feb*. Madrid: WTO.

WTO (1995a). *Yearbook of Tourism Statistics* (47th Ed.). Madrid: WTO.

WTO (1995b). *Compendium of Tourism Statisctics 1989-1993* (15th Ed.). Madrid: WTO.

WTO (1995c). *International Tourism Overview*. Madrid: WTO.

WTO (1995d). *East Asia and the Pacific*. Madrid: WTO.

WTO (1996a). *Yearbook of Tourism Statistics* (48th Ed.). Madrid: WTO.

WTO (1996b). *Compendium of Tourism Statisctics 1990-1994* (16th Ed.). Madrid: WTO.

WTO (1996c). *Tourism Trends Highlights 1995*. Madrid: WTO.

WTO (1997a). Global Overview - Preliminary Results 1996. Madrid: WTO. (http://www.world-tourism.org/esta/highlights/prelres.htm; loaded on 21 April 1997).

WTO (1997b). Tourist Arrivals to Reach 1.6 billion by 2020. Press Release, 9 March 1997. Madrid: WTO. (http://www.world-tourism.org/pressrel/09-03-97.htm; loaded on 21 April 1997).

WTO (1997c). Online-Access to Masterbase Statistics on Outbound Data. Madrid: WTO. (http:www.world-tourism.org/omt-agent/owa/; acccessed 14 August 1997).

Xing, W. (1993). The Increasing Impact of Tourism on Protected Areas in China. *Contours* 6(3/4): 38-43.

Yacoumis, J. (1989). South Pacific Tourism Promotion: A Regional Approach. *Tourism Management* 10: 15-28.

Yacoumis, J. (1990). Tourism in the South Pacific: A Significant Development Potential. *The Courier*, July/August, 81-82.

Yongwei, Z. (1995). An Assessment of China's Tourism Resources. In: Lew, A.A., and Yu, L. (Eds), *Tourism in China: Geographic, Political and Economic Perspectives*. Boulder: Westview Press, pp. 41-59.

Zeppel, H. (1993). Getting to Know the Iban: The Tourist Experience of Visiting an Iban Longhouse in Sarawak. In: King, V.T. (Ed.), *Tourism in Borneo*. Williamsburg: Borneo Research Council, pp. 59-66.

Zeppel, H. (1994). *Authenticity and the Iban: Cultural Tourism at Iban Longhouses in Sarawak, East Malaysia*. James Cook University: PhD (unpublished).

Zeppel, H. (1995). Authenticity and Iban Longhouse Tourism in Sarawak. *Borneo Review* 6(2): 109-123.

Zeppel, H., and Hall, C.M. (1991). Selling Art and History: Cultural Heritage and Tourism. *Journal of Tourism Studies* 2(1): 29-54.

Zhang, G. (1995). China's Tourism Development Since 1978: Policies, Experiences and Lessons Learned. In: Lew, A.A., and Yu, L. (Eds), *Tourism in China: Geographic, Political and Economic Perspectives*. Boulder: Westview Press, pp. 3-17.

Zhao, Z., and Han, N. (1996). Open Management Strategy: Biosphere Reserves in China. In: *China's Biosphere Reserves - Special English Issue*. Beijing: Chinese National Committee for Man the Biosphere Program, pp. 4-6.

Index